A celebration
of the paintings of
Tom Thomson
1877–1917

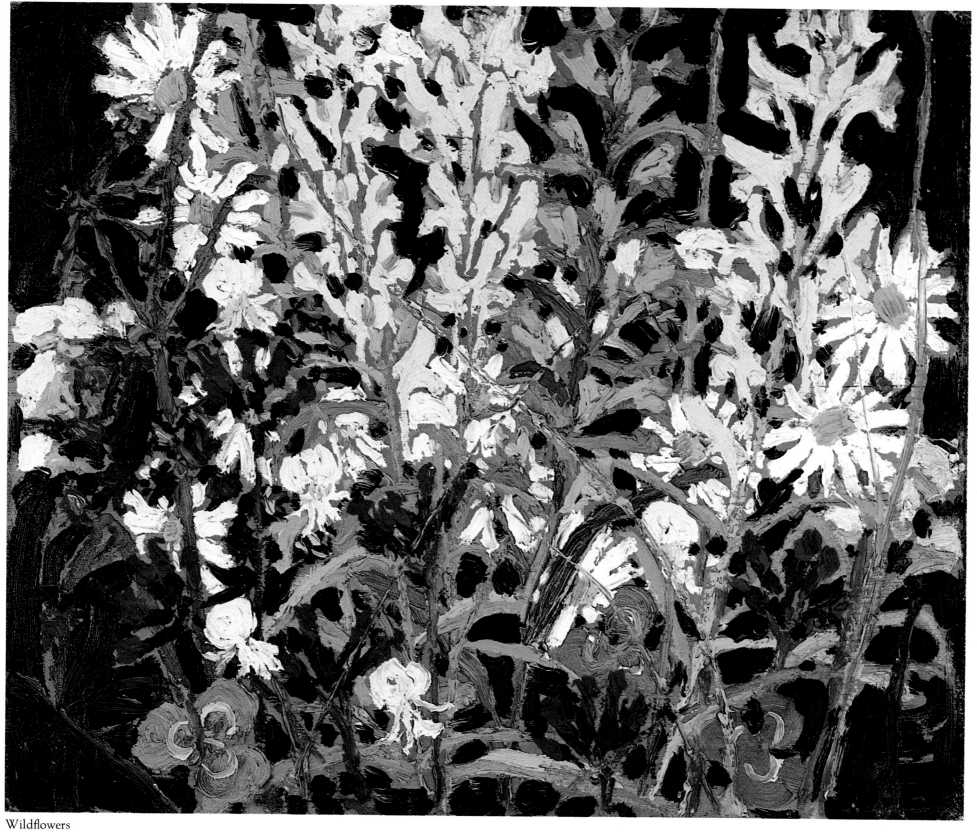

Wildflowers

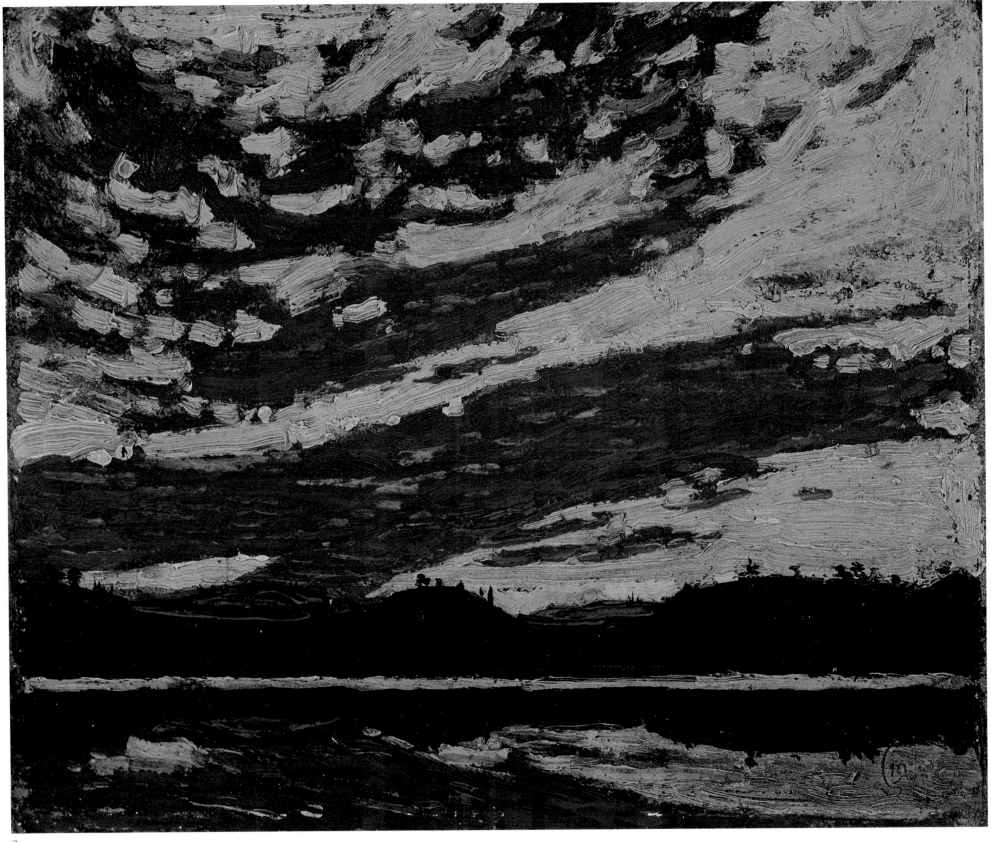

Sunset

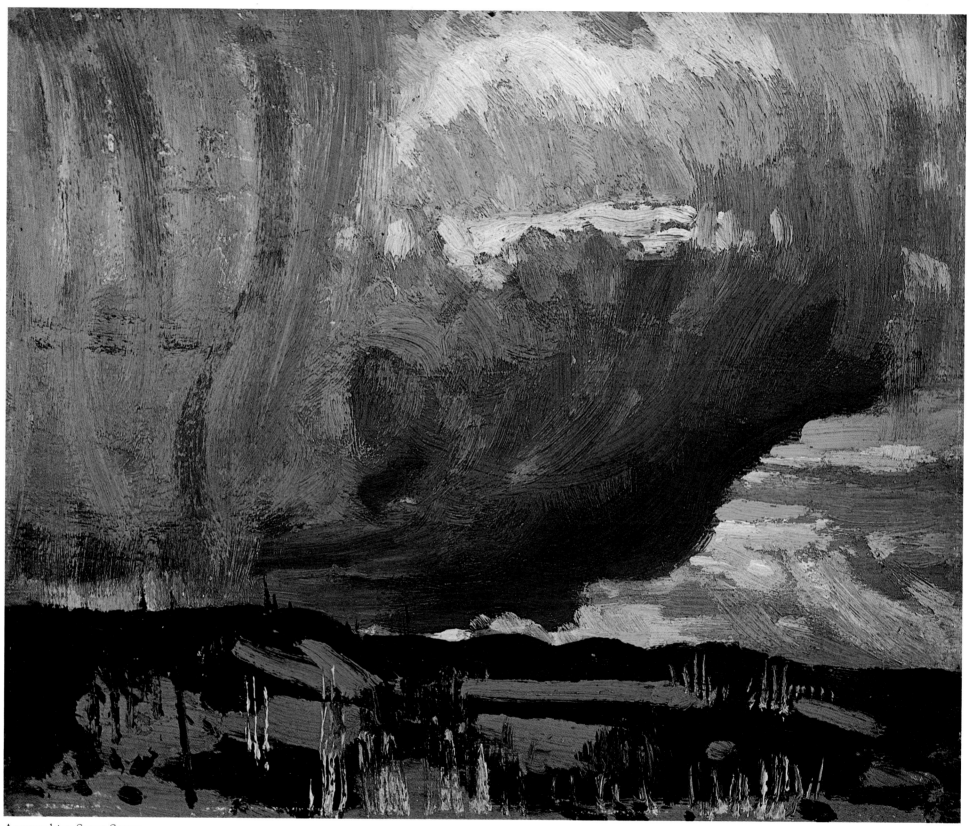

Approaching Snow Storm

TOM THOMSON

THE SILENCE AND THE STORM

Harold Town and David P. Silcox

McCLELLAND AND STEWART

The Canadian Publishers
McClelland and Stewart Limited
25 Hollinger Road, Toronto M4B 3G2

0-7710-8482-X

Printed and bound in Canada

CANADIAN CATALOGUING IN PUBLICATION DATA

Town, Harold, date
 Tom Thomson

Bibliography: p.
Includes index.
ISBN 0-7710-8482-X

1. Thomson, Tom, 1877-1917. I. Silcox, David P., date

ND249.T5T69 1977 759.11 C77-001436-4

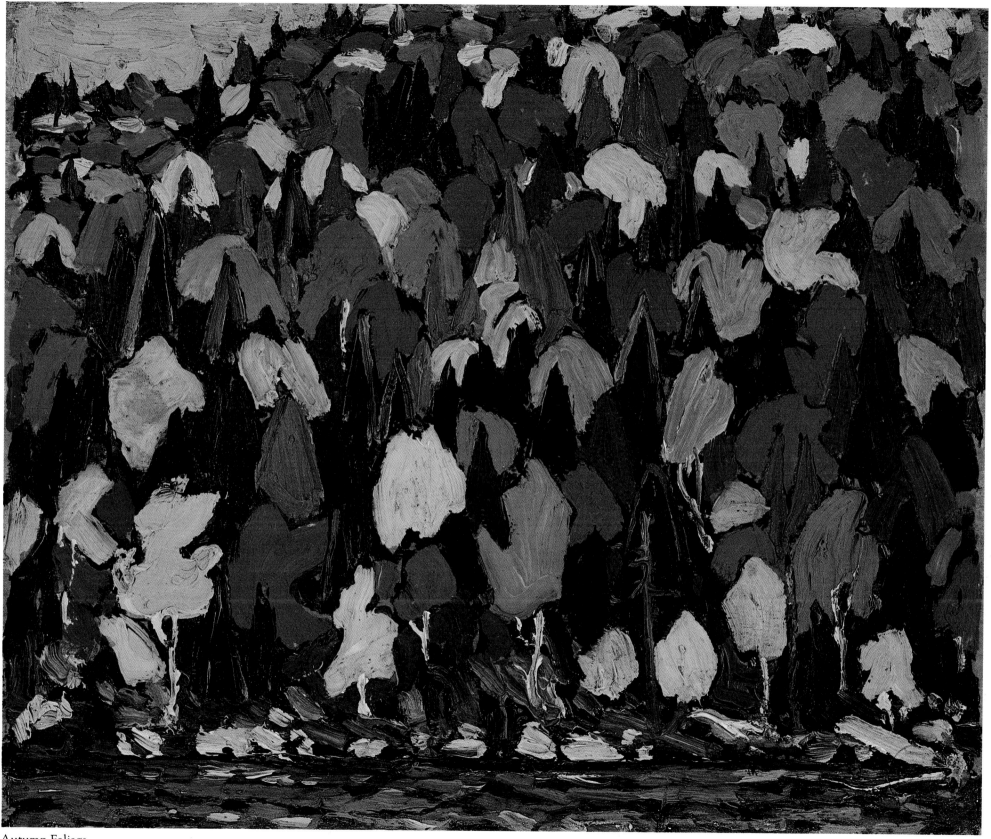

Autumn Foliage

11

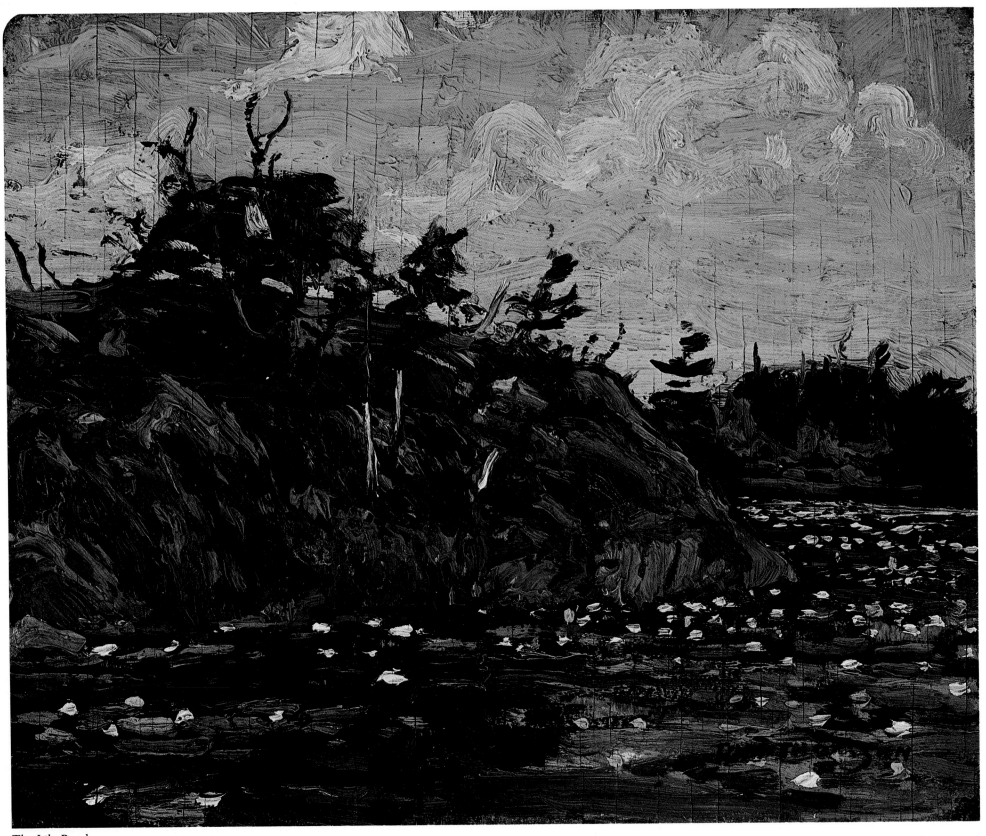

The Lily Pond

Acknowledgements

One cannot individually thank all those who helped with the book. A response to a letter or a phone call, a remembrance that led to other information, a visit or welcome refreshment – the cooperation and assistance we received was always enthusiastic and generous. For all assistance, large or small, we extend our appreciation.

Iris Nowell undertook most of the initial research, and nourished the project throughout. The owners of Thomson's paintings were most accommodating in the course of photography and they often suffered inconvenience which they bore courteously. We hope they are pleased with the result. The members of the Thomson family, and particularly Tom Thomson's niece, Mrs. F.E. Fisk, were open and helpful, and gave us access to important material.

While the public galleries across the country responded readily, we are particularly indebted to the staffs of the National Gallery of Canada, especially Helen Clark; the Art Gallery of Ontario, especially Maia-Mari Sutnik; the McMichael Canadian Collection, and Catherine Harrison and James Logan of the Tom Thomson Memorial Gallery and Museum of Fine Art in Owen Sound.

Joan Murray, the Director of the Robert McLaughlin Gallery in Oshawa, has done much of the recent research on Thomson. While she was at the Art Gallery of Ontario she prepared the 1971 exhibition of Thomson's paintings and wrote the catalogue. Without her extensive study, our work would have been immensely difficult and protracted. She freely gave us access to her files and notes, made useful suggestions, and aided in every way possible.

The quality of the colour reproductions is due in large part to the talents of two men. Michael Neill photographed all but seven of the colour plates with a skill that is as astonishing as it is meticulous. His work made it possible for Arne

Roosman, who supervised the colour work and did the manual etching, to prepare colour separations of remarkable calibre.

For assistance with typing, compilation of lists and checking, we also wish to thank Sandra Shaul, Margaret MacDonald and Barbara Bugner.

Photography credits
Colour photography: all works by Michael Neill, except National Gallery of Canada, pp. 70 (*Spring Ice*), 95, 124, 181 and 191 (*Winter in the Woods*); and Ron Vickers, pp. 45 (*Early Snow*) and 169.

Black and white photography: Michael Neill: pp. 50, 51, 52, 54, 212, 214 (except *Man in a Riding Costume*), 224, 225.

Ron Vickers: pp. 33, 55, 56, 57, 98, 99, 100, 101, 102, 103, 104, 147, 148, 149, 150, 151, 152, 196, 197, 202, 210, 211, 213, 214 (*Man in a Riding Costume*), 215.

D. P. S.

Preface

We intend this book to serve a double purpose: to mark the one-hundredth anniversary of Tom Thomson's birth, and to celebrate the artist's talent. Although Thomson is one of Canada's creative heroes, he is known by too few paintings and too many dark speculations. There is a great deal written about how he died; our purpose is to show what he lived for.

Our primary goal was to display the range and power of Thomson's achievement as a painter. The importance and subtlety of his colour and the persistent horizontality of his work, not unusual for a landscape painter, demanded an unusual format. One hundred and thirty of the 177 colour plates are of pictures published in colour for the first time, and nearly half are reproduced in their actual size.

Our selection was made from over five hundred works, which we culled, sorted and discussed for over a year. The choices were our own, as was the arrangement, which was in part dictated by a compatibility of colour that would give the best results in printing. The design, within the normal limits of colour and text sequences, was under our control and we accept responsibility for any shortcomings. Our aim was to avoid flamboyant graphic solutions – to allow viewers to concentrate on the works themselves. The paintings have been trimmed only where the unpainted edges left by the slides that held the work in Thomson's sketch box seemed intrusive and detrimental to his intent. We have put the sketches and the larger paintings of the same subject side by side for comparison, and gathered pictures together that seemed to us to have common attributes. Regretfully, we had to omit a number of excellent works.

In stripping away the discolouring varnish that the years have laid over the facts and the perceptions of Thomson's life and art, we have found, for ourselves

at least, a painter who needs no puffery or protection. The exaggeration of his skills and habits, the irony of his death and, above all, the uncritical and myopic adulation of anything that passes as one of his paintings can no longer be sustained. Thomson's work and his legend can bear tough scrutiny without losing either grace or power.

What finally matters most in painting is looking and savouring. This volume is not a comprehensive or a chronological regimentation of Thomson's work. Though our information is based as much as possible on primary sources, we have not included the exhaustive detail of interest only to scholars. We have set out to present a feast for the eye and the mind, in the hope that this representation of Thomson's paintings will allow others to share our sense of celebration of a great Canadian.

David P. Silcox
Old Orchard Farm
Peterborough

Contents

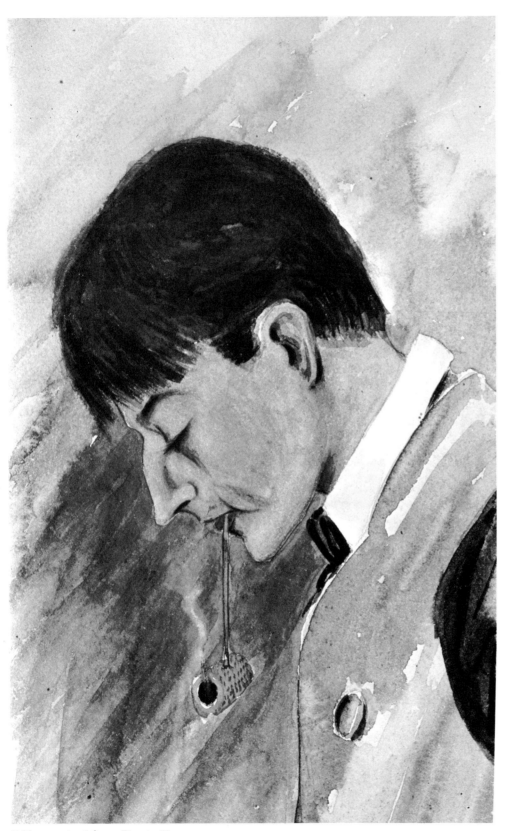

Self-portrait: After a Day in Tacoma

Introduction
by Harold Town

Above Picasso's protean achievements flies a banner cut from the lives of the women who punctuated his career and received in the popular press as much attention as his work. Jackson Pollock's death, in a tangle of girls and crumpled steel, when inflated by the huge prices currently paid for his paintings, is more interesting to the public than the fact that academic abstractionists have circled back to his breakthrough style, making his art central again to the problems of modern painting. Van Gogh's torment, his struggle with private demons and public contempt, has been trivialized in mass entertainment by his ear, a bloody present for a strumpet who wouldn't hear his cry. The painter's ear, though an inept symbol for his extraordinary life, is an appropriate one for the dilemma of contemporary art, which is covered by a slick guano of words disguised as criticism while in fact being nothing more than advertising copy, press-agentry and an easy game for tenth-rate sensibilities. People prefer to read about painters, to hear about painting, to speculate in the art market—anything rather than look at painting, anything but make art a re-creative part of their lives. Painting is a pariah waiting to be told by art authorities where to stand and beg, so as not to interfere with the flow of commerce in the marketplace.

In Canada the canvases of Tom Thomson are seen through a scrim of printed supposition on which is projected his death in the waters of Canoe Lake—waters that since that time have been continually muddied by the club-footed wading of art ghouls and plain fools who have turned his creative odyssey into the pedestrian plot for a drug-rack paperback. Unquestionably, Tom Thomson is Canada's most famous artist, yet only a few of his works are well known and those are mainly his studio machines, the heavy efforts near to his talent but far from his heart.

At the time of Thomson's death in July 1917, the useless carnage continued

in Europe. Month in, month out, exploding shells tore the earth; yet art, like the famous poppies of Flanders, flowered. Frank Kupka, the Czech painter, was forty-six years old and had been for many years the pioneer of completely non-objective art. Cubism, under the direction of Braque and Picasso, was busy cutting space into shallow planes and angles; two years before, Duchamp intentionally preserved his cracked glass abstraction, *Nine Malic Moulds*. In 1914 English vorticist Wyndham Lewis, in the country that so long had stifled Canadian creativity, produced the first issue of a counter-culture magazine called *Blast* and exhibited his painting *Plan of War*, which consisted of lines and blocks of colour presaging the First World War. (Ironically, after such a dashing start, Lewis was caught in Toronto during the Second World War working for and hating Douglas Duncan.) Despite the war, Europe was in creative ferment. Debussy complained he was "too old to do anything but guard a fence," yet continued composing music. Poetry shot from the trenches as rapidly as machine-gun bullets. Duchamp and Picabia founded the Society of Independent Artists in New York in 1916 and their arrival in North America initiated a period of growth and adventure in painting which by 1960 made New York the art capital of the world.

It seems preposterous, in retrospect, that anything done by Thomson or the Group of Seven during this particularly fecund period of western art could be deemed either revolutionary or interesting. It has been said that war is the spur in art, yet Rembrandt just sat down and painted his nose as Spanish guns boomed down the street. While da Vinci saw no conflict for the artist's soul in designing cannon and fortifications, Cellini was as ready to stick a dagger into a rival as compliment his coat.

European art thrived through many upheavals, especially during the Napoleonic, Franco-Prussian and Great Wars. So much creative talent perished in the First World War that the survivors, such as Léger, La Fresnaye, Braque and many more (assuming that the good die young), make one wonder if the whole of Europe was about to turn to art before the butchery of the trenches shattered the ranks of the advance guard of western creativity.

A. Y. Jackson, one of the first Canadian painters to volunteer for duty, produced much of our best war painting. His lyrical works of this period, often Fauvish in colour, seemed to long for peace and frequently put nature ahead of the war. Varley as a war artist carried a heavy symbolic load; his pictures could well have been titled before they were started. He was marked by a concern for man that in later years took him away from landscape painting. Both Jackson and Varley returned to Canada free from the virus of plastic revolt and immediately continued Thomson's unfinished war with an intransigent North. They raised arms against lonely skies and hills in a land that uniquely marked them all (just as lower-

ing skies had done the painters of Zeeland in the sixteenth century) and, with the exception of Harris, turned away once and for all from Europe and the cerebrations of space as a problem rather than a paintable fact.

Giving Thomson his overrated skill as a woodsman, Jackson a proven ability to withstand cold and Varley his Olympic prowess with drink (which could be witnessed any day at Malloney's bar in the early 1950s in Toronto), none of these men was as rugged as Augustus John, whose excesses with women were matched by unnecessary physical risk and athleticism. Or Percy Grainger, composer of bucolic airs, a precious spirit capable of running twenty miles and then giving a concert. Thomson and the Group of Seven had a strong mystical, even didactic bent and at this distance they would seem to be the ripe and steamy compost for revolutionary ideas, yet they preferred woodsy philosophy. Some of today's younger artists view them as a kind of premature macho school of *coureurs de bois* stomping about in the bush compensating for effete beginnings in classical foreign art schools and tiresome jobs in commercial engraving houses. Whatever the truth in this assessment, it changes nothing. Our concern should remain with their work.

Where do Thomson and the Seven fit in that warehouse behind our eyes that stores images of Tintoretto and the Taj Mahal? It is mindless to complain that Thomson or the Group failed to change the face of world art; it is what they did that matters. Theirs was an involution of pivotal national significance precisely because it did not mirror, substantiate, imitate or pay the slightest heed to world art. French painter André Marchand said it is necessary to step back to jump a fence. Thomson and the Group did not just step back, they raced back to the markers and started over, all the way, past the brown gravy and tight military needlepoint of our pioneer art, to the beginning, to the land as it looked before it was forced into the both familiar and accepted shape of other times and other cultures.

This was the expression of a remarkable instinct. Something told them to clean house, to begin again, to ignore fashion – a brave stance at any time, for painters are as conscious of fashion as *Vogue* magazine. Despite concomitant developments in Quebec with Suzor-Coté, Cullen and Gagnon, Thomson and the Group came to stand for Canadian art. Like it or not, we had something identified as Canadian art, a cohesive lump in our national gut – seemingly rough painters who said to hell with trends and gave us an assessable, simple beginning, a fire for some, dying embers for others. We could love them or hate them but we had a starting line, a palpable place from which to move forward. Their strength was in numbers, understandable in a huge country, and the fact that others working alone did not receive attention equally deserved is unfortunate but does not diminish the accomplishments of Tom Thomson and the Group of Seven in any way. Theirs was an

idea so simple, even innocent, that we have often missed its point, and are the beneficiaries of its effect to this day. It was an implosion, not an explosion. And by looking inward it gave us an outward identity.

Traditionally Canadians have accepted foreign domination in the arts as naturally as medieval peasants the power of the barons, and without a whimper we have delivered up our bounty for everything from doctored French wine to doctored economic theory. Recently, with the growth of Canadian nationalism, we have given the mantle of fame to a few of our own, but grudgingly (a certain segment of Canadian academia seems determined to reduce the experimental brilliance of Marshall McLuhan to the level of provincial eccentricity). However, the deification of Tom Thomson is complete, solidified in sales that have broken Canadian records. His works are no longer paintings but stock in an investment portfolio, or a neat tax write-off – pictures that are distanced from simple understanding with every price rise. Thomson's life rather than his art is searched by the national consciousness for hints, portents and even criminal reasons for his premature death at the height of his powers. Though artificially inflated, the tragedy of Thomson's death fulfills the Canadian love of defeat and annihilation, a national tick that may be explained by our tiny seasons of pleasure. Harried by cold, we jerk about to a rigid rhythm of slow growth and expeditious dying. Our short, nearly non-existent summers, in which flowers wither and fall before we know their names, as birds nest and vanish leaving a random feather blowing in brief sun, entice us into another cycle of life. But they do not satisfy. Thomson's slow development and sudden departure precisely duplicated the severity of our climate. Bloated in the water, dead before the leaves of fall, his death spelled out a symbolic end to the Canadian art we colonials had no right to expect. Tragedy could be substituted for promise; we would mourn Thomson and forget Canadian art.

In an eerie manner the Group of Seven, formed after Thomson's death, unconsciously promoted a sense of loss. Summer, that joy at the centre of most schools of landscape painting with its quietus of green, appears rarely in their work. Absent are Corot's quick-silver fugues of leaf, Constable's pulsating shadows aching with life, the cartwheeling exuberances of Marin's sky-crazed inscapes, Monet's golden muffins of hay or his waterlilies capable of persuading Ophelia to live. Instead, our painters gave us spring, that glimpse of a season, or the garishness of fall and the embalming death of snow, but rarely hedonistic summer. It became the illegitimate season of Canadian art. Green was on the proscribed list. I remember my surprise, at a small exhibition in the Art Gallery of Toronto of Peter Lanyon, an English artist, over his excessive greens; and as late as the 1960s I heard someone remark at a show of de Tonnancour's painting at the Laing Galleries,

"Yes, they're nice, but the *green!*" Summer was for foreigners; we preferred to suffer.

It would be difficult to exaggerate the power of Thomson and the Group's influence during the thirties and forties. I saw my first reproduction of a Thomson at the age of ten in the hall at Regal Road Public School glowing between two politely gory depictions of our boys in the mud of France. Heavy competition. A few years later at Western Tech I was made to feel that MacDonald's *The Tangled Garden* was all the summer I would ever need and that Thomson had gone to heaven to save us all from the sin of desiring alien art. A fellow student painted a copy of *The Pointers* while nipping on a mickey of rye, thinking he was emulating Thomson. At the Ontario College of Art in 1943 the commercial art department was directed by Franklin Carmichael of the Group, whose influence was considerable. Principal Fred S. Haines blustered into the painting class and delivered a well-meant but incoherent harangue on the pernicious influence of Modigliani, and teacher John Alfsen went into a funk when I suggested Rembrandt had architectonic weaknesses. In Canada it was a period of resistance to the winds of change; we buttoned up our conceptual overcoats and backed into the past.

Nevertheless, Thomson and the Seven cannot be blamed for a stasis that was international. A colossus named Picasso towered over world art. He symbolized modern painting and brushes bowed to the mecca of Paris. Matisse at the age of fifty was lost in Picasso's shadow, despite the fact that the future ran past Picasso's feet in the form of an insidious movement called Dada and left the Spaniard in a cul-de-sac, secure in his role as perhaps the last great classic artist. During this period the Group did very little to redefine their myth, nor did they hang together trying to perpetuate the communal force of their passionate beginning. Art writers swiped at any sign of change with the swatter of Group virtue and the sanctity of landscape. Canadian art was there for the taking but no one grabbed. Milne's oil drawings, which rejected fortissimo impasto for an eastern delicacy of touch, and FitzGerald's snow painted from his kitchen window, were not the stuff of fable; they lacked the public appeal of pioneering art trappers on the trail of creation. Emily Carr was seen as a felinophile eccentric who wrote darling books and was too worked up about trees – she even came all the way from Vancouver to Toronto to be blessed by the Group. Morrice, a painter of rare grace, had little long-term influence. Borduas was effectively driven from Quebec by his visual experiments, the publication of *Refus Global* and the church. Canadian art was in hold, with no clear pattern of flight.

Ironically, the vacuum left by the death of Thomson and the dispersion of the Group was filled in the early 1950s by the brute power of that multinational conglomerate of influence, the New York school of Abstract Expressionism, which

led to a tacit rejection of everything that had gone before (all art movements have a genesis complex). The effect of the conquest has been salubrious. We have survived. And in the new national awakening we are able to appreciate Thomson and the Group of Seven realistically, within the perimeters of their influence on Canada, without fear of comparison.

Though the early impact made on Thomson's skills as a painter by J. W. Beatty has been underrated, Beatty's influence is evident in works such as *Marsh, Lake Scugog, Near Owen Sound, Fairy Lake* and *Big Elm*. Yet it was Jackson's painting, *The Edge of the Maple Wood*, that pulled the mat out from under the status quo and set Thomson and his mentors in new directions. *The Edge of the Maple Wood* was to Canadian art what *Le Déjeuner sur l'Herbe* or *Les Demoiselles d'Avignon* was to French art. Its plangent colour and effortless virtuosity, its sense of absolute Canadian place, galvanized a grumble of dissatisfaction into the tumble of revolt. To this day the painting has not been fully appreciated. Few masters (given the context of Jackson's humble intention) could surpass the impeccable retreat from the picture plane of shadow over lumpy, out-cropped earth, shadow that snakes the ground rather than digging eye-stopping trenches. The colour cast in a dominant green ochre is like a family, different from hue to hue, unique from stroke to stroke, but bound together by a mystique of blood, a heritage going back to Sassetta. Though unglazed, it is bathed in an all-over cohesion of light that makes its casual surface nearly classic. I can understand how Thomson felt when he saw the painting and later claimed it made him see the Canadian landscape for the first time, for I still remember it whacking me across the eyes at the Art Gallery of Toronto years ago. With his Fauve-like *Springtime in Picardy, 1918,* Jackson left *The Edge of the Maple Wood* and was on the edge of a break with his past. Upon his return to Canada after the war Jackson seemed to step back from his reaching instinct and pursued an ever-increasing brown-out of colour; his simplifications carried a dead weight of unfelt rhythm.

Thomson, though influenced by Jackson, instinctively knew better. The latent violence in his character inclined him to face down the storm and bash and thump the canvas into plasticized diminutions of form and fugitive light. His colour, aided by a stiff-armed brush, had a natural roughness. Thomson was not a wrist painter; he jabbed a picture into submission and consequently did not have to strain for roughness. For a brief time MacDonald, in paintings such as *Church by the Sea*, attacked the panel as if Thomson's shade possessed him. Thomson and the consequential members of the Group – Varley, MacDonald, Lismer, Harris and Jackson – were genuine Super Realists, for they worked beyond the celluloid tedium of the currently fashionable photographic schools and tried to subdue the space, not just in front but behind their heads. Theirs was not to be a replication made simply

through a jellied lens set in the skull, but an apprehension of sound and odour coming from the nerve endings; and when they failed it was the moment at which the tickle of cold in the nostrils and the sting of bracken scratches did not enter and become a part of the sketch.

In the making of significant art there is no middle ground, no safe pasture for the meandering stream of a quiet talent. Really bad art is close at any given moment to high art, for high art is the art of failure, a constantly interrupted journey to some impossible reality at the centre of the brain. Bad art is failure as a journey sometimes graced by an accidental success. Cézanne's slashed canvas hanging in a tree cried failure. Picasso loathed the slaughter of Guernica and transformed his pain into a decorative assemblage of shadow feeling, emotion lost through preparatory drawing. For Thomson, passion was immediate; emotion, like cloud, changes, transforms, fades, deepens, disappears – he would have gone directly to canvas and got it down. But what a picture *Guernica* became. That it has in its final appearance little to do with the bombing of a Spanish town but a lot to do with Picasso is beside the point. Art succeeds in inverse proportion to the degree of failure in the artist's intentions. As Cézanne wrote to Roger Marx, "My age and my health will never allow me to realize the dream of art I have pursued all my life." Thomson and the Group succeeded in those years when their ambition overwhelmed their talent, when they tried to reduce the stupendous size of Canada to an 8 x 10 sketch. What survives is the force of effort past attainment.

Thomson, however, did not fail. His death saw to that. He was moving forward and there was no wall yet in front of his ambition. Much more than an aging ploughboy, Thomson was reaching into a dark place within reticence and pulling out eggs laid by chickens he had never seen. His skill was greater than generally conceded and he knew it. The silence and woodsy simplicity was possibly a disguise, even a defence against the revelation of a masterly technique, for open ability has never been admired in Canada.

Thomson could manipulate a brush with easy virtuosity, hesitating in the middle of a stroke, turning abruptly during sweep, flattening and extending the width, contracting, rolling the hair to its edge without, like a great baseball pitcher, losing his rhythm. The brush caught just enough of the wet underpainting to adhere and mark the pigment without muddying the individual hues. When necessary Thomson pressed down and produced a neutralized squash of colour that saved him from interrupting a stabbing arm movement by mixing on the palette those indeterminate shades of oil that referee the struggle between brilliant colours. He mastered a trick common to hacks who paint flowers on trays, in which the brush is loaded with local colour, then a judicious amount of pure colour is picked up by the edge of the brush so that the major tone of the stroke is delivered

to the canvas with a streaking of pure colour. It is a minor though useful aid to a painter's cunning and requires a refined sensibility to avoid the look of midway kitsch.

Milne admired Thomson and wrote in a letter to H. O. McCurry of the National Gallery of Canada in 1932, "I rather think it would have been wiser to have taken your ten most prominent Canadians and sunk them in Canoe Lake – and saved Tom Thomson." Both artists had in common a similar inability to draw the human figure, and hidden in their outwardly incompatible styles is a juncture at which their drawing connects.

Milne was the master of a very personal split-hair, dry-brush technique in which the two contiguous lines applied simultaneously by the same instrument form one line. The divided brush reduces the fluidity of application and hampers overbearing skill but brings a compensational eccentricity to the line in that the two separate strokes are not equal in shape or density. The force of line is reduced and to be successful a precise relationship must exist between the colour around the line and the division within the line. The division is as important as the line it divides.

Thomson used the natural wood colour of his birchwood support and occasionally the painted ground as a linear path for the eye between areas of colour. The American artist A. V. Tack pioneered a completely abstract use of this technique in the 1930s and, in effect, the method could be called the intimated line, drawing without brush and, in Milne's case, the divided or third line process. Most of the Group used the natural colour of the panel or a painted ground to separate and neutralize the edge of local colour. None, however, was as instinctively precise and natural in the method as Thomson. Rarely does the colour key of his paint next to the invisible line formed by the uncovered panel jar tonal relationships or tilt and confuse the orderly progression of planes moving from the surface of the picture to the limit of implied depth. Thomson's "invisible drawing" sticks to the skin of the work and is like a mesh pulling form together, a web that spins into space but clings to the eye. Occasionally, as in *Georgian Bay, Byng Inlet,* Thomson's facility outstrips his emotion and is held in check only by the jerky rhythm of the elusive line formed by unpainted panel and the consistent hue and texture of the wood. These natural sections of unfinished birchwood boards are central to the infrangible skin of his pictures; the intimated line is the skeleton of the past in the flesh of the present picture and displays the core of Thomson's daring.

In certain works, *The Pointers,* for example, a dark ground is scraped away so that the top of the texture of the canvas shows through, providing a black contrast to the final coat of paint, not unlike that of a colour television tube. The linked

"invisible drawing" is an insurance policy against crackling in the paint, for when faults occur they seem to join and support the unpainted sections between colour mass which is a prototype for the deformity.

Thomson's panel, the thin yet sturdy surfaces of birch panel and occasionally plywood, was more than a support for his paint. He took advantage of the leeching effect of the wood on the medium (usually linseed or poppy oil at that time) in his pigment and adjusted the faster drying colour to speed of application in overpainting. He painted to the loss of oil which gave, despite the swift brushing, a firmness plus weight and texture to pigment that was crusty rather than slippery, sculptural rather than frothy. The current practice of spraying a shiny varnish over his sketches diminishes the plasticity of Thomson's intent.

Thomson was a master colourist. Rarely did he miss the mark, and then inexplicably with those canvases containing a sizable amount of red. In large portions this colour upset his judgment and he lost the ratio between local colour values, and consequently the middle tones became strident in hue. *Autumn Foliage* (in the National Gallery of Canada collection) is an idiosyncratic example of this shortcoming. His prime achievements with brilliant colour are often set back from a succulent yellow, such as the blocks of trees in *Autumn Foliage* (page 11) which, having given the time signature for a specific beat, step back in an interrogatory order. *The Lily Pond* (page 12) is notable for a lamination of colour mixed by touch and tone into what Duchamp defined as "that quality beyond painting"–a tremble of the kind you feel when a subway train passes under a building. Its resonance would do credit to Courbet.

Composition was not a factor in the mechanics of painting that bothered Thomson. Despite the awkward, tentative design of some early work he quickly achieved an admirable simplicity of attack, an easy, even casual approach to the construction of his painting. Certainly, he left out elements of the Algonquin bushscape, adding and subtracting forms, moving nature about at will, rearranging things like a cleaning lady, a push here and pull there, and on to the main business of clothing his naked reaction to the fickle light of Algonquin with paint. The force behind the developing signature of his impetuous brush champed at the bit of composition and struggled to get at the joy of slabbing colour over the barest of working plans. It was the desire to paint, to mix colour and expeditiously get on with it that saved Thomson from the compositional fussiness that pervades the structure of some Group painting.

All artists are recidivists and the best excel in visiting their past. Thomson was no exception. Occasionally he would slide back and embrace a whirling arabesque and dance to the distant tunes of Art Nouveau; however, on the whole he was distinctively free of compositional devices and platitudes of form, interior

cones, hidden highways for the eye, leading perspective and other floor plans of a typical art education. Thomson was fortunate that he had so little to forget. As a priest would, he accepted the grinding restriction of the horizon and the discipline that came with the fact that the Algonquin experience was presented best in a horizontal format. Thomson depended on his passion, on the rabid bite of his excitement to compensate for the limits imposed on his work by both his model and methods of execution. Considering the sudden thrust of his power to express himself with paint he displayed admirable restraint in the delineation of the natural staffage of bush, small trees growing out of stumps, fungus like half pies on the side of dead wood, and those precious compositional life-savers—fallen tree diagonals. Instead, he relied on brush mark and colour to support this unique way of seeing. Excepting the complicated tracery of *Northern River*, Thomson rarely used a *repoussoir* tree or other configuration in his foregrounds as a fulcrum in order to increase an illusion of depth. His focus generally rested in the middle ground, as he was capable of stretching the eye past the foreground into a satisfying openness. The perpendicular drive of elements within the design is handled with natural skill in the way colour is marshalled through the military precision of trees guarding a hill or parading in the woods, so that counterbalancing rhythms have a plosive effect on the stifling order of bush, which may seem wild but has a stultifying predictability; most of it starts on the ground and grows up. If trees refused to stay in place within the scheme of recession, he often transposed their positions by the simple act of changing the direction of the brush stroke between branches, which brought deep space forward or shoved it back.

There is, under the nimble application of paint, an implicit classicism, equally moved by the silence and the storm. Thomson could materialize the bleached light of noon and those periods between dawn and sunset when the mechanical eye of the camera sees little. In this part of the day Thomson decreased his contrasts and increased the complexity of stroke. Conversely in *Nocturne* (page 85) the night was taken into account with the broadest of handling. Thomson's colour is further characterized by a limited range of tone. Contracting the stretch between maximum dark and maximum light he condensed the scope of hue within these reduced parameters. Often, as a consequence, purely local colour jumps into a more vibrant relationship with the key pigments. This aspect of his sensitivity is clearly graphic in character. *Burnt Over Forest*, though based on only four significant differences of tone, delivers an intense feeling of crisp air, yet there is no appreciable shading; the pulsation is projected by muscular force of brush. Very often Thomson was able to produce colour which seemed so much a stroke of the brush that it came on to the canvas with an implied tone not actually in the paint. *Petawawa Gorges* (pages 72 and 73) on the other hand, is scruffed into submission by half scumbling

that merchandises the texture of canvas instead of feeling. When he attempted to scumble in long strokes his hand was directed by a metronome. It took the short, staccato dabs of *Spring Ice* to preserve emotion within an expanded tonal procedure.

Much has been made of Thomson's spontaneity, a kinship to rock and brotherhood with tree that poured through a simple nature directly on to the canvas. It would be foolish to deny his small sketches the spriteliness that comes from rapid application of paint, yet there is a certainty in the variation of local colour placed against his brightest pigment that marks a degree of thought beyond the sudden push of instinct. Knowingly Thomson reduced the range of tone within his graphic sense of colour so as to add a ping, a sharpness to the personal but somewhat faceless calligraphy of form. Extremes of tone are the goalposts of his methodology, yet it is the large spread of middle tone when the score is made and magic is added to his vision of Algonquin. The dangerous stretch of middle tone became a No Man's Land tempting the attack of his brush and produced tension, for the urge to prettify, soften and fill such areas with grace notes had to be continually resisted. Harold Rosenberg, in *Art on the Edge*, writes, "Greatness in art is always a by-product, but of an activity that begins and ends in art"; so tension in art is often derived from the resistance to tendencies never quite controlled, in a constant war with negative or easy procedures. In Thomson, simplification was not a goal but the result of struggle with pictorially negative solutions, the by-product of a deeply felt response to a landscape that brought out the best and the worst in him simultaneously.

Known as a retreating colour during the Renaissance, blue was considered difficult to manage in the foreground of composition, and was generally positioned through the scheme of design in gradually lightened hues until it reached an infinity of typical Raphael sky. Few painters in Canada's brief history have used blue with more skill than Thomson. In the treatment of water he deceived the eye with colours other than blue, and in his skies rejected the facile retreat of light blue in favour of a daring range of tone and hue which formed a relationship to land and water that agitated the propinquities of mass.

Though more precise and committed to a complete range of tone, J.E.H. MacDonald was nearly the equal of Thomson as a colourist. His *Young Maples Algoma, 1918* has the ripeness of a Thomson but is marred by the dainty detail in the yellow maple leaves. Varley attempted to achieve more with colour than any painter of the period. His tortured surfaces and ruptured coruscations of paint make one think of the artist in de Maupassant's story who laboured so long on a canvas he obliterated all figuration—in a literary premonition of twentieth-century abstraction. Comprised on the whole of strong colourists, none of the Group could control density and tone and still make neutral contrast hues seem

brilliant in the manner of Thomson. He possessed an uncanny ability to stop down and deepen hues, or conversely lighten them without losing the intensity of contrast typical to work of greater tonal range.

Delacroix wrote in his journal in 1850, "The two conceptions of painting … that of colour as *colour* and of light as *light*, have got to be reconciled in a single operation." This Thomson seemed to do with ease. He tried so intensely to achieve fleeting effects of light that he forced light and colour on to his brush in a single sweep. I have been unable to find any reference to his admiration of Veronese, yet he knew as well as that great master that when you throw a broad light on a canvas you strengthen the local colour so as to avoid scamping the harmonics of the picture's orchestration.

Ingres felt that "… when one has learned well how to imitate nature, the chief consideration for a good painter is to *think out* the whole of his picture, to have it in his head as a whole … as if the entire thing were done at the same time." This is a prime characteristic of the later Thomson. The paint appears to be pulled over the support in one piece, like a sheet over the bed of his working method. During the apotheosis of Thomson's style in 1917 his vision and the creative apparatus he had assembled through instinct and hard practice revealed a sense of strain; the paint shoved against the limitations of scale. He seemed impatient with what he knew and wished to make the brush a sword rather than a trowel. Conception was no longer a rope leading up to better things but a halter reining in inspiration. Dissatisfied with heaping paint on the canvas, he ached to cut through the panels to a deeper reality. His momentum was toward a concept of painting such as Abstract Expressionism. It is the confluence of explosive power and imprisoned impulse that agitates the work of the final period, a force of application that hums with frustration and yearns for action – a consuming appetite for paint fed on too small a fork.

At the time of his death a perturbed Thomson was poised on the crevasse between figurative and non-figurative art. Whether he would have survived the jump is a matter of conjecture; that he would have jumped is, to me at least, a certainty.

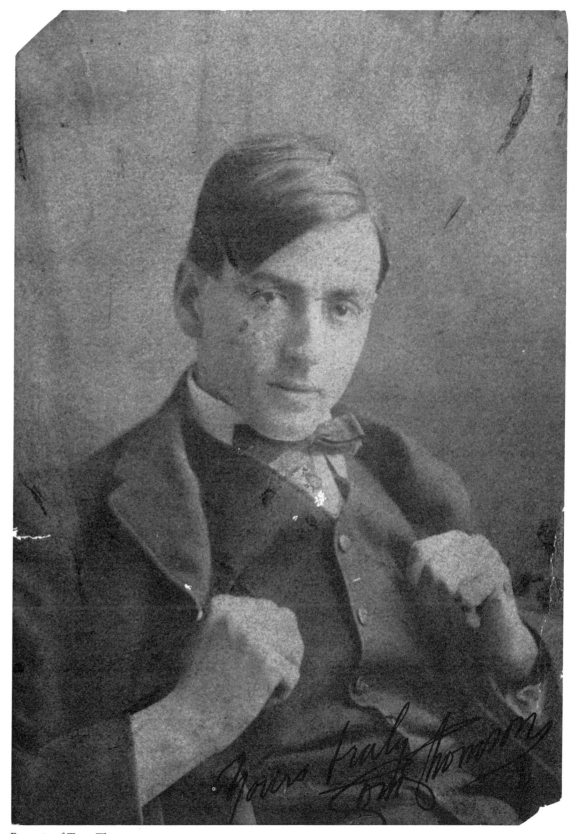

Portrait of Tom Thomson

The Paintings
of Tom Thomson

Tight, constricted, utterly undistinguished in the context of the period, *Burns' Blessing* as a commercial design would be at home on the pages of one of today's magazines, where it might be construed as a wry piece of deliberate whimsy. However, it does have another dimension. All the various parts are subservient to the plump, cheeky cloud in the centre which easily dominates the design, eclipses the lettering and hovers in the picture like the Goodyear blimp, advertising Thomson's future love affair with clouds.

The black and white illustration is extraordinary for the bemused, inwardly focused expression of the gentleman at table – his line of sight is aimed directly at the lady's bosom. Although unintentional, the focus is appropriate for the words of womanizing Robert Burns, and the drawing is a particularly effective rendering of two people in sanctimonious harmony with their good fortune.

Burns' Blessing

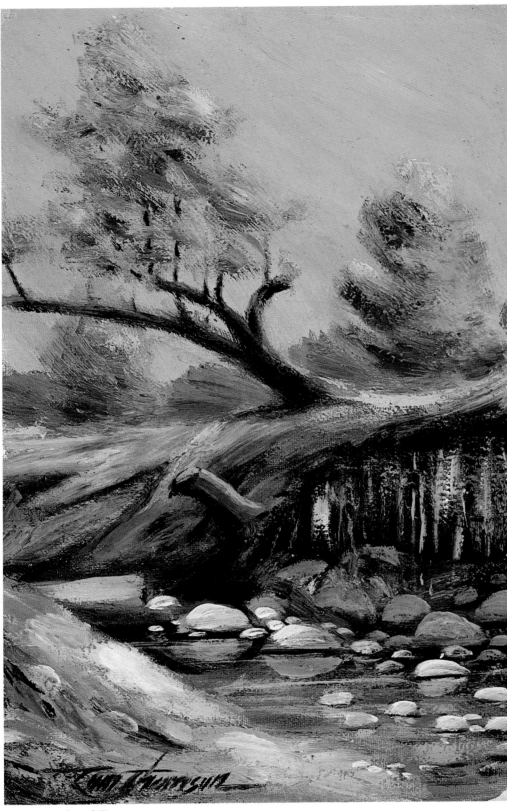

Stream Bank and Tree

Stream Bank is an amateur work which has that awkward force often associated with a slight skill trying to snatch a free ride on the caboose of art history. It is as bad as those horrors painted on velvet and sold on the fringe of every fall festival. The brushwork compulsively running to the left gives the work brio and is checked only by an inexplicable collection of perpendicular strokes that form a bank, waterfall or what have you, on the right. The colour, splendidly acrid, aids the general ineptitude, all of which is held together by a polite compulsion – it is a tinny kettle threatening to boil.

Team of Horses is similar in approach but quieter. The man and his beasts centred in the picture appear to be frozen, as if Thomson caught them having their picture taken by an invisible photographer. The sky dominates and receives most of the artist's attention.

The Bridge and *Landscape* are watercolours that might have been worried into existence by any amateur sketcher of the time, although the water in *The Bridge* is ably rendered, a typical fledgling advance in technique.

Sailboat is another matter altogether. Freely, even casually rendered, it is a bright Impressionist study which loses control only at the horizon and is remarkable for the fact that the sky has been, in the blue at least, created by the use of a sponge or rag pressed against and then lifted from the surface. *Sailboat* represents one of the earliest examples of Thomson's ability to make a sudden leap forward, an acceleration of skill that is preceded by no orderly methodical progression of technical effects.

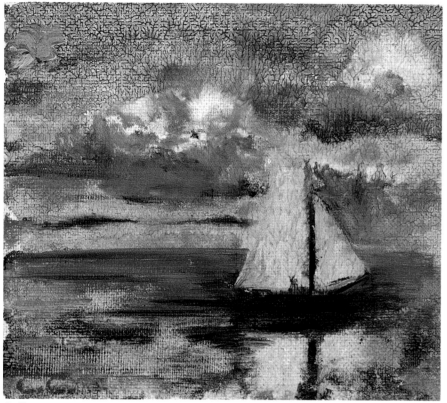

Sailboat

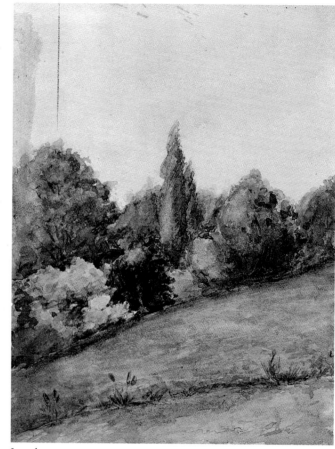

Landscape

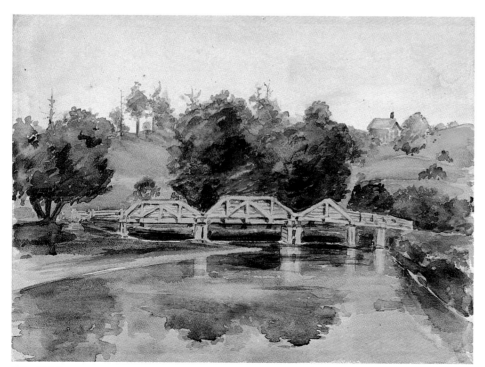

The Bridge

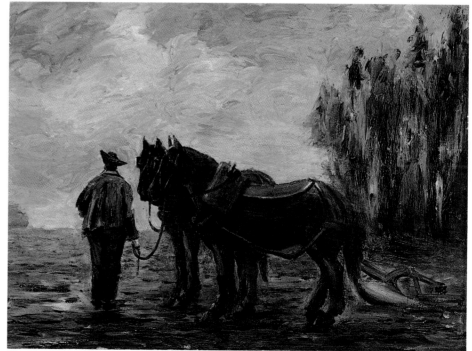

Team of Horses

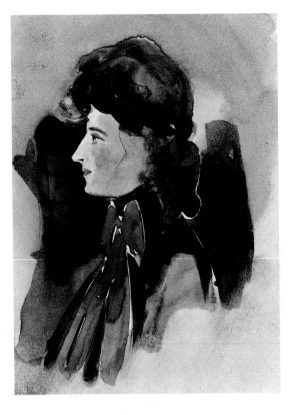

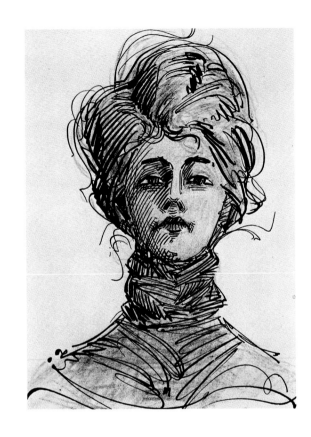

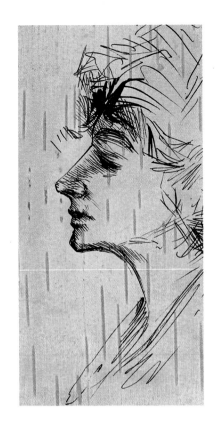

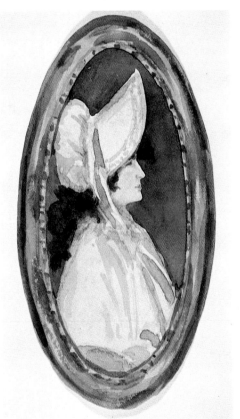

Sketches: Women's Heads

Charles Dana Gibson, the American illustrator, was famous at the age of thirty for his creation of a patrician, wasp-waisted beauty with upswept hair. Stately as a marble column, her desirable flesh covered from sole to chin, his pen and ink version of woman dominated the 1900s in the United States and was known as the Gibson Girl. Just as Bob Peak's illustrative style swept over the sixties, Gibson's influence was all-pervasive in the 1900s and easily reached neophyte illustrator Tom Thomson.

Two of the profiles are rendered on birchbark, a substance that the elegant ladies of Gibson's imagination were likely to touch only in the form of a souvenir purchased to commemorate a parasoled holiday. Although derivative, Thomson's pen and ink technique is agile, crisp and forceful, an intimation of his later bravura mastery of pigment. The two watercolour profiles, stiffly drawn and probably copied, are direct in application. Both reveal and control the wetness of the colour and suggest Thomson may have been capable of making a major statement in a medium other than oil paint.

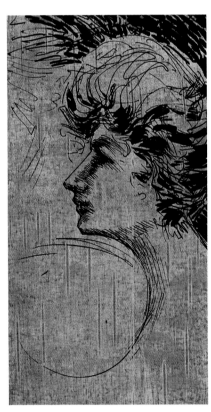

The part played by the experiences stored away in the artist during those restrictive periods when he has to work at something other than his trade to make a living is hard to assess. Just the straining against frustration can develop a type of psychic muscle; and the shape, colour and even sound of the survival activity may surface in future innovations. When T.S. Eliot counted bank notes did some of the controlled rhythm of that mundane task insinuate its way into *The Waste Land*? Has the ritual of Massey College, a kind of random formalization abetted by the architecture of the building, entered into the novels of Robertson Davies? How much of the surreal imagery of Florence Vale's drawings was cooked up as she roasted a chicken for painter Albert Franck? Some fraction of the control displayed by Thomson in his years of indenture as a minor commercial artist rose in the maelstrom of his final painting and served to counterbalance an excess of passion.

This tiny work, *View from the Window of Grip*, painted in gouache and watercolour during Thomson's days at Grip, could easily be an early study by the American artist Edward Hopper. Though there is an apt restraint in the rendering of old brick and the grime of coal-fueled industrial Toronto, it is supported by a firm precision of compositional grid and a reduction of detail to scale. Eccentricity of shape, tilt of chimney, debris on the roof, have been ignored in a scheme of retreat from the picture plane that avoids quaintness and forces a nearly monochromatic colouring to serve the composition. It is a lovely little picture and feels good when held in the hand.

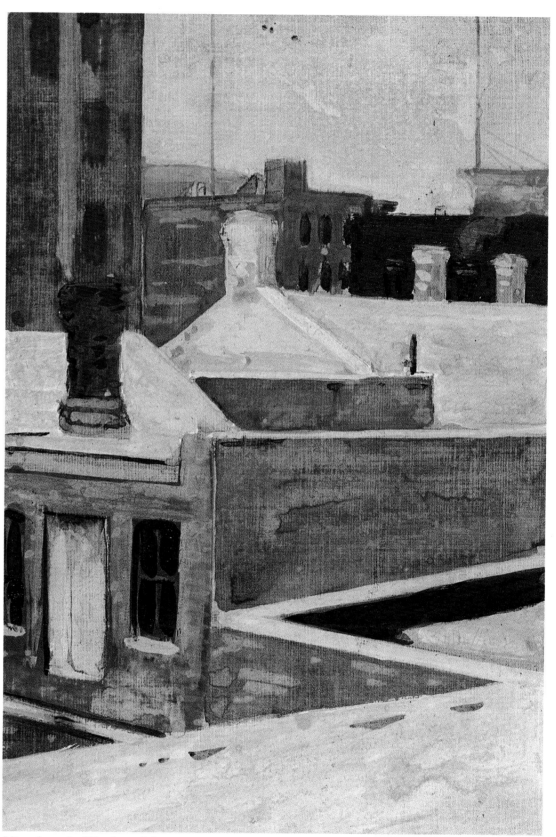

View from the Window of Grip

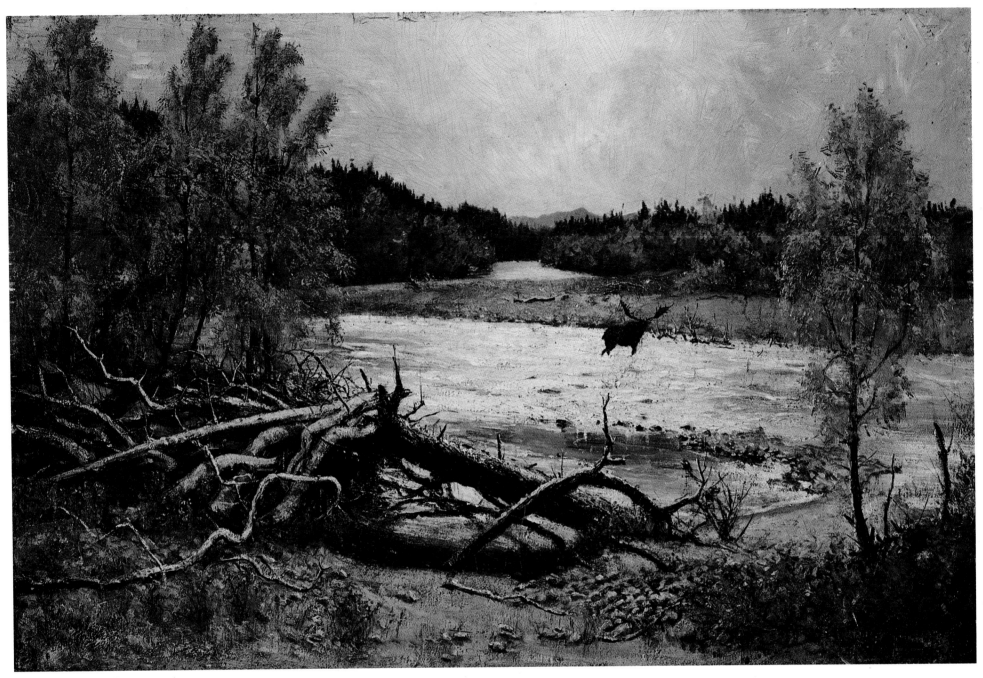

Moose Crossing a River

It takes a Pippin or a Rousseau to paint properly a beast that belongs in the bush, to impart that quality of predictable surprise that one feels when coming upon an animal in its natural setting. The moose in *Moose Crossing a River* (a work that is possibly a copy, though not as some suggest a fake) seems to have just landed from another planet, its helicopter-blade antlers like ears listening for trouble, about to start whirling. Awkwardly placed to the right centre, the creature rivets our attention, and the shape of the fallen tree in the foreground repeats the thrust of antler.

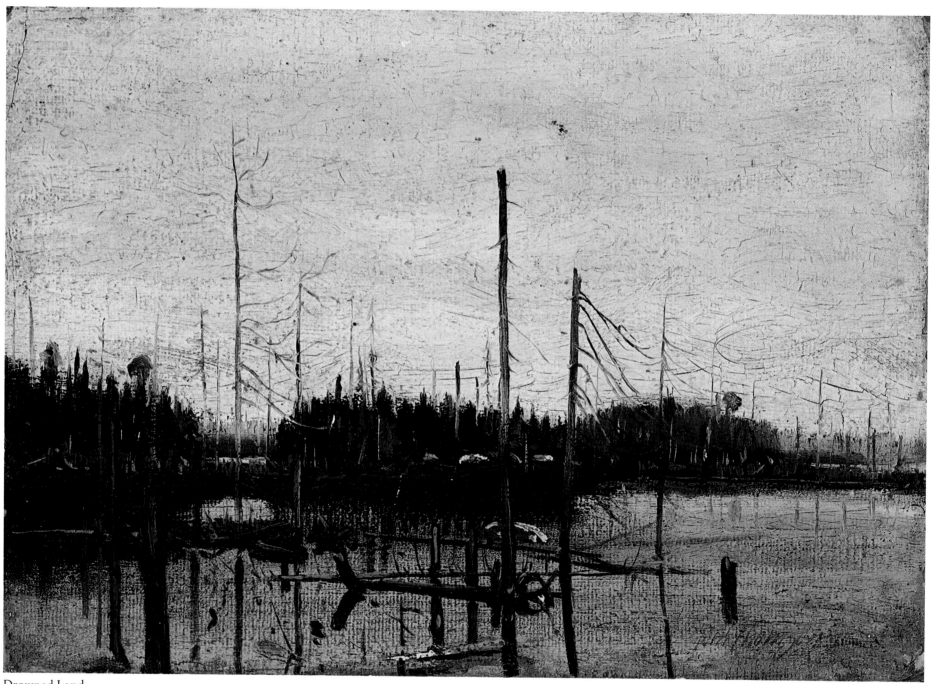

Drowned Land

Both *Drowned Land* and *Near Owen Sound* represent a level of technical accomplishment that indicates without any doubt that Thomson at this juncture in his career had many options. His talent was sufficient for a popular career as a limner of what would now be called Super Realism and, given the precise order of distancing from the picture plane and a natural, ductile amalgam of form, he just might have concluded such investigations with works of high art.

Drowned Land foreshadows the dashing brushwork of the last years in the muscular thrust of the dead trees.

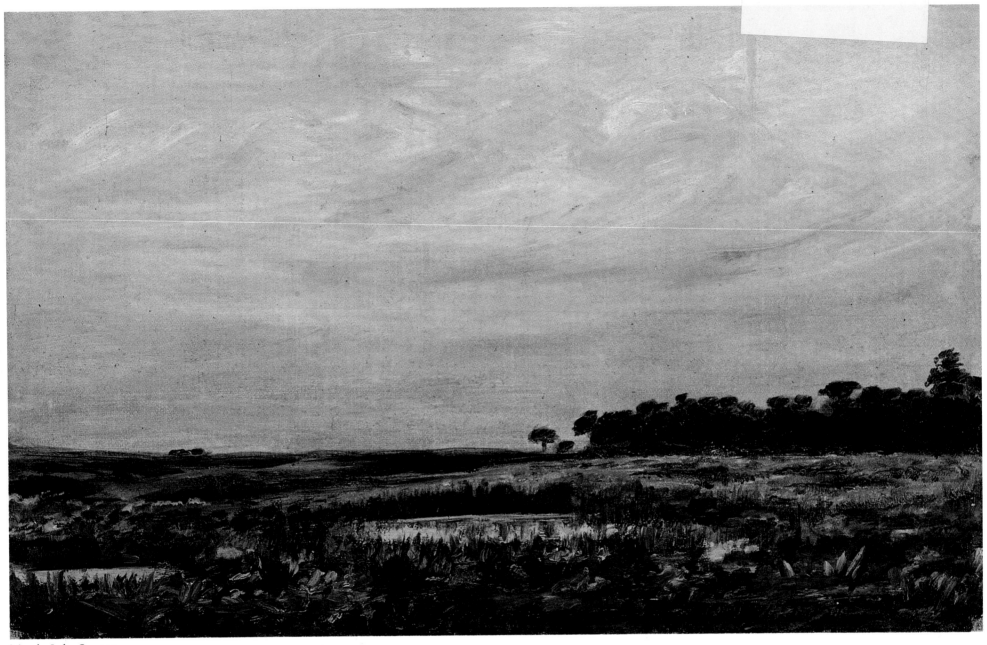

Marsh, Lake Scugog

Marsh, Lake Scugog, Near Owen Sound, Fairy Lake and *Big Elm* can be grouped together as examples of Thomson's sonorous handling of tone. They have a painterly density far in excess of the ability given to Thomson by most critics. *Near Owen Sound* is particularly acute in the relationship between the rich brown of the land and the edible colour of the sky. It was painted at the speed of his greatest pictures and with nearly as much skill, the difference being that his mind was carrying another country's bricks; he was putting forms together with the rote of teaching, not the mortar of his heart.

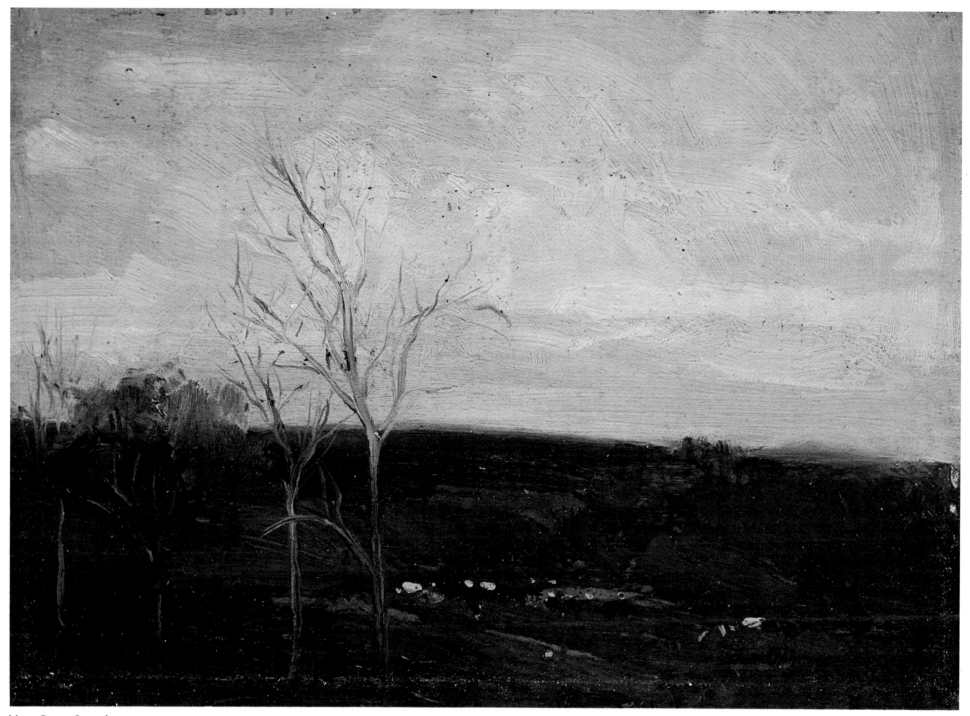

Near Owen Sound

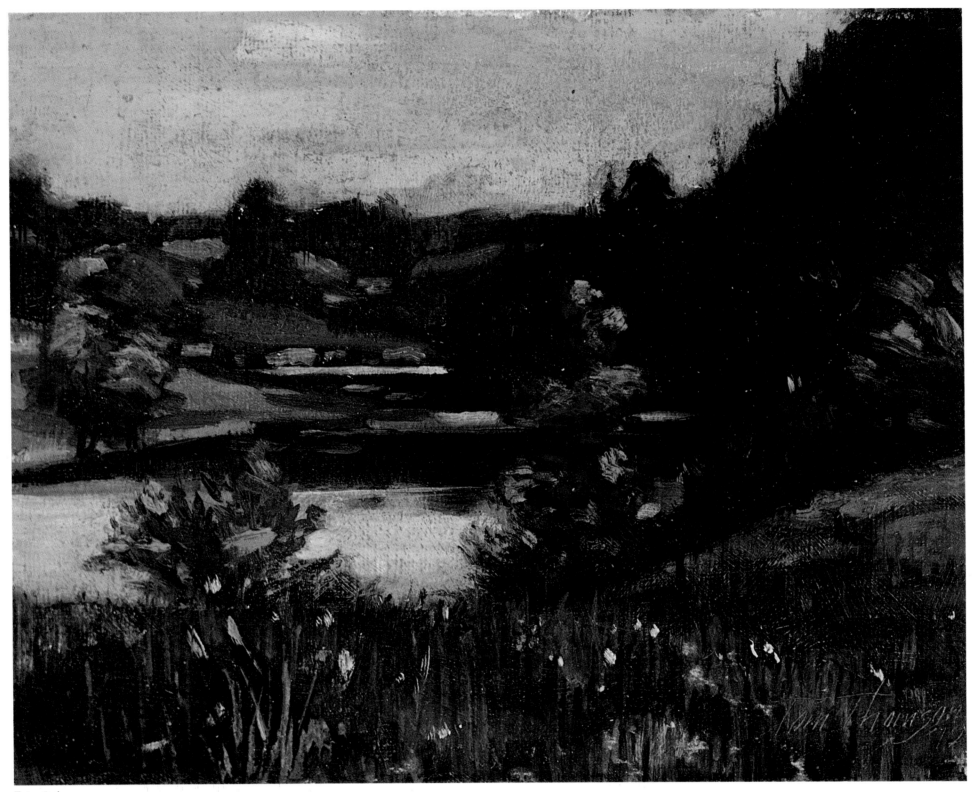

Fairy Lake

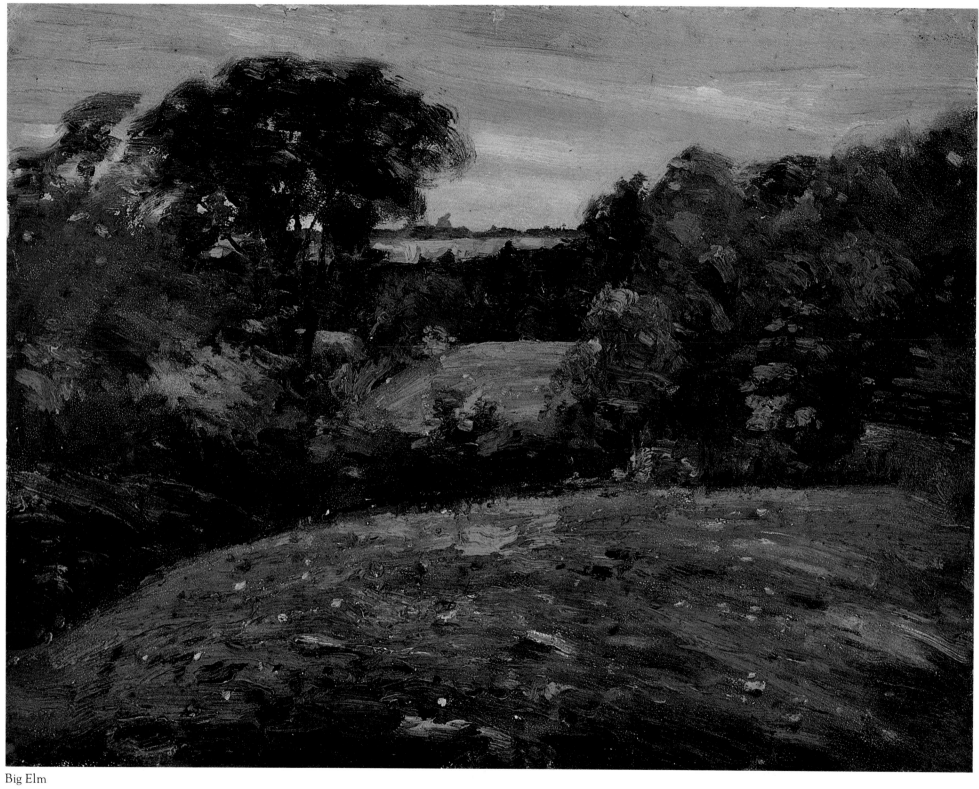

Big Elm

van der Weyden, Landscape

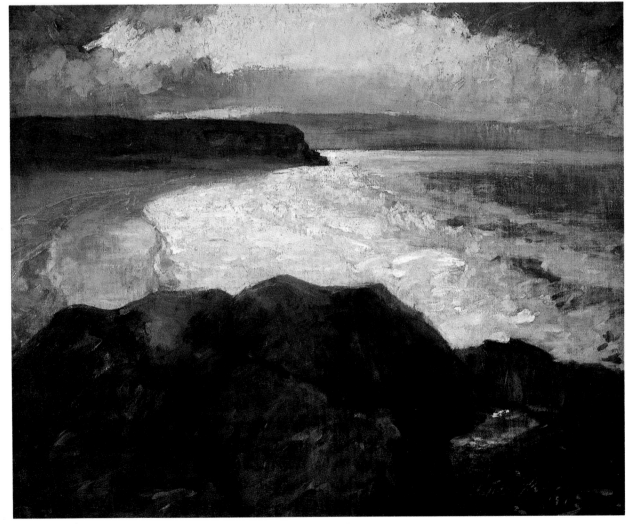

Northern Shore

Northern Shore is purported to be a copy of a painting by Harry van der Weyden which was reproduced on page 350 of *The Studio* magazine in 1904. Imitation is the one common link joining the early careers of most important artists. Ingres said, "I think I shall know how to be original even when imitating." Blake's remark, "The difference between a bad artist and a good one is: the bad artist seems to copy a great deal. The good one really does copy a great deal," is an apposite summation of this shared characteristic. There is unquestionably a similarity between Thomson's *Northern Shore* and van der Weyden's *Landscape,* although copy is a misnomer. Thomson's work, if anything, is a re-creation. He has turned a dayscape into a nightscape, used the top line of trees in the van der Weyden picture as the edge for rocks in what has become a brooding work – awkward, even crude – that avoids the easy Art Nouveau curve of the shore in the original. Thomson's painting, in its drive and thwarted ambition, is plainly superior to its inspiration.

Earlier in my study of Thomson I acceded to the general view as to the importance of the influence of Art Nouveau on his painting, although now I realize there had been an implicit condemnation of Thomson and the Group's response to this influence. Most commentary (mine included) has given the impression that they should have known better. How could they be seduced by such an obvious stylistic sophistry? Fortunately, they held to good company in straying from the conceded purity, the hallowed plastic evolution of western art that commenced with the simplistic visions of Duccio, a continuum of structural change taken as gospel by its faithful. Genuine inventiveness is a weed that grows anywhere and feeds on the strangest things. Kandinsky's early development grew upon decadent symbolism, Mondrian was like Lawren Harris, a theosophist, Gauguin produced a sketch entitled *Figure de Spectre,* an Art Nouveau occult fabrication. Moreau, the teacher of such luminaries as Matisse

and Rouault, wrote in his unpublished notes, "Art died the day when, in composition, the rational combination of intelligence and common sense took the place in the artist of the almost purely plastic imaginative concept, in short: love of arabesque." The arabesque swept its elegant way through most of the art of the late nineteenth and twentieth centuries through Nouveau, Deco and other styles. It had a spectacular rebirth in the Pop arts of the flower-power sixties. The linear history of western art has been ultimately a struggle between the straight line and the curve, and the effect of Art Nouveau on Thomson and the Group has been exaggerated. Their concern for the curvilinear was not finally tied to a philosophical or literary concept. As a group they were not trapped in the mystical delights of communicating with the infinite, but rather with the land they painted, the natural rhythm of the Precambrian Shield, a landscape that slew the petrified serpentines of Art Nouveau.

Thomson's Nouveau-inspired confections are capable assessments of the style, able, as in *Decorative Landscape: Birches,* to use the trees as a roof of a vault, cutting through to a sugary sky without losing the validity of the forceful uprights and reducing the tension of the picture plane. Though vorticular in design the composition is made structurally sound by interdicting the swirl of leaf. His work in this mode has a peculiar authority and is pushing to make something more of the style.

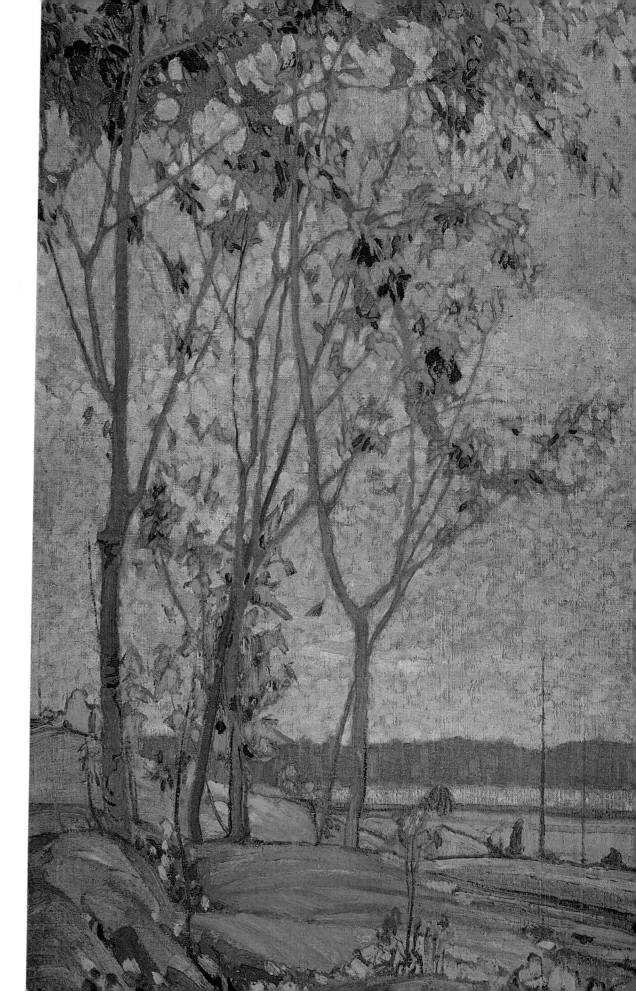

Spring

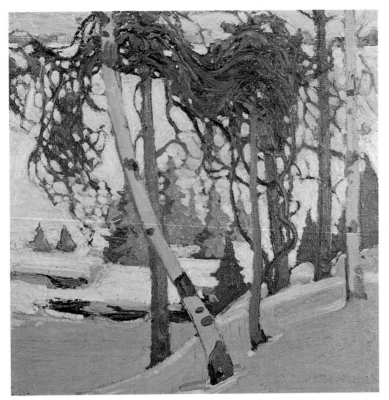

Early Snow

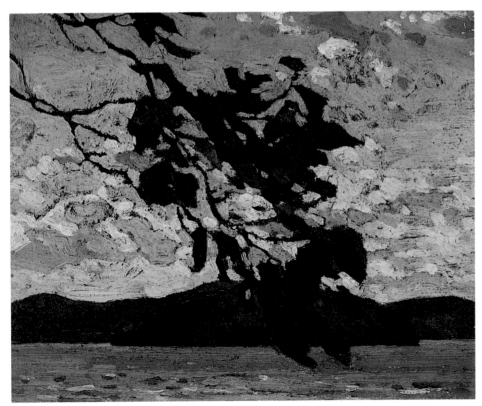

In Algonquin Park

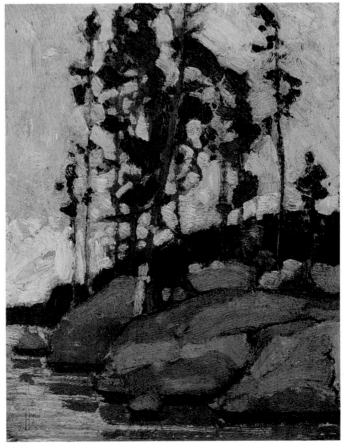

Red Rocks, Georgian Bay

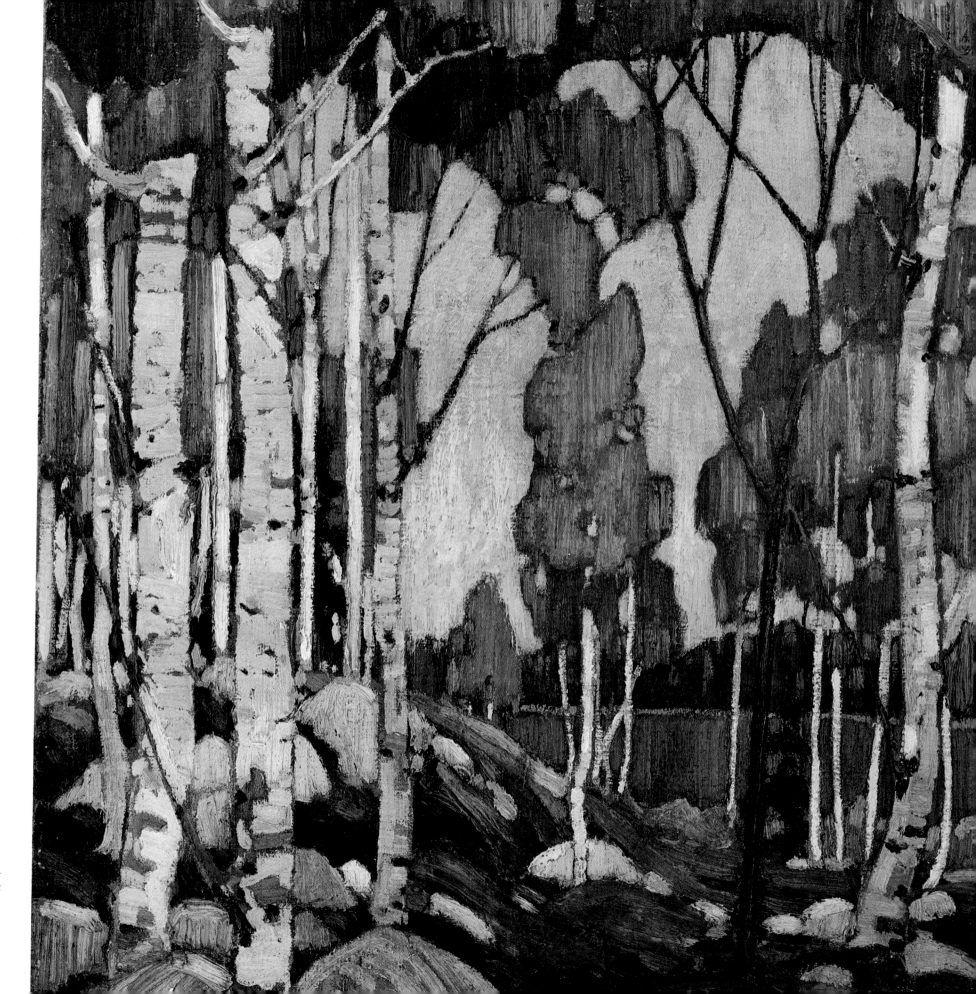

Decorative
Landscape:
Birches

Decorative Panel I

Tom Thomson's Life
by David P. Silcox

Thomas John Thomson was born into a large family, the sixth of ten children and the third of six sons, on August 4, 1877, in a small stone house near Claremont, Ontario. He grew up, however, at Rose Hill, a farm near Leith, Ontario, on the Georgian Bay, to which the family moved two months later.

According to his father, John–a tall, handsome man with a passion for apples–Thomson had an ordinary boyhood. When asked about intimations of his son's talent he replied, "I can't recall anything particular. He was a normal, healthy boy." Thomson got along well with other children, shared the family's good humour and love of music, and especially enjoyed tramping about the woods and fields. Like his father, he was, according to one of his boyhood chums, "born with a shotgun in one hand and a fishing rod in the other." His father remembered that "he liked to go fishing. I remember it was he who first got me to get a hunting dog."

At some point his schooling was broken off for a year because of what was variously described as "weak lungs" or "inflammatory rheumatism," and he was allowed to roam the countryside at will. He was enthusiastic about sports and once, while playing football, broke his toe. Later in Toronto he went to boxing matches and baseball games.

Like most people in his community, he went regularly to church. There are reports of his having sketched in the hymn books during church services, and of having regaled his sisters with caricatures of neighbours; but since one sister claimed that the fun was in "guessing who they were," I imagine that they were not terribly good. Painting and sketching would have been a normal activity in the Thomson house, however, for most of his sisters and brothers applied themselves to it. One source claimed that Thomson's father was a sketcher who inspired him,

but he denied it: "There is nothing in myself to account for it. I never had the least bent for drawing."

The other arts were also present in the house. Thomson's mother kept a good library which contained many of the classics, though she tended to favour romantic writers like Walter Scott. Thomson's later illustrations of quotations from Robert Burns, Maurice Maeterlinck and Ella Wheeler Wilcox are proof of his pursuing his mother's inclinations, and manifesting a strong preference for poetry.

The family was also musical. The Thomson brothers were stalwarts of the Leith Band where Thomson sometimes played the drums, just one of his musical accomplishments. He is reported by various people—and surely some of them are mistaken—to have played the mandolin, the cornet, the tenor trombone, the violin, the trombone, the organ, the bass horn, and one recent illustration shows him picking on a banjo. The mandolin was his most constant instrument. He had a good voice, sang in the Leith choir, and later took voice lessons. He went to concerts frequently when he lived in Toronto.

No one has said whether Thomson completed his high-school education or not, but it is likely that he did. What shows in his later life, however, is the lack of advanced learning as it affected both his art and his life. His sister Minnie thought it "a tragedy that he did not have the advantage of a university education. I know for a fact that he was bitterly disappointed over the lack of opportunity." Perhaps the reason that he wrote so little was that he was neither accustomed to it nor confident of expressing himself verbally. His patron, Dr. James MacCallum, was emphatic that Thomson's way was in paint, "not words," and what we have that he has written tends to bear this out. His letters were without style, and they conveyed neither intelligence nor observation, nor even an attractive hand that one might expect from the graduate of a course in penmanship. Once he had decided what it was that he wanted to do he was ambitious for knowledge, but by that time he had not had either the discipline or the background to do much about it.

His sister also felt that Thomson had a "hunger for the refinements and niceties of life," and she wondered if his friends had guessed at this. He was some-what envious of sophistication, which shows in his contempt for pretension without refinement. His striving for sophistication later expressed itself in rather extravagant gestures, such as mixing expensive artists' paint to get the right colour on his canoe, in his good pipes and Hudson's Bay tobacco, his dressy silk shirts and his silk tent. He used the best painting material he could obtain and he admired well-crafted things. One of his favourite words of contempt was "shoddy," and he would be mortified to see the disintegration in the three-ply panels he used in 1914. He told one of his sisters that he loved the elegance of George S. McKonkey's restaurant in Toronto, where he sometimes used to go later.

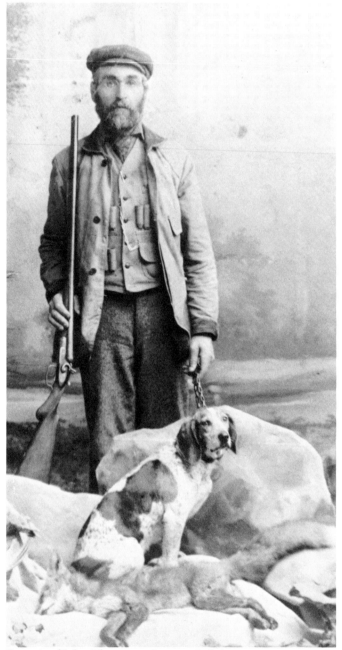

Portrait of John Thomson, the artist's father

When he reached his majority, in 1898, he inherited from his grandfather something in the order of two thousand dollars, a rather large sum in those days. In any event, he frittered it away in relatively short order. He tried three times to enlist in the Boer War, but was found unfit for service: fallen arches, according to his sister. In 1899 he finally apprenticed as a machinist with William Kennedy and Sons in Owen Sound, but stayed there only eight months. He also that year joined the Ancient Order of Foresters, an organization which had little to do with forestry, but did provide life insurance, a status of manhood and, ironically, guarantees for burial.

After an interval at home he followed the example of two older brothers and went to the Canadian Business College in Chatham, Ontario, but stayed only a year before he again pursued them to Seattle in 1901. His eldest brother, George, had helped to establish the Acme Business College in Seattle, and Thomson enrolled in penmanship for six months before quitting to work for Maring and Ladd, a photo-engraving firm and one of the first in that part of the country. C. C. Maring was also a Canadian and Thomson boarded at his home, even after he later accepted a higher-paying position with the rival Seattle Engraving Company.

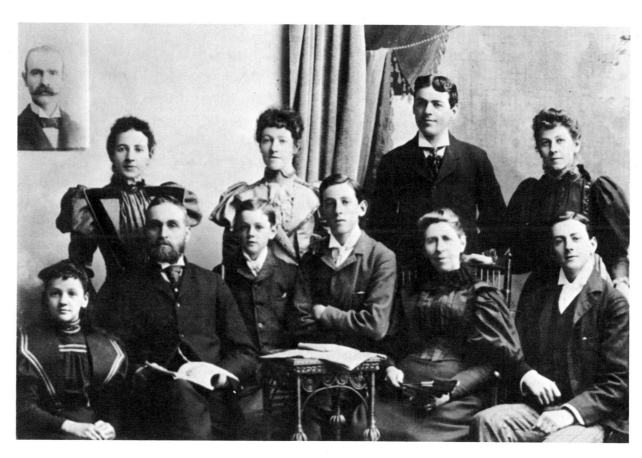

The Thomson family. Left to right, back row: Elizabeth, Louise, Henry, Minnie; front row: Margaret, John (the artist's father), Fraser, Ralph, Margaret (the artist's mother), Tom; insert: George

Thomson's interest in art gathered strength during his three years in Seattle. How much he did, apart from his commercial duties, is hard to know, but little now exists. There are occasional felicities, such as the self-portrait (p. 18), but nothing unusual. He appears to have restricted himself to pen drawings and water-colours, but at least his work made him look and think. By all reports he was an ingenious and quick illustrator.

A rebuff of a marriage proposal to Alice Lambert seems to have been the cause of his sudden return to Canada. Miss Lambert was the highly-strung and imaginative daughter of a minister, who later in life wrote several novels. Although they were quite fond of each other, she laughed nervously when Thomson proposed, perhaps with some justification, since she was about fifteen and he about twenty-eight. He took her reaction amiss and was reported to have left Seattle the next morning. Physically, Thomson was tall and handsome and always very attractive to the ladies. He was probably more of a womanizer than he has been given credit for, though little hard evidence exists.

Thomson returned to Canada late in 1904 and for the next five years worked for a variety of photo-engraving houses, including Legge Brothers, possibly Reid Press in Hamilton, Grip Limited, and Rous and Mann Press. He may have done some freelance work since, in 1914, when he was with Rous and Mann, he was

reported to have done the Owen Sound stamps (p. 225) for Legge Brothers. He pursued his art in a dilatory way, and left a number of pencil sketches, pen drawings and watercolours, none of them very distinguished. He began to use oil paints in about 1906, with rather tentative results (see *Team of Horses*, page 35), and that may have encouraged him to take some lessons or have been the result of them. His teacher was probably William Cruikshank, whom A.Y. Jackson called "a cantankerous old snorter," who would have taught life classes and the traditional study of old masters.

Thomson began to emerge from obscurity after he joined Grip Limited in either 1907 or 1908. There, and later at Rous and Mann to which he moved in 1912, he met a group of men who stimulated his creative work. Chief among them was J.E.H. MacDonald, head of the lettering and design shop, though Thomson was brought into the firm by Albert Robson who had a reputation – an inflated one according to Jackson – for aiding creative thinking. Certainly Robson had the loyalty of those who worked with him, for when he moved to Rous and Mann in 1912, nearly all the important artists followed him. It was at Grip that Thomson met William Broadhead, who went with him on his only trip to Northern Ontario, H.B. (Ben) Jackson, who first took him to Algonquin Park in the spring of 1912, the artist Rowley Murphy, and, as they arrived, the men who were to become members of the Group of Seven in 1920: Frank Johnston, Franklin Carmichael, Frederick Varley and Arthur Lismer. It would have been from these men that A.Y. Jackson, who abandoned commercial art early in his life, was able to report that Thomson was regarded as "the best letter man in the country." Thomson's first tedious job at Grip was socking in the dots and tints on the Ben-Day plates.

This effervescent crowd organized weekend sketching trips into the upper reaches of the Don and Humber Rivers, and sometimes up to Lake Scugog, not great distances from Toronto. Thomson also returned to his home from time to time, and several of the works from these transitional years were done in the Owen Sound area. *Near Owen Sound* (page 41), done in November 1911, is the harbinger of Thomson's tardy arrival as an artist. It marks the ignition point of his career. Despite all the uncertainty and mediocrity that had preceded and that would follow, he had finally, at the age of thirty-four, found his true vocation and showed some sense of vision.

Thomson's moodiness and diffidence was commented on by all his new friends. Lawren Harris referred to "his remoteness, his genius, his reticence." Albert Robson found him bashful and "generous to the point of a fault." Mark Robinson, a ranger in Algonquin Park, said that at times he "appeared quite melancholy and defeated in manner." Jackson reported that "he had fits of unrea-

sonable despondency. He was erratic and sensitive." Lismer found him "almost monastic" in his desire for seclusion, but that may have been a combination of his need to be alone to concentrate and of his pleasure in a degree of solitude.

The other side of his shyness was his gregariousness, and the same companions, again unanimously, vouched for his congenial, easy manner. One friend found him "always plain and easy-going as an old shoe." He enjoyed visitors and once wrote to MacCallum from South River in 1915: "I should like awfully well to have some company." Another acquaintance said that "it was impossible not to get along with him because of his unselfish and kindly disposition." He enchanted and was enchanted by children, and was reported to have spent hours drawing for them or playing with them. He laughed easily, did things impetuously, and was something of a smart alec. He enjoyed the eccentric gesture, such as tearing up a cheque because the bank teller, who supposedly knew him, would not cash it without identification. He was careless with money and spent it easily and sometimes foolishly, but always with a flourish. He was reported to have bought an unknown boy a complete set of clothes because his shoes were badly worn. There was a streak of the dandy in him too, and he affected flamboyant silk shirts. He sometimes rose before dawn, and at times stayed up all night, contemptuous of time or schedules.

His sunny personality was often eclipsed by a fierce temper. One night he violently heaved his sketch box into the woods in frustration with himself and his work. He and Jackson retrieved it in the morning and had it repaired. He once was infuriated with Varley over an issue that was not disclosed, but it may have

End of a letter with self-portrait

been his drinking. Not that Thomson had anything to be sanctimonious about on that account, for he did some fairly heavy drinking himself when he had the opportunity. One earlier employer thought Thomson was "lazy, incompetent and quarrelsome," and it may be that he had had a rough period in his life before finding his salvation at Grip. He was not without grudges and dislikes, and one of his close friends, Alan Ross, related that "the few people he disliked he hated most cordially; he was not at all disciplined in concealing it either."

Neither his moody personality nor his lack of education kept Thomson from becoming a rather sophisticated and accomplished painter, even if he was set at an initial disadvantage. Nor did they subtract from a powerful sense of pride. He was, according to one source, "instinctively a cultured person," and Lismer, in a fine tribute, said he was "refined and delicate. He had a graceful mind."

If the earlier years of his life were murky and unpromising, the narrative of his last years is simple and straightforward and can be briefly told. For two weeks in the spring of 1912 he went with Ben Jackson to Algonquin Park, which had already been touted by other artists such as William Beatty and Tom McLean as an area noted for its fishing and healthy air. In late July and through to the end of September, he and William Broadhead canoed from Biscotasing northeast of Sault Ste. Marie, along the Spanish River through to the Mississagi Forest Reserve. After fetching up at last on the shore of Lake Huron, the pair took a steamer and arrived in Owen Sound on September 27. They had spilled their canoe at least twice and lost some of their sketches and fourteen dozen rolls of film for which Thomson obviously had some urgent purpose, for he wrote to his friend John McRuer about another man who had been photographing in that area. Perhaps a comment by Albert Robson gives us a clue; he wrote that the railways then were demanding bright posters and the artists "were in a position to provide something of the true spirit of the country."

On his return to Toronto, Thomson followed Robson to Rous and Mann where he was hired at seventy-five cents an hour, a good wage at the time. Robson and Thomson's other friends who were there were excited by his sketches, and he spent his spare time during the winter working up at least one of them, *A Northern Lake*, on canvas. This first major effort as a painter—a point that flies directly in the face of the later groaning about hostile receptions—was purchased by the Ontario government for $250 from the 1913 spring exhibition of the Ontario Society of Artists.

In May of 1913 Thomson went to Algonquin Park on his own and spent the summer and fall there. He was at first suspected by the ranger Mark Robinson of being a poacher, but he quickly became a friend and fixture of the community at Canoe Lake. He stayed first at Mowat Lodge, owned by Shannon Fraser (page 137),

ENGRAVING

Thomson's business card

and then camped out when the warm weather came. It was probably at this time that he met Winnifred Trainor, who later became his fiancée and whom he planned to marry in the autumn of 1917. He saw her frequently, both at Canoe Lake and at her home in Huntsville.

Despite his long and probably dissolute life in the city, Thomson proved to be lithe and strong in the bush. His childhood "weak lungs," his flat feet, and his interest in art did not interfere with his ability to paddle well, carry a lot, work hard or stay up all night. He had an abundance of energy which showed not only in his art and his way of working, but in most things that he did. Jackson's description of him conveys this charged energy well: "You liked Tom right away, a quiet friendly chap, something of the Indian in his bearing, a kind of indolence that changed to sudden alertness and quick movement where occasion arose." Thoreau MacDonald remembered that "while he ate he drummed his fingers on the table with great speed and vigour." Jackson also remembered that "Thomson was not a great reader, but if he found a book that interested him he would sit up all night to read through it, then go on with his work without a break for sleep." Thomson's athletic ability and his woodsman's proficiency probably helped to offset substantially the rather too refined air of effeteness that the making of art is often associated with in the popular mind. Certainly the loggers and rangers who knew him were respectful of his profession, and held him in high regard, though the short circuit between good woodsmanship and good art has been a means of looking at Thomson's great achievement in one light only.

"Tom was never very proud of his painting," J.E.H. MacDonald wrote, "but he was very cocky about his fishing." Of all the legendary stories about him, those that can hardly be exaggerated are the ones related to his mania for fishing. He not only became an expert among experts on the habits and ways of trout, but he made many of his own lures, tested them, changed them, and seemed to know when which ones would work and why. He fashioned them out of coins, piano wire, feathers and other bits and pieces, and was very generous, as he was with everything else, in giving them to others.

When he returned to Toronto in October 1913 he met A.Y. Jackson, who had just arrived from Montreal and who became an important influence on his painting, and Dr. James MacCallum, who became an important patron. MacCallum and Lawren Harris were financial partners in the construction, just then, of the Studio Building at 25 Severn Street. MacCallum was enthusiastic about Thomson's work and proposed, as he did to Jackson, that he would meet Thomson's expenses for a year if he would devote himself solely to painting. In January 1914 Jackson and Thomson moved into studio one of the new building while it was still being completed, and shared the $22-a-month rent. Thereafter MacCallum concerned

Endorsement of the Acme
Business College

Quotation from Maeterlinck

himself with Thomson's financial affairs, often doing his banking and sometimes selling, as well as buying, his work. Harris, too, occasionally involved himself with the financial side of Thomson's life, or unpacked his sketches and sent works to exhibitions.

Thomson's submission to the Ontario Society of Artists' exhibition in 1914, *Moonlight, Early Evening,* was purchased by the National Gallery of Canada, then just taking fresh life under its new director, Eric Brown.

Jackson and Thomson were not together in the studio long. Jackson, persuaded by Thomson, went to Algonquin Park late in February, and then in the spring went west for the summer with William Beatty. Thomson returned to the park in the early spring and was shortly joined by Arthur Lismer, who stayed for two or three weeks. During the summer he went to MacCallum's summer place near Go Home Bay on Georgian Bay, where he worked well and productively. He canoed leisurely back to the park and stayed there until the fall, when he was joined by Jackson for six weeks, and then by Varley and Lismer. They were all anxious about the war which had just erupted in Europe, and before the year was out the group had dispersed. It was the last time Jackson saw Thomson. He knew him little more than a year, and they went sketching together only on this occasion. They might have met in the army, but Thomson was again rejected when he tried to enlist.

All the studios had been rented for the winter, so he temporarily shared Franklin Carmichael's studio. Then Harris and MacCallum paid $176.02 to renovate what has become known as Thomson's shack, a small building that had been, according to Jackson, a cabinet-maker's place before it was used as a tool shed during construction of the Studio Building. Thomson made his own bunk, shelves, table and easel and moved in at one dollar a month in rent. MacCallum's (and Harris') support certainly continued in this oblique way, but in any case there was little opportunity for employment; because of the war commercial houses closed down or reduced their work substantially. The Studio Building and Thomson's new home seemed to perk with camaraderie. Lismer was a constant visitor. Tenants of the Studio Building included William Beatty, Curtis Williamson and Arthur Heming, a trio which, Jackson said, had in common only their intense dislike of each other.

In the early spring of 1915 Thomson again took up residence at Canoe Lake. There he received word that the National Gallery had purchased *Northern River* for $500, one of the works he had done that winter and shown with two others at the annual spring Ontario Society of Artists' show.

Although Thomson had evidently done some guiding for fishing parties the previous year, he was not able to earn much that way in 1915. It was a slow year

and visitors to the park were not as numerous, he wrote to MacDonald. He worked briefly as a firefighter, according to Lismer. The time gave him the opportunity to paint more, however, and his work developed into a thrusting, jabbing certainty. He now knew exactly what he was doing. He travelled quite extensively that summer and spoke of following the timber drive along the Magnetawan River and finding country similar to that around Sudbury, where he had probably gone in 1913 or 1914. He wrote laconically to MacCallum that he had not painted many sketches – "about a hundred so far"! He thought about taking the "Harvest Excursion" to the prairies to "work at the wheat for a month or two," but MacCallum commissioned some decorative wall panels for his cottage, and Thomson probably went there in the fall before returning to his studio in Toronto. He was honoured shortly after his return by an exhibition of his work at the Arts and Letters Club in December.

In the summer of 1916 he obtained a job as a ranger, though he found that it did not permit much time for painting. He was stationed at Achray in the northern part of the park with Ed Godin who reported, conversely, that Thomson managed to do quite a lot of painting. They travelled the Petawawa River (see pages 130 and 131), and Thomson again followed and painted part of the Booth Company's timber drive along the Petawawa. His colour deepened and grew richer, his brush strokes broader and fuller, and his conception developed into simpler and poetically more forceful images.

After another productive winter in his Toronto studio, Thomson again returned to Algonquin Park early in the spring of 1917. MacCallum joined him for a short while in May for some fishing. Thomson had paid one dollar for a guide's licence on April 28, for he had found that the ranging work was too much of an interference with his painting. According to Mark Robinson (and perhaps influenced by MacCallum who saw his work as an "Encyclopedia of the North"), he painted a series of sixty-two sketches which depicted the daily unfolding of spring. This is a conceit which may never be unravelled, if it ever existed, and no one has successfully assembled them. From the work that we know now, it seems impossible to reconstruct.

At about noon on July 8, a dull and drizzly day, Thomson paddled off to fish at one of the lakes not far from Canoe Lake. He rounded the Wapomeo islands and was never seen alive again. The date of his death was never ascertained or determined medically, although his upturned canoe was spotted later that afternoon. His body was recovered on July 16. Shannon Fraser sent a pathetically ambiguous telegram to the family: "Found Tom this morning," though by that time little hope could have been left that he would be found alive.

The official cause of his death was "accidental drowning," though it was noted

that he had sustained a four-inch cut on his right temple and that his right ear had bled. How he died has been a mystery veiled in surmise, yet there is no certain proof and people will always prefer a mystery to facts.

The hardest thing to accept, mostly because we do not want to, is that Thomson's death was an accident. Thomson had carefully bound fishing line around a sprained ankle to give it support: Robinson distinctly recalled cutting the line off wrap by wrap and remarking on how neat it was. Thomson's foot was not fouled in a tangle of wire as has been often suggested. Did he do something as foolish as to try to stand up for a moment to relieve himself, shift his weight when the ankle gave way, and then slip and strike his head on the gunwhale of the canoe? Too simple, perhaps, but also very possible. The large majority of drowned canoe fishermen are found with their flies open.

Thomson was buried at Canoe Lake on July 18; his body was then exhumed, transported to Leith and reinterred on July 21. His brother-in-law, Tom Harkness, was selected to settle the estate, and there ensued a certain amount of rancorous correspondence about the costs of embalming (the decayed corpse had taken extraordinary measures and double the usual amount of embalming fluid), about the gathering of Thomson's effects, and about the rumour that Thomson might have taken his own life. A more fitting conclusion was lovingly provided by his friends later that summer, when they erected at Canoe Lake a cairn to his memory.

Thomson's short life was over. In itself it offered little of interest or precept. Had he not in his last few years created those tiny panels of magic, his life and his death would have passed unnoticed. Part of the reason that he has become such a legendary figure is that so little was known about him, and so little was expected for so long, that his ultimate achievement is the more striking because it arrived like a comet, unheralded, brief and glorious.

The Overhead Lake

Much of Algonquin Park is low, most of the lakes are actually green pots of dark water relieved only by white-caps. Where city trees sway and clatter, a northern bush resists the wind like the end of a janitor's pushbroom held to the gust. The great movement of Algonquin is sky and cloud, dazzling in the unpolluted air. Clouds were for Thomson a ceiling of water, an overhead lake.

Thomson and bush, Thomson and gypsy-coated hills lording it over lakes, have been so completely welded together in the public mind that we have overlooked the fact that he was Canada's first compulsive painter of clouds. He turned to the sky for relief from the relentless slate-grey repetition of water that glistened like the side of a knife on a table. He could whap his brush about with impunity in the stratosphere and release his frustration with the daily problems of painting and mucking out a living. Hanging his absence from home, hearth and ironed sheets in the clouds, he transformed his loneliness into a strength of sky, a party at which he was the only guest. Thomson's brush was never as free of stroke, as reckless with form, as given to broken-field running as when he played out his feeling in the heavens. Nature's roof gives pardon to excess. The sky belongs to everyone; we've all watched clouds metamorphose into castles, horses, giants, an elephant become a wheel, a train break into a flight of birds – and eye-climbed through colour beyond the range of oil, acrylic or neon, supported by shadows of unbelievable depth. One can be forgiven for tampering with the air, with sky – but a tree is another matter; with the exception of sky-writers few of us have carved our initials in a cloud.

In the sky Thomson's daring seemed natural. It was less likely to elicit criticism from fellow artists or complaint from the critics. Thomson repeated Turner's lesson in his own classroom, particularly in *Sky: The Light That Never Was*. In his last work the sky was creeping into the landscape, big rhythms supplanting small movement. He was on the brink of destroying the horizon, that *bête noire* of the landscape tradition which gave birth to serpentine movement as a reaction. The horizon, a comfortable reminder that a round world was after all flat, which identifies a picture before it is seen, was in jeopardy. Thomson's future was in the sky. He was destined, in the epithet used against Abstract Expressionism in the fifties, to become a space cadet.

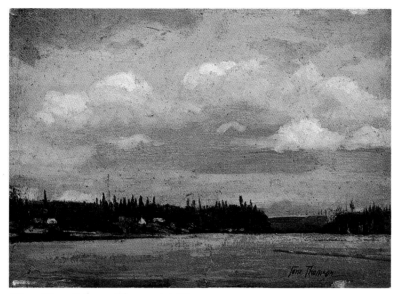

View Over Lake to Shore with Houses

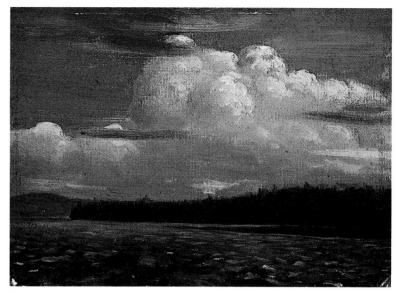

Thundercloud

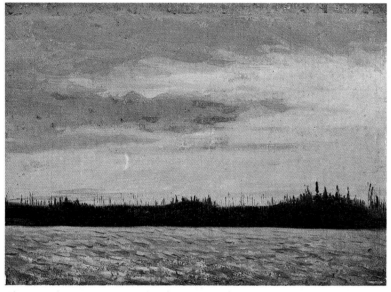

Canoe Lake

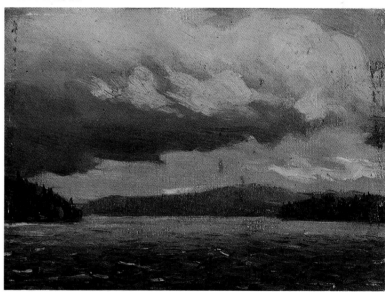

Smoke Lake

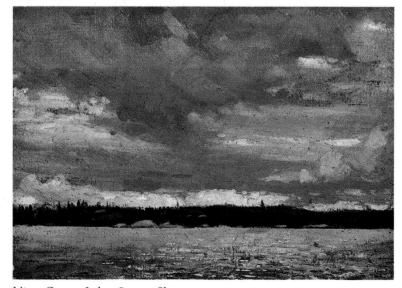

View Over a Lake: Sunset Sky

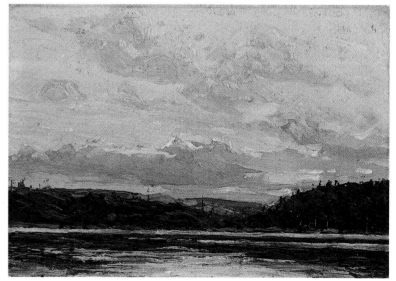

Northland Sunset

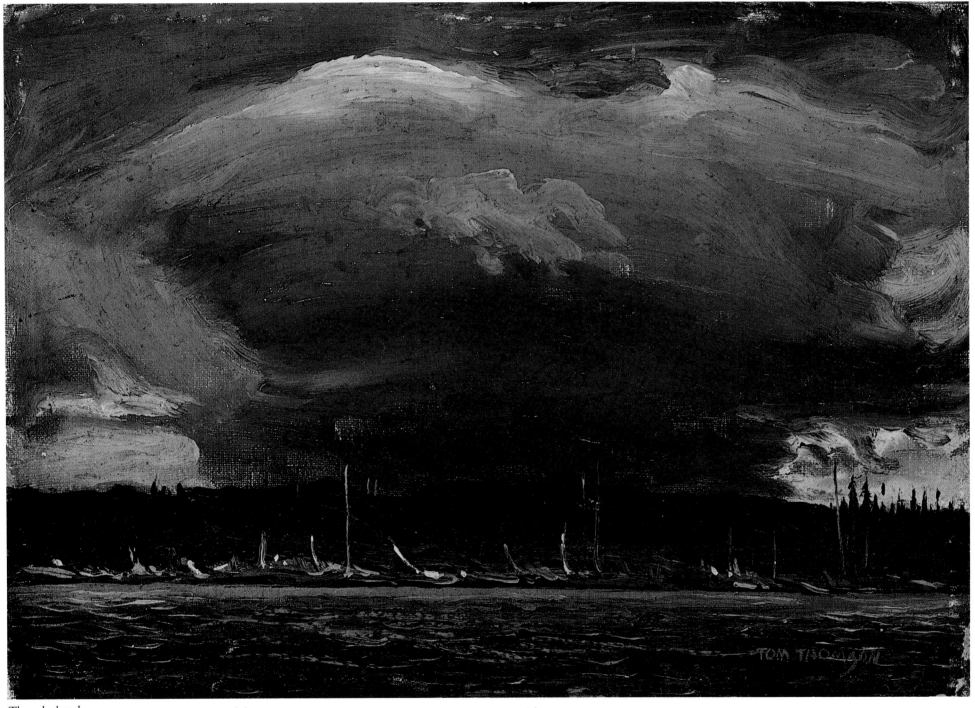

Thunderhead

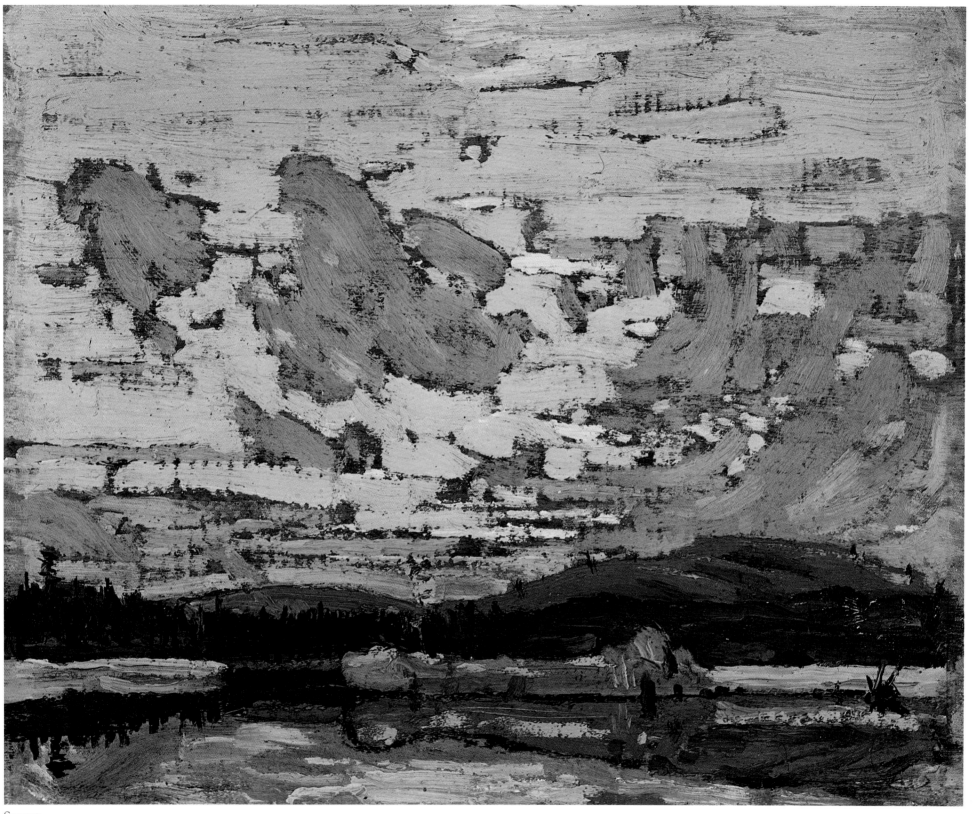

Sunset

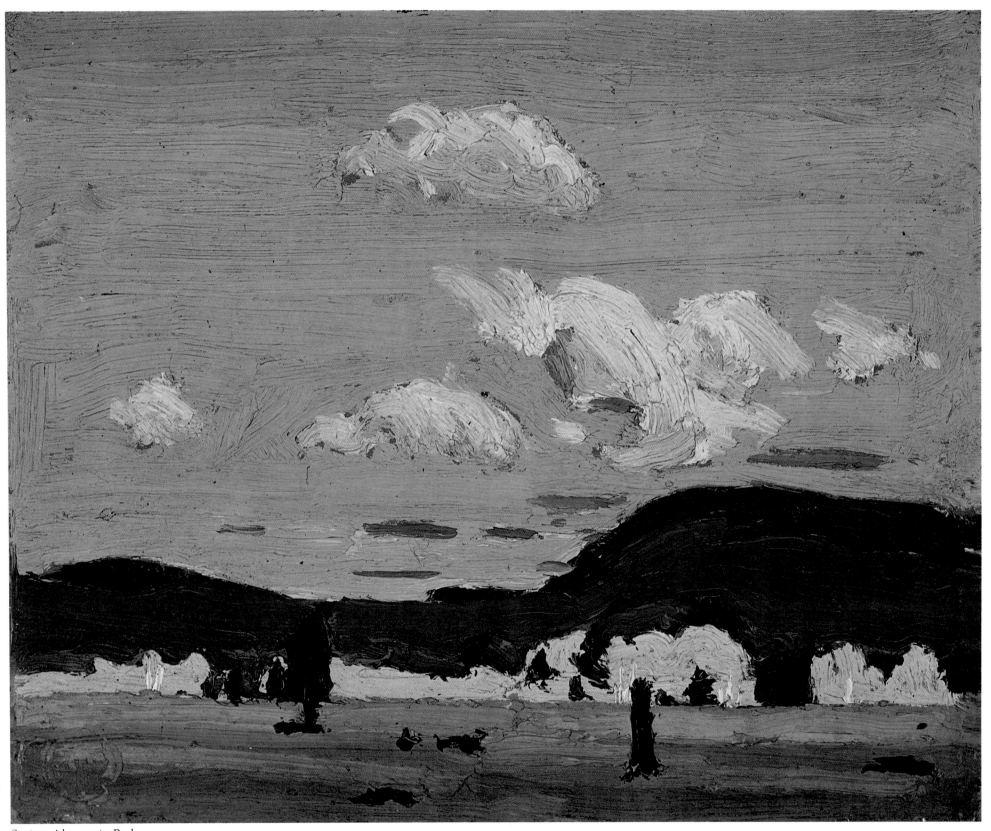

Spring, Algonquin Park

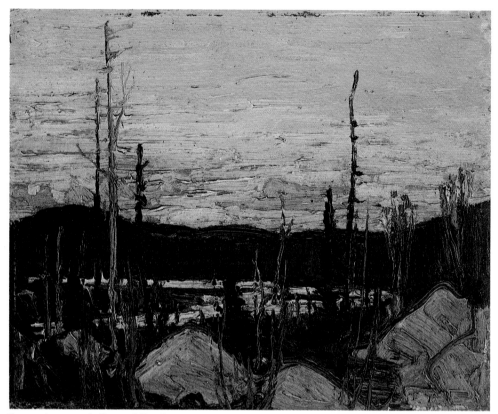

Burnt Area with Ragged Rocks

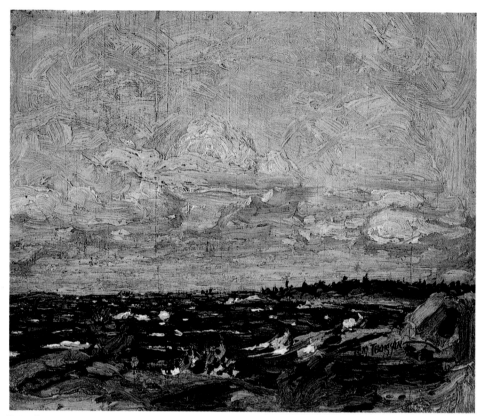

Windy Day: Rough Weather in the Islands

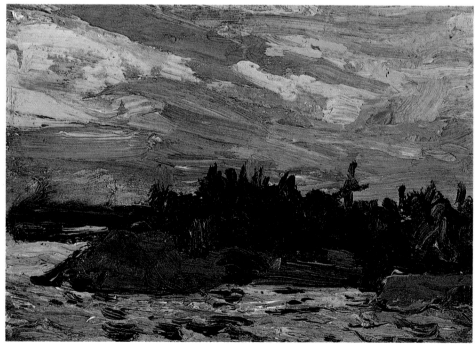

Sunset, Canoe Lake

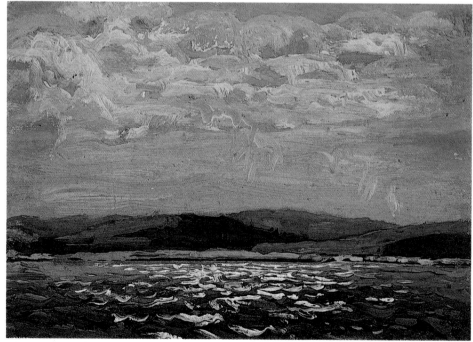

Algonquin Park

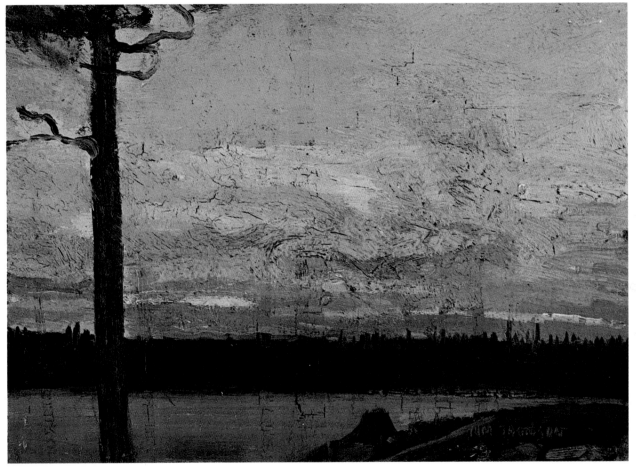

Evening Sky

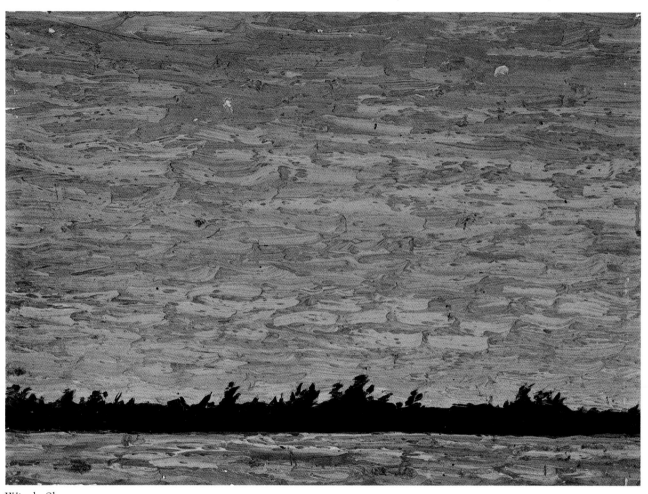

Windy Sky

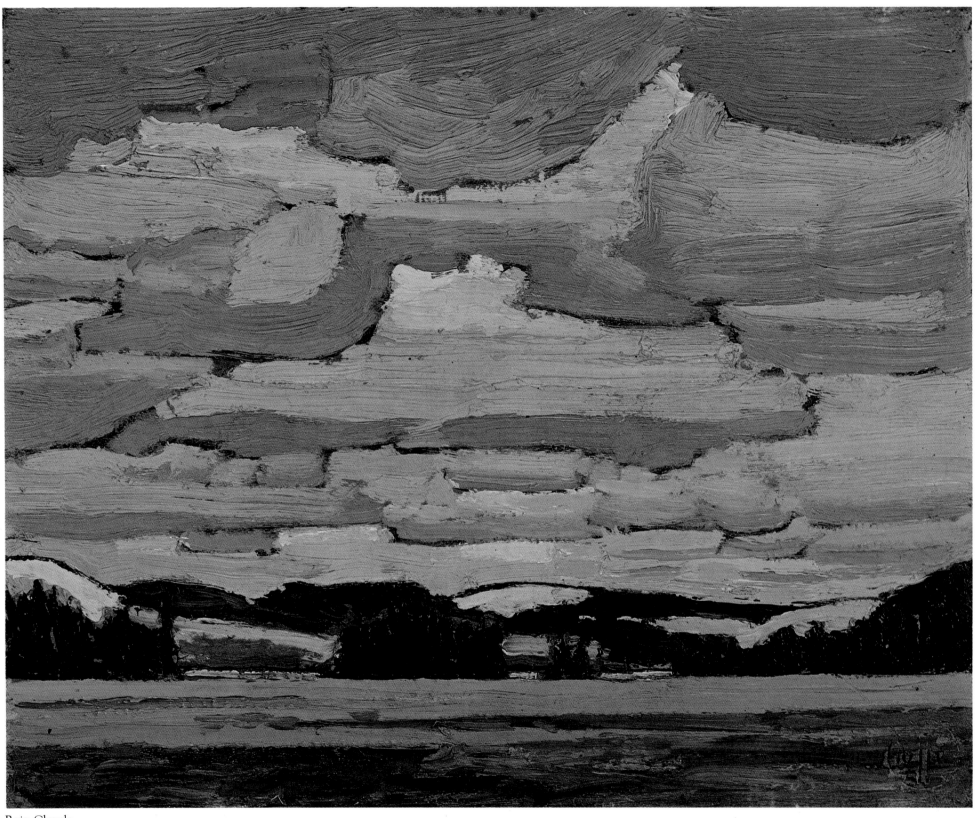

Rain Clouds

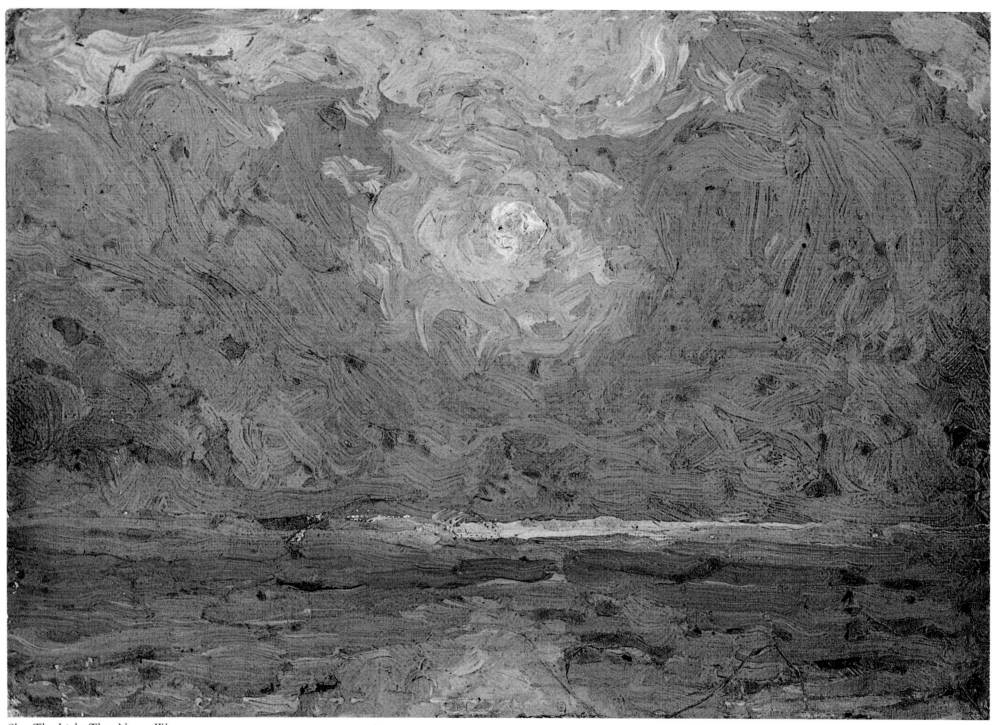

Sky: The Light That Never Was

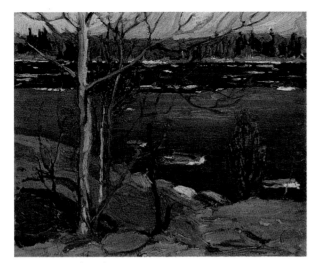
Spring Ice (sketch)

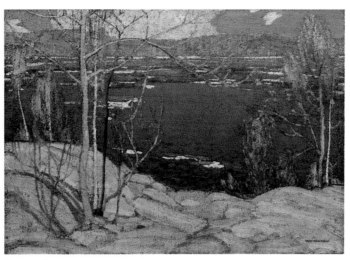
Spring Ice

Botticelli, the Italian master and painter of *Primavera*, would have admired *Spring Ice* and approved of its wise colour – hues held in a light that will fight through winter as long as the world lasts. A light as pale as the thought of moonlight, a light that surprises the colour out of things and sets the ground to shrugging. Displaying virtuoso modulations of hue in the middle range, *Spring Ice* represents the maximum amount of tonal stretch in Thomson's work and produces a surprising flatness and integrity to the picture plane. His most admired bravura sketches rarely surpass the controlled passion of the dragged and scumbled brushwork in this painting that allows just the right amount of under-painting to show through. The colour is meticulously matched, subtly contrasted and applied with a stunning command of weight and hue. Often overlooked in the praise of other paintings, *Spring Ice* provides absolute proof that Thomson could master a larger format and succeed without athletic toughness of attack.

Spring Ice (sketch): detail

Spring Ice: detail

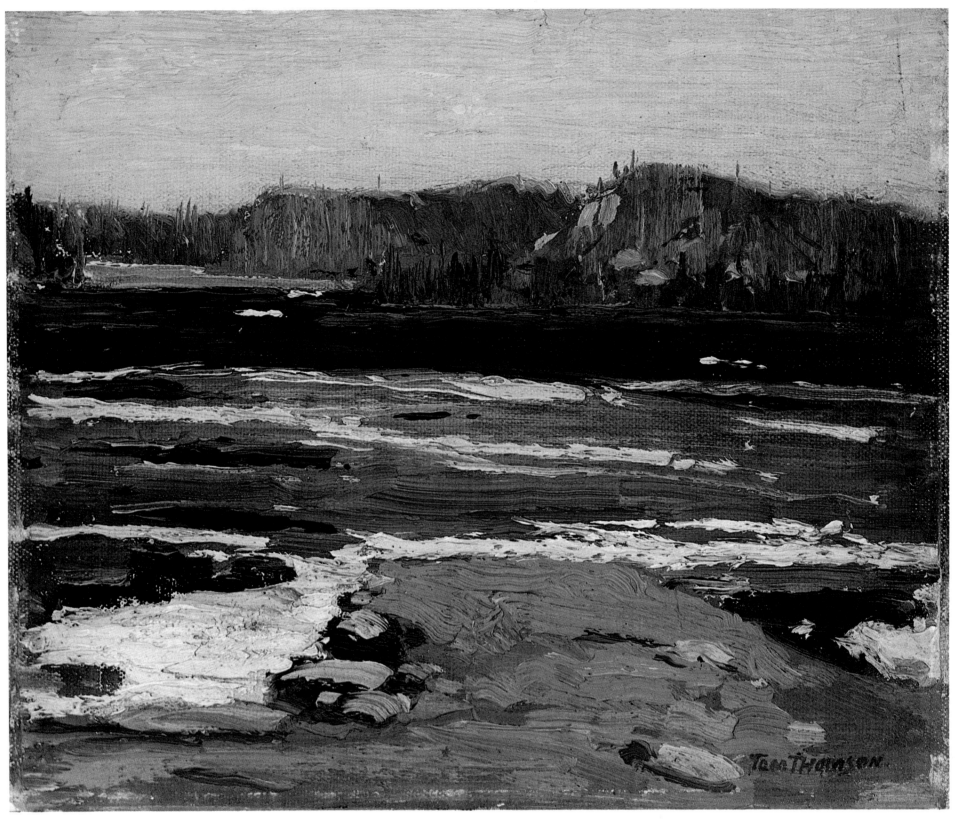

Petawawa Gorges

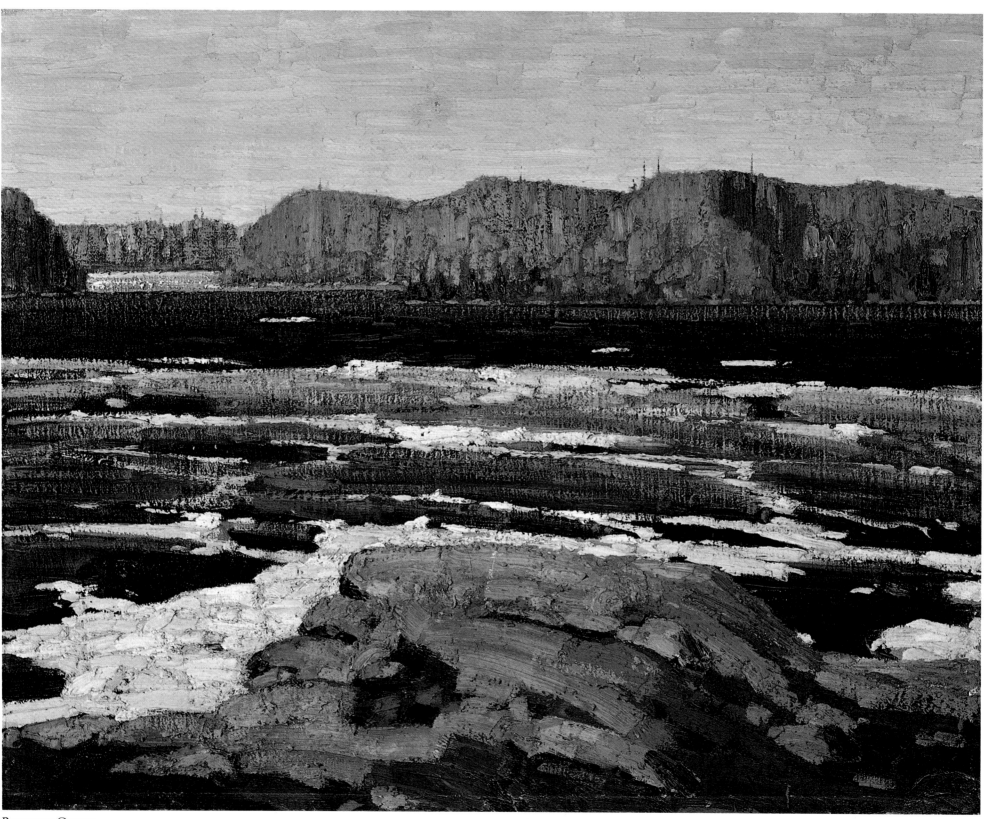

Petawawa Gorges

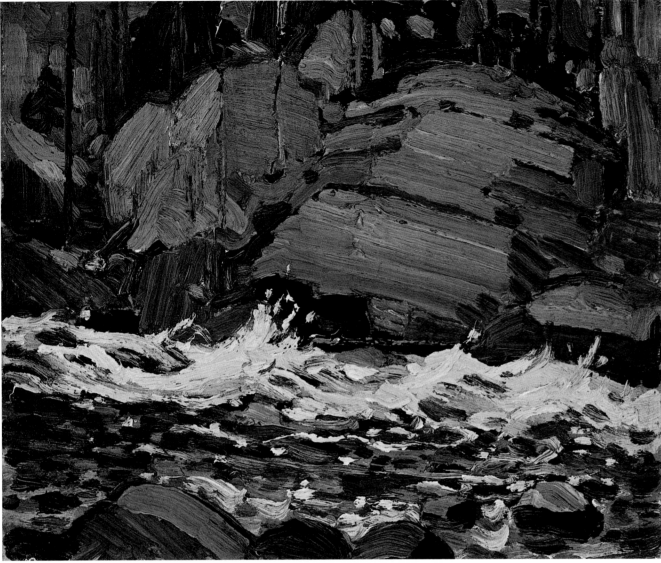

Swift Water

The rivers, streams and freshets of Thomson's forest are given that special dash he favoured in sky and cloud. Turbulent white water impatiently breaking the silence of the bush, humming at a distance and then nearer, bursting like the sound of city traffic through an open window on ears tuned to rabbit scamper, a tumultuous throughway by-passing rock, undermining tree, as relentless as fire. Water sometimes races the wind and wins in those sun-dappled caverns. The minor freshets, too puny for a canoe, are still a highway for a floating leaf and home to creatures of the final cold. Thomson, when he painted streams, seemed to be wrestling with sound as much as sight, trying to pay the current for the friendliness of its greeting. He often over-worked his river subjects so that the thrust and drive of the movement upset order and pop holes through to infinity in the painting's skin. He tried to activate the stabilizing forms that contained the water into the general tumult.

A Rapid (opposite), by comparison, pours from a dark mass directly into the eye, bringing with it the tang and bite of river-fed air, the authority of mass and weight, contrast and colour that declares this is the way it was.

The Rapids (page 77), in which the water is handled with succulent impasto, is keenly toned to give the richness of the spill, yet the foreground rock is impetuously outlined with bravura strokes more daring than any in the water, reducing the intrinsic hardness of rock to a liquidity that complements the water rather than contrasting it.

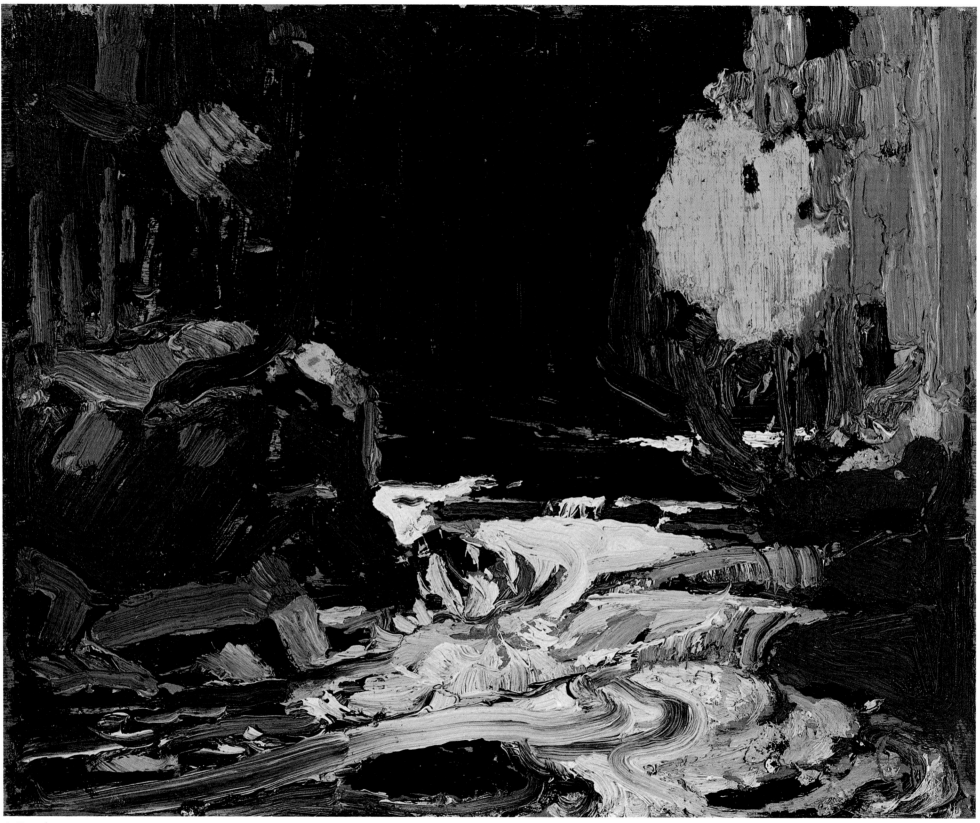

A Rapid

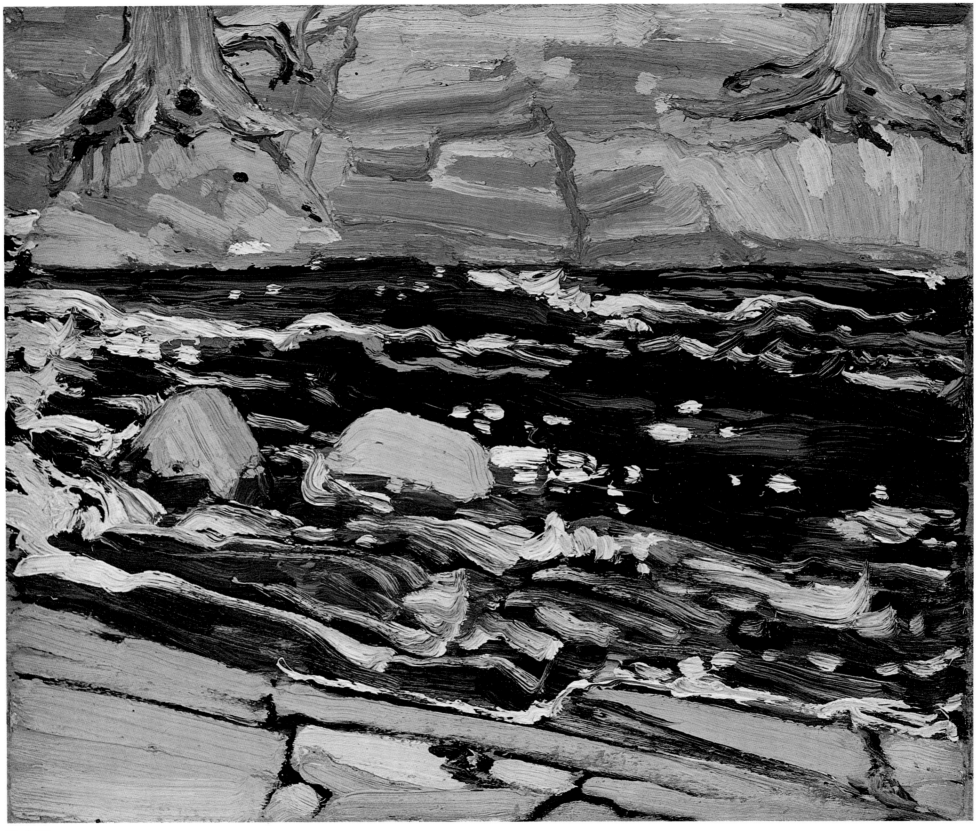

Dark Waters

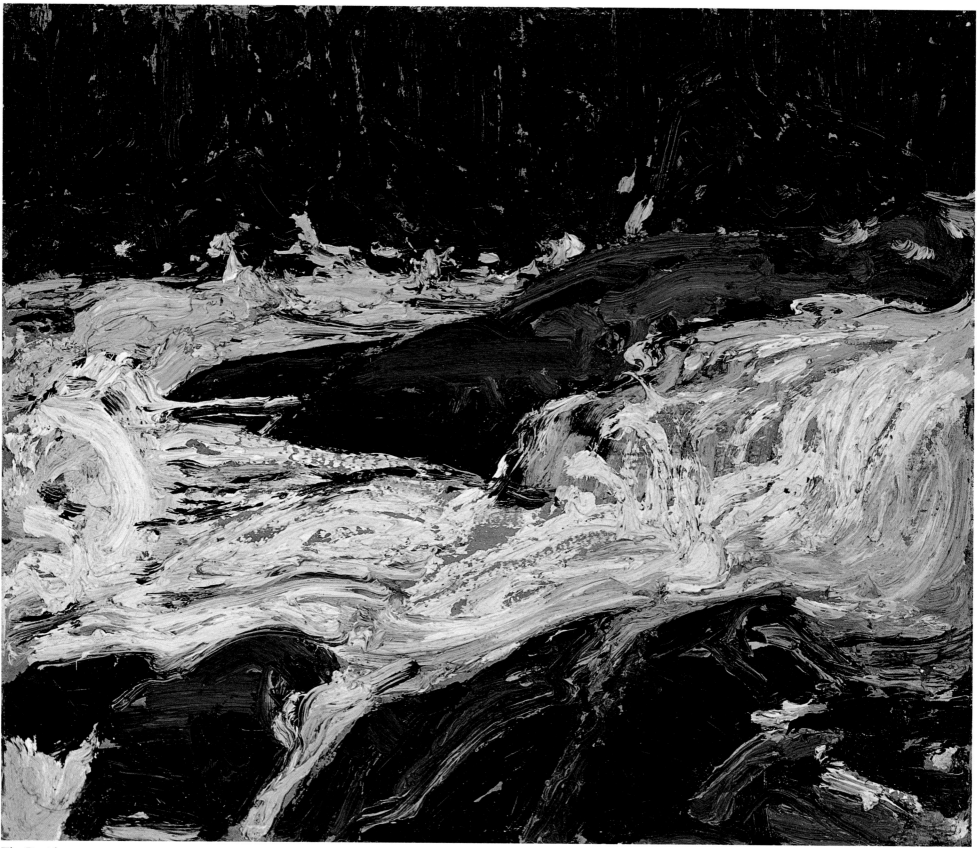

The Rapids

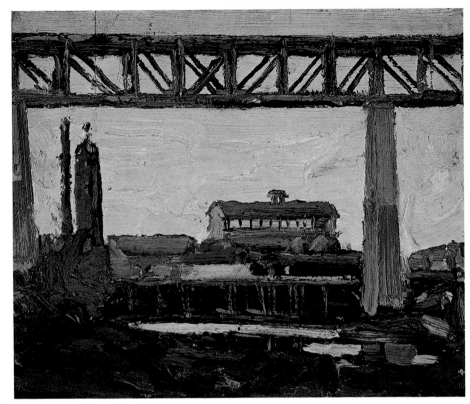

Trestle at Parry Sound

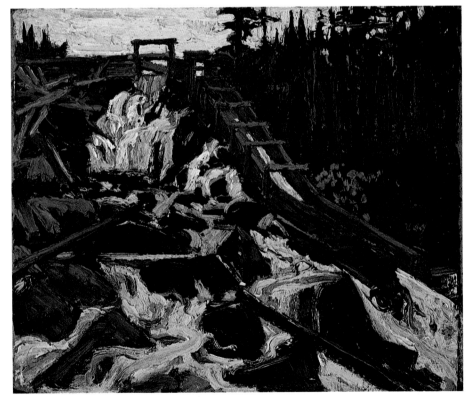

Timber Chute

Thomson and the Seven were poetic men, though certainly not as precious as the sticky prose that celebrated and hung the tinsel of unreality over their surfacing in the national consciousness. Throughout the many conflicting accounts of the early days there is an implied relationship to the naturalism of Frost and Thoreau. J.E.H. MacDonald is purported to have lettered, "With the breath of the four seasons in one's breast, one will be able to create on paper; the five colours well applied will enlighten the world " across the horizontal floor band of the balcony in the studio I have occupied for eighteen years in the old Studio Building. Assuming in part the truth of their poetic bent, one is struck by the calm with which they accepted the terrible change brought to their sketching ground by the development of industry, mining, logging and even recreation. In *Fireswept Hills* (page 89), for instance, Thomson actually created a lavender paean to destruction. It would be unfair, safely wrapped in the comforter of history, to accuse the Group of a lack of feeling, for I suspect, impressed constantly by the emptiness of Algonquin, they viewed machinery, huts and dams as a touch of home, a welcome sketching diversion. How were they to know that a time would come when fish contained more mercury than a thermometer and beer cans bobbed in the dark trout pools they loved? Or women with bouffant hair-dos, wearing sparkle pants and high-heeled shoes could be seen trying to pull an imitation birchbark plastic canoe over a portage on a rope?

Thomson did not glorify industry in the bush – he was no Charles Sheeler; industry's profile in Thomson's north is low. There was no red carpet or front row seat for commerce in his work. He was wary and treated industry as a slight relief from the omnipotence of Nature, but not as an alternate subject for cloud or rock.

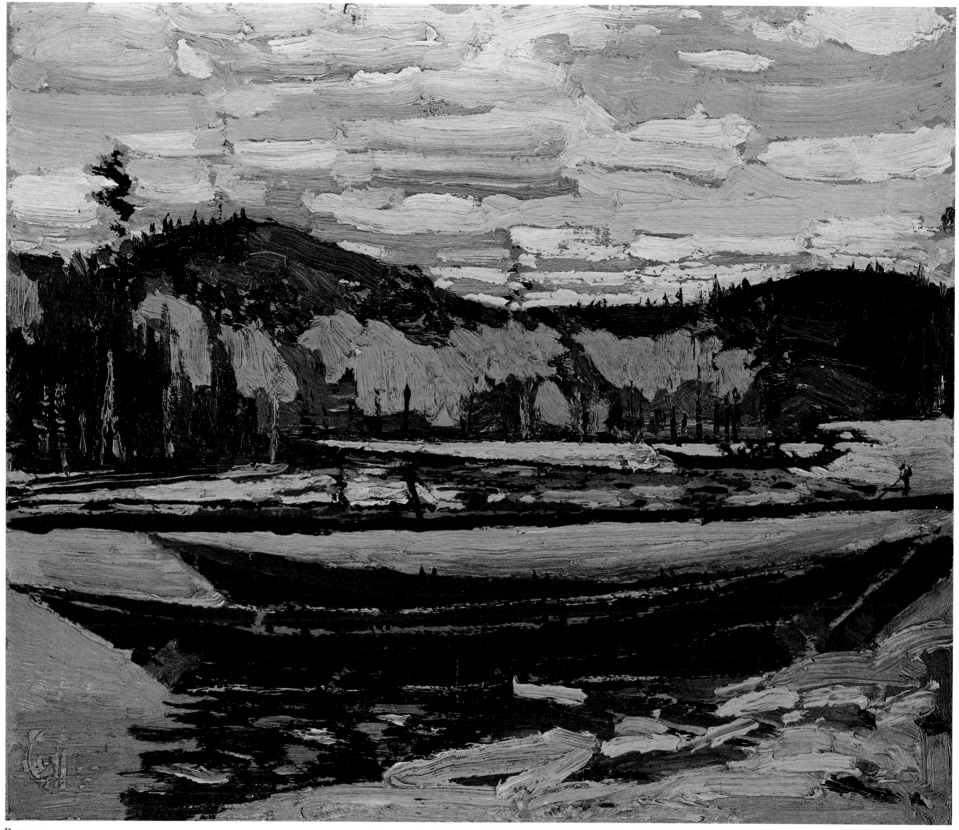

Bateaux

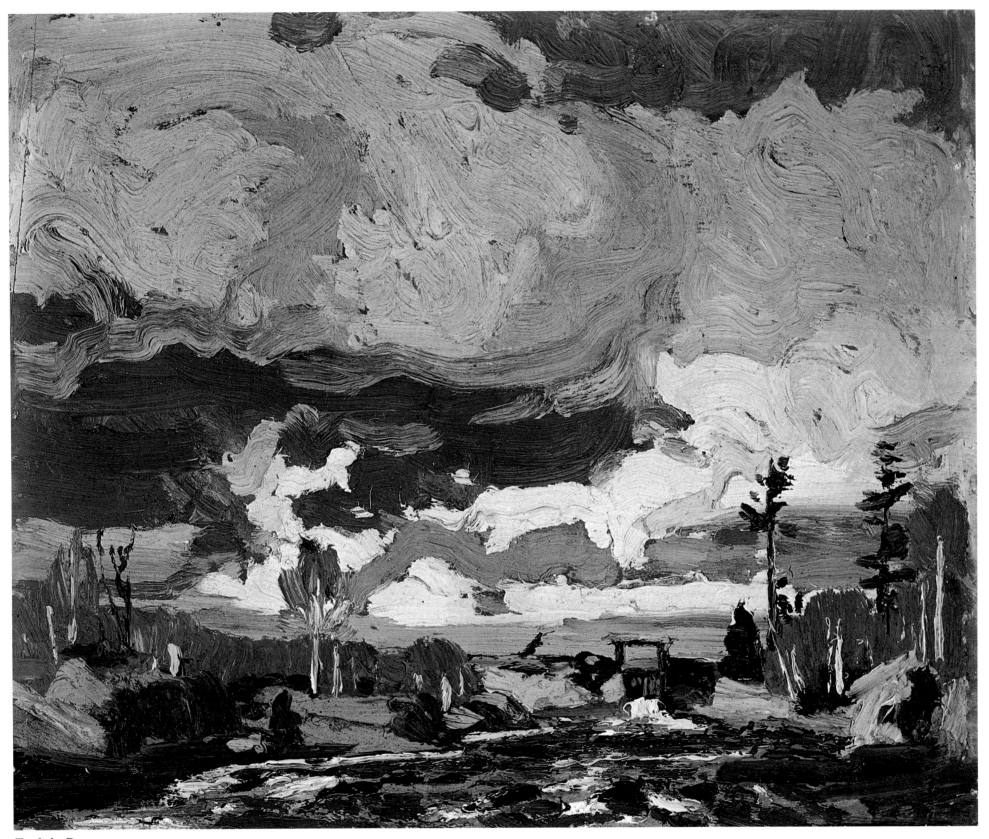

Tea Lake Dam

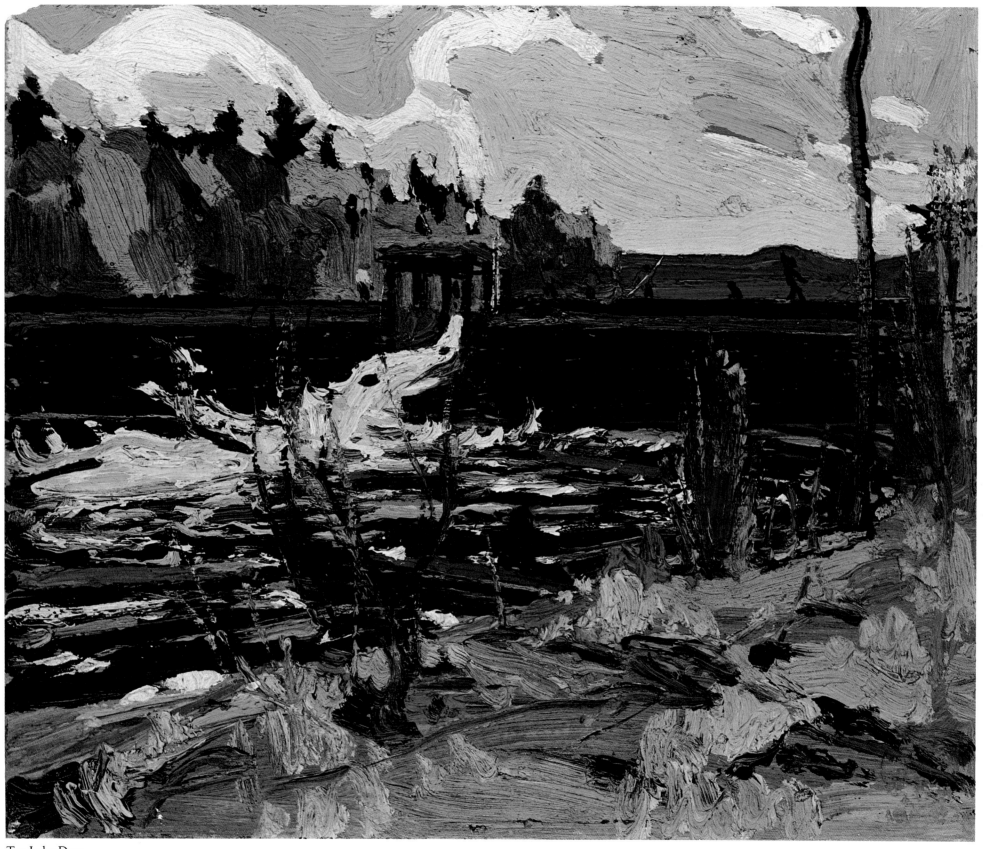

Tea Lake Dam

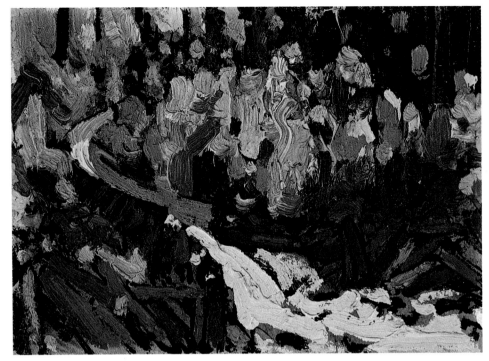

Log Jam

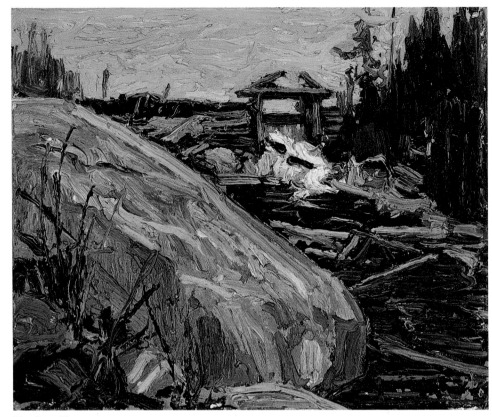

Timber Chute

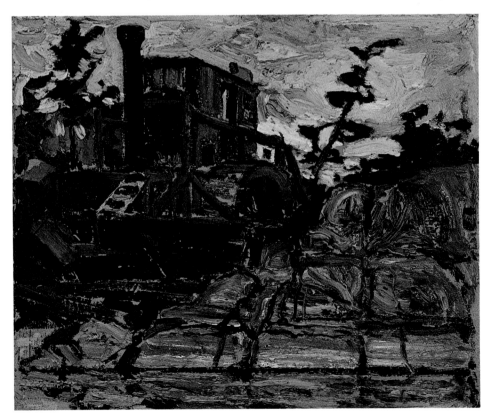

Alligator

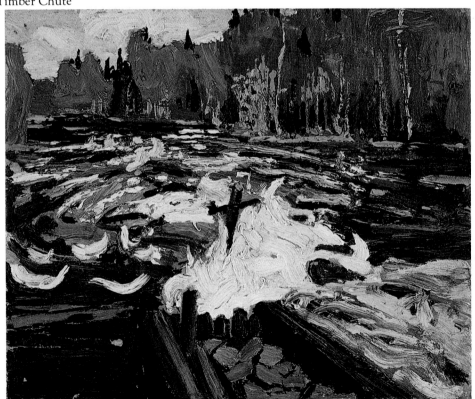

Log Run

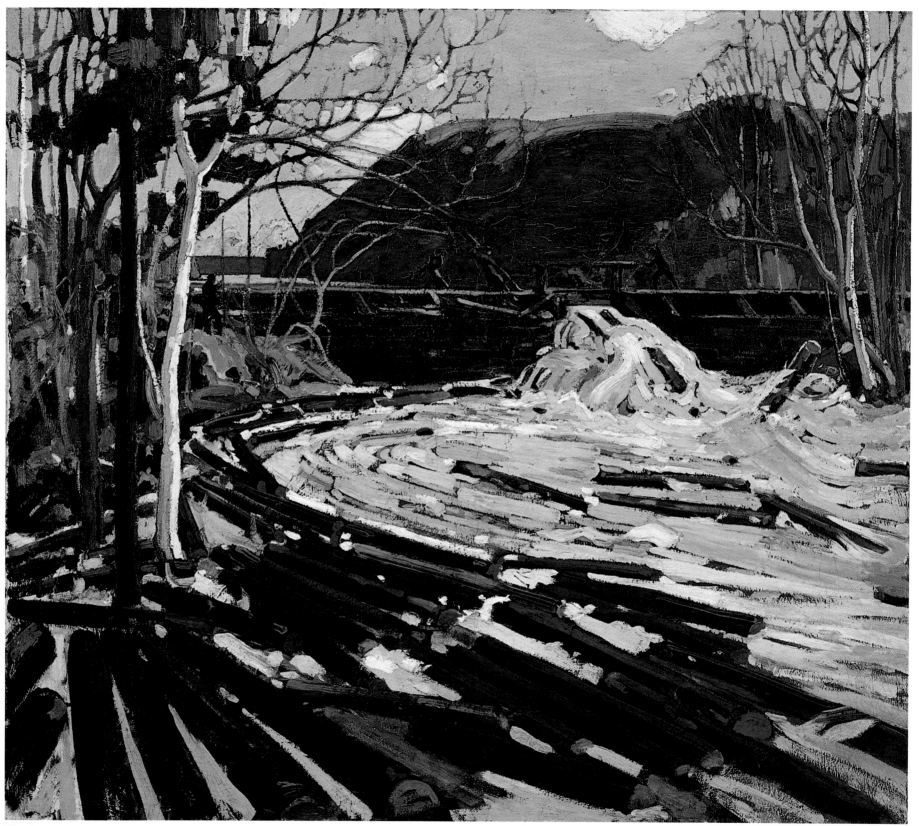

The Drive

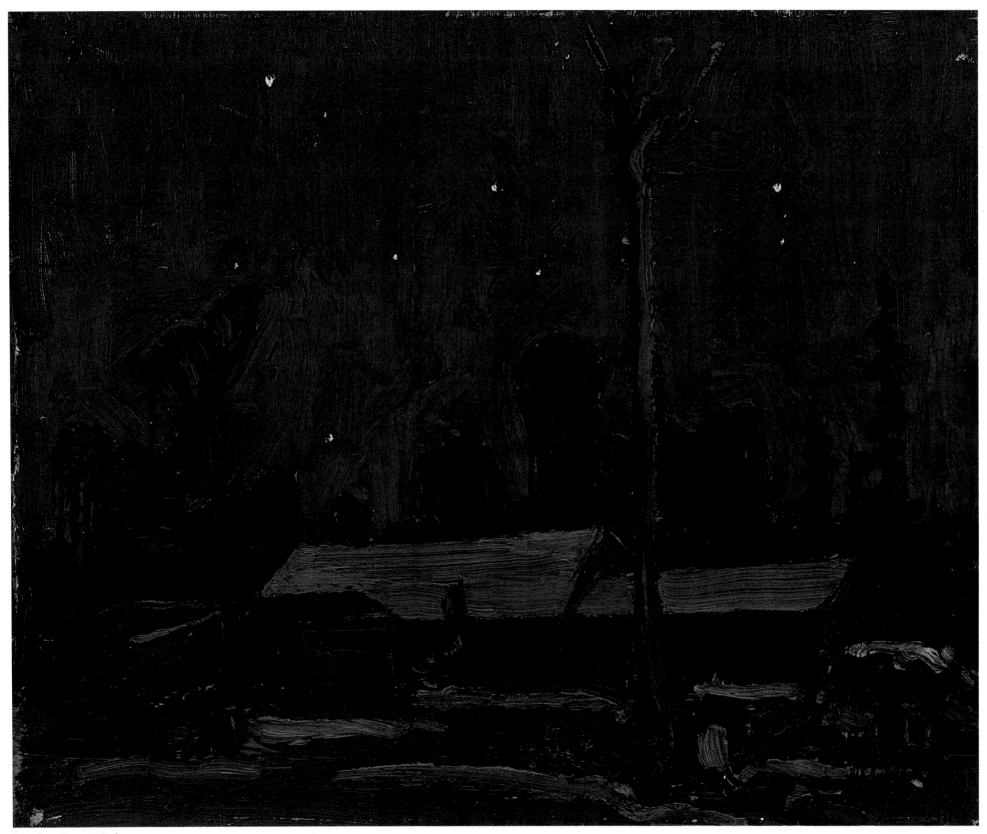

Lumber Camp, Night

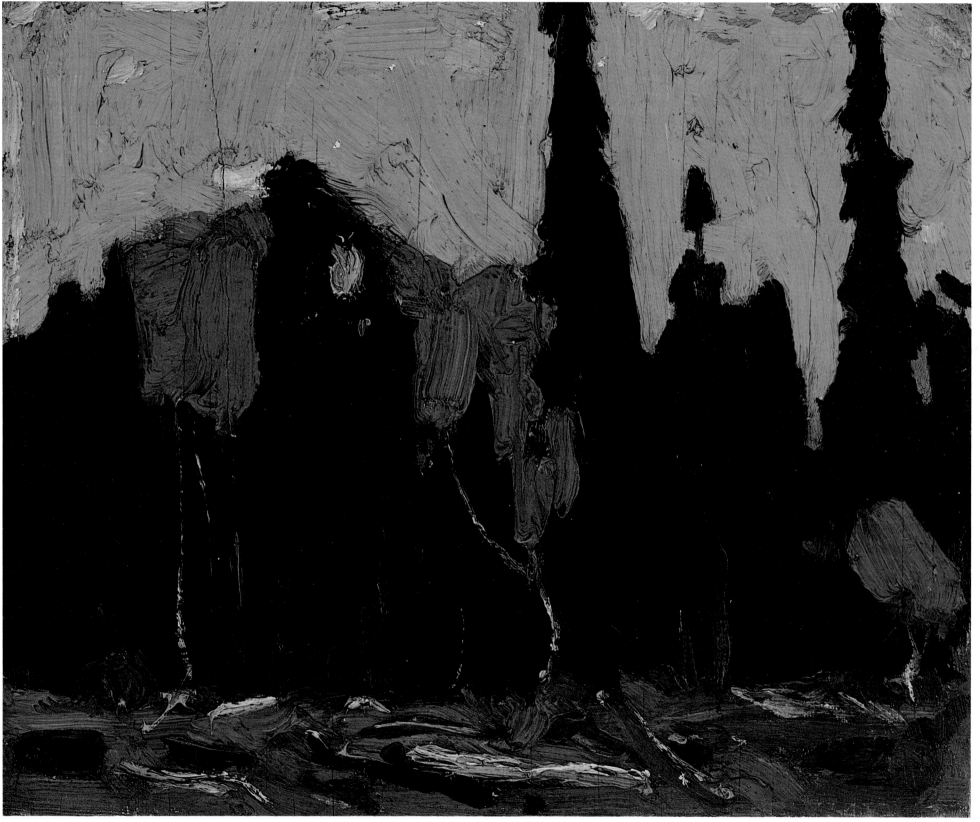

Nocturne

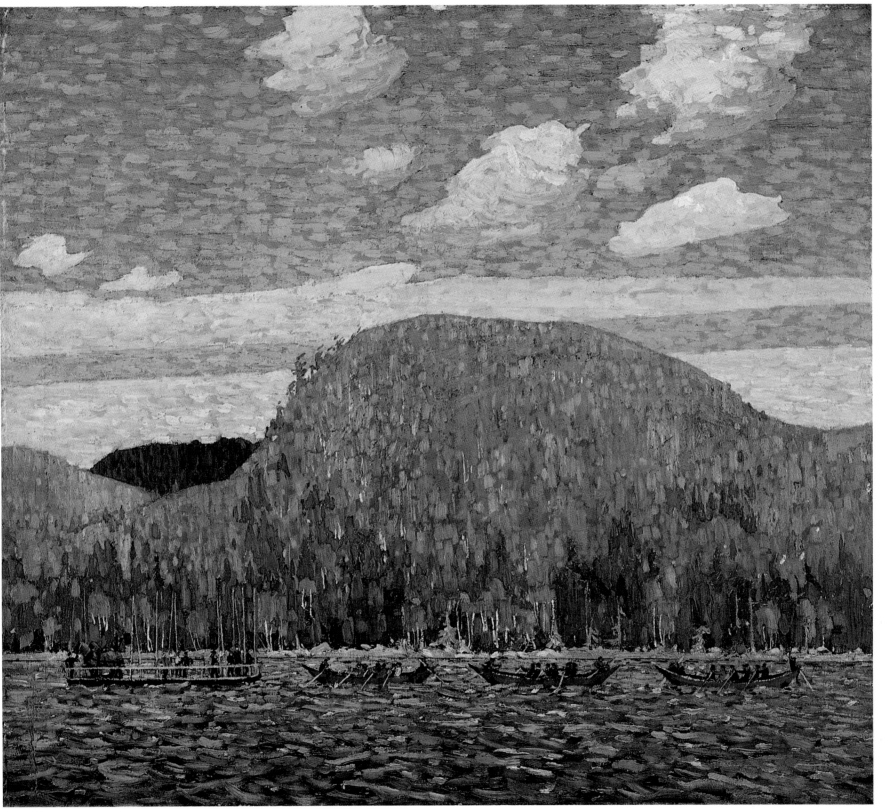

The Pointers

The Pointers: detail

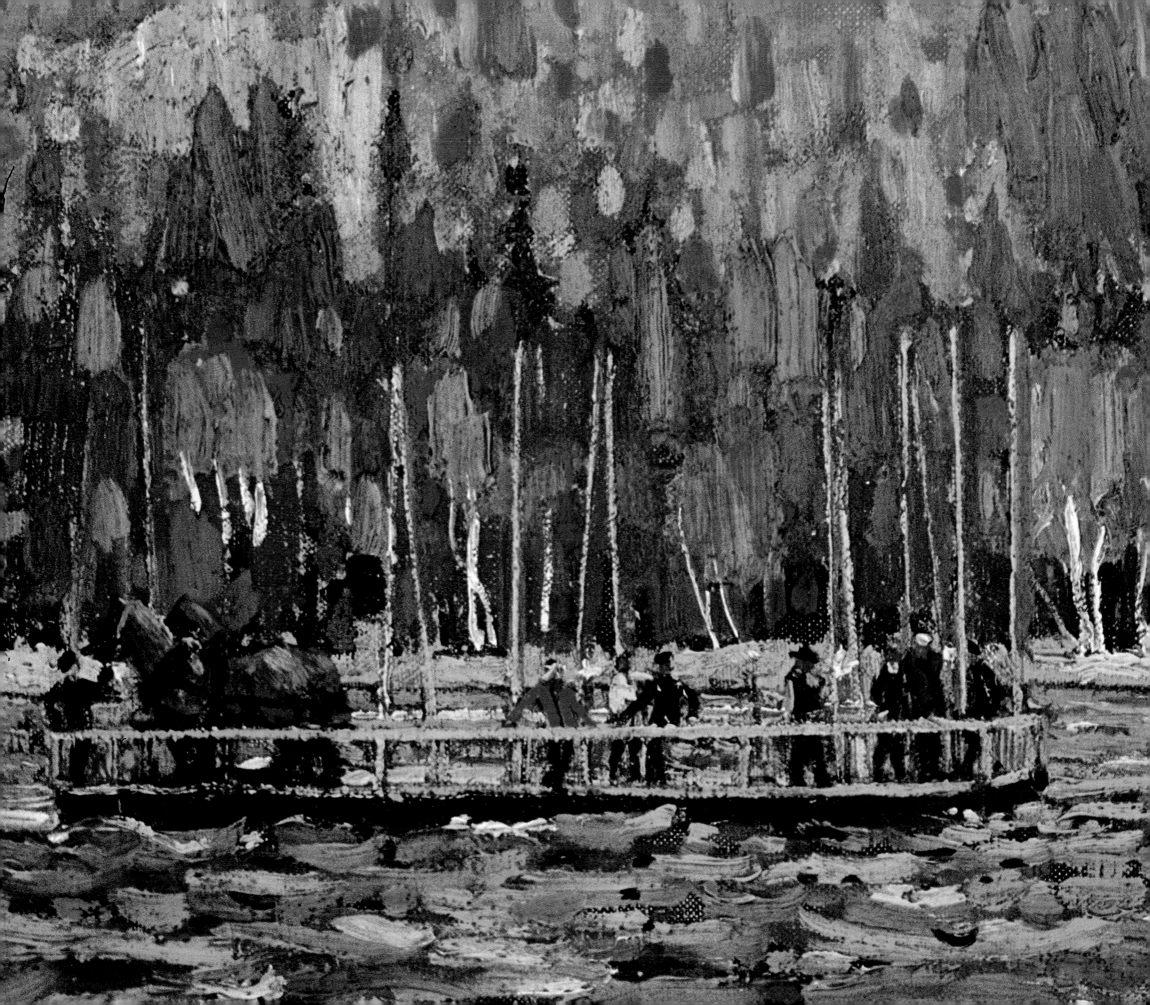

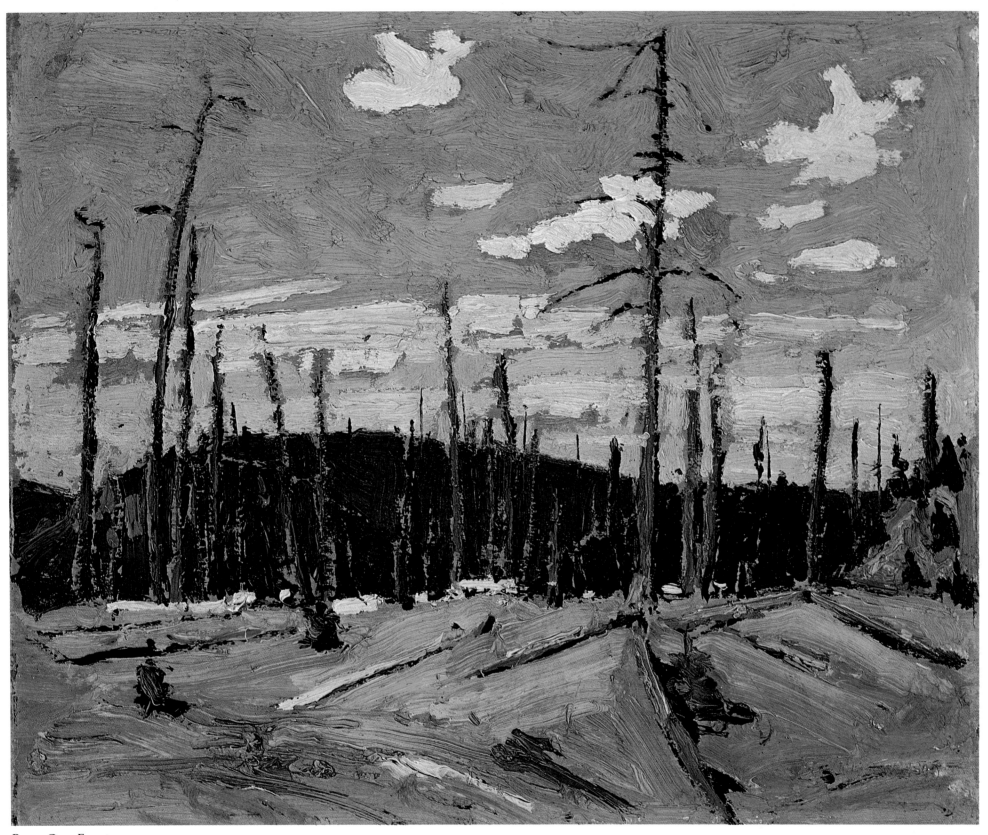

Burnt Over Forest

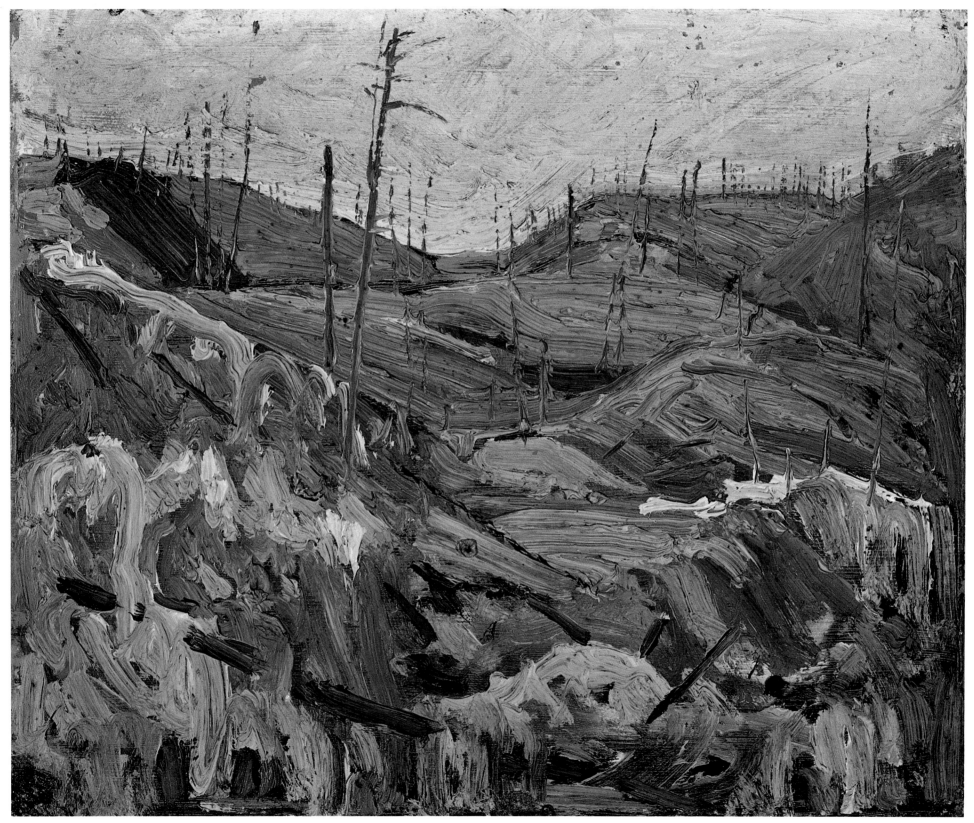

Fireswept Hills

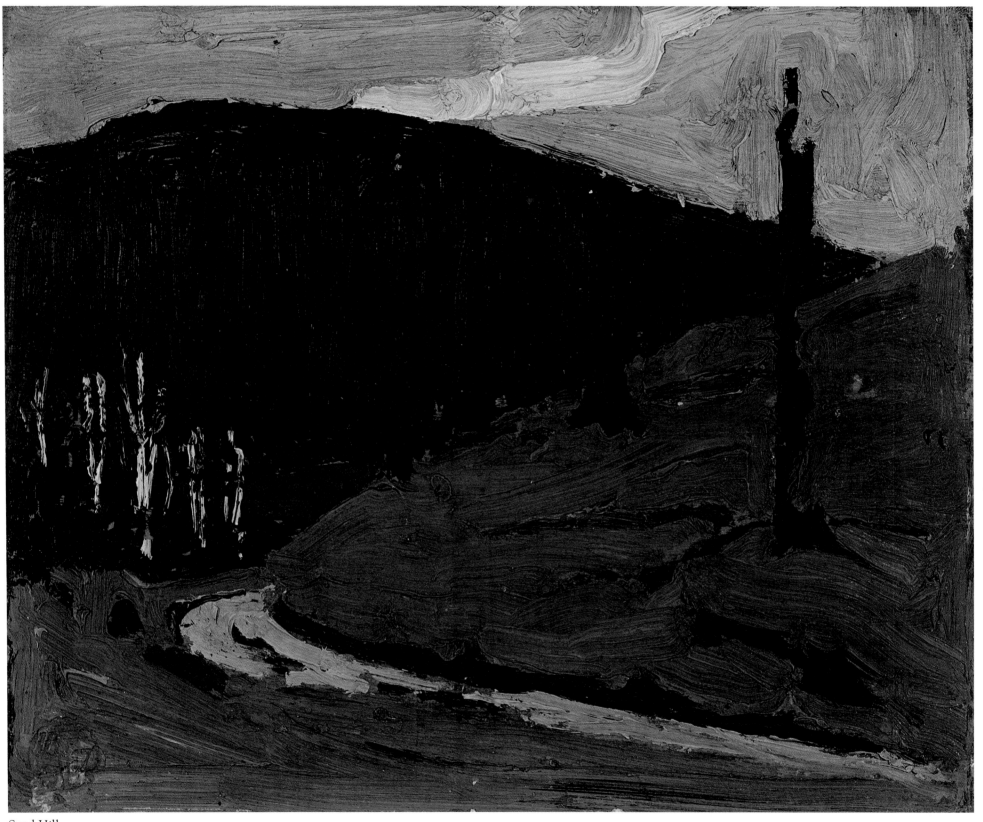

Sand Hill

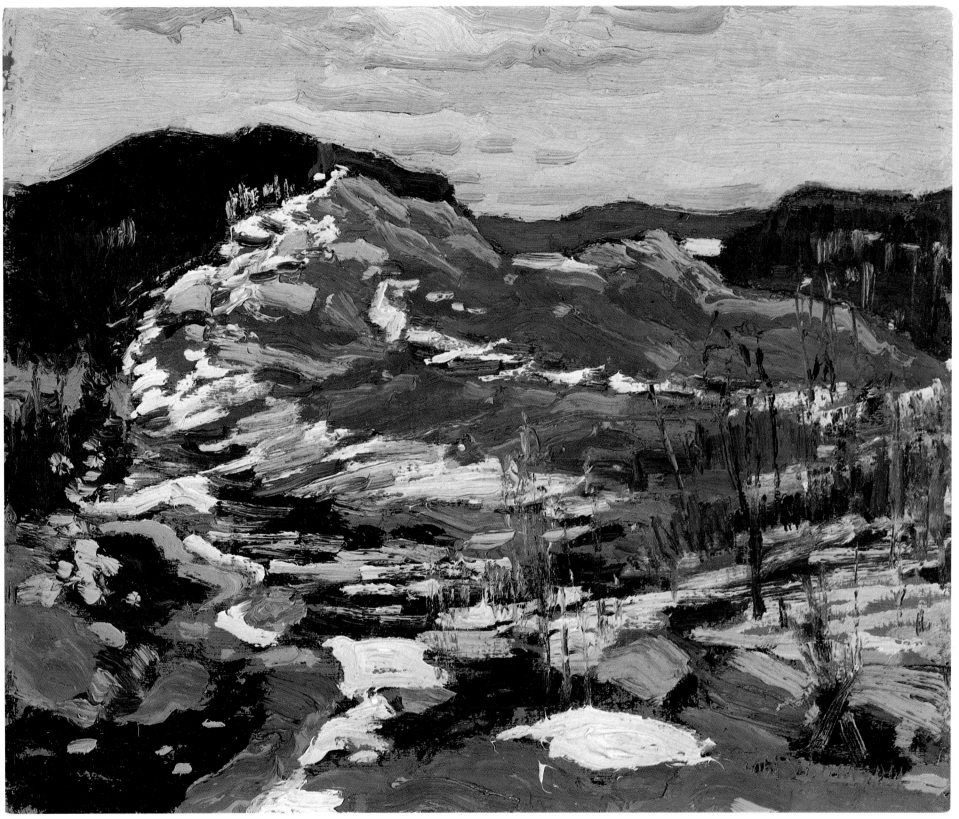

Forbes Hill, Huntsville

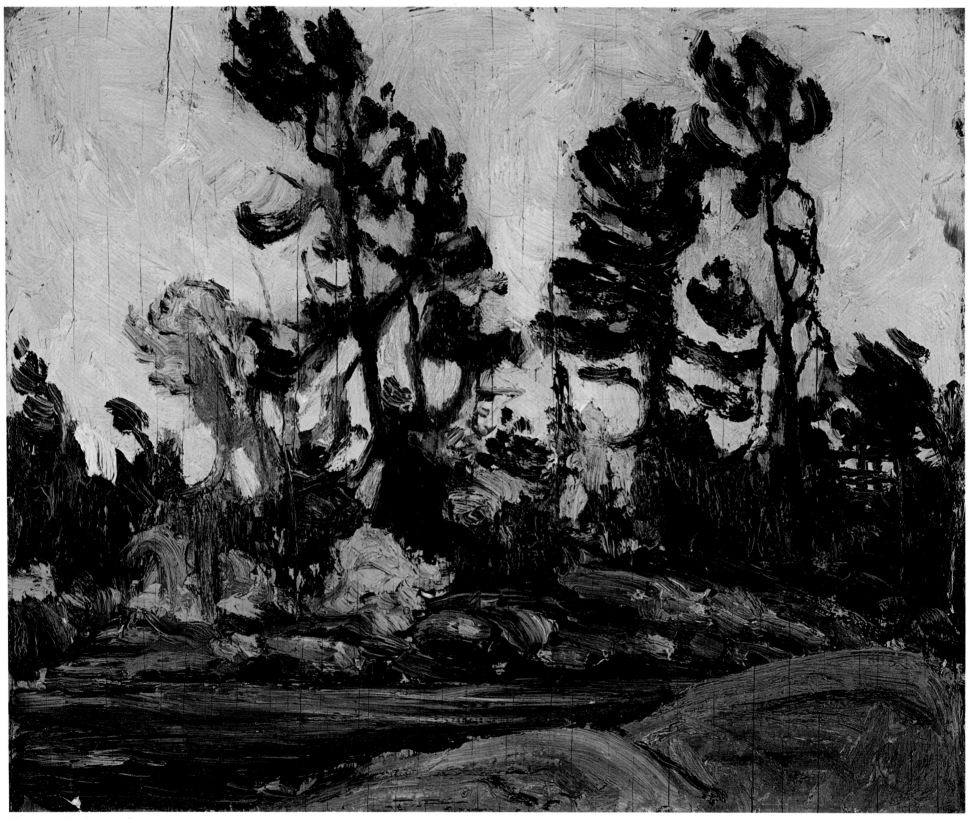

Georgian Bay, Byng Inlet

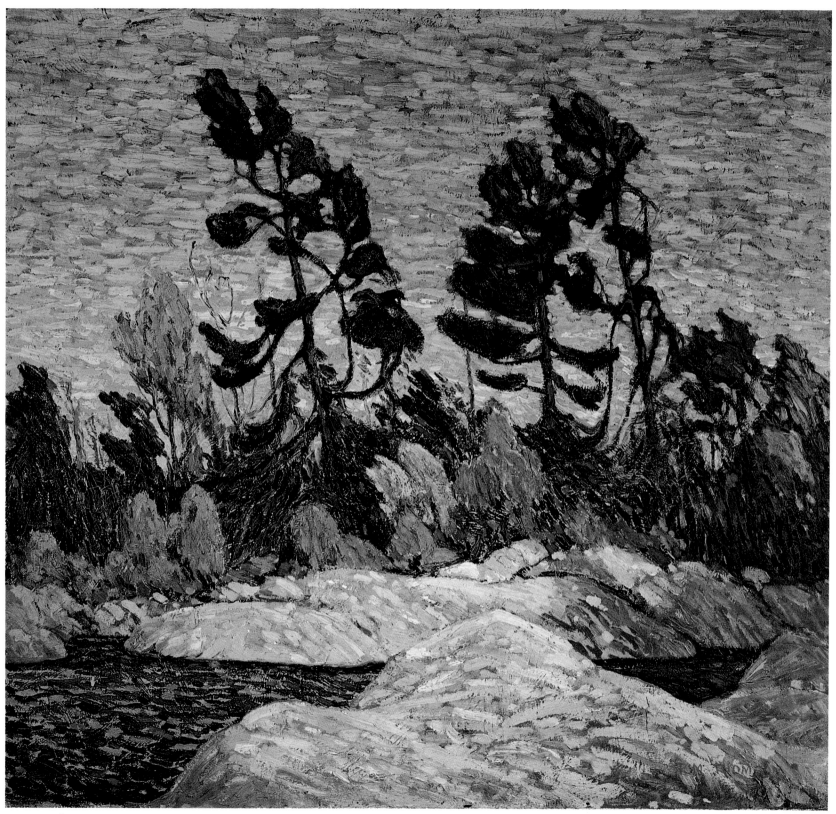

Summer Shore, Georgian Bay

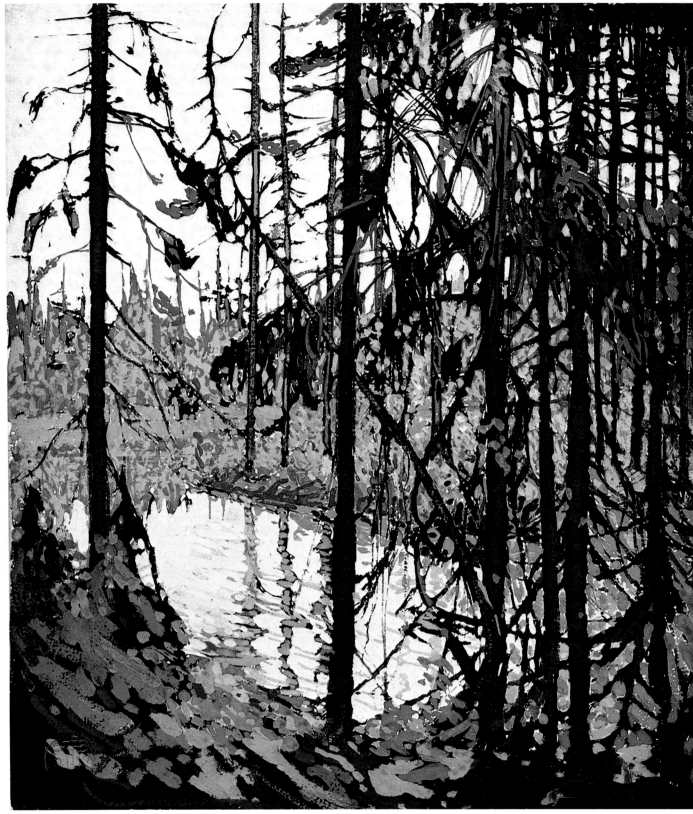

Northern River (sketch)

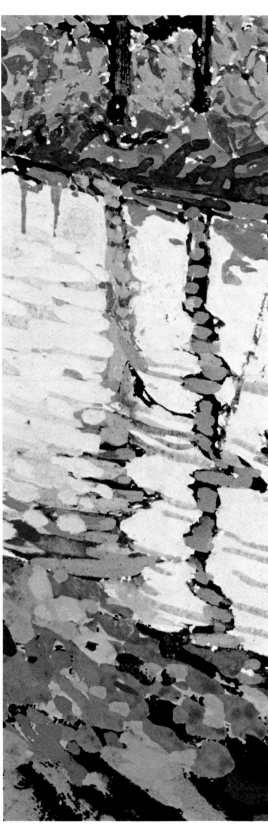

Northern River (sketch): detail

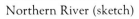

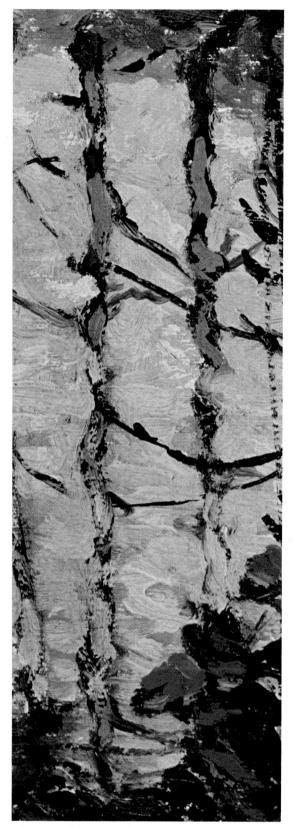

Northern River: detail

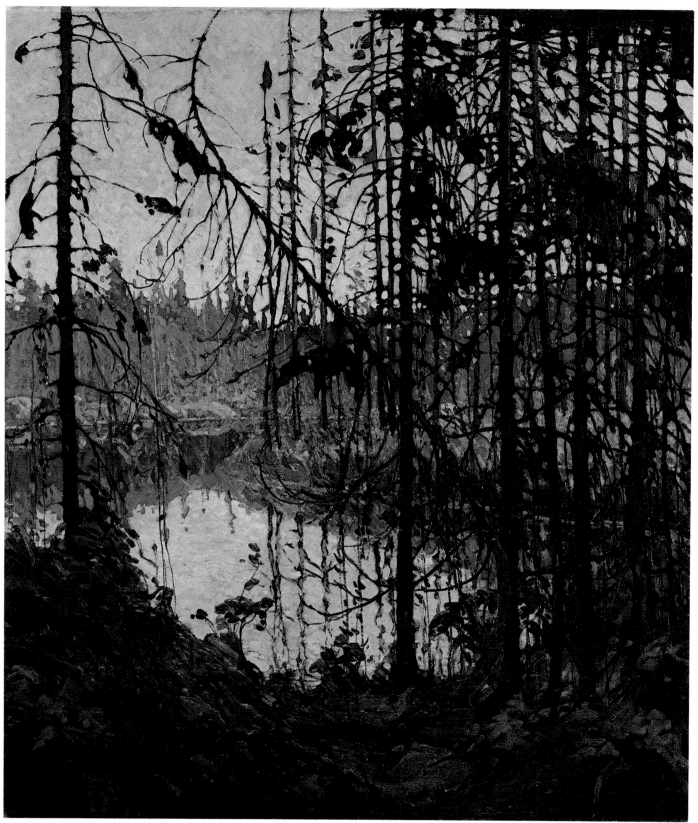

Northern River

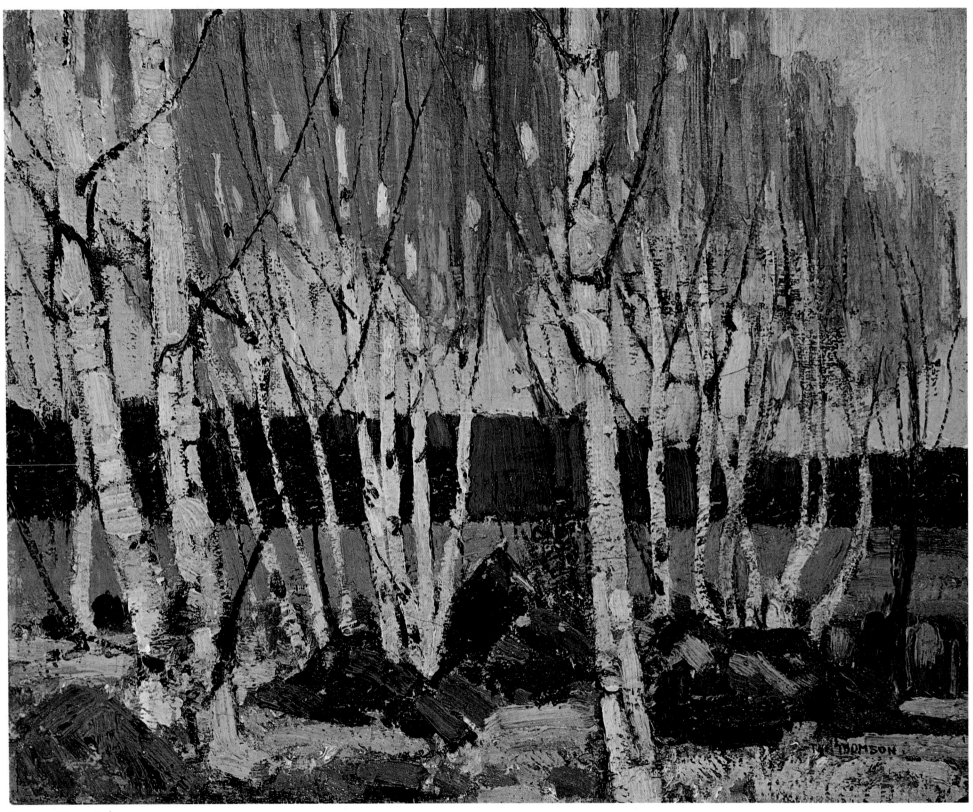

Evening, Canoe Lake

Tom Thomson's Art:
Origins and Influences

After Thomson's death it became fashionable to say that he had emerged wholly formed from the Canadian soil, as if his attitude to landscape had been coeval with the Precambrian Shield itself. It was imagined, since he had never been to Europe, that he was "untouched by European traditions," or, since he had never visited the large museums of the United States, that he must have invented his expression in an artistic vacuum sealed off from the virulent experiments of artists and styles elsewhere. There is, as with many of the mythical qualities attributed to Thomson, a seed of truth to these beliefs; but it was soon inundated by the compulsive surge of hero-making that followed.

Thomson's friends were chiefly responsible for spreading this gospel and for Thomson's later canonization. Arthur Lismer, for example, preached that Thomson had "no connection with styles or schools.... He had nothing to do with Europe and in his art there is not a trace of inherited style or influence from abroad." He further asserted that "If one knew Thomson one also realized that he knew nothing of such things as [Art Nouveau, Impressionism], etc." Possibly Thomson did not know the works of these movements in the familiar sense that Lismer did from travels and studies, though he could have seen some Monet paintings at the Canadian National Exhibition. Possibly, too, Thomson affected not to know as much as he did, for he was a diffident man on occasion, and he would have been particularly uneasy where his own lack of a thorough education might have been revealed.

A.Y. Jackson was less dogmatic but just as forceful as Lismer. For him, Thomson's "rugged individuality was never dominated by any outside influence." Jackson could not have meant that Thomson was above taking ideas wherever he could find them, for he certainly was not. He may have meant that Thomson was

not imitative in the pejorative sense of the word. Both Lismer and Jackson were anxious to promote the idea of a new Canadian art and it was a prevalent belief at the time, Lismer and Varley notwithstanding, that artists born or trained in Europe suffered a distinct disadvantage in painting Canadian subjects. The native-trained artist was felt, when it served the purpose, to be the only vehicle that could render the Canadian landscape with authenticity. Thomson was believed to have it in his bones. As late as 1972, Robert Ayre, a Montreal critic, wrote that Thomson's "paintings spring, not from painting, but straight out of the soil, the moss, the weather and the sky of the north woods."

Thomson's art, however, is a conglomeration of sources that are often painfully evident. He assembled them from an eclectic assortment of "outside" movements all quite different in their aims and intentions. He grabbed a little knowledge here and a little there, picked a great deal up informally, and trusted to his own sense for anything that was missing. That may have given rise to some of the frustration that he frequently experienced. What he had the power to do was to blend these diverse elements in the crucible of his own creative vision; but that should not distract us from acknowledging what or how he collected. His knowledge of art was much greater than is imagined and he gathered it where and when he could.

Thomson had a number of art books which he lent or gave to friends, and he borrowed others to consult. He was a compulsive but sporadic reader, although the only work we know he read was Walton's *The Compleat Angler*. MacDonald must have pressed the works of Thoreau and Emerson on him, but there is no mention of it. He also read art magazines closely, and particularly *The Studio*, from which he filched ideas and once, in 1913, even copied, rather pathetically, an innocuous work by an American artist, Harry van der Weyden, that had been reproduced in black and white in the March 1904 issue (see page 44).

Thomson also saw a number of exhibitions that would have given him indications of what other artists were doing in the world, even though he might not have seen either superb work, or work that was on the cutting edge of the great new developments of twentieth-century painting. Jackson, perhaps thinking of the riches he had accumulated during his sojourn in Europe, stated that "Tom Thomson never saw a good picture in Toronto, European or otherwise." He knew that it was important for artists to see good work that could challenge and inspire them; he must have been aware that Thomson was not able to grapple, first hand, with the best that was being done elsewhere (as Emily Carr and David Milne, for example, had already done), and that this was bound to be an obvious deterrent to his development. Thomson had a capacity to absorb that was never used as fully as it might have been. On the other hand, the lack of direct, contemporary influ-

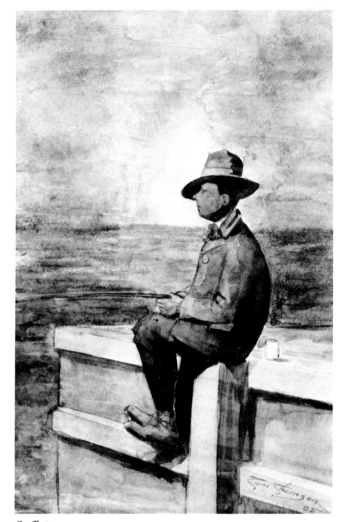

Sufficiency

ences must have driven Thomson to his own resources of observation. Had he been more exposed, he might never have discovered within himself that precious vein of imagery by which we now know him. Thomson was so responsive to influence on occasion, that it is conceivable that his own originality might have been overwhelmed.

It is difficult to imagine what a red apple on a tree looks or tastes like when one's only experience is with a dish of applesauce. Most of Thomson's knowledge of art came to him already transformed, either strained through editors, critics and the press, or predigested by the experience of others. Jackson related that Thomson told him about camping, canoeing and Algonquin Park (after one summer there!) and he told Thomson about the Impressionists. Being one remove from powerful, original thought in one sense deprived Thomson from the start. The uncertainty in his development and the arbitrary shifts in the course of his brief career are more than ample evidence that he suffered from artistic malnutrition. What is impressive is that in spite of the handicaps he began with, he was still able to create as much and as powerfully as he did.

The impulse to create first comes from the itch to imitate other art where the rules and conventions are clearly set out as examples for the novice to follow and to learn from. Most artists begin with imitation of a very servile kind which is not

Tiger in a Heart

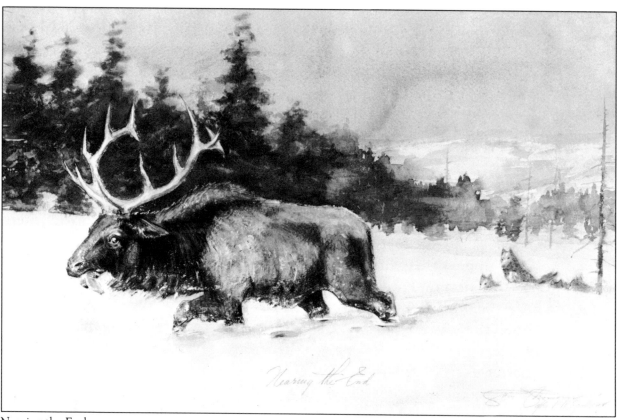

Nearing the End

Decorated bowl and detail

far removed from copying. Nevertheless, it is a kind of learning, and Thomson's variation of the van der Weyden is a raw disclosure about his lack of preparation and of his hesitation that previous writers have ignored. The *Moose Crossing a River* (page 38) probably dates from about the same year and is not an original conception either, though it may possibly be after one of Thomson's own photographs. It is embarrassing to find a man at the age of thirty-five, about to be hailed as one of the greatest painters the country had known, hacking away at appallingly simple-minded themes and trite ideas. Yet these exercises were nourishment, and they were a necessary initiation to his new profession.

An artist learns from other art, but he also learns and discovers through personal observation, which is then translated into images through the rules and conventions that he knows and uses. It was Thomson's understanding and intensity of vision of his subject matter that gave his work the ring of authenticity, and he was able to support this with technical means that were not nearly as original as is commonly believed. The vital act of creation occurs when the artist reaches a stage in his art at which he invents or modifies the rules to suit his own observations. Whether this causes only minor adjustments to accepted conventions or compels the creation of a radical new structure to carry fresh perceptions, is a secondary matter as far as the making of good art is concerned. Delacroix felt that genius was less often the expression of new ideas than the work of men who felt that a great deal more needed to be said about what had already been said. In either

Design for stained glass window,
Havergal College

case, however, the point of departure is, always, the tradition of art, just as the new expression itself becomes part of the tradition for a later generation.

Thomson's innovations and contributions to the traditions of the art he has become a part of were not particularly great. He did not invent a new language with the importance, for example, that Cubism had. He did not develop a major style that was coherent or far-reaching in its impact, though from what he did achieve, it is possible that he might have if he had lived. The fact that his work was more original and alive than that of most of his contemporaries is not a basis for over-estimating his contribution. What most people have taken as his great achievement, the painting of the North, was possibly the least of his accomplishments and the least of his real concerns. Had he decided to paint cityscapes, still lifes or farming country, his qualities as a painter would have remained unchanged, even if our assessment of his importance would necessarily be different.

Where he did offer some modifications to the art of his time was in his acute sense of colour. Without knowing profoundly the considerable advances that had been made in France and in America in the century's first decade, Thomson managed by luck, possibly by a sense of the *zeitgeist*, and by original extension of second-hand ideas, to unite the subtle colouration of the Impressionists with the demands of the clear, brittle light of Ontario's northland. He edged up to the colours of the Post-Impressionists, but he did this mostly on his own and not through any evident knowledge of the Fauves, the Futurists, the Cubists or the later German Expressionists.

His other contribution lay in his very late development of gestural brushwork, one aspect of his painting that made the weight of his loss so great. The very brusqueness and roughness of his approach in technique seemed a perfect marriage with the vision of the north country then and as it still seems now. It is the spontaneity in the thick, full stabs of his brush that makes his small sketches so much truer a reflection of his talent than the smoother, more self-consciously designed large paintings for which his impulsive and impatient nature was ill-equipped.

Worse than the second-hand nature of the information he received was the fact that the directions he was pushed by his friends did not challenge him enough. The then current developments of art in the United States and in Europe were generally scorned by the men who were later to form the Group of Seven. Instead, they gazed upon a conservative and tired tradition which had already declined into the sunset of its years. The Barbizon painters and the Impressionists, who had been a major force in the 1860s and 1870s, and before that the art of Corot and of Constable, were the springs from which Thomson's colleagues drew most heavily, even while they disparaged others for the same servility. While Jackson was study-

ing in France between 1907 and 1910, at the height of the Cubist and Fauvist revolutions, he took instruction from Jean-Paul Laurens who approved neither of Adolphe Bouguereau, a facile but popular academic painter, nor of Cézanne, who had already died. The vital work of Jackson's own contemporaries, Picasso, Matisse, Duchamp, Delaunay and others, was largely overlooked, and led Graham McInnes, in 1938, to comment that the enthusiastic interest by Canadian artists of the thirties in the mechanics of painting and in the art of other countries was "a reaction to the rather excessive nationalism of the Group, which led to a cursory dismissal of Post-Impressionist art—an art which deeply and beneficially affected American painting." Indeed, when David Milne arrived back in Canada from the United States in 1929, he found artists beginning to get excited about ideas and trends that he had absorbed and digested nearly two decades earlier.

There are four major components in Thomson's work which came from the four colleagues he was most affected by or with whom he worked most closely. Jackson had worked in Europe and gleaned from the Impressionists a succulent delicacy of colour which enhanced his early work but which can seldom be found in his work after the First World War. Thomson took from him the very best that he was able to achieve in this direction. From Lawren Harris came a sense of power and vitality that Harris brought from his knowledge of the earlier German Expressionists when he studied in Munich. This aspect of Thomson's work was what, in my opinion, drove him to the abstract and vigorous application of paint that his last works show most vividly. From Lismer, Thomson learned of the tradition of Constable and of the English watercolourists, with its concern for the subtle nuances of weather and atmosphere, and the love of immediate and intimate subjects. Finally, from MacDonald, Thomson inherited a grasp of the importance of design, both in its two-dimensional, decorative use, and in its meaning as underlying structure and form. Each of these components deserves attention.

The one quality that is stamped on Thomson's work more than any other is his exquisite feeling for colour. It was a gift that his colleagues readily and sometimes enviously acknowledged. Jackson admitted that "Tom could do things with colour that none of the rest of us could." For all the awkwardness in his work, in the drawing, the composition and the concept, the one gracious element that emerges time and again is the originality and the miraculous ingenuity of his colour. It was, and is, the quality which sets his work above that of his fellows; and in subsequent critical appraisals in England and in France, Thomson's colour gave immeasurable stature to those few iconic images which are so well known. Even Dr. MacCallum, who rarely concerned himself with the aesthetic aspects of painting, but may have echoed the opinions of other artists, went so far as to claim, immediately after Thomson's death, that "of all Canadian artists he was, I believe,

Poster for the Sydenham Mutual Fire Insurance Company

Quotation from Rudyard Kipling's
The Light That Failed

the greatest colourist." When one looks at works like *Fireswept Hills* (page 89) or *Tamarack* (page 167), it is difficult to think of artists who have since challenged his supremacy in this.

Thomson learned from Jackson a great deal about colour and about the methods of achieving specific effects. Jackson, in turn, had learned from his viewing of Impressionist painters such as Pissarro, Sisley and, most of all, Monet. When Jackson moved to Toronto in 1913, he felt that "the artists in Toronto were woefully lacking in information about trends in art in other parts of the world. A few good paintings by Monet, Sisley and Pissarro would have been an inspiration to them." How Jackson could charge Horatio Walker with "Corot's dictum that those who follow are always behind!" without condemning himself is difficult to understand. Even the crisp bite of Cézanne is absent from his work. Yet the monumental contribution of Thomson was to take the limited experience of Jackson, and what he could garner from bad reproductions, and weld that into a strong, individual mixture which suited his personal vision. He manifestly surpassed his younger teacher, and Jackson even worried on occasion about his running too far ahead. There are works by Thomson which separate themselves from all the Group's works by their magical blending of French colour and the hard, clear light of the Ontario landscape.

The Expressionist impulse to emphasize the personal gesture and to key pictures to a high value must have come in part from Harris' familiarity and commitment to the Germanic insistence on bold, strong form and colour. So far as one can determine from the paintings, this was the only characteristic of Post-Impressionist art welcomed into the vocabulary of the Thomson circle, and it is most evident in the use of pure, unmixed pigments. The "harsh" depiction of the landscape, the apparent brutality of the Expressionist method, is often taken as an attitude to the subject painted rather than as the painting convention that it really is. Contrary to the popular belief that Thomson and his friends "forced us to see the essential violence of the Canadian landscape ... those pine trees writhing in solitary agony," the bush country was seen by Thomson and his colleagues as a place of wonder and delight, a "paradise." The tendency to refer to the North as a hostile, unforgiving land was a much later description, perhaps to buttress the declaration that the painters had tamed this wilderness of the imagination, or at least to make it seem as if they had been at some hazard in doing so. Yet there is not one contemporary reference that I have found which describes the North as "grim": indeed, the references are all of the glory and innocence, a heaven just a hundred or so miles from Toronto. The gestural means of painting must be seen as a painting convention adapted by Thomson to give strength to his vision not to his subject. Jackson told Jack Shadbolt that Thomson was also keenly interested

Head of a Woman

in the work of Vincent Van Gogh. That influence would have reinforced this aspect of his work.

Harris, with his theosophically inclined spirit, must also have given Thomson some sense of the transcendental philosophy that he believed in and with which his later work is imbued. While MacDonald was also a convinced transcendentalist, the early work of Harris gives more visible proof of it. His work also had a crisp, sharp power that none of the others had. Thomson perhaps learned from him about treating subjects with simplicity and on a magnified scale, and of looking particularly for the symbol of a larger idea—the very essence of a simple, strong observation.

Harris was the most travelled and in many ways the most sophisticated of the circle. It was he who had initiated the idea of going to see, with MacDonald, the Scandinavian exhibition in Buffalo in 1913 and who talked then of a Canadian movement. It was Harris who took the initiative to build the Studio Building, a tangible, practical investment in his beliefs that, for all the misuse then and later, reaped great profits for his convictions and his country. Harris appears to have brought back from his travels the most diverse ideas and influences.

J.E.H. MacDonald was an even greater influence on Thomson, and his position among the small band of friends has not yet been adequately appreciated. He was the most widely talented of them all, the most broadly read, the most philosophical, and in many ways the best painter. He was the senior member, forty-four at Thomson's death. He shared this seniority with Thomson, who was just four years his junior, whereas the others were between seven and twelve years younger. Jackson, in his later writings, always makes it seem that he was the elder statesman then, at the age of thirty-one, rather than later: "a shy young fellow" in his description of Thomson when they first met, though Thomson was older by five years. Thomson and MacDonald both contributed stability to the Group, taking energy and enthusiasm from their younger associates and curbing or channelling foolishness and excessiveness, though Thomson's prankish nature was often the equal of his younger associates.

MacDonald was passionate about the writings of Ralph Waldo Emerson and Henry David Thoreau (after whom he named his son), and was the one who most of all in his work gave a sense of the dynamic link between man and nature. The transcendentalists' philosophy inspired many of his paintings, and his insistence upon Canadian motifs of which he had immediate, personal experience must have been an inspiration for Thomson. He conditioned the way Thomson saw the landscape and it was through his influence that Thomson approached the painting of it with reverence and purpose.

MacDonald was also the senior commercial artist. His knowledge of typogra-

phy, heraldry and the history of design permeated the thinking of his younger colleagues. He elevated the principles of design to a broad philosophical level, and saw in painting a larger application of design principles to thought and expression. Jackson noted that "a lot of Thomson's knowledge of design came from MacDonald." But design meant more to them than the mere arrangement of elements in a painting. Lismer expressed it as "the most fundamental gesture of the creative spirit—the foundation of art and life." For MacDonald, "the Decorative Element is perhaps not so much a component part, as the element in which art lives and moves and has its being. It is an element more in the sense of the universal ether." MacDonald was the intellectual of the movement and was as well its poet, for he wrote verse as well as occasionally inspired prose. Where Jackson may have given Thomson some of the technical help he needed to achieve certain things in pigment, MacDonald gave him a mental framework within which to work.

Arthur Lismer was mesmerized by the northern landscape, largely because it was such a contrast to the landscapes he had known in England and Europe. Despite his protestations of having rejected his origins, Lismer brought with him a love for landscape that was founded on the English watercolour landscape tradition and the father of landscape, John Constable. In some of his early works in Canada, Lismer shows the influence of Turner, as well as a slight brush by the Fauve colourists, both of which were useful to Thomson. Perhaps most of all, however, Lismer brought that concern with the weather, the preoccupation with the sky and clouds which is such a hallmark of Thomson's work, more even than his portrayal of the splendour of autumn. Lismer's later work exhibits that concern with the close-up, intimate features of landscape which Thomson so excelled in. Thomson may have been inspired, through Lismer, with some of Constable's ambition as a chronicler of rain, cloud and sun in ordinary places. He once rebuked one of his sisters for complaining about the cloudy, rainy weather: he found it full of excitement and mystery.

Thomson owed so much to his friends who helped him become a painter, that it is difficult to discover what he had brought with him from his earlier experiences. He was largely untutored and ignorant, yet his mind was not quite a *tabula rasa*. His family's interests had made him conscious early in life of a place for visual excitement and the grace that fine things can give. This was not of a high order and clearly not of a depth to sate his capacious talent.

There must have been some glimmer of excitement, too, in the work that Thomson did for commercial art houses, and what he brought from that source marked his later painting indelibly. It was an avenue that all of his later friends and many artists in the United States had to traverse on the way to their real vocation. While what he did was tailored assembly work that took a minimum

of creative power, he was still trading in visual ideas. The slickness of his commercial work, which stuck to his later painting rather more than one might wish for, was partly due to his technical facility and inventive flair which allowed him to work rapidly and effectively, and partly due to the nature of the Art Nouveau style in which he most frequently would have worked at that time.

Much has been made of the powerful influence of Art Nouveau on Thomson, but it is worth noting that this elegant confluence of machine-like precision and botanical form had occurred in the last decade of the nineteenth century. As a creative force it was practically spent when Thomson was introduced to it, and his experience with it came as it was entering the common vocabulary of forms and being applied to advertising, mass-produced furniture, jewelry, and other sorts of domesticated uses. Fortunately, this style lies well in the background of most of Thomson's work, for when it did emerge, as in the decorative panels he did in 1915-16, it tended to swamp his own creative gifts. Graham McInnes called the panels "the very nadir of his art," and it is difficult to disagree. The decorative rhetoric of these works spread to the dishes, teacups, basins and bowls that Thomson painted at this time, and his grounding in advertising, or his aim to please, with saccharin shapes and colours, was never more evident.

The origins of Thomson's art, and the influences he was so easily swayed by, are numerous and diverse. While one might regret that so prodigious a talent did not receive every possible benefit in making its way, it is also a measure of his capabilities that he finally found the path that he wanted to follow. He managed to forge all that he learned into the shape of his own understanding. Yet who might have imagined, to meet him in 1911 or 1912, that what he had done was a preparation for what was to follow? For most of his adult life, Thomson was an underachiever whose talents languished while he waited for a larger purpose. D. P. S.

Flowers, Skies and People

From the garlands worn by the Bacchantes on Greek amphorae to the dash of a Matisse cut-out, artists have traditionally looked on flowers with affection, not just for intricacy of form and variety of colour but as a stand-in, a substitute model for unreliable human flesh, or a landscape drenched in rain. Flowers are a mother-hood subject for the painter. No matter how they are distorted by the artist's vision there is bound to be a connection with some other sensitivity, if abstracted by title alone. As models they may wilt but they never complain; they visit the sick room of the painter's frustration and cheer him up, get his brush moving again and his brain pan to frying new ideas. Often the release from higher purpose and the angst of visual breakthroughs granted the artist by a day staring at the geometrical disorder of a bouquet heals his soul and repairs his vision.

MacDonald's *The Tangled Garden,* one of the best known and possibly most popular of Canadian paintings, has become a kind of Judas goat leading us to think that many Canadian artists have made floral works. Few have. One could wish that Thomson, like Morandi, had set to painting still life in his isolation, for the flowers Thomson placed directly before his palette in shallow space – objects freed from the amphitheatre of the sky or the towering dark of pine – made him flatten out the picture plane, draw it nearer to the eye. He perceived his surface as an area for pattern-making; ephemeral light was no longer of prime concern. He gave nothing to the perfume of delicacy of his flowers, no hostage to sentimentality, but transcribed them simply as broad strokes of colour which impart a toughness of design sometimes missing in his harder themes of rock and bracken. In these few pictures Thomson proved he was able to move to the particular from the panoramic, from air and sun to its product, with ease and sureness of touch.

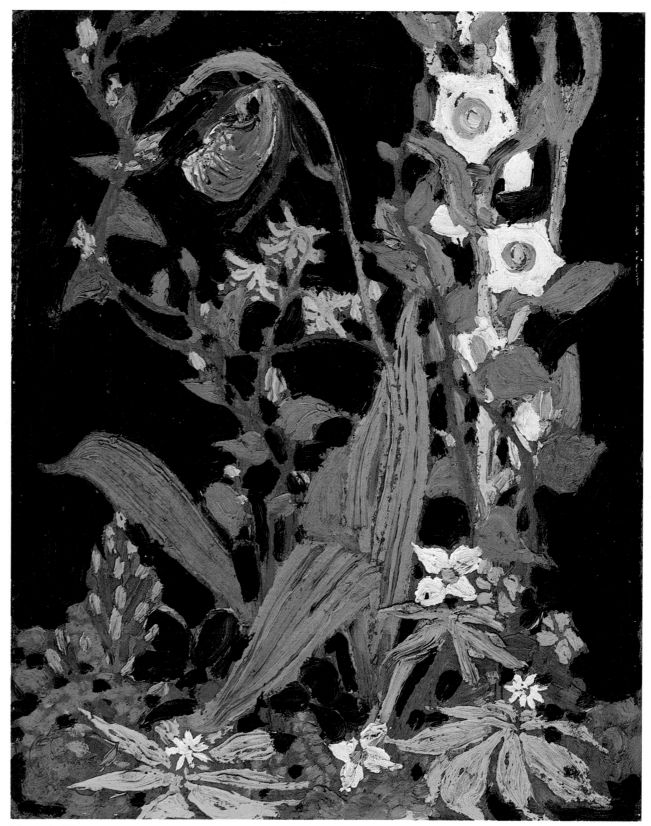

Moccasin Flower

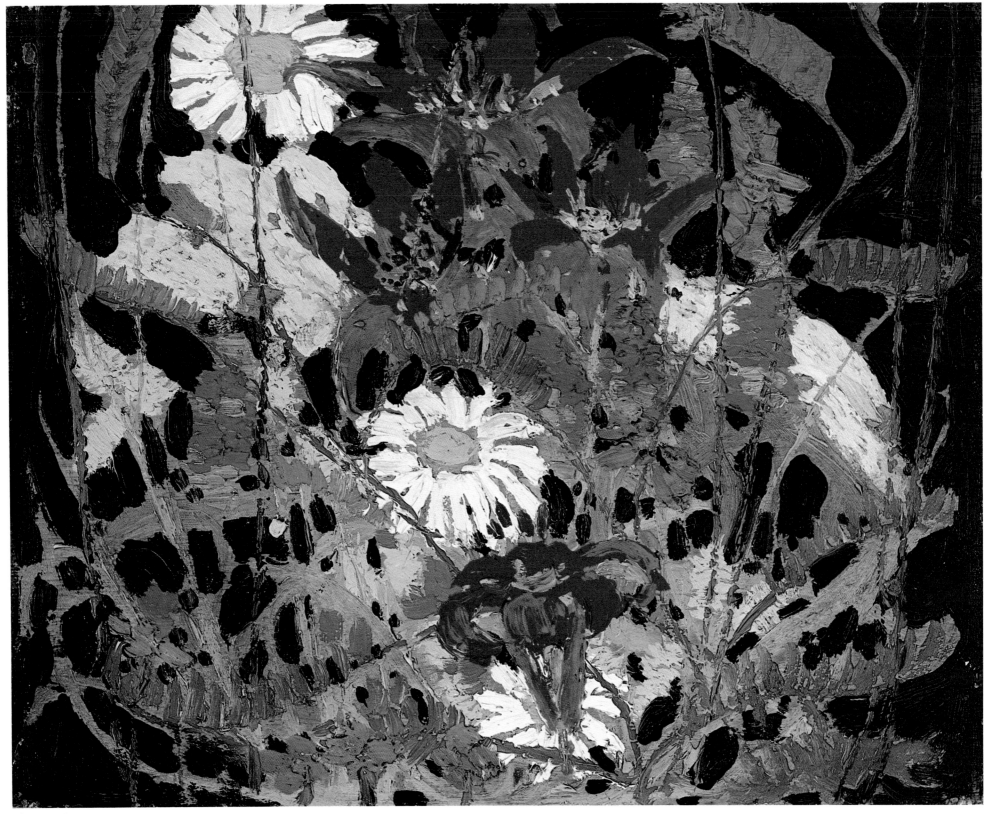

Flowers

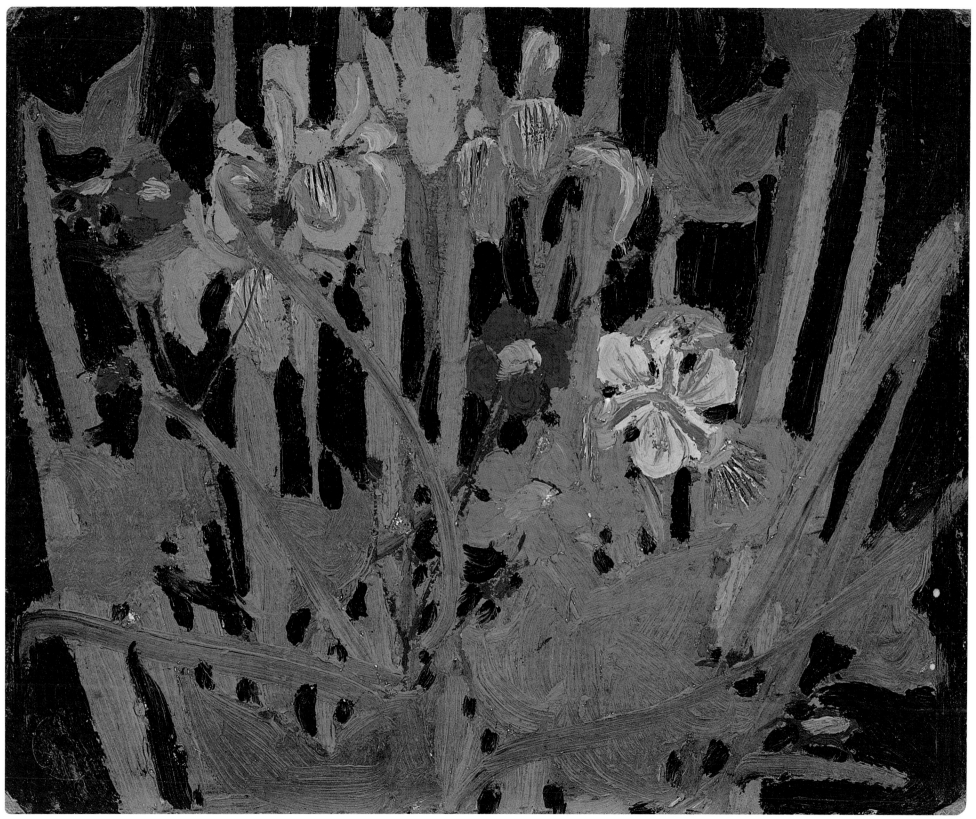

Wildflowers

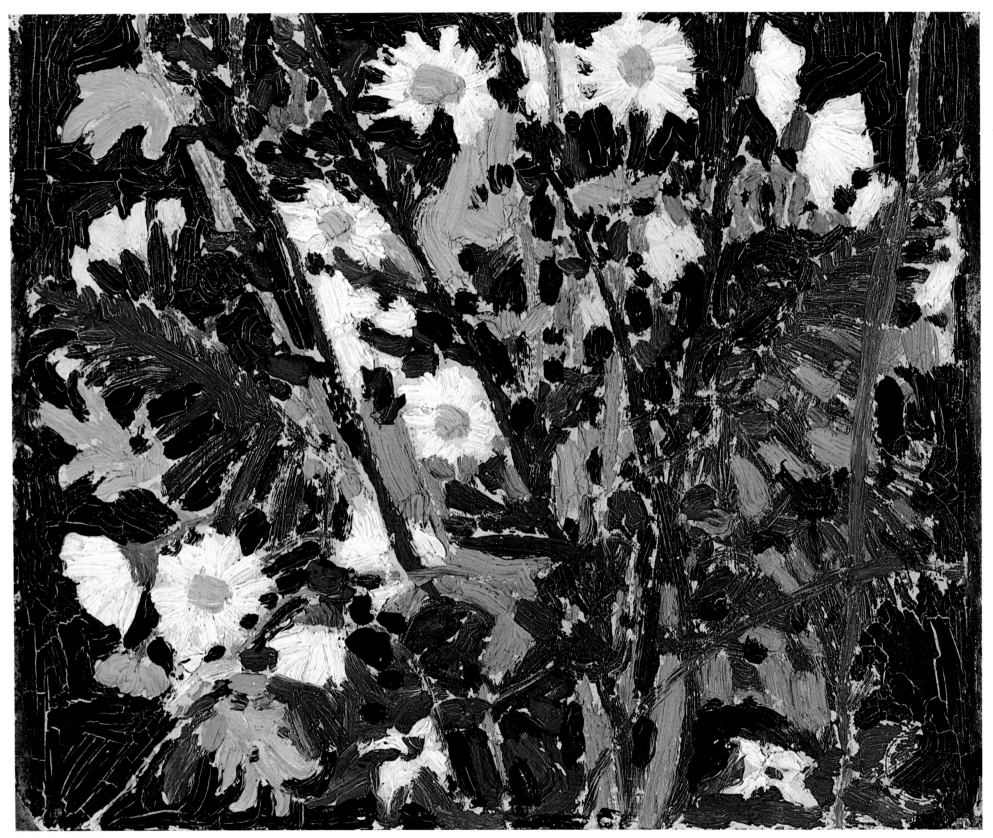

Canadian Wildflowers

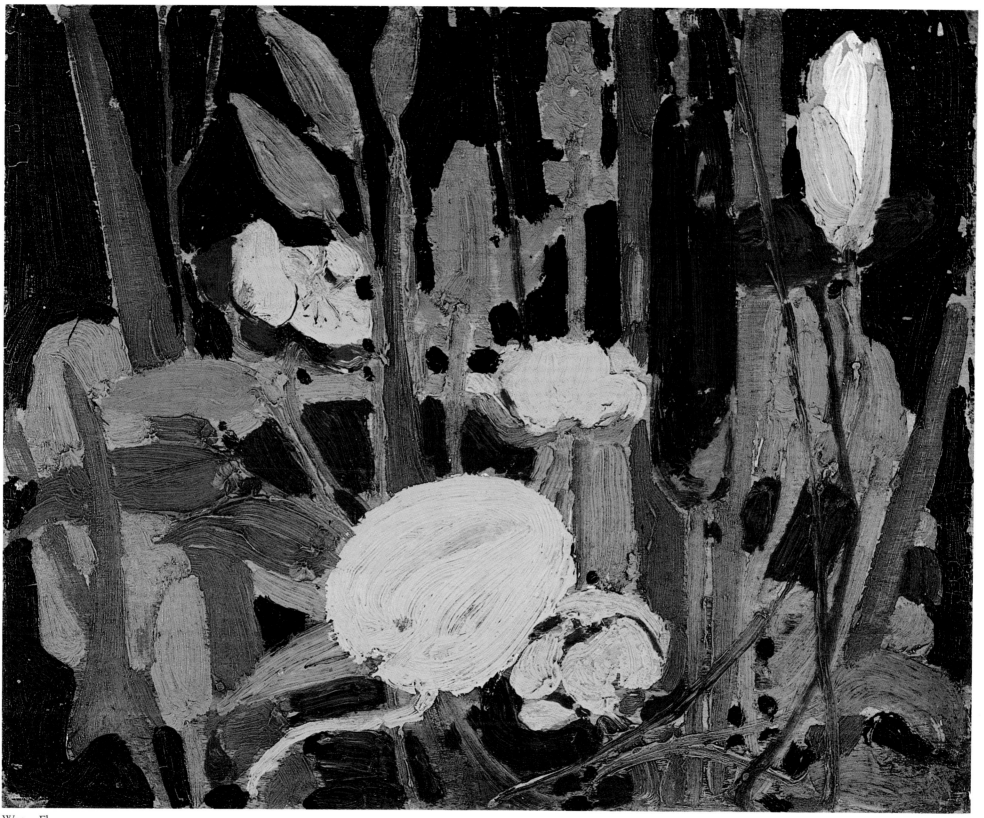

Water Flowers

Every statement about art, whether spang on the mark or off the target, contains a contradiction and a truth. There can be no absolute in creativity. The slug can strike the bulls-eye but the shell left in the breech tests credulity and denies the score. Simplicity may seem to be the keystone to great art, yet as Sickert wrote in 1916, Rembrandt upholstered to death his etching *Burgomaster Six*; Bonnard tickled every fraction of his succulent pictures into pampered miracles; and Klee spent days in complicated patterning that he allowed to grow into a title and very often an explanation. Blake said the road to excess leads to the palace of wisdom. Indeed, the hollowness of most of today's stripped-down art derives from the fact that it comes from academic theories of simplicity as a goal and arrives at nothingness. Reduction has real force only when it is strained through a complicated and excessive vision. Thomson was naturally excessive. His love of detail for its own sake is evident in his commercial art and paintings such as *Snow in October* (page 181) and *Northern River* (page 95), but at the core, at the hot centre of his conception, he boiled out the fat and and got to the marrow of his feelings.

To this day research into the mystery of the rainbow continues. No matter how much more we learn about one of Nature's most celebrated optical caprices, when translated into paint on canvas the rainbow is a carnival colour ride. Varley sneaked the toe of a rainbow into the corner of his war painting *The Sunken Road*; it looks like a plastic garden hose in ketchup. The problem when rendering a rainbow is not how to make it spectacular but how to make it sit naturally in the composition. Thomson's *Rainbow* (page 119), which to my mind is superior to Constable's, needs no scientific explanation or permit from a visual authority to drive light through air; its path is ordinary, inevitable and right – it ends in the yellow on Thomson's palette. His rainbow is the one that Dorothy would never sing about, no witch or wizard could possibly consider it grand enough.

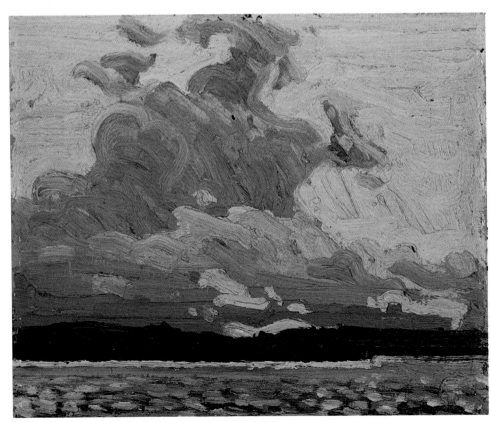

Thunderhead: Pink Cloud Over a Lake

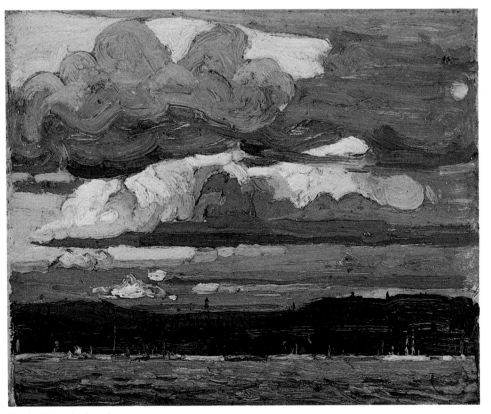

Dark Thunderheads

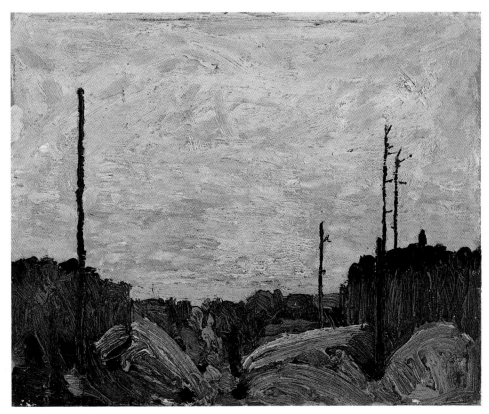

Burned Over Land

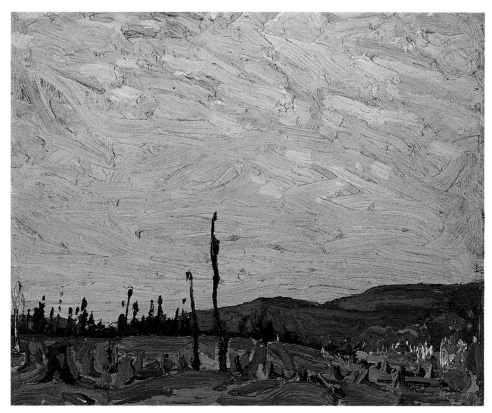

Spring

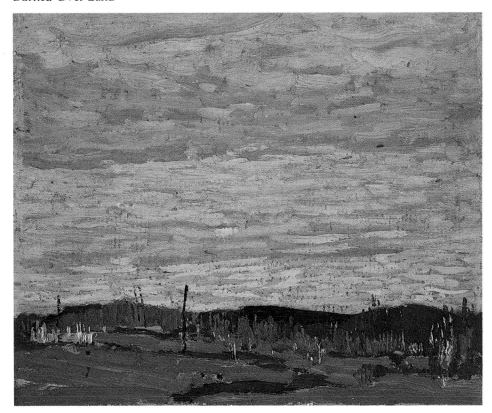

Burnt Country

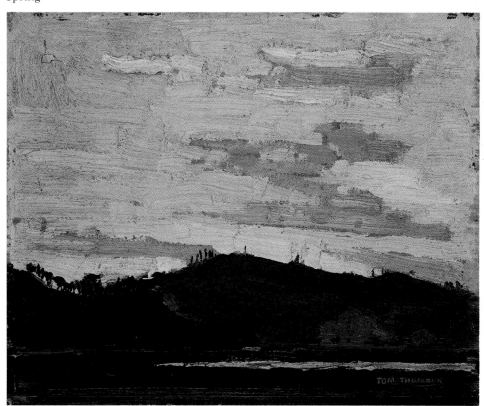

Yellow Sunset

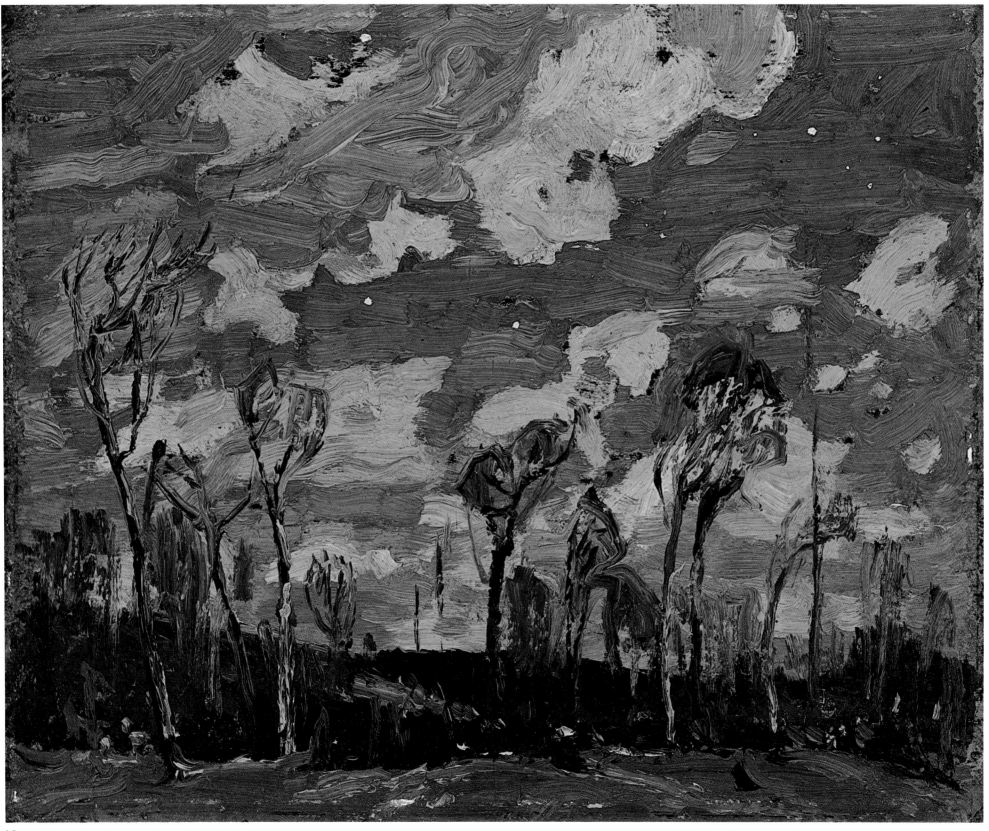

Nocturne

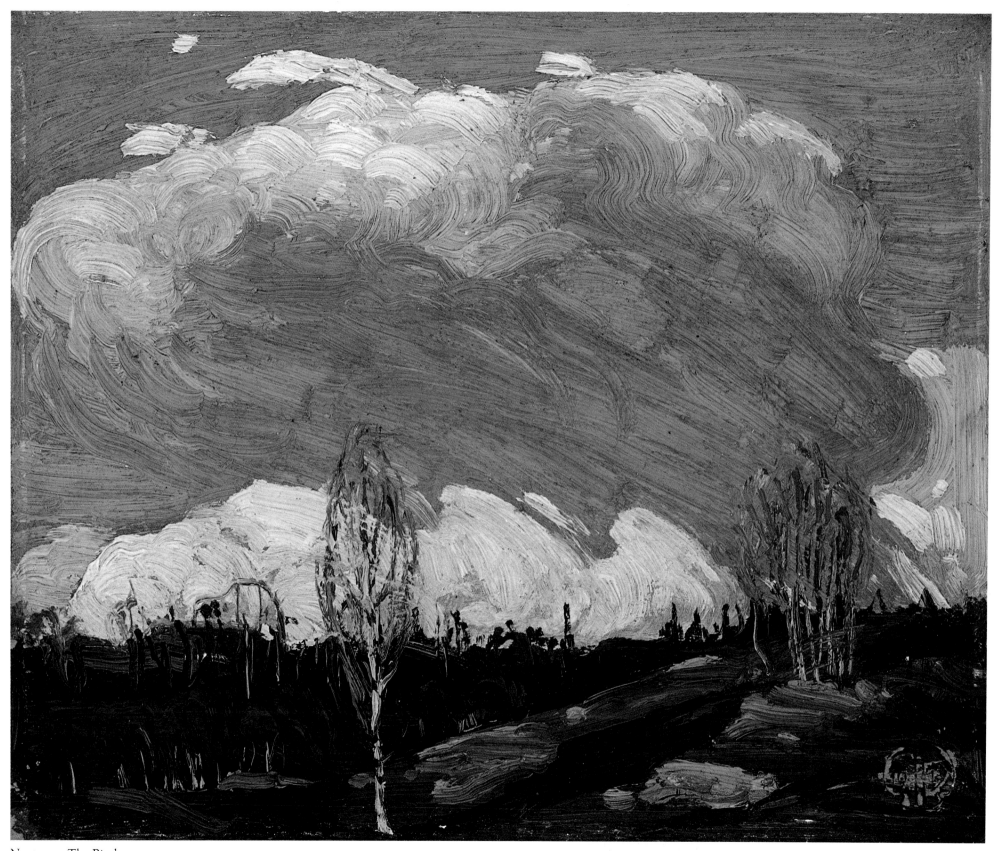

Nocturne: The Birches

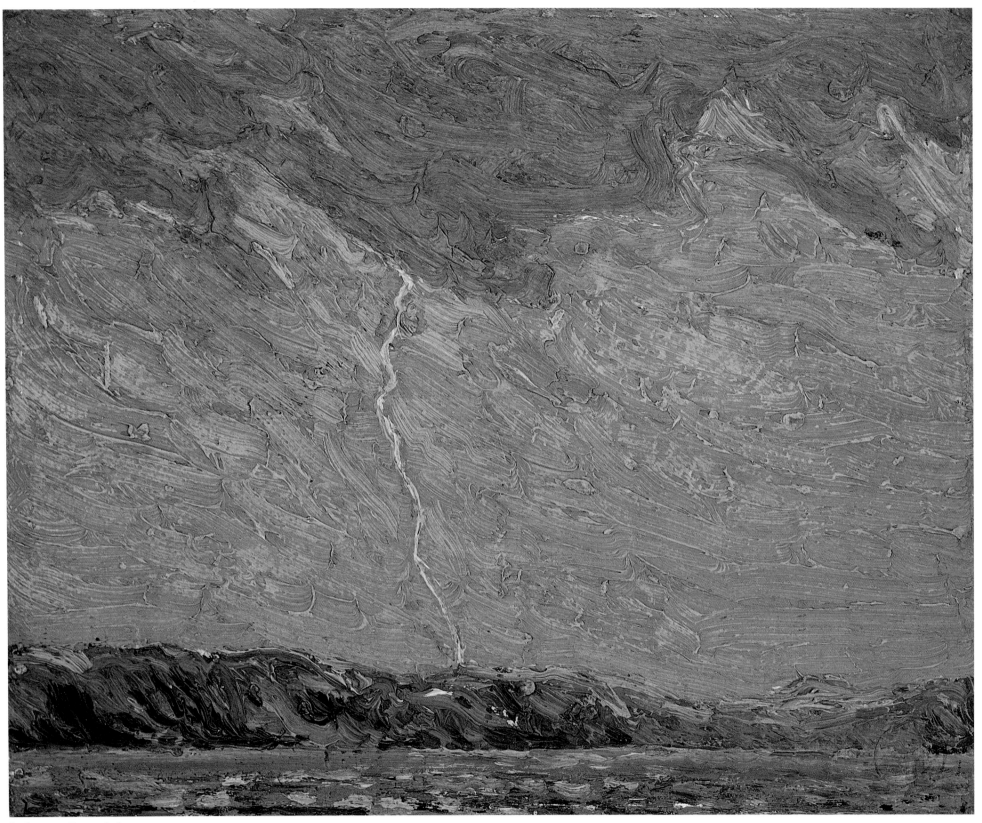

Lightning, Canoe Lake

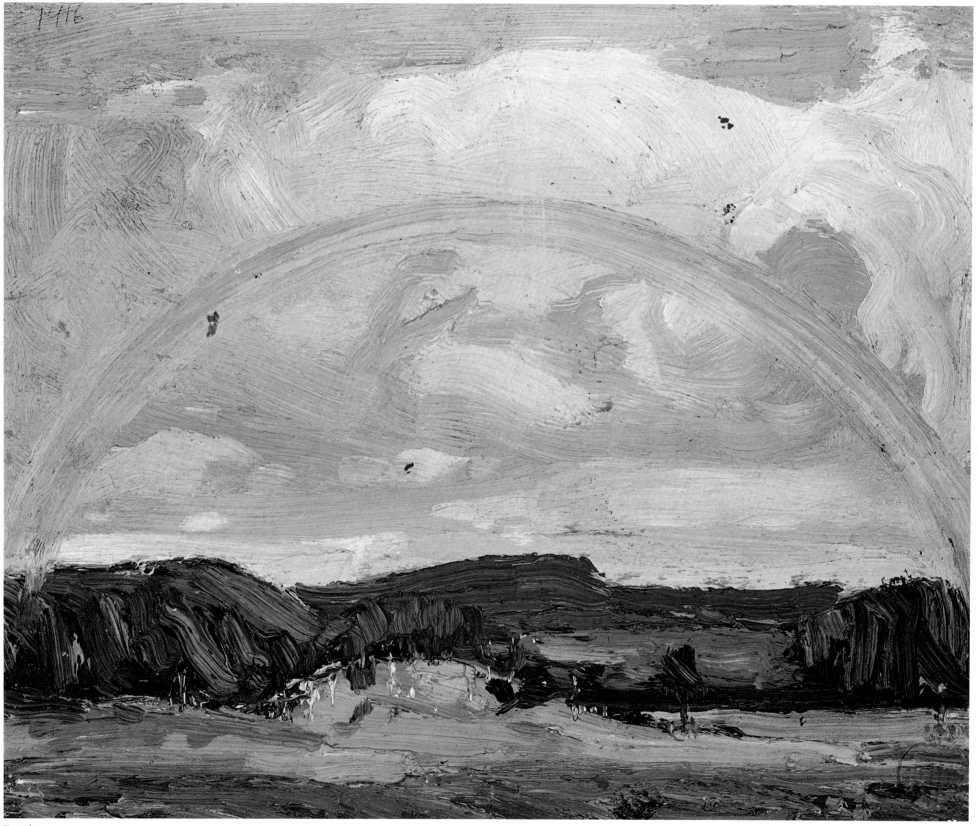

Rainbow

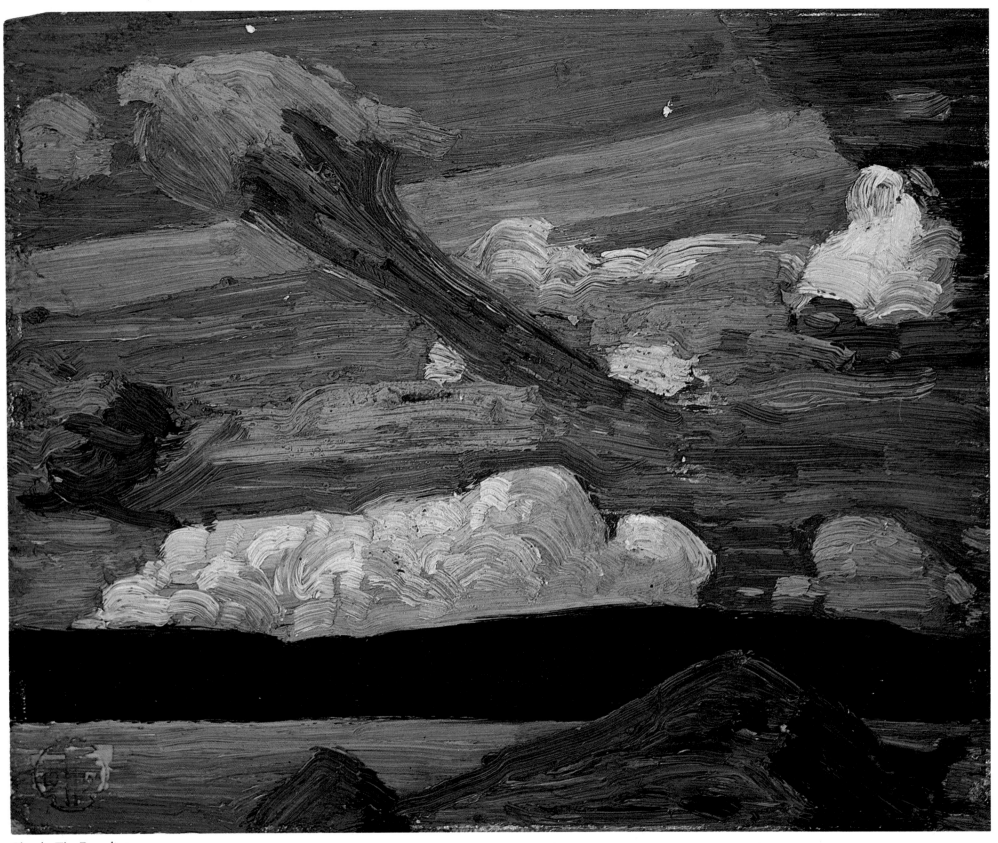

Clouds: The Zeppelins

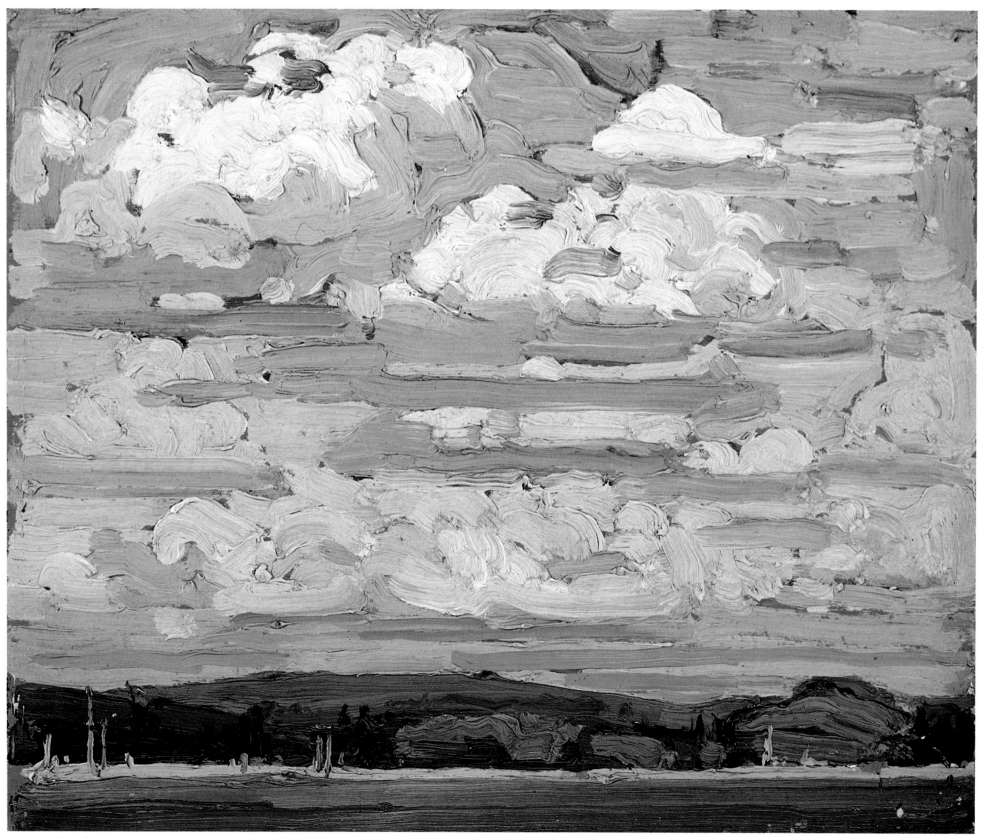

Summer Clouds

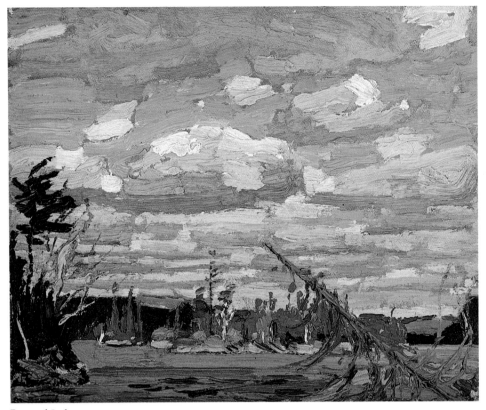

Ragged Lake

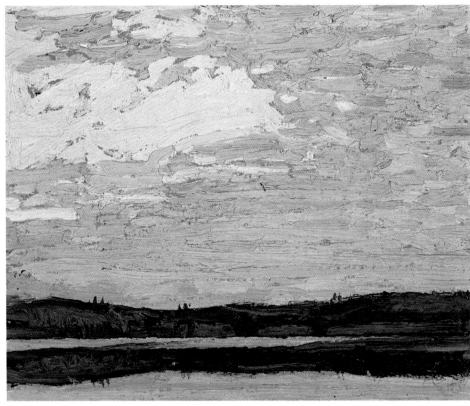

Sunset Sky

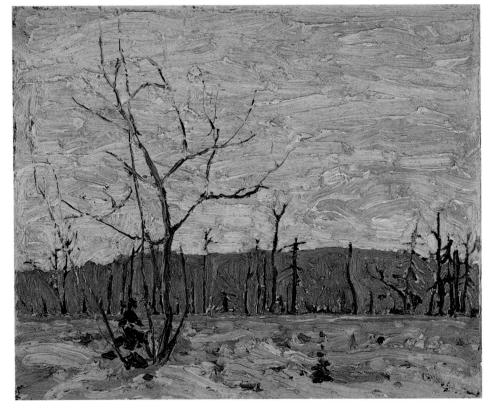

Sombre Day

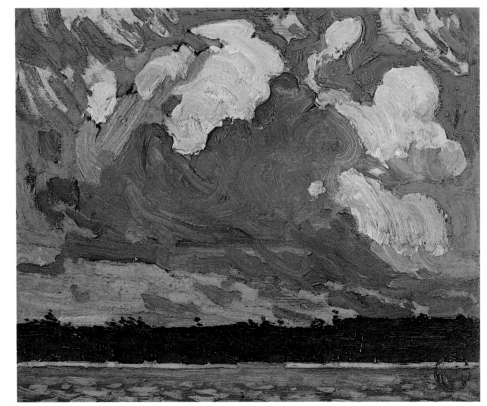

Storm Cloud

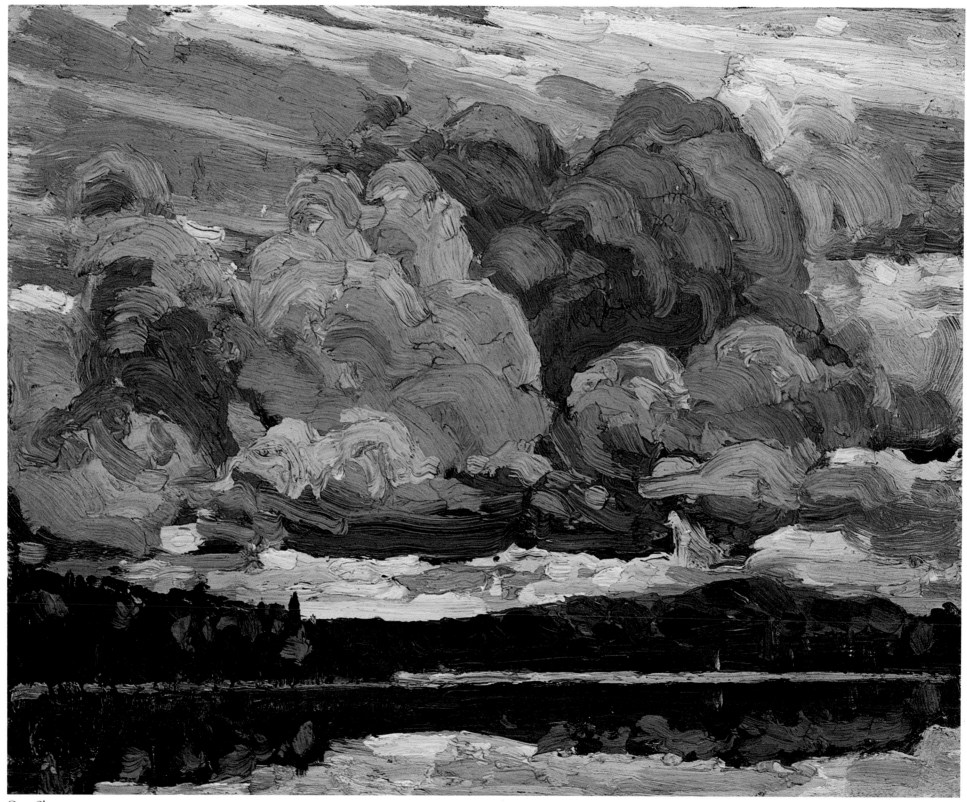

Grey Sky

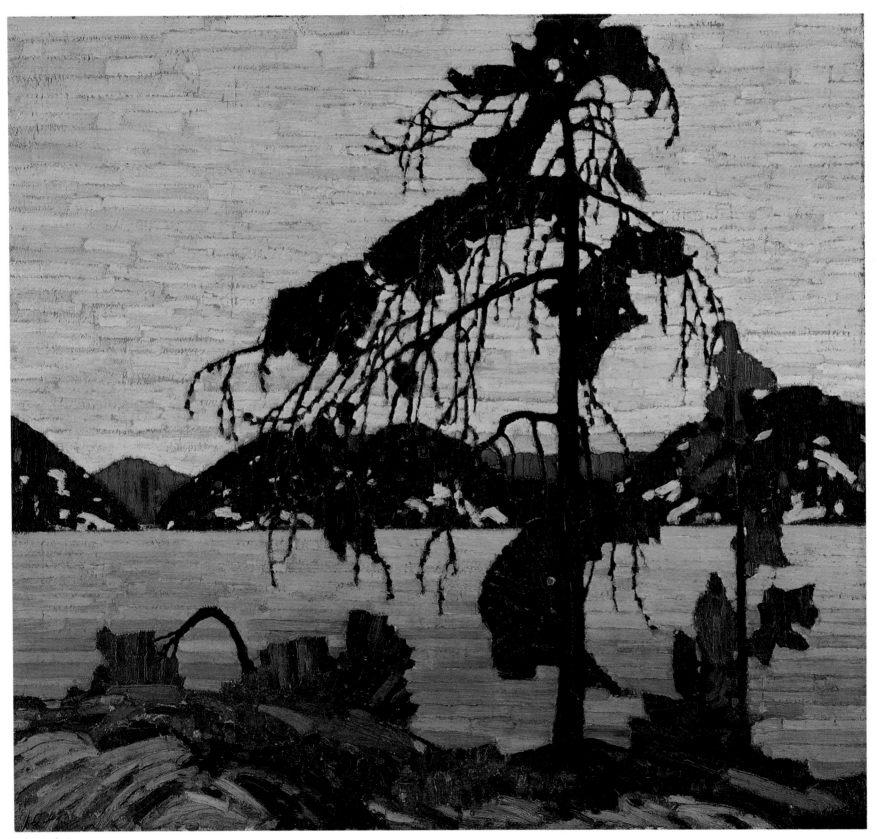

The Jack Pine

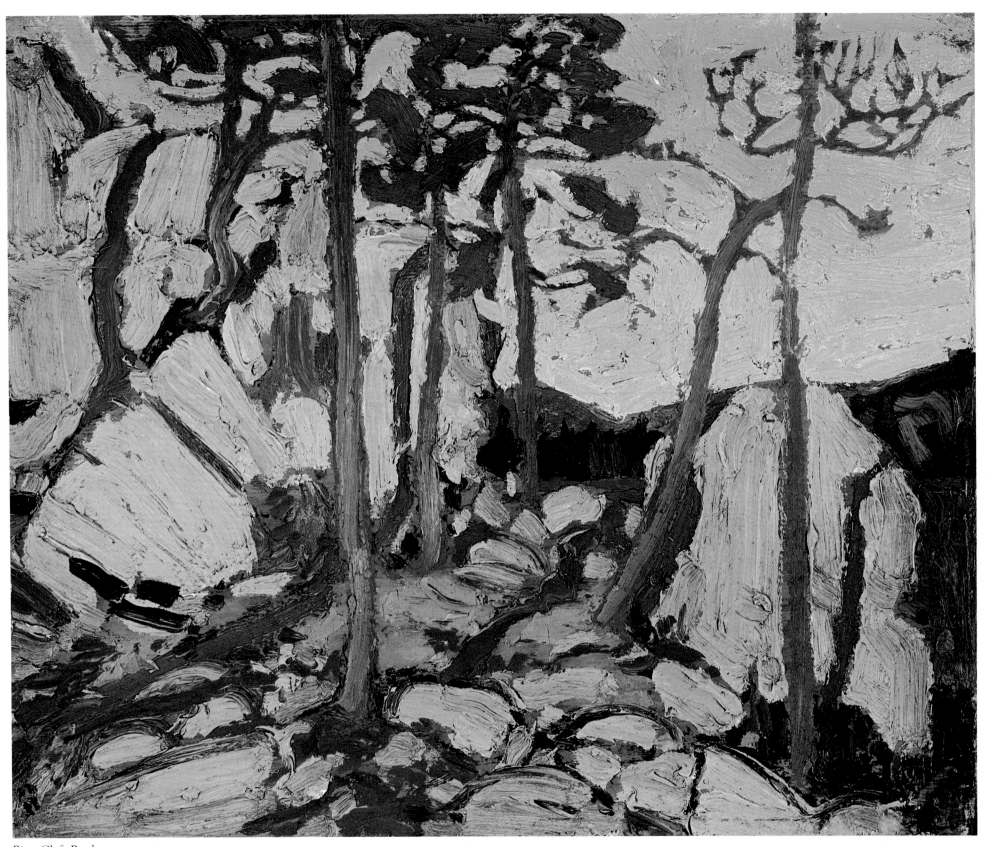

Pine-Cleft Rocks

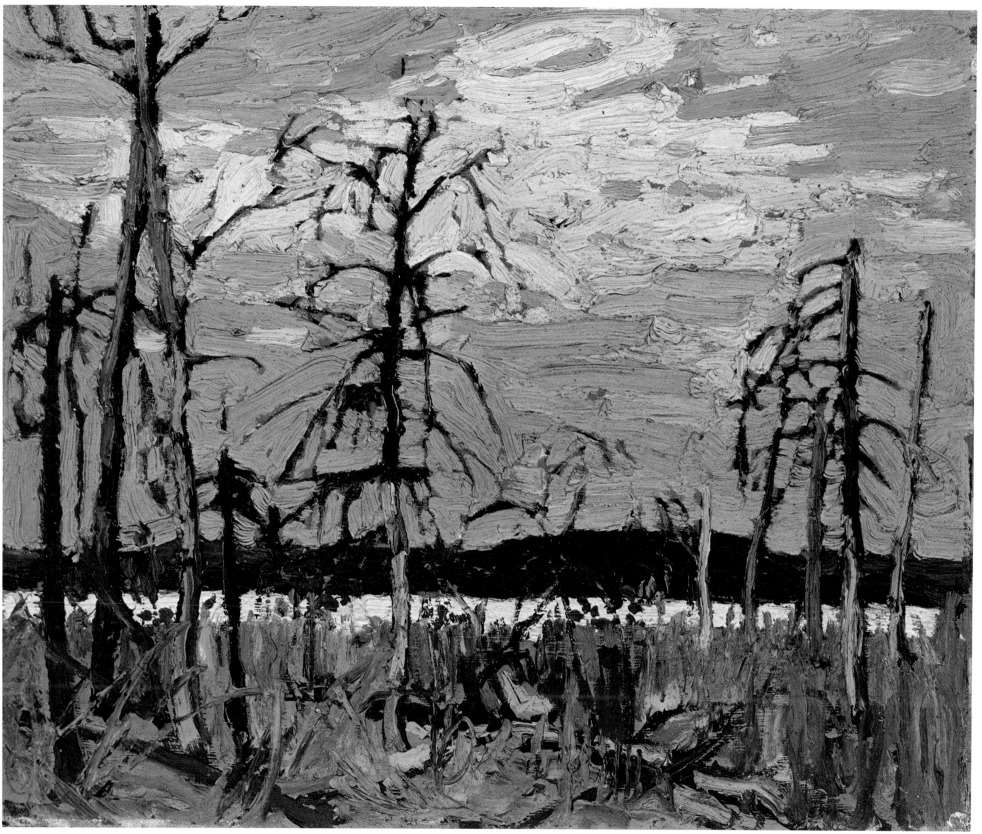

Tamarack Swamp

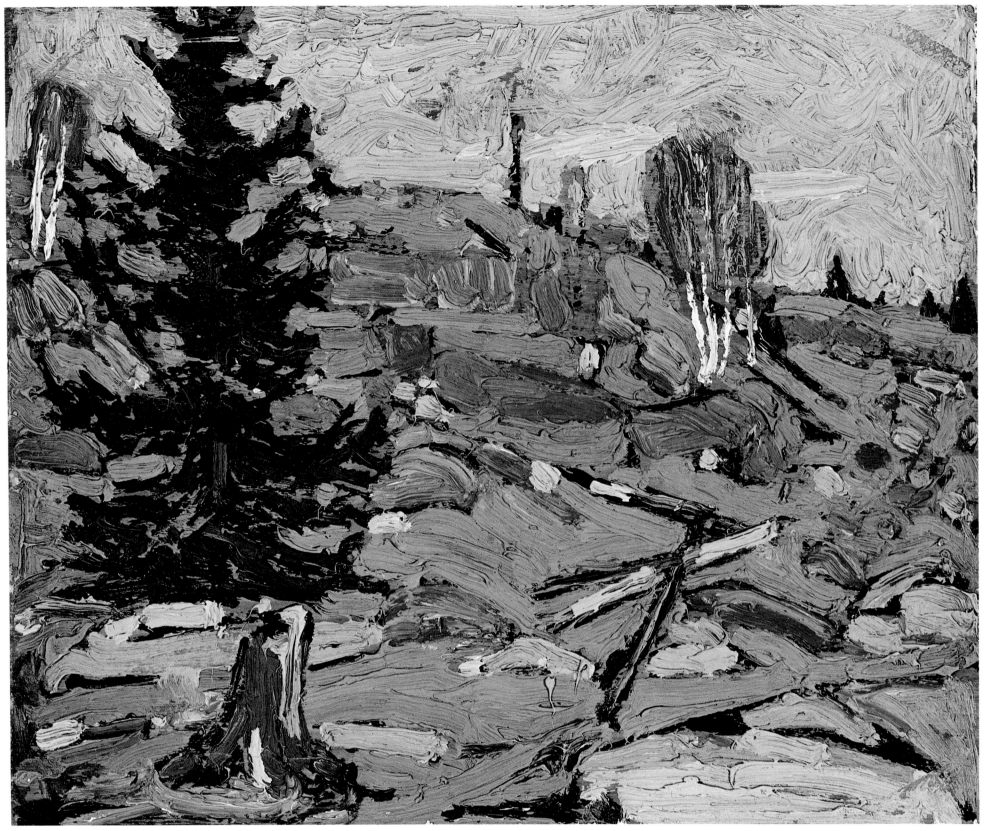

Hillside

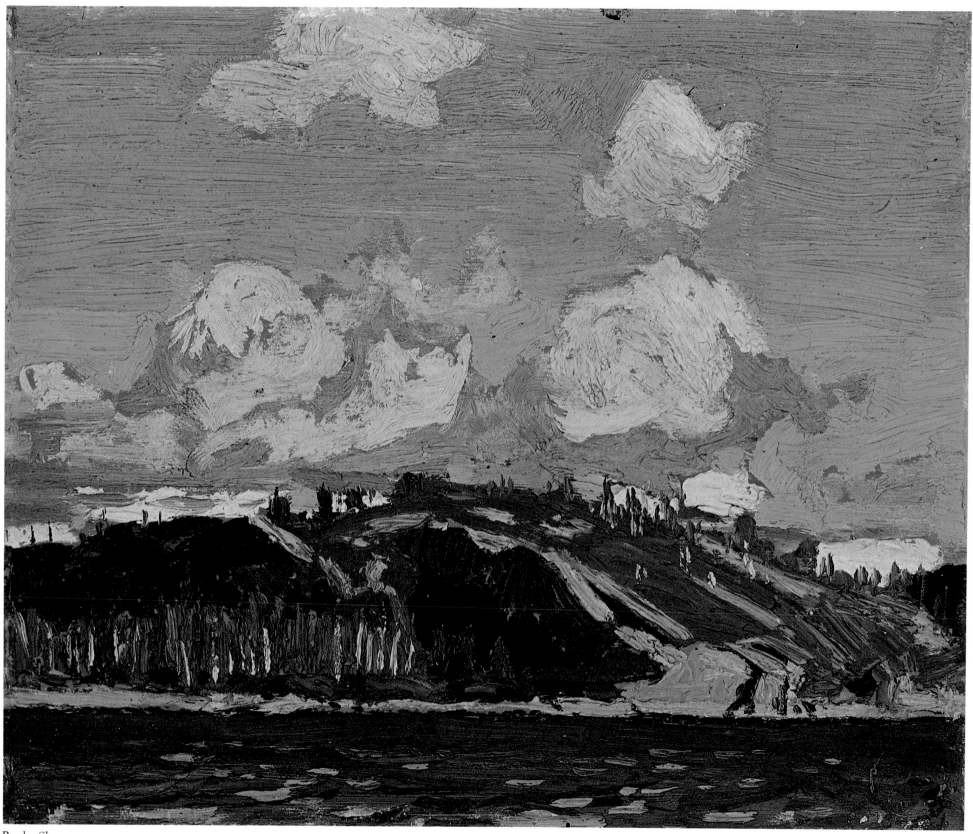

Rocky Shore

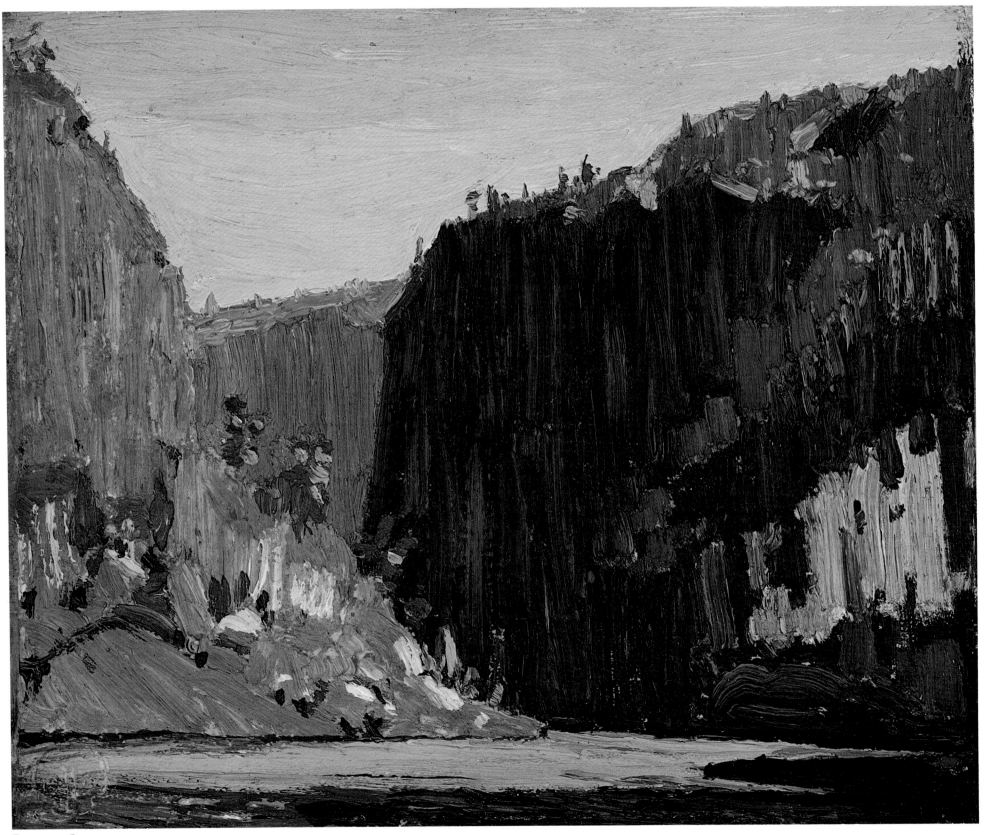

Petawawa Gorges

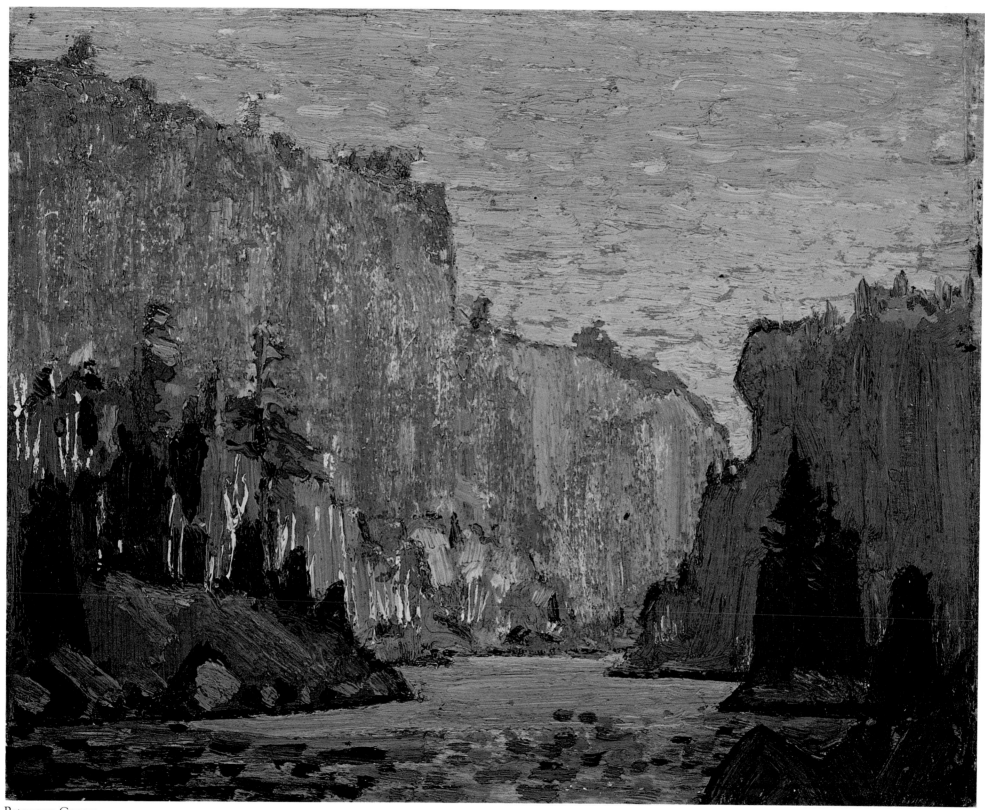

Petawawa Gorges

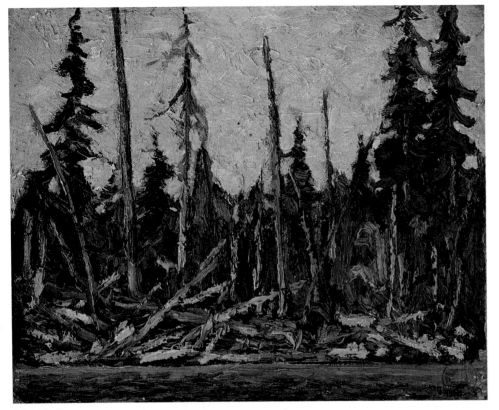

Untitled

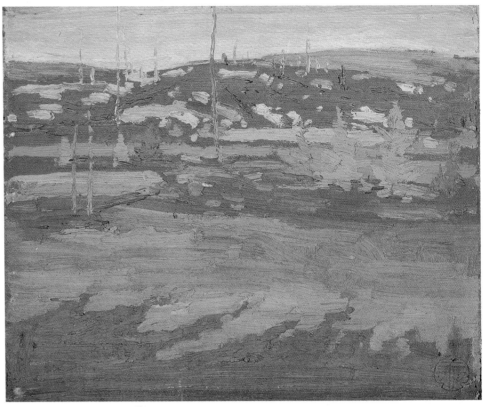

Cranberry Marsh and Hill

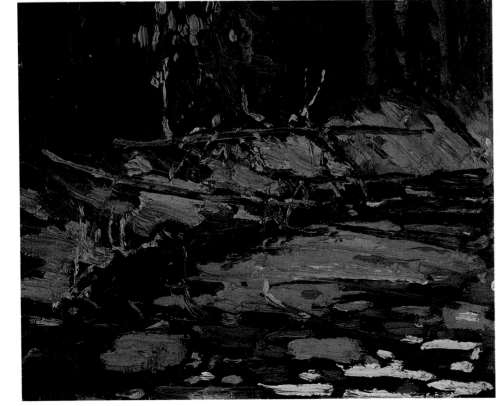

Woodland Stream

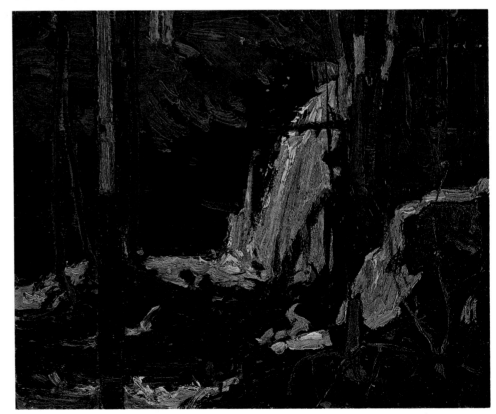

The Waterfall

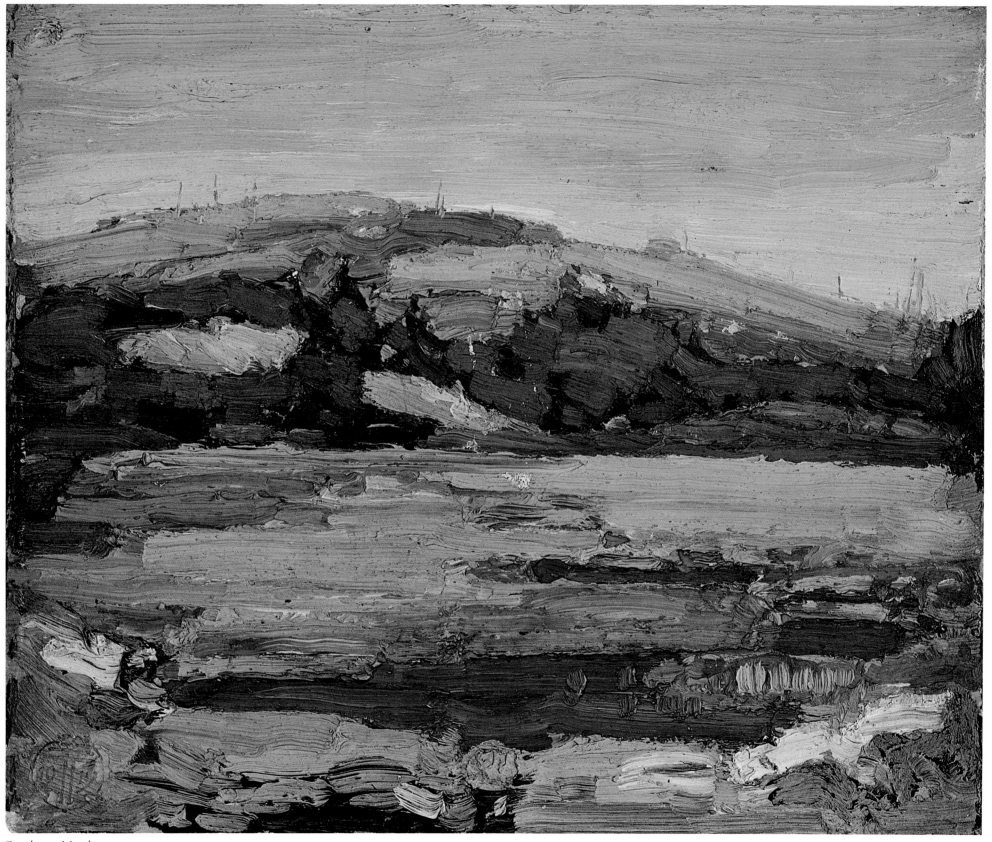

Cranberry Marsh

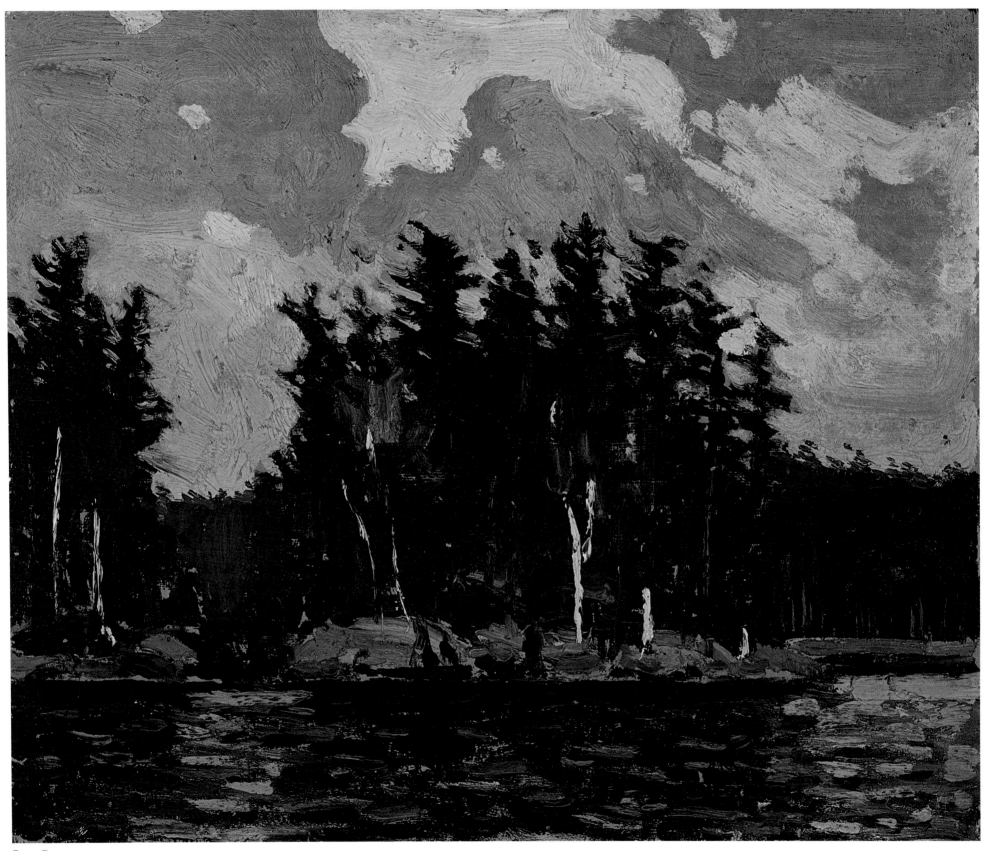

Pine Country

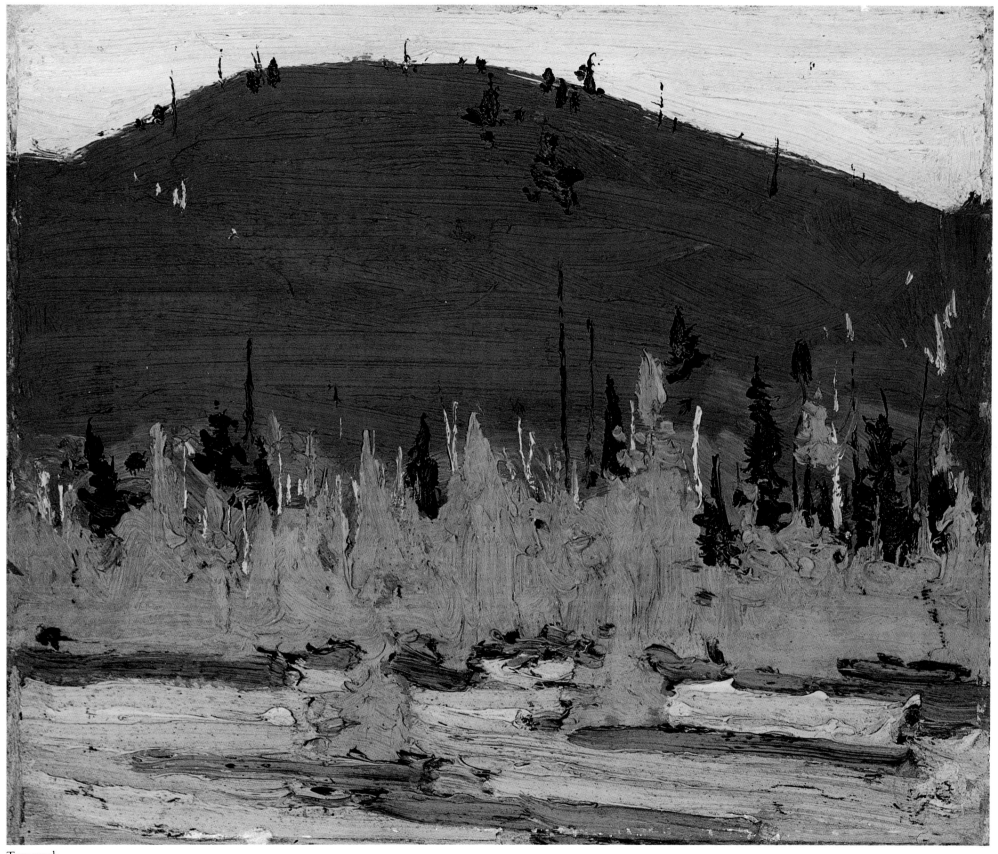

Tamarack

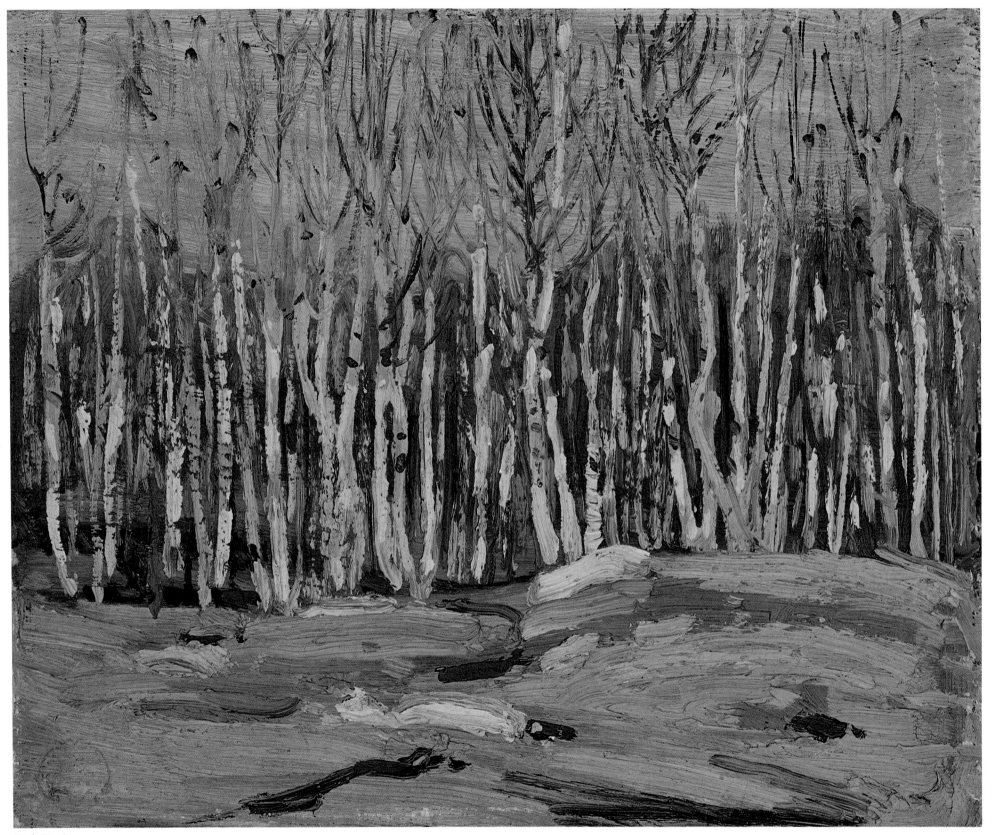

Pink Birches

With the exception of Varley and Frank Johnson in his later commercial phase, Thomson and the Seven rarely painted the human figure. Indeed, Varley, in his symbolist painting *Dharana*, seemed intent on turning the lady into landscape, as did Rackham or others of the Mauve Period.

The stiffness of *Larry Dixon Splitting Wood* might be justified if one related the feeling of arthritic bone in the figure to the sticks of kindling. Despite any such conceits of interpretation, what holds the work together is a cohesive crudity.

The subject in *In the Sugar Bush (Shannon Fraser)* is insensitively brushed in as if he were a tree stump. Although the bits of light blue through the painting may well be maple syrup tins, the all-over redness pushes the rich raking light of fall into one's mind – a feeling of heat without warmth. *Figure of a Lady* is a tender work, so capable in the simple presentation of suggesting costume detail that the style of the period is instantly identifiable. The figure placed quixotically to the right of centre is one of the few examples of Thomson giving way to the western method of reading and setting his dominant element in the composition towards the natural direction of the eye. Well designed and plainly expressed, this loving picture is so secure in intention that it survives, indeed triumphs, over the severe cracking of the paint.

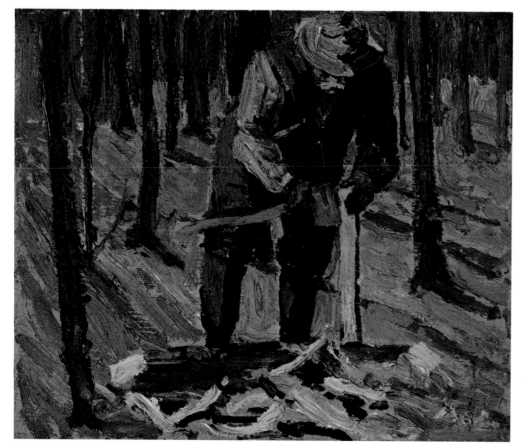

Larry Dixon Splitting Wood

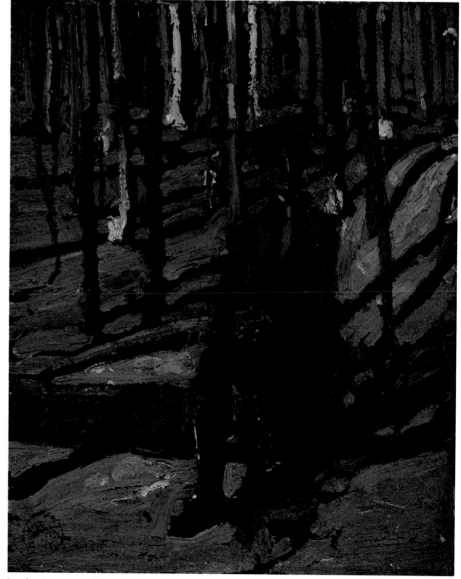

In the Sugar Bush (Shannon Fraser)

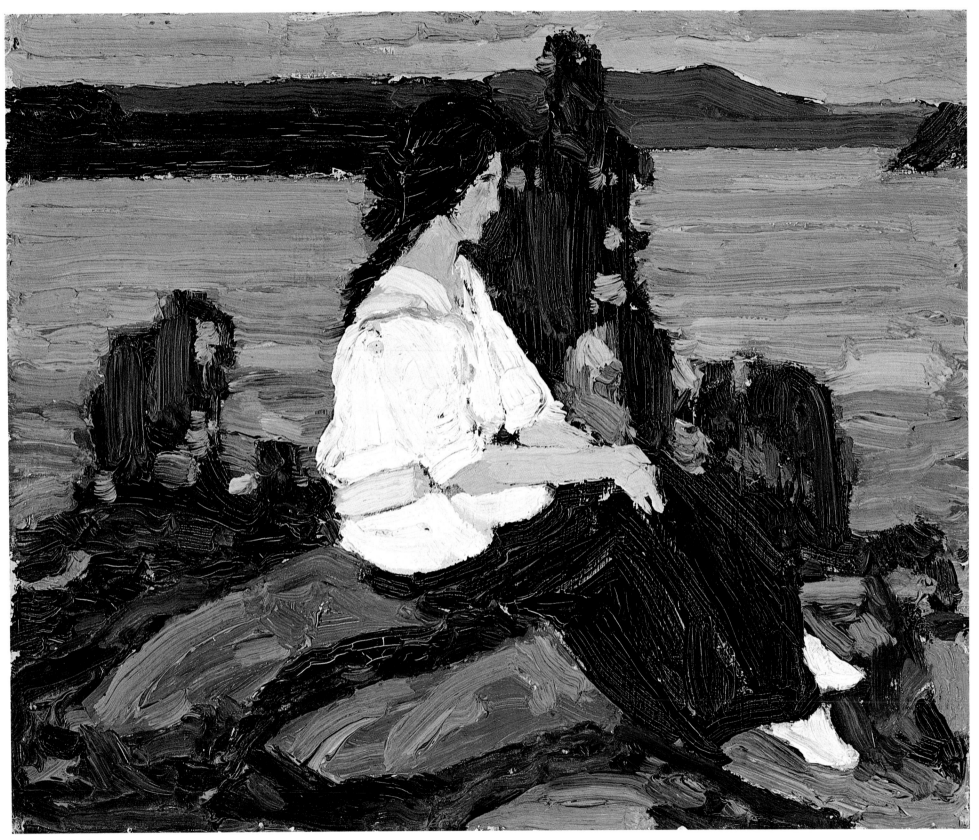

Figure of a Lady

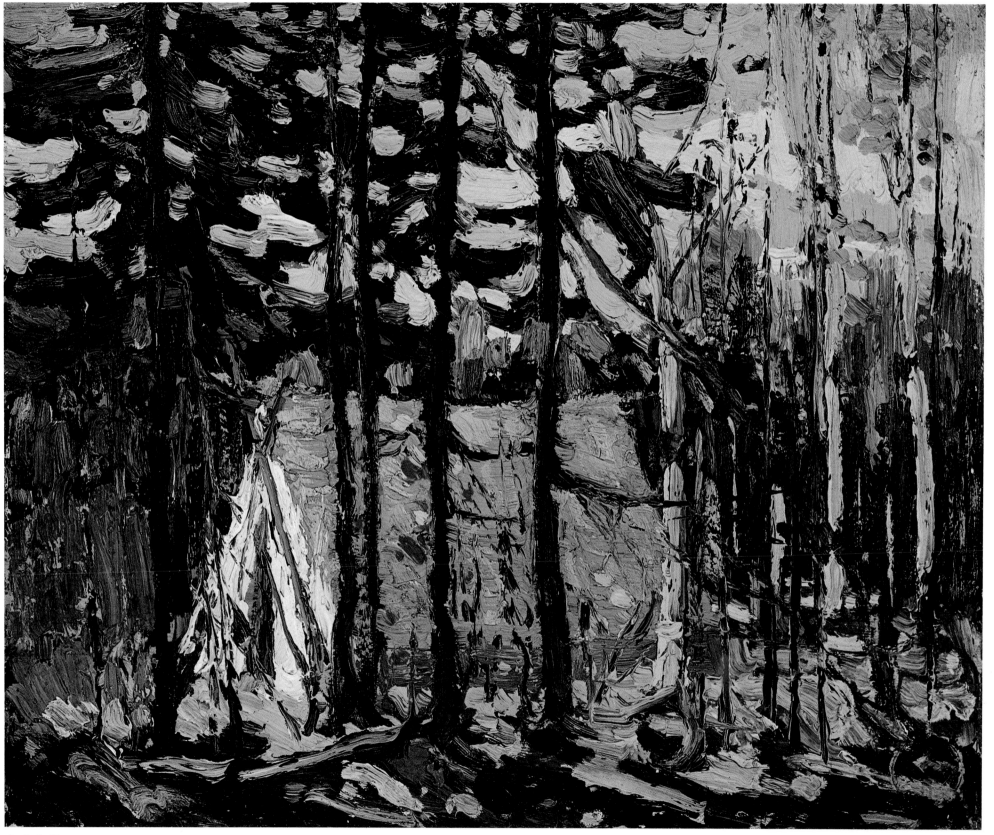

Artist's Camp

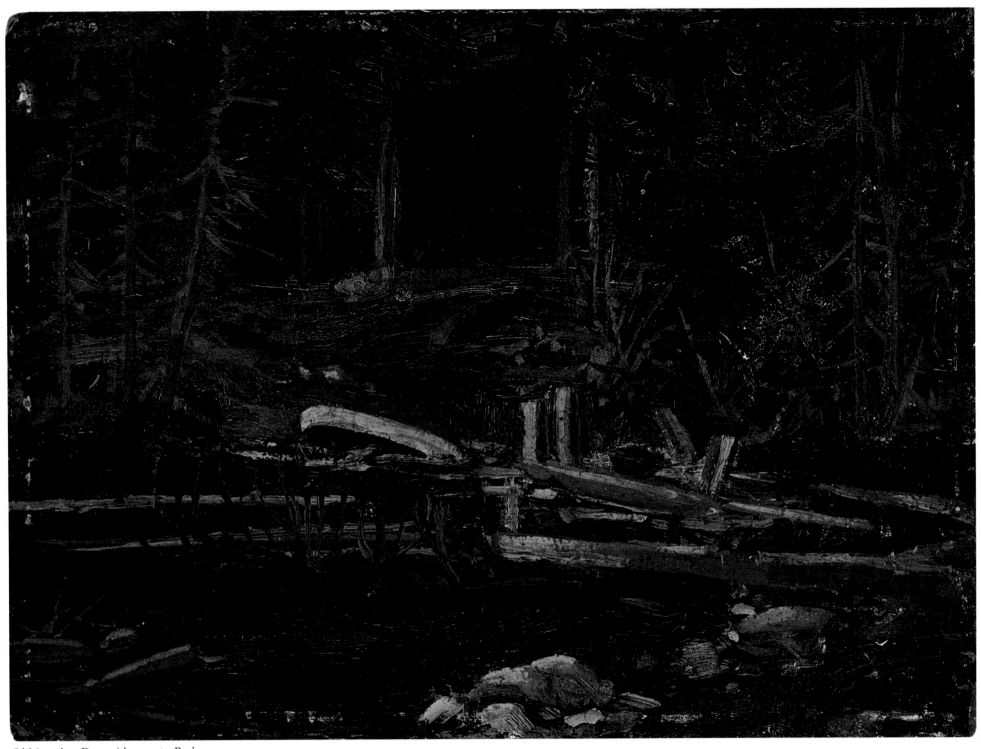

Old Lumber Dam, Algonquin Park

For Thomson and his companions a tent was more than a migratory home, protection from the cold, wet and bugs – it was a relief from the numbing consistency of bush. Inside the tent, with the day still burning on their faces and the afternoon's work shining in the lid of a sketch box, thoughts of glory and revenge on the critics would creep out of the night through the tent flaps and into the glow of a kerosene lamp. It was a time for banter, philosophy, thick coffee and tobacco, a time of companionship and purpose that would never return.

The pushy yellow of the tent interior in *Campfire* dominates the foreground fire and upsets a logical painterly priority of light. Despite this flaw, the work has an intense feeling of forest night and makes you want to share the warmth and a plate of beans. Had Thomson been commissioned to paint Richard the Lion Heart's tent before Acre he would not have treated it more royally than the fabric he lugged around in the Algonquin. His tents were portable architecture; they brought a city shape to the bush that he could admire without reservation. A tent is a fold conceived as a house and I wonder if Thomson's reliance on the fragile skin of canoe, tent and knapsack made his love of the small, hard, finite wood panels he painted on more intense.

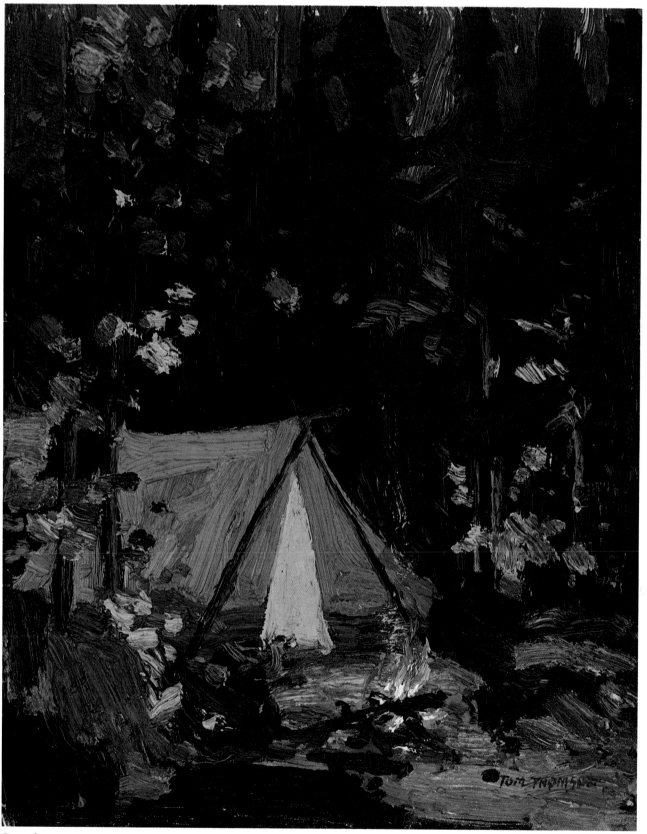

Campfire

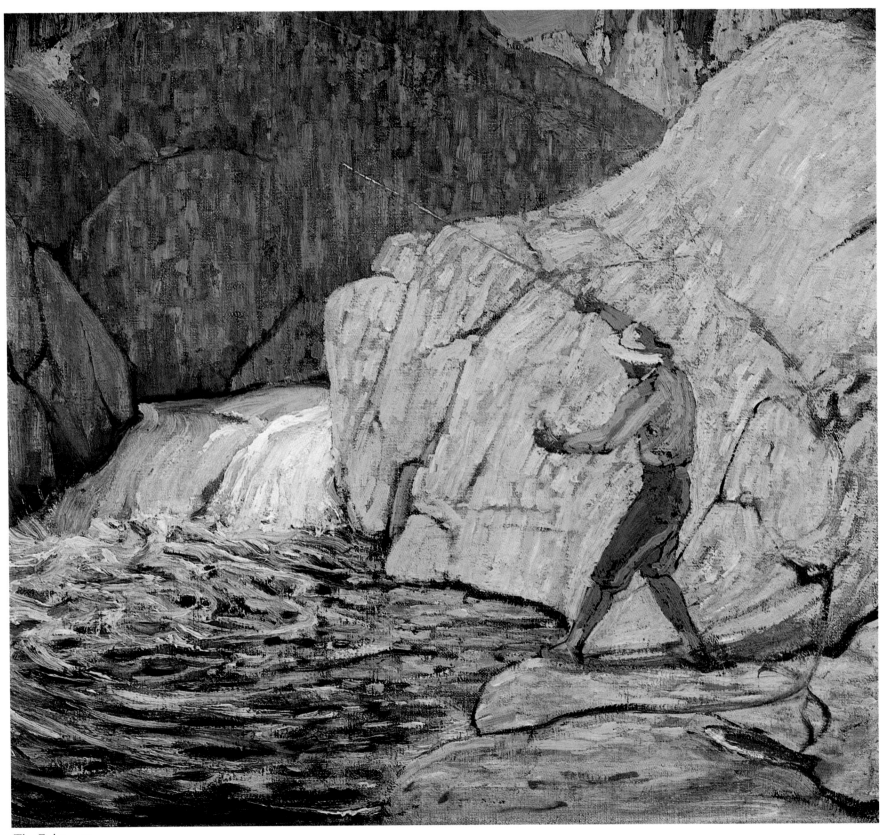

The Fisherman

People appeared in Thomson's work as stick puppets, amalgamated into the landscape theme so completely that they anthropomorphosed into tree or rock. The drawing of the angler in *The Fisherman* has lost itself in the pursuit of action; the artist, by attempting an overly dramatic emphasis of the figure within a static composition, destroyed the order of his design and made the fisherman as glaringly obtrusive as a doorknob in a wedding cake.

The nimrod is more successful in *Little Cauchon Lake* because Thomson disguised the inadequacy of his drawing by integrating the fisherman into the pattern of brushwork.

Surprisingly, Thomson's finest handling of the human figure is rarely noticed. His latent skill is apparent only in the infinitesimal workers on the dam in *The Drive* (page 83) and the loggers on the rafts in *The Pointers* (page 86). Though unskilled, even inept, as a draftsman, as with everything about Thomson, the potential was there.

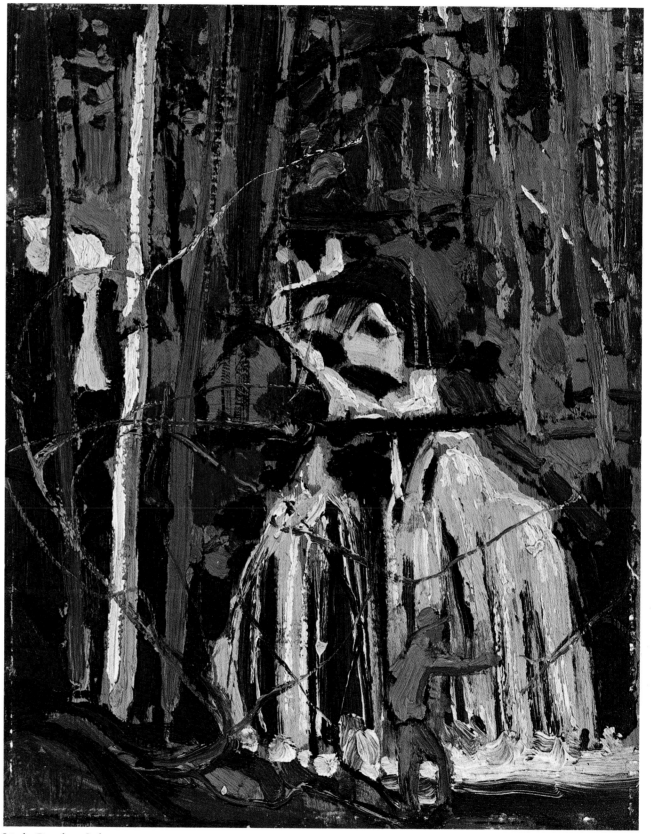

Little Cauchon Lake

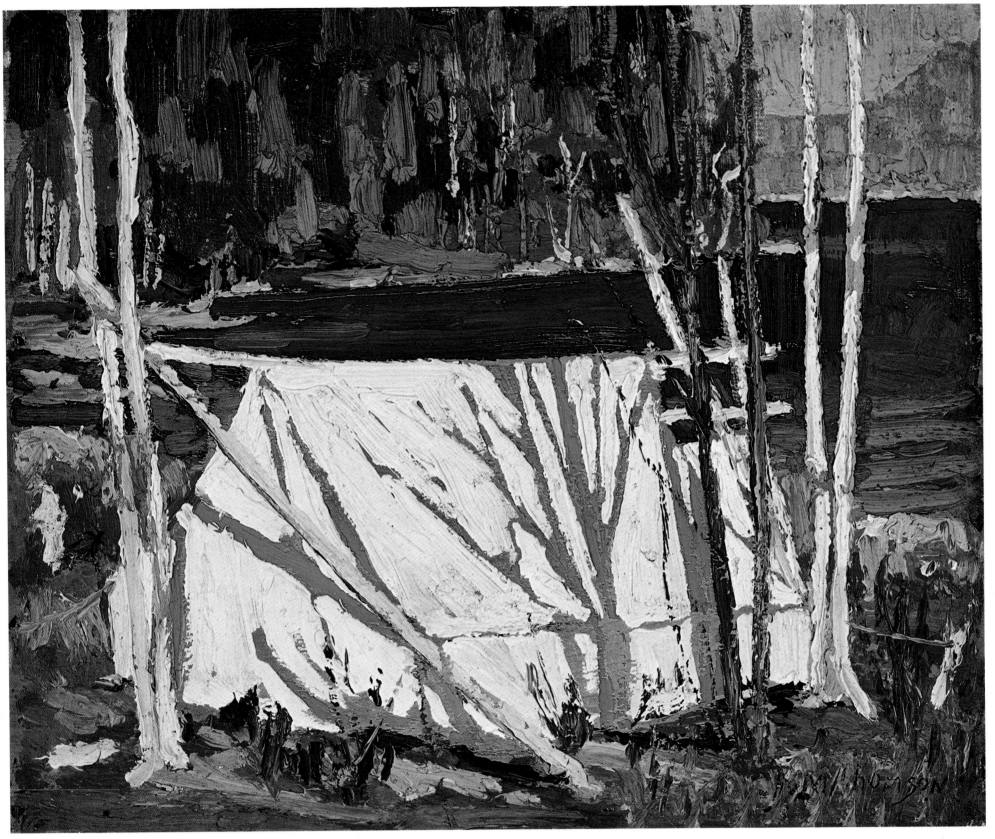

The Tent

Tom Thomson's Art:
Later Development

Thomson probably never thought of becoming a professional painter until about 1913. He had been brought up to consider painting a tangential refinement to life, but not the means to life itself. He had no models to emulate and, as far as we know, knew no one whose whole life was devoted to art until he met Lawren Harris, J.E.H. MacDonald and A.Y. Jackson. His predilection for drawing had but one practical application, and that was illustration and advertising. He probably would have preferred soldiering—if one takes his repeated attempts to enlist as an indication—but his fate was to muster lines and colours on paper. Once he discovered the vast difference between commercial art and the creative act of original composition, his development was a phenomenal rush, as spectacular as it was unexpected.

Thomson had begun to paint, mostly in watercolours, and for his own pleasure, while in Seattle, but little or nothing from those years indicates latent ability or ambition. The work is almost all trite, sentimental and awkward and barely removed, in spirit or intention, from the kind of commercial work he probably did. After his return to Canada and his beginning to work in Toronto, he showed little improvement. The work is insignificant, small in scale, and derivative. In a painting like *Team of Horses* (page 35), for example, his work was syrupy and reminiscent of Millet. The meticulous care of the drawings done about 1908 (see page 147) shows more conscious organization, but instead of departing from commercial modes, seems more closely tied to them. Nothing impelled him to consider anything more meaningful than casual illustration.

The insurgent ambition of the men at Grip Limited, to which Thomson moved in about 1908, was the spur to his dormant capabilities. They were men of much the same frame of mind as himself—that is, illustrators by necessity rather

than choice—and with the same ambivalence toward painting. A.Y. Jackson has described this condition and these men well:

> There was no definite division between painters and graphic artists. Many artists painted during weekends and in the summer months, and were illustrators and commercial artists the rest of the time.
>
> Most of them were familiar with Northern Ontario, some of them had worked as fire-rangers. Good canoe men and campers, they knew their country. ... They painted with much enthusiasm but not much understanding. They had no background, no traditions, no collections of good art they could go to for guidance. The painters who were recognized and received financial support were the ones who painted like Corot, Constable or Millet—pictures with a sentimental appeal.

It was at Grip that Thomson was obliged to confront two quite distinct and separate factors which together combined to make him the painter that we have all come to know. The first was an adulation for the "Northland," as it was referred to, but which was in essence another wave of the preoccupation that Canadians have always had with the landscape and the environment that totally surrounds and profoundly affects everything they do and are. Up to this point Thomson had not travelled in the North so far as we know, though popular mythology has always assumed this. The commitment to the northern vision that his new associates had was not only infectious, but it triggered a response in him which brought back his boyhood days on the shore of Georgian Bay with considerable force. Instead of affecting the pose of the city dandy, which Thomson rather consciously did, he was compelled to delve into his own background and the origins of himself as a person.

The other factor was a mild but determined iconoclasm which was bent on severing traditional European art conventions in order to foster a form of expression more indigenous to Canadian sensibilities. Since Thomson did not know these conventions well, he had the advantage of ignorance and of not having yet made a commitment. When he began to paint, his observations of his own country were naturally foremost in his mind and experience. Both these aims at Grip, therefore, found a poised and waiting agent in Thomson. According to Jackson, Thomson "did not realize he possessed a large store of knowledge he was not using." His friends helped him to liberate it, to put it to use, but they also helped to shape it. The release had magnificent results, but the shaping and the controlling of it, when all is said and done, leave a melancholy note, for we are left to wonder if a larger fulfilment might have come, or whether Thomson was just a groomed puppet whose later life might have been a nightmare of insincerity and falsehood.

On the Don River

The Banks of the River

The Old McKeen Home

On the Harkness Farm

147

Yet that speculation is no more real than trying to imagine Romeo and Juliet in old age. The genuineness of his and their young love can hardly be questioned.

The Canadian landscape has always been romanticized by Canadian artists: it is the only reaction one can have to something which so completely dominates one's life. Whether it is smoothed into a gentle pastoral with the ruggedness and danger suppressed, as the generation prior to Thomson had dealt with it, or whether it is treated as a brooding and grim menace, as people then liked to imagine it, the distortion allows one to come to grips with an idea or a concept of it which matches, for a time, the emotional and intellectual response one wants to have of it. The irony of the reaction to the movement of which Thomson was a part is that while its artists portrayed the wilderness that lay little more than a hundred miles from Toronto, and thought of it initially as a haven or a paradise, their depiction of it often was applauded for the wrong reasons. Since people wanted to believe that it was a trackless, "wolf-ridden" land, they were prepared to accept a style of painting it which was itself somewhat brutal and crude, at least compared to the gentle, low-toned depictions of an earlier generation. The romantic North permitted a latitude in colour and technique that would not have been tolerated in painting something in Toronto in the same way.

A good example of this double standard was provided in 1916 when MacDonald's *The Tangled Garden* was first exhibited. Had his subject been a tangle of pines or maples in autumn colours on the edge of a northern lake, the furor might never have arisen. It was *how* he painted it that suddenly became the topic of alarm, and it was the subject that drew attention to the means of expressing the idea. Most of the critics had not been in the North in any case, so what the painters did or said they encountered there was not questioned. The MacDonald episode merely emphasizes the fact that the issue was one of common ideas about art, and that it was brought to a head by challenging common ideas about nature and society's perception of it. The Thomson circle touched a latent love-hate relationship that Canadians have for their landscape. The "monotonous, dreary" North was in fact the summer playground of city-dwellers, and one was bound to think of it as one might of an illicit lover.

Further than that, there had been a sustained preoccupation with the North. Thomson and his colleagues came at the end of a strong, nationalist, northern-looking movement, not at its commencement, and Thomson was not the first to paint it. What drew the admiration of the critics and of the audience which developed more rapidly than is often intimated, was the artistic and aesthetic canons that were adopted. It was the style and not the subject matter that struck home. Everyone already had a mental idea about the subject, for it was always far too close for people not to have. Even the members of the future Group of Seven, with

Grazing Sheep

the exception of Varley and Lismer, had had personal experience with the North from boyhood.

Artists had busily portrayed the range and breadth of the Canadian landscape for at least two decades before Thomson and his friends burst upon the scene. Cornelius Van Horne had sent painters to the West in the 1890s when he was president of the Canadian Pacific Railway. Arthur Heming's writings and illustrations of the North and of wildlife had begun. C.W. Jefferys had produced his *Chronicles of Canada* and painted extensively in the West. The Toronto Art League had actively promoted "the North," and there had been paintings by A.W. Parsons of *The North Country,* and *The New North* by D.F. Thomson (no relation) before Thomson turned his attention to it. J.W. Beatty, in 1910, had painted *The Evening Cloud of the Northland,* a work not unlike Thomson's first essays when his transition finally began.

The conditions that made the Group of Seven finally possible had been forming for many years. Maurice Cullen had already brought his brand of Impressionism back from France and applied it to his painting of the Laurentian Shield before Jackson followed him. Daniel Fowler had brought the English watercolour tradition to focus on Canadian flowers and Canadian game in his still lifes. Edmund Morris tried to give a distinctly Canadian flavour to his portraits, and he had formed the Canadian Art Club in 1907 to support and to promote a higher quality of work which reflected the Canadian experience with more authenticity. When Thomson and his circle emerged, there was little need to plump for Canadian subjects: that had already been accomplished. It was to adopt a way or a manner of painting different from what was perceived to have still a lingering association with a European manner of painting.

Jackson was only one voice among those who saw this as the crucial issue. "It was not so much a desire to create a Canadian art," he wrote, "as it was to end the dependence on stale European conventions long abandoned in Europe." Yet the anomaly is that he and his associates drew from the same well as their predecessors, and as a consequence nearly everything they did now strikes us as still having direct and obvious ties to European expression. They transformed their borrowed conventions a little more and a little differently than Cullen or Morris had, but the pathos of the Group of Seven is that they exchanged stale conventions for less stale ones. They did not brace themselves with the fresh vigour with which both Paris and New York were then seething. Their own contemporaries in Germany, Italy and Holland met the challenge of the twentieth century with infinitely greater originality, all of which the Canadians seemed to be totally unaware of. There is not a word in all their writings about the Armory Show of 1913 in New York, which sent shock waves through the art worlds of the United States

Church in St. Thomas

and of Europe. Perhaps this latter fact is one good example of how Thomson's friends kept him hermetically protected from ideas which he instinctively groped toward, for they were in the air, and contact with them might have given Canada a major twentieth-century artist when one was most needed.

Thomson's development as an artist was erratic and eclectic. He had become an illustrator and a dauber by interest and by strong avocation. Yet he had never extensively or formally studied art, and when he began to emerge with his own voice in 1912, he was already thirty-five years old. J.W. Beatty claimed to have taught Thomson all he knew, and to judge from Beatty's own earlier paintings of Algonquin Park, he might well have provided Thomson with some inspiration at the outset. Jackson, a petit-nemesis for just about everyone, did not like Beatty's work and dogmatically stated that his "atmospheric approach was not effective." This meant only that one had to be careful to make distant colours less intense than near ones. Yet this method occasionally served Thomson, particularly in 1912 and 1913, and even Jackson fell into the old "atmospheric approach" unconsciously from time to time, for he wrote to Dr. MacCallum in 1914:

> So you find the mountains I painted quiet after Bill's [Beatty's] description of them. Bill is so well soaked in monochrome that very mild things excite him. The country up here [Algonquin Park] is much more intimate than the mountains, and colour close up is brighter than colour a long way off.

Jackson wanted a new approach, but not too new.

Jackson was the closest and strongest influence on Thomson's development for a brief but crucial time. From Jackson, who was technically a fine and well-trained painter, Thomson learned more about mixing paint, about brushwork, colour, drawing effects and so on. He was anxious to arm himself with techniques because his own arsenal was so limited. His work prior to his brief but fruitful association with Jackson was constricted, fussy and dark. Though it bore the stamp of his intentions and interests, the way he was painting did not suit the vision that was developing in his work. Jackson gave him the tools to make what was in his mind. By the end of 1914 it was possible to say that Thomson knew where he was going and how to get there: "with a full brush he put his colour on and left it. No puddling or modifying ... no fumbling or lack of direction."

Thomson probably learned a good deal, too, from other painters, as one does in constant companionship with them. He spent two weeks sketching with Lismer in Algonquin Park in the spring of 1914, and some of Lismer's best work was done at this time. Thomson also saw Curtis Williamson and Arthur Heming regularly, since they had studios in the Studio Building, and he would have taken what they

Decorative border for portrait by
Curtis Williamson

had to offer. Certainly the later claims that Thomson was not interested in techniques or methods are patently false. MacCallum, whose knowledge of art was considerably less than his enthusiam for it, helped to spread this idea: "He was not concerned with any special technique, any particular mode of application of colour, with this kind of brush stroke or that. If it were true to nature, the technique might be anything." Thomson may have chosen any means to achieve a desired effect, but he had to know what could or could not be done. MacCallum's disclaimer smacks of myth-making, and has tended to support the erroneous view of Thomson as some sort of self-trained, naturally talented innocent, whose genius flowered miraculously without any visible signs of support or nourishment.

As Thomson jumped from style to style in the brief years that he did significant paintings, so his energy seemed to come in starts. From all the contemporary reports about him he was a fitful painter. Lismer called him "a creature of depressions and ecstatic moments of creative accomplishment." On another occasion he wrote that "Thomson seemed to drift with the mood, surrendering, waiting for the moment of vision." Jackson also noted the erratic quality of Thomson's work habits: "When the artistic urge came upon him, he would work as if life itself depended upon speed." But when he was working, Thomson "could 'lick in' a five-foot canvas in an hour or two." From all accounts he had the ability to concentrate intensely, to become wholly absorbed in the solution of whatever problem he had before him. Painting rapidly was a natural concomitant of Thomson's deep concentration, and there are accounts of his not noticing people going past while he was working, or of even not responding when spoken to.

Fierce concentration suited Thomson's expressionist style. It was less the subject that was the essence of his work than the record of his reaction to it, as if the subject acted only as a catalyst to set off the artist's response. We are driven, always, not to what he painted so much as to a consideration of the way he painted it. Indeed, many of his subjects are in themselves insignificant and distinctly unpromising. His colleagues remarked that while they went hiking off to find striking subjects to paint, Thomson would linger around the campsite, and produce more than they in less time from what seemed uninspiring material. It was always a wonder to his subject-minded friends that Thomson could find what they could not see; but it is also a clear indication that the process of seeing and painting was what mattered most to Thomson. Even Jackson acknowledged this when he wrote that in Thomson's work there was "always the feeling of the country, seldom the feeling of being tied down to a particular place in it." This is one of the reasons why Thomson's sketches are more valuable works of art than his larger paintings and are the only true indicators of his achievement as an artist.

In spite of Thomson's moodiness and dilatory habits, he was a prolific painter.

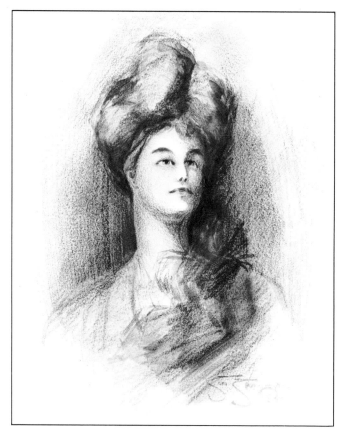

Head of a Woman

The speed with which he worked was a factor, and of course he worked in a tiny format most of the time. Even though, according to Jackson, he burned much of his work, an impressive amount remains, considering the short span over which it was done. Bonfires notwithstanding, his high productivity may also account for the rather large number of thoroughly mediocre paintings in his complete *œuvre*.

Despite the considerable achievement in his work, and the sustained recognition he received, Thomson was dissatisfied with his own painting. His enthusiasm for the work of other artists may have been one of the traits which endeared him to so many of them, if painters then were anything like painters today, and his "poor opinion of his own work" would have enhanced his praise. Jackson, Harris and MacDonald all commented on this strange lack of self-importance. Harris recounted how Thomson "would often sit in the twilight, leaning over from his chair, facing his painting, after working at high pitch all day, and flick bits of broken wooden matches on the thick wet paint where they stuck." His friends tried to protect him from visitors, for they knew that a hint of admiration for a sketch would be enough to encourage Thomson to give it away. His singular diffidence was endearing, no doubt, but it belies his uncertain beginnings.

For the Thomson circle, sketches, or "boards" as he sometimes called them, were only the raw material for the more elevated and important business of painting a large canvas back in the studio. Though he used canvas board quite extensively in 1912 and 1913, he switched in 1914 to slightly larger birch panels of approximately 8½″ x 10½″, which he often purchased at a veneer mill at South River. At the same time he also painted on three-ply panels which have deteriorated badly. He always used paints of good quality, and the thickness with which he often applied them meant that his boards frequently stuck together when packed or stacked. Flattened patches are still visible on some works, and when he shipped his sketches down to Toronto he asked MacCallum or Harris to spread them out.

An accumulation of sketches gave one the sources for "painting up" a larger canvas. According to Lismer, it was only in the city that Thomson's "dreams became reality" and that the "work itself" finally came into existence. But as we know of Constable that his sketches were superior to his final canvases which lacked the springiness and vitality of the first vision, so we now know of the Thomson school that their sketches were in most cases superior to the canvases derived from them. The freshness and immediacy are thrilling, whereas many of the large works are rhetorical and stiff by comparison. They strike one as being more pompous than was perhaps intended. But the sketches are truth itself. It is another sad truth about the Group of Seven that they did not realize where their real strength lay, and it also belies their nineteenth-century academism in no

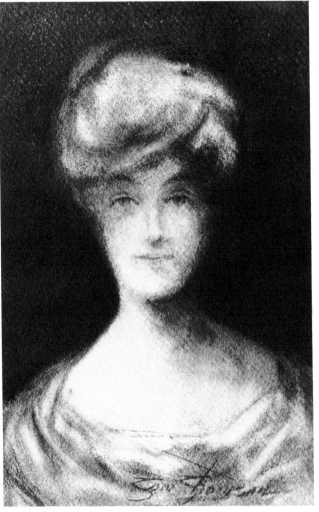

Head of a Woman

uncertain terms. The practicality of using sketches on long and sometimes difficult trails is a definite consideration, but not one that deterred either Emily Carr or David Milne.

Although Thomson's real subject was the act of painting itself, the objects that took his attention deserve some comment. The whole of his work gives a markedly different impression of his interests than one has from the standard canvases that are reproduced so frequently, and one of the aims of this book is to present Thomson in a more characteristic light. Jackson observed of Thomson that "not knowing all the rules and conventions regarding what is paintable, he found it all paintable" – an admission that Thomson perceived differently and was not as inhibited by established artistic canons. MacCallum and other commentators wanted only to know if what Thomson painted was taken from Nature, and seemed satisfied if Thomson told them that he actually saw what he set down in paint. Because he was convinced by what he thought of in Thomson's work as a meticulous representation, MacCallum referred to Thomson's whole production as an "Encyclopedia of the North" and tried to sell a block of Thomson's sketches to the National Gallery on this basis.

The light on the landscapes Thomson painted was particularly adroit and subtle. One can almost calculate the exact time of day and the quality of the air from the colours he used. This aspect of Thomson's achievement is what charges his work with strong emotion and refinement at the same time. It also is the invisible but pervasive quality which locates his work in Ontario. The light and atmosphere of a locale is unique and Thomson's significance lies in the authenticity with which he captured this feeling and translated it into the language of paint. The Canadian understanding of the landscape was finally complete through his profound sensitivity to it.

Harold Town comments elsewhere on our stereotyped view of Thomson as the painter of autumn, one of the most distinct and moving of the seasons in Canada, and one that we would naturally like to associate with the most reputed of our landscape artists. But while Thomson did indulge himself in the brilliant fall colours, and was urged by his friends to do so, the extra drama of autumn was not necessary to his palette and it was not his favourite of the seasons. The fall gave his colleagues an oblique opportunity to approach the colour of the Post-Impressionists without foresaking something "real." But Thomson's fall canvases were, for the most part, rhetorical and mannered in conception, over-painted and ponderous.

The two great preoccupations Thomson had, to judge from the quality and quantity of his paintings, were the sky, in all its variable and magic configurations, and the miracle of spring. The skies were part of the Constable tradition that he

had been made aware of, but they were also the constant indicator for the bush traveller of either storms or fair weather, of winds and of rain or snow, and they were Thomson's navigation chart. The clouds suggested new forms and a range of colour, from the most subtle to the most theatrical, that urged him along in his self-discovery.

Spring held a special fascination for Thomson and for the few years that he went to Algonquin Park he liked to arrive early enough to see it through from the first tentative settling of the snow to the final warm day when the leaves burst into summer. In his last spring he was reported to have painted a daily sequence to depict the unfolding new year, a fiction in part, but with some basis in fact. He initiated his colleagues into this worship, for Lismer later wrote, "Never have I appreciated the big idea of Spring before so strongly." Thomson's portrait of Canada is more securely locked into these works than any others.

Nearly all of Thomson's painting was done in Algonquin Park, the Georgian Bay area, or in the country near Huntsville. His point of view was generally that of the canoeist, where the horizon line is low and emphasizes the shape of surrounding shorelines and the immensity of the sky gives one a feeling of cowering in a vast space. There is seldom a sense of infinite distance, for the far shore is never far away, and there is frequently a distant hill seen through trees which again sets a boundary to the visible space. There is always a sense of being surrounded. Those few works which scan the countryside from a hilltop are mostly awkward and uncomfortable. The conquering stance from a high vantage point is less in tune with the Canadian sensibility than the closed-off, low point of view which was more typical of Thomson. Whether he would have modified this unconscious and sometimes disturbing character of his work if, as he had planned, he had gone to paint the Rockies or followed the Rupert River up to James Bay, is speculation, though he had seen the mountains earlier in his life and they seem not to have affected his art.

The actual style of Thomson's painting is a series of attempts at different traditions which tumble over each other without a clear line of thought or development. In the last three years he seems to have settled upon, with the exception of the slick decorative panels of 1915-16, a way of jabbing down quickly little licks of pure colour in a thick but loose, gestural way. What he apparently was striving toward is partly indicated by the apprehension that his colleagues had about his development. In 1914 Varley wrote to MacCallum from Algonquin Park that "we have been busy 'slopping' paint about and Tom is rapidly developing into a *new* cubist." Jackson wrote that "Tom is doing some good work: very different from last year's stuff. He shows decided cubistical tendencies and I may have to use a restraining influence on him yet." And to MacDonald at about the same time:

"Tom is doing some exciting stuff. He keeps one up to time. Very often I have to figure out if I am leading or following. He plasters on the paint and gets fine quality, but there is a danger in wandering too far down that road." It is hard not to imagine from these sentiments that Thomson was in some ways being held back from his real concerns with the aesthetic properties of the paintings he was doing. David Milne seems to have sensed the ambivalence in his work when he wrote about him in 1932:

> Tom Thomson isn't popular for what aesthetic qualities he showed, but because his work is close enough to representation to get by with the average man, besides, his subjects were ones that have pleasant associations for most of us, holidays, rest, recreation. Pleasant associations—beautiful subject; beautiful subject—good painting!
>
> Then, in Canada, we like our heroes made to order, and in our own image. They mustn't be too good and, above all, not too different.

Thomson's brief life and mysterious death would not hold its fascination if his art had not displayed great gifts. His painting was not carefully constructed nor was it logically conceived. The appeal it has stems from the intense emotional reaction he had to the things he saw. From the Gibson girls and the cloying pastorals to the Byronic vigour of his last years, Thomson's art made heroic strides in a short time. The sentimental tinge in much of his work is offset by the rough vitality of his expression; the glitter of his vision, like Van Gogh's, shines through the most mundane of subjects.

D.P.S.

The Major Seasons

Unfinished Sketch presents another opportunity to support my 1965 thesis that Thomson's pattern of creative evolution would have brought him well in advance of New York painters to a form of Abstract Expressionism, in which the manipulation of paint on a two-dimensional surface amalgamated both the search and the goal of the creative act. However tempting as a theory, I believe this abstract is a perpendicular sky, an expression of Thomson's frustration with the constricting act of poking paint into the interstices between the forms made by trees, rock and thicket. In this unfinished work he was trying out the broad shapes of sky in a terrestrial situation and considering drawing over the abstract pattern, rather than filling in around drawing, whether it be the "absent drawing" made by the panel's ground or the actual drawing that delineates shape. Even in this abortive experiment he could not resist a hot lick highlight in the two forms in the dark area. No one can state with certainty what Thomson had in mind – even a living artist can form a barrier between understanding and his work – though unquestionably *Unfinished Sketch* can be designated as the first completely abstract work in Canadian art.

Late Autumn is an impatient study of the kind that gave rise to the abstract experiment. Areas between the branches are brusquely smacked into place, and the foreground is similar to the treatment of *Unfinished Sketch*. Much of the force in Thomson is a by-product of that desperation that comes to the artist when a picture is finishing itself well short of aspiration.

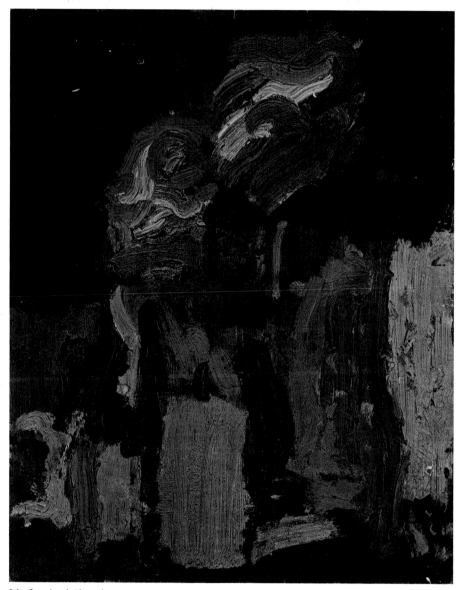

Unfinished Sketch

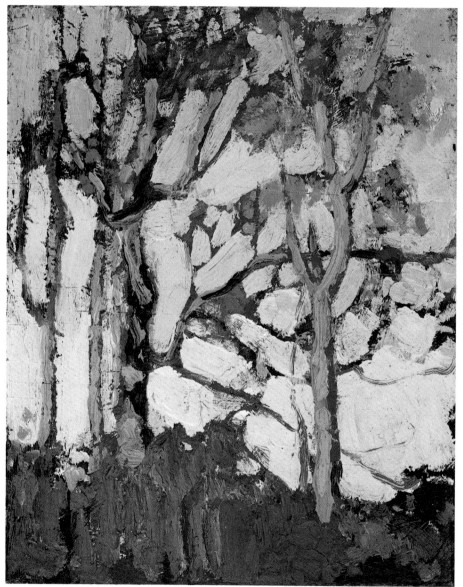

Late Autumn

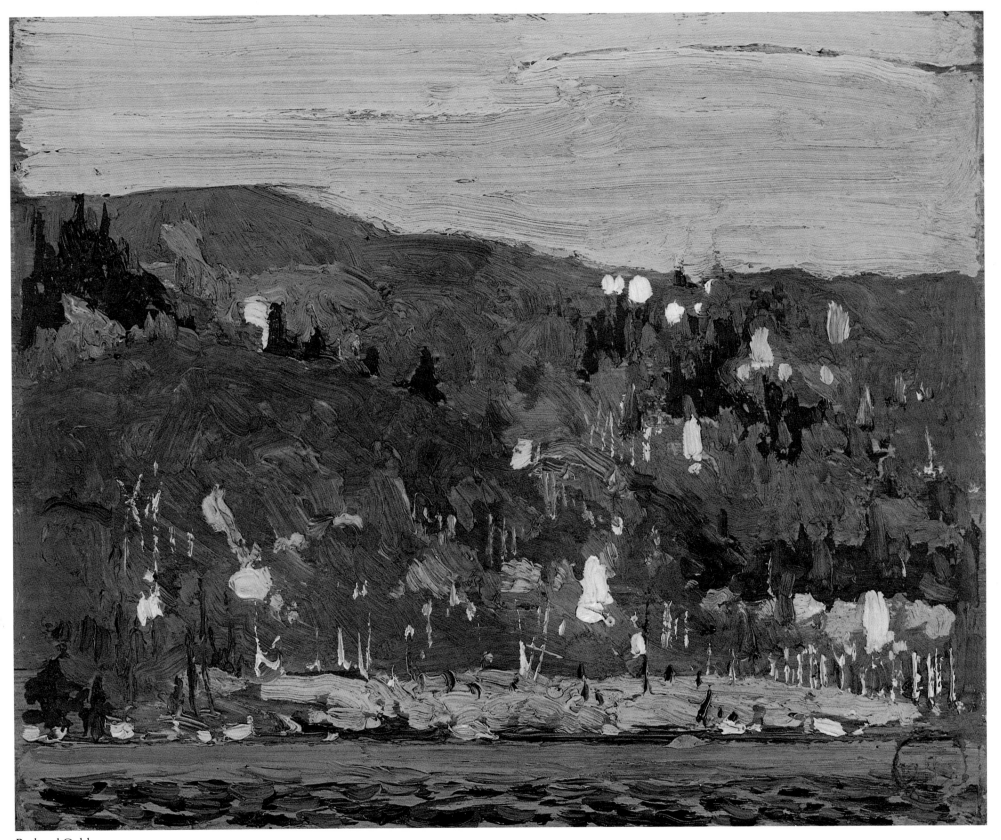

Red and Gold

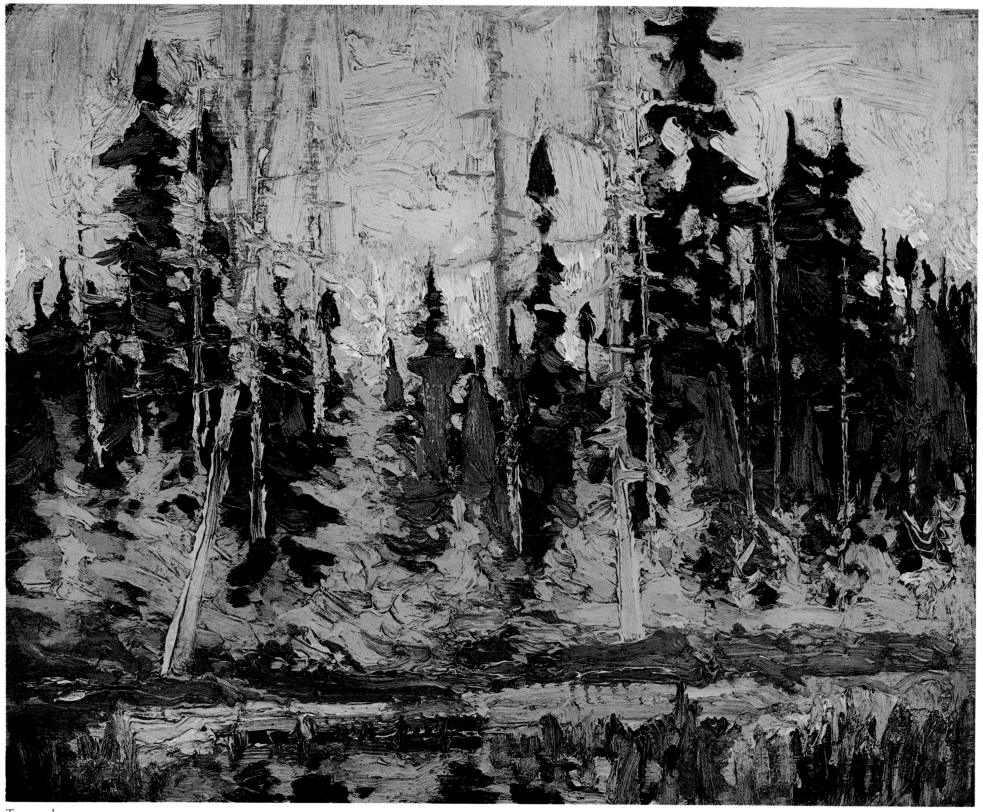

Tamaracks

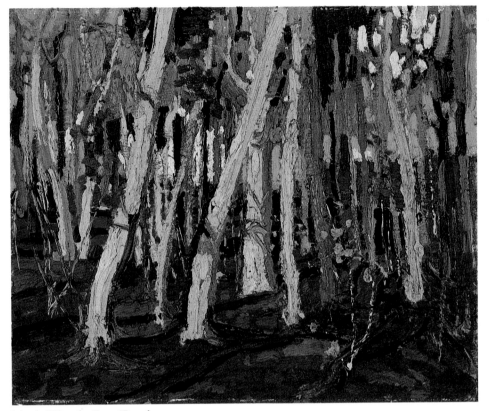

Maple Woods: Bare Trunks

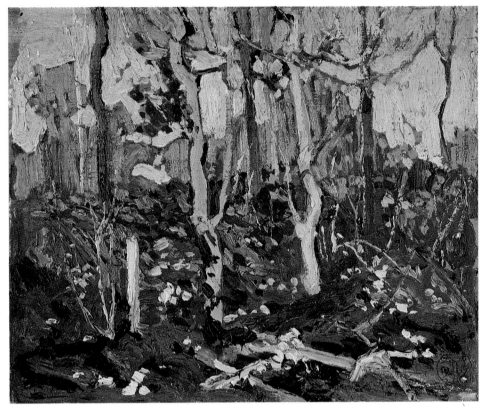

Ragged Oaks

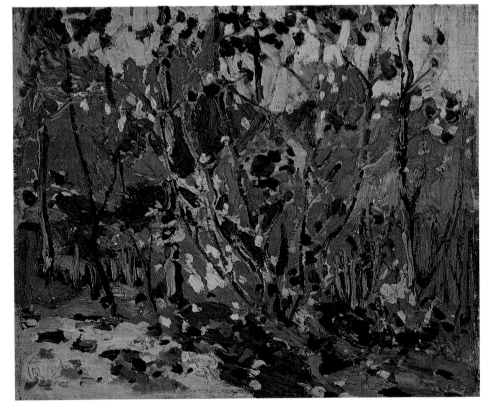

Maple Saplings

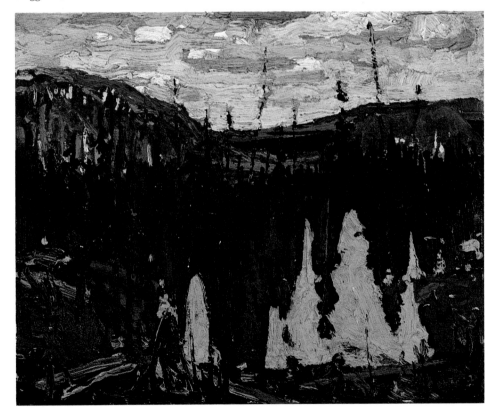

Burnt Land

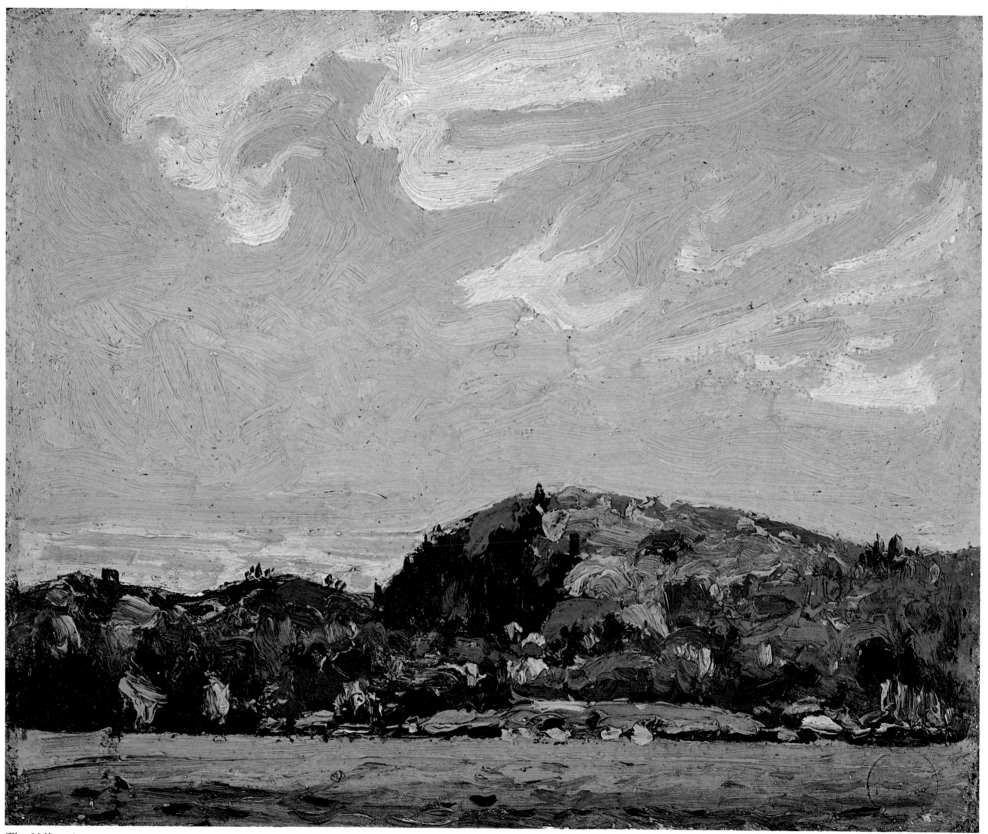

The Hill in Autumn

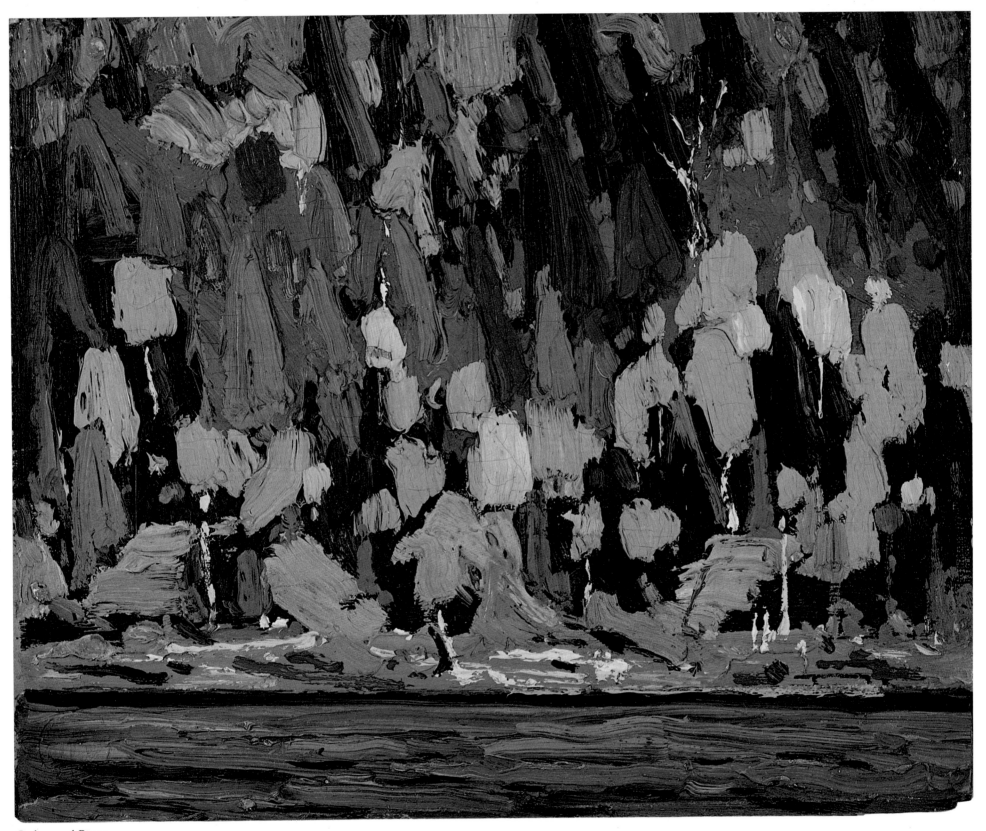

Cedars and Pines

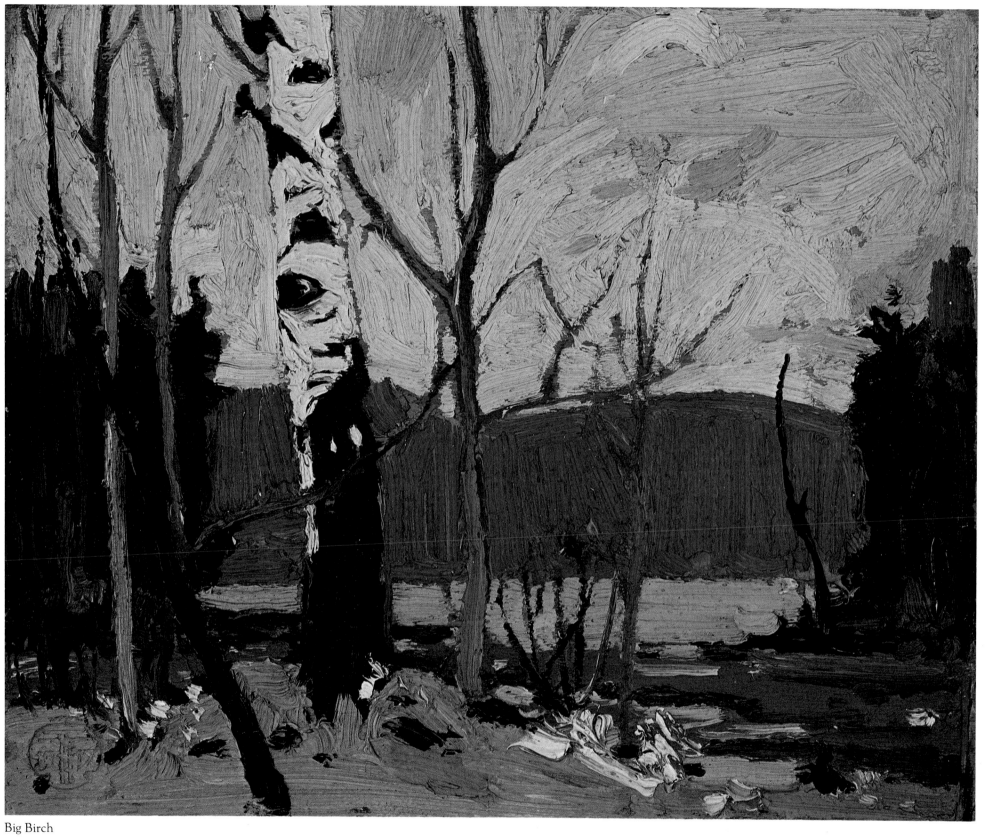

Big Birch

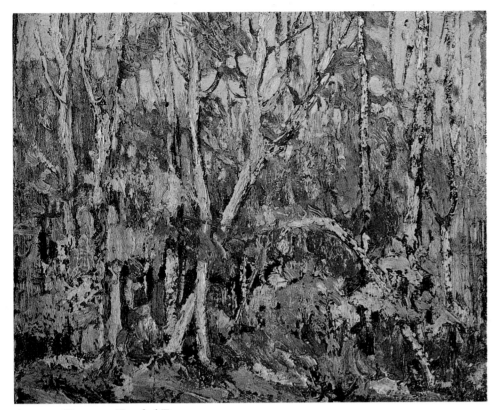

Autumn Tapestry: Tangled Trees

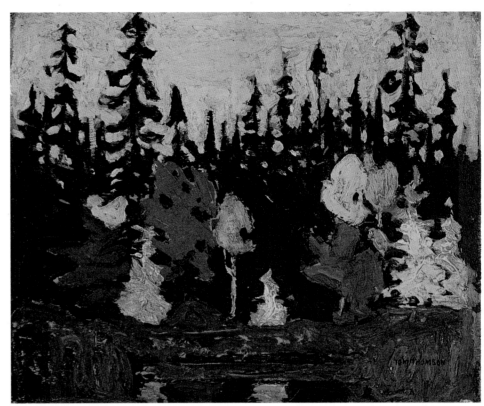

Black Spruce and Maple

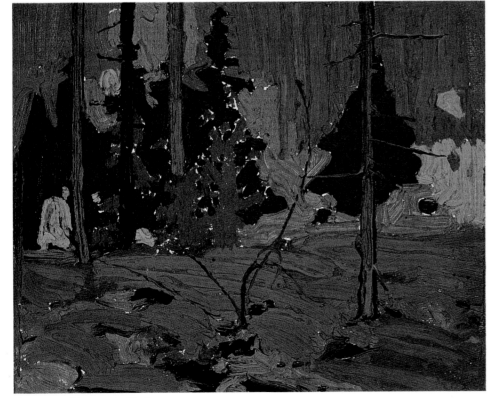

Autumn, Algonquin Park

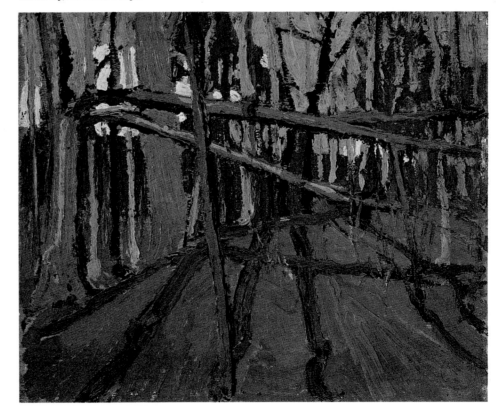

Forest, October

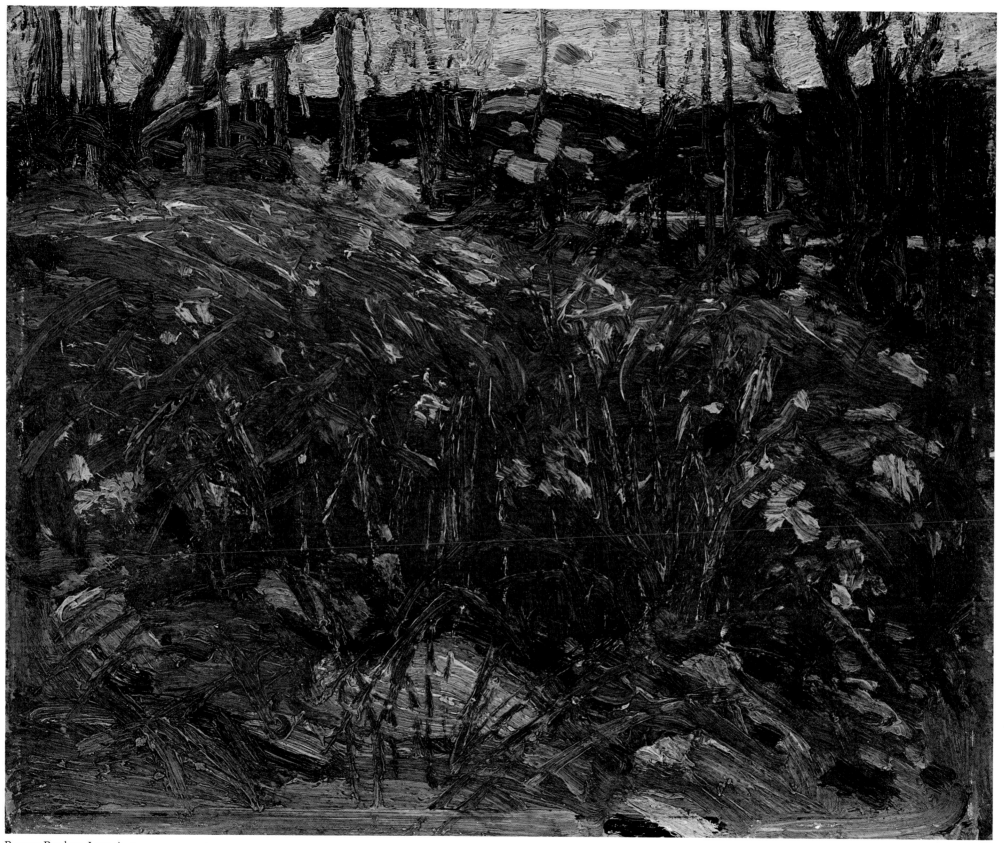

Brown Bushes, Late Autumn

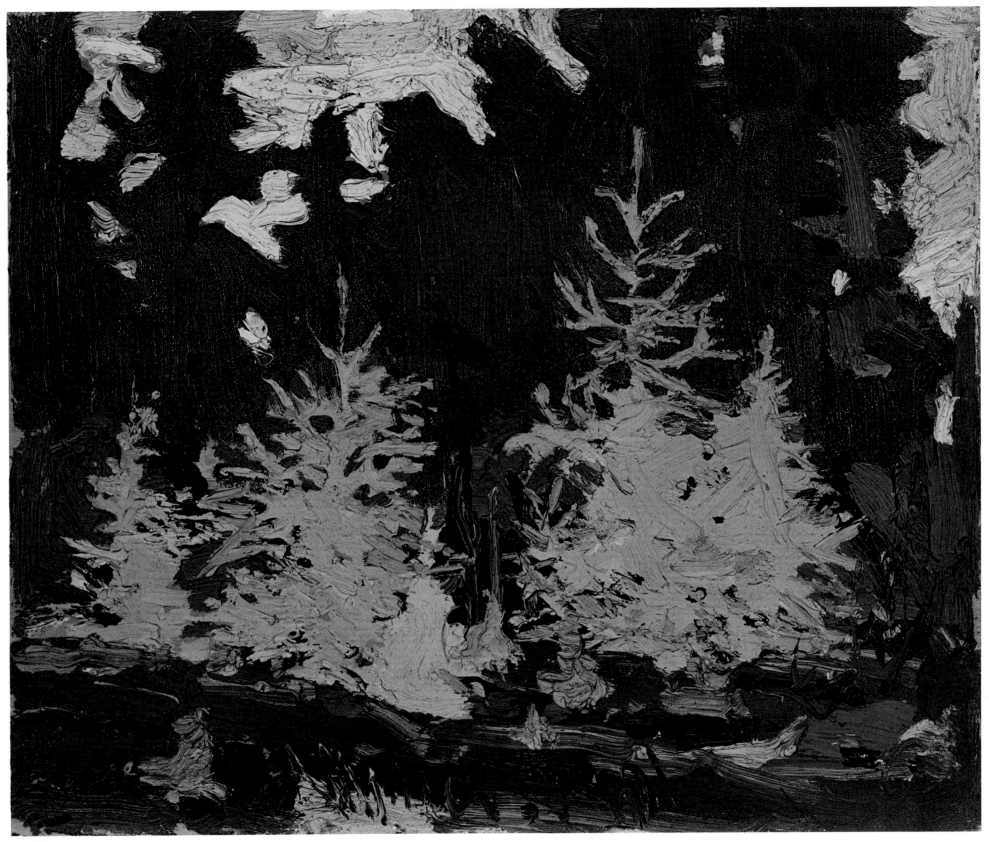

Dead Spruce

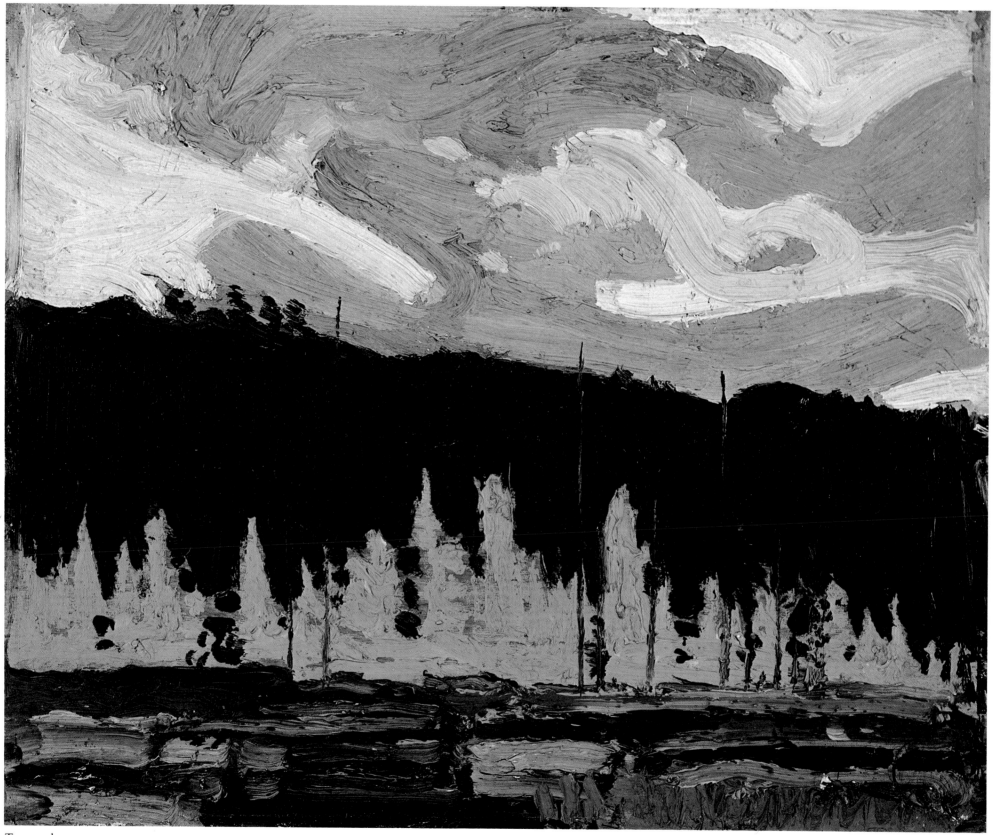

Tamarack

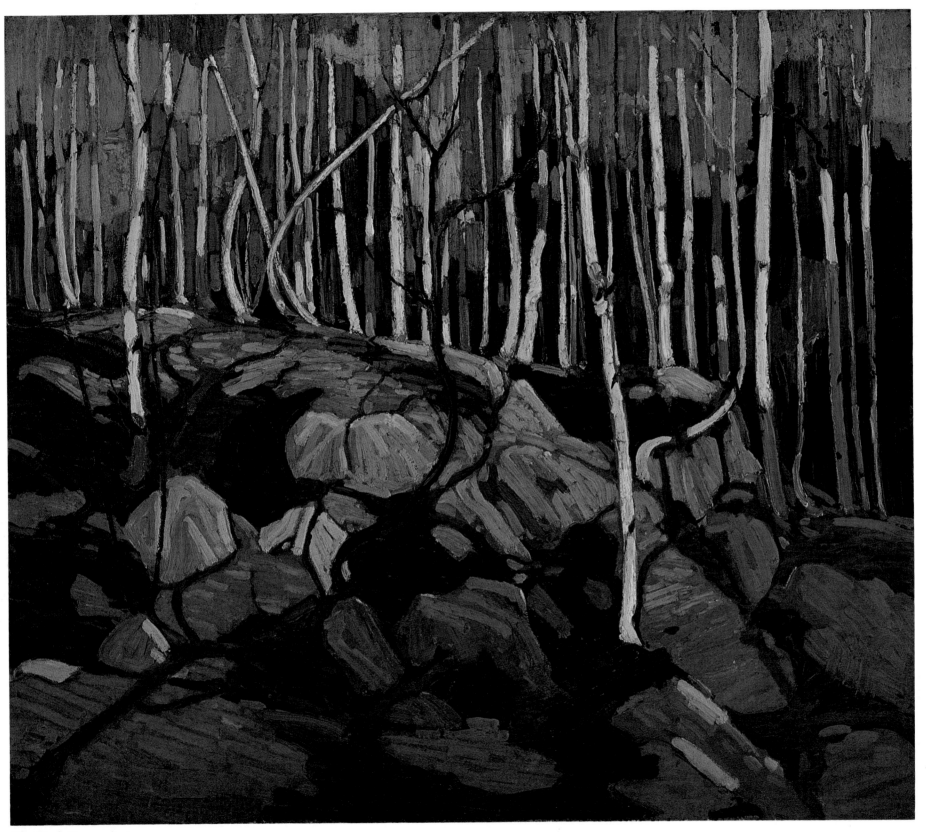

The Birch Grove, Autumn

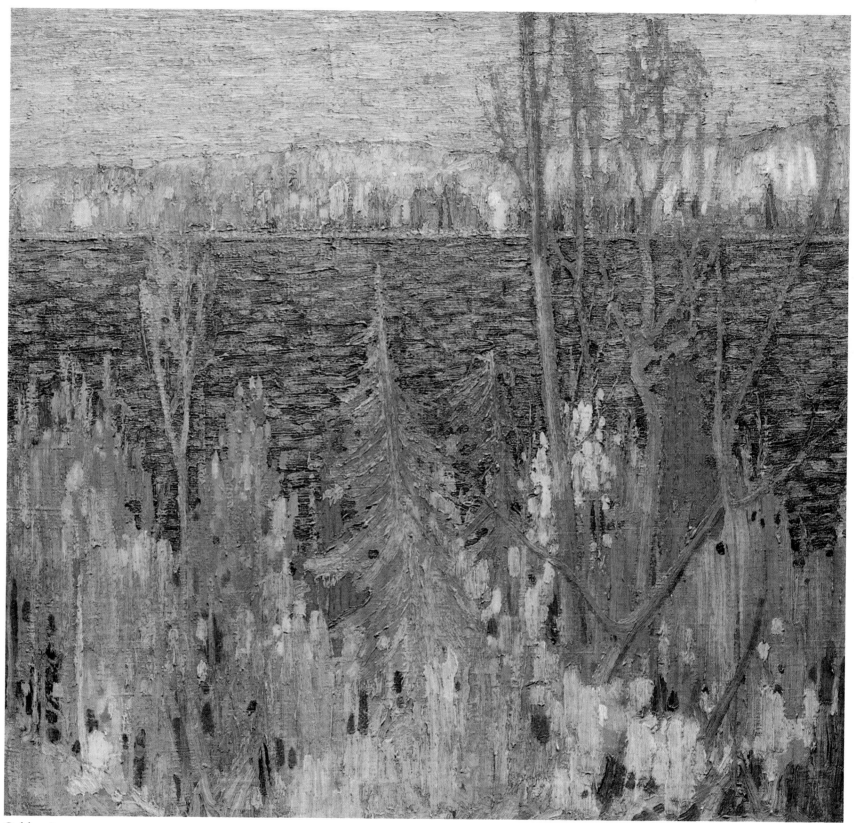

Golden Autumn

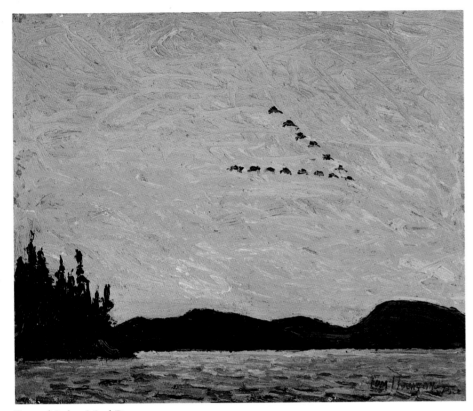

Round Lake, Mud Bay

Unless you use Audubon's eye and replicate the creatures of flight with detail of feather and claw, you paint birds high in the sky where they are little more than motes on the retina, lofting specks as impersonal as wind-blown paper. Excepting the fooling around that sometimes takes place during periods of courting, birds fly to purpose and certainly nothing reveals that drive more dramatically than a flight of geese or ducks taking a season south or bringing one north, a sounding arrow that declares with swift determination something has died, or is to be born. It would appear that Thomson was privileged for one occasion at least. In *Round Lake, Mud Bay* he seems to have witnessed the tidiest of migrational flights, a spearhead as symmetrical as a mathematician's dream. *Chill November* and its sketch, *Wild Geese*, mark a passage in orderly disarray so familiar in the North; the asymmetrical geese, however, are no more convincing than the symmetrical flight, for they are broken beads, an abstract caprice in a realistic setting. Birds and planes are difficult to paint in flight unless you use a cartoonist's speed marks or, as did the painters of angels and cherubim during the Renaissance, tie objects in the air to the ground by hidden compositional devices – stacked ellipses, pyramids, corner diagonals – that make the sky as supportive as the earth. Though a challenge bravely pursued, these works represent Tom taking a whack at the impossible.

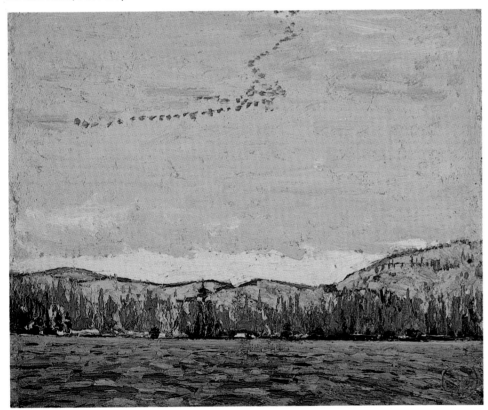

Wild Geese

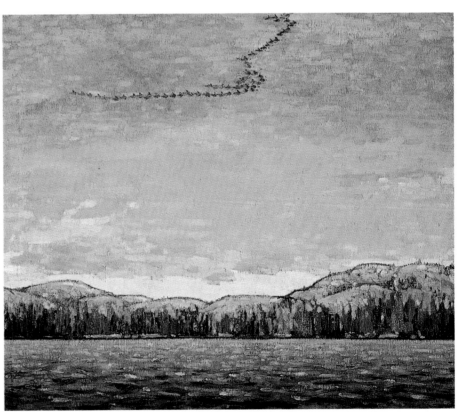

Chill November

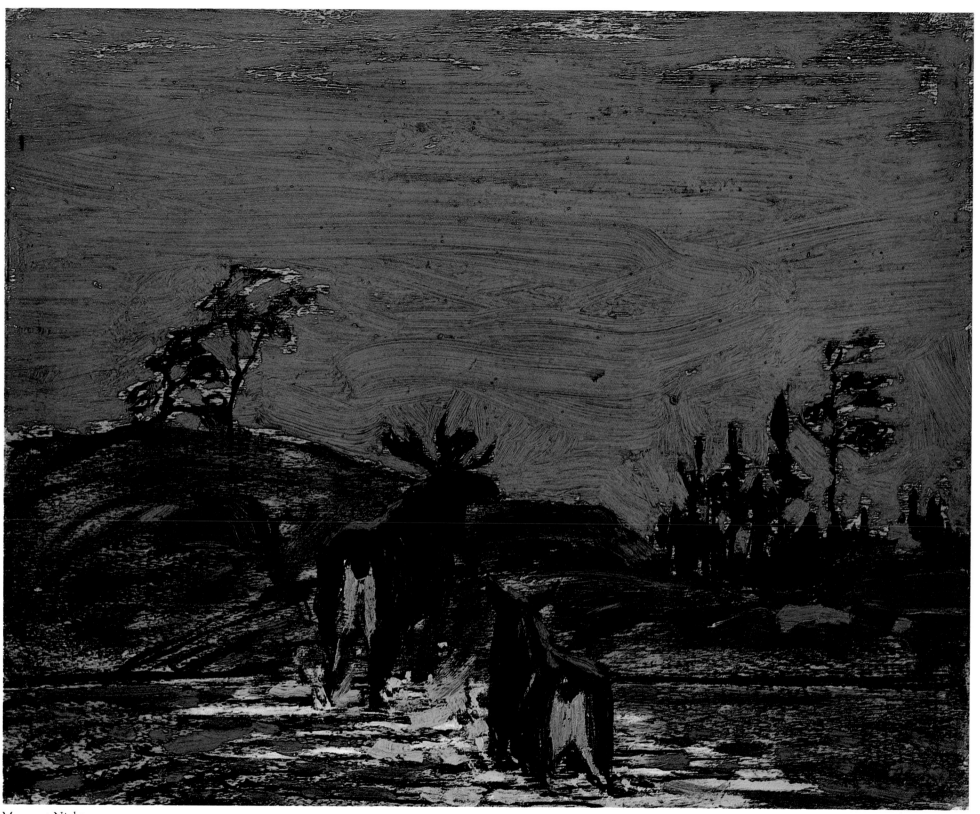

Moose at Night

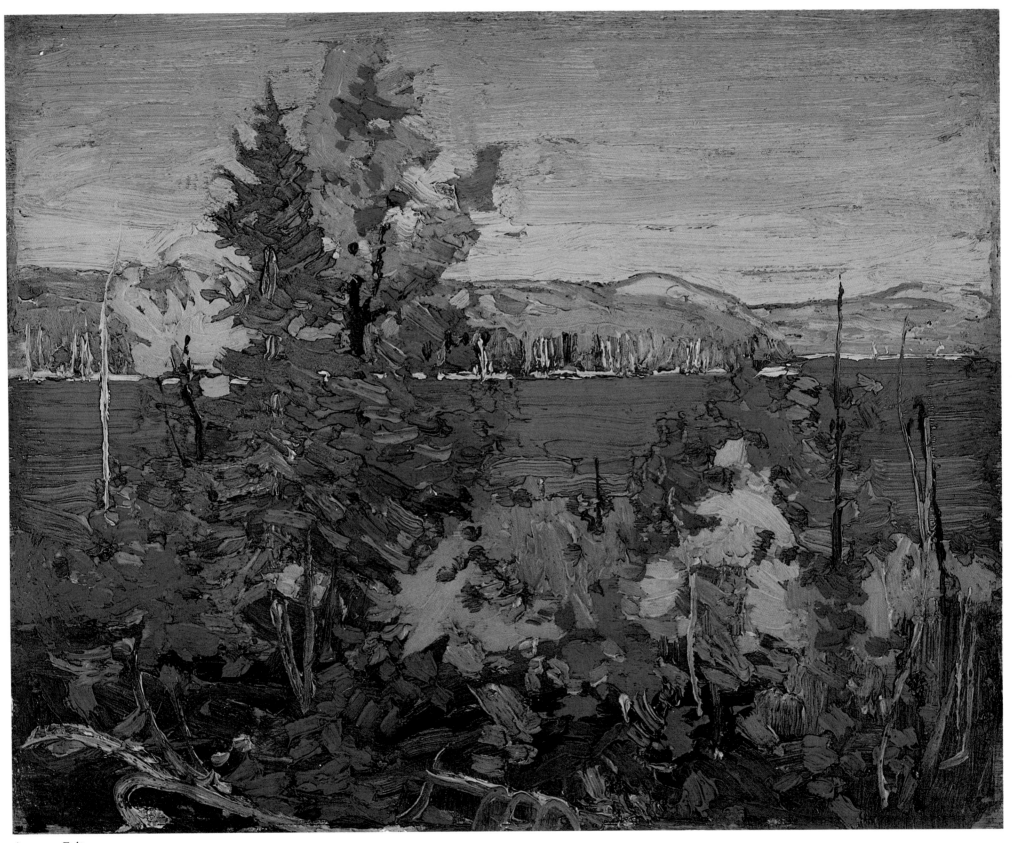

Autumn Foliage

Northern Lights is a notable run at another unpaintable subject. Thomson is not over-awed, he just sat down, squeezed out the colour, and made the painting, as if the light show was something he tackled every day and as a consequence we have an accurate replication of the phenomenon. The same is true of *Snow Pillars*, a movement in sky that is awe-inspiring. Yet the artist stroked it down as directly as if he were painting a kitchen chair.

Thomson's skies were not great events on specially produced heavenly occasions calculated to overwhelm a city-slicker – they were his models and he winkled out of the transitory activity of air a feeling of absoluteness of time and cloud, held forever in frozen motion. These skies are portraits of clouds. No matter how typical of his working method, there is another dimension, one of personality, a gallery of faces – new clouds, old clouds, buoyant clouds, angry clouds and some that were simply local characters.

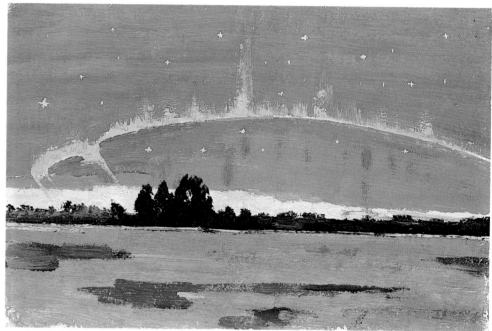

Northern Lights

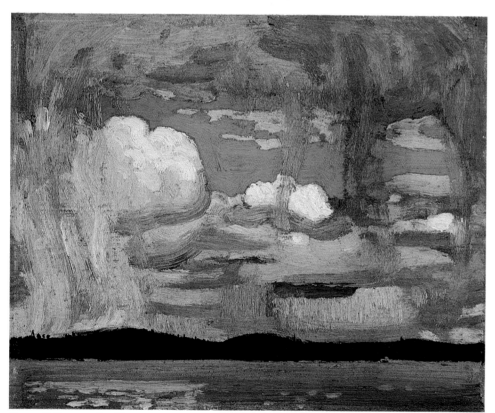

Snow Pillars in the Sky

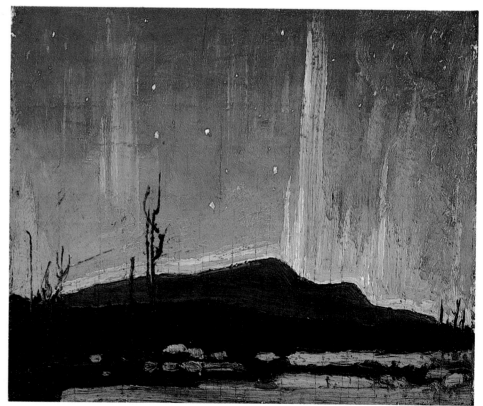

Northern Lights

173

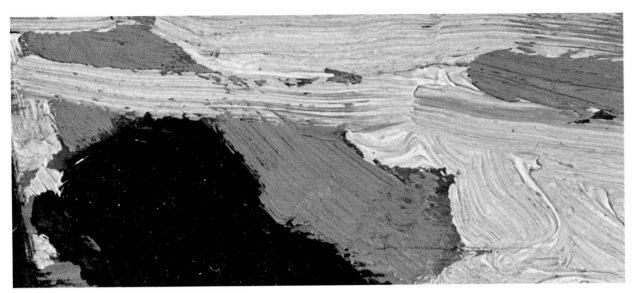

The West Wind (sketch): detail

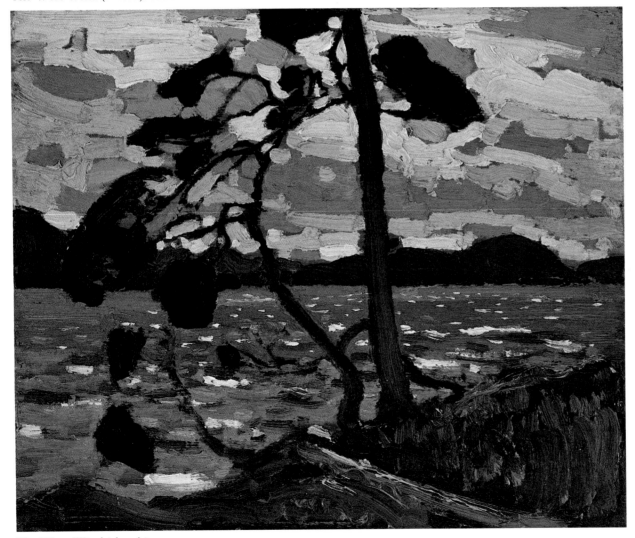

The West Wind (sketch)

Thomson's *The West Wind*, despite the title, is a portrait of a pine tree. It grows in the national ethos as our one and only tree in a country of trees. We seem never to have been without that tree, that ubiquitous tree. Emily Carr specialized in trees, whirling masses of trees – in fact at one point it seemed that all Canadian artists painted trees – yet this one tree won out. It is our emblem tree, our token tree, and the question is, why? First, because it is alone and despite a paramount position in the composition formed as a commanding open arabesque, it allows an easy, faceted entry into the windswept distance. Thomson's pine, though a genuine portrait, gives us the comfort of a tree plus a sense of decoration. It is easily acquired firewood that we could knock down without much trouble, not a giant redwood – ten days work with an axe – but a magnified bonsai; in short, an elegant twirl that says *tree*, yet is manageable, a front-lawn tree humanizing the cold, scudding cloud and marching caps of forbidding water. *The West Wind* reminds us of a day at the cottage that everyone dreads and how a pine like Thomson's makes it tolerable.

The sketch, crisply conceived and freer in attack than the finished picture, cannot be compared in quality with the larger work which, by moving the tree trunk to the right and lowering the horizon, has gained refinement of composition. The foreground, changed from amorphous tone to defined rock, is improved by the absence of the unnecessary diagonal thrust of dead wood, and the entire conception achieves an additional sonority through stepping down of colour tone.

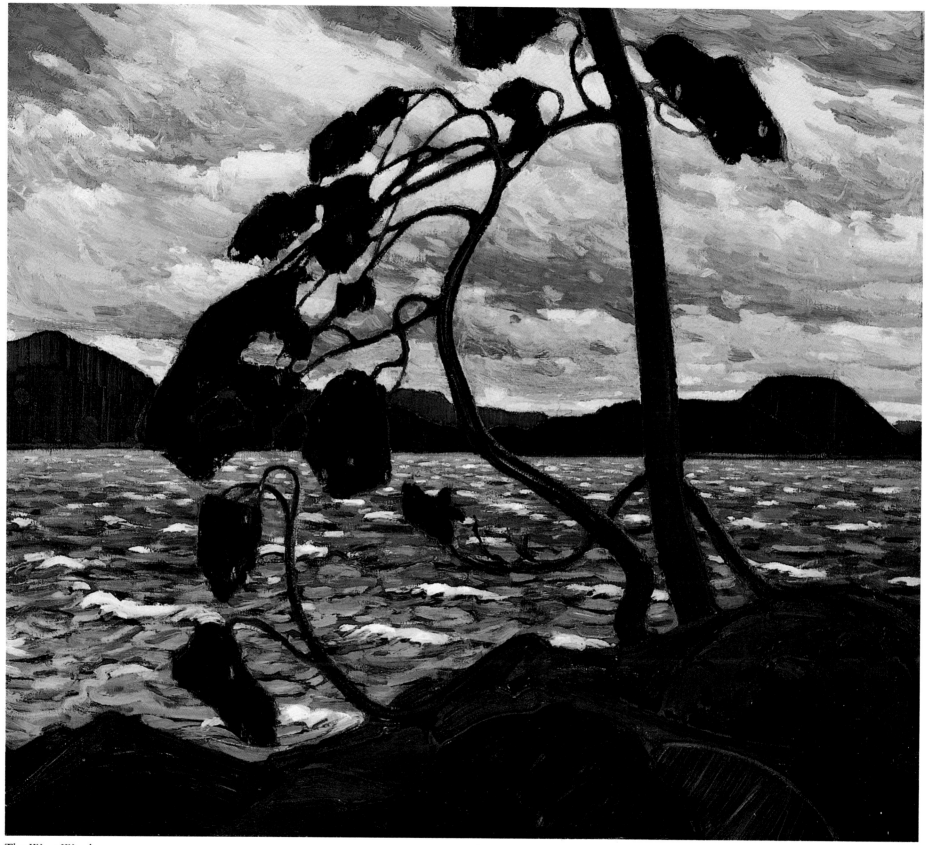

The West Wind

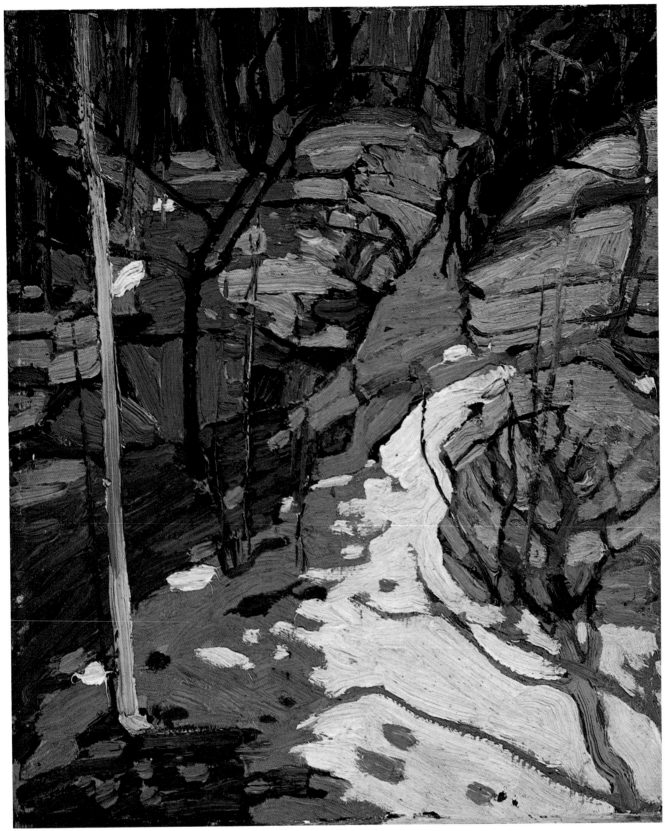

Snow and Rocks

Snow as rendered by a pompier artist or one of today's pseudo Realists is twice fallen – once in nature and again in the painting. Snow can be applied to the surface of a canvas like icing over the stale cake of tired inspiration, when in fact it is a smothering weight in the form of an avalanche or a delicate symmetrical amalgam of frozen water wrecking itself on your nose.

Though much snow has fallen on the painters of western art it has not been high on the list of hit subject matter. Certain masters, such as Bruegel and Monet, have painted snow but on the whole it has remained the pet prop of mountebanks skilled in the representation of waifs and fallen maidens or retreats from Moscow and is currently much favoured by the paint-by-number set.

Despite the needlepoint intricacy of *Snow-Covered Trees* and the scumbled excess of *Frost-Laden Cedars, Big Cauchon Lake*, Thomson gave little to the delicacy of the Christmas card tradition of snow. He used it not so much to declare the presence of winter as to signify form. He avoided the temptations of melted edge and deep shadowed interstices with a brush that struck snow as form resting on form, just as his clouds are form held within form. *First Snow in Autumn* and *Snow in the Woods* (pages 184-85) are examples of his ability to reverse the procedure and drag his brush in sweeping impastos that treat the snow more as texture and less as shape within a larger design. He opted for snow as form through taste rather than a limitation of ability to render its more picturesque effects. Paradoxically, Thomson, who dared the rainbow, Aurora Borealis and the star-filled night, made few works such as Jackson's *First Snow, Algoma*, in which the flakes and a whirl of powder snow are part of the concept. He preferred the weight of snow to its movements.

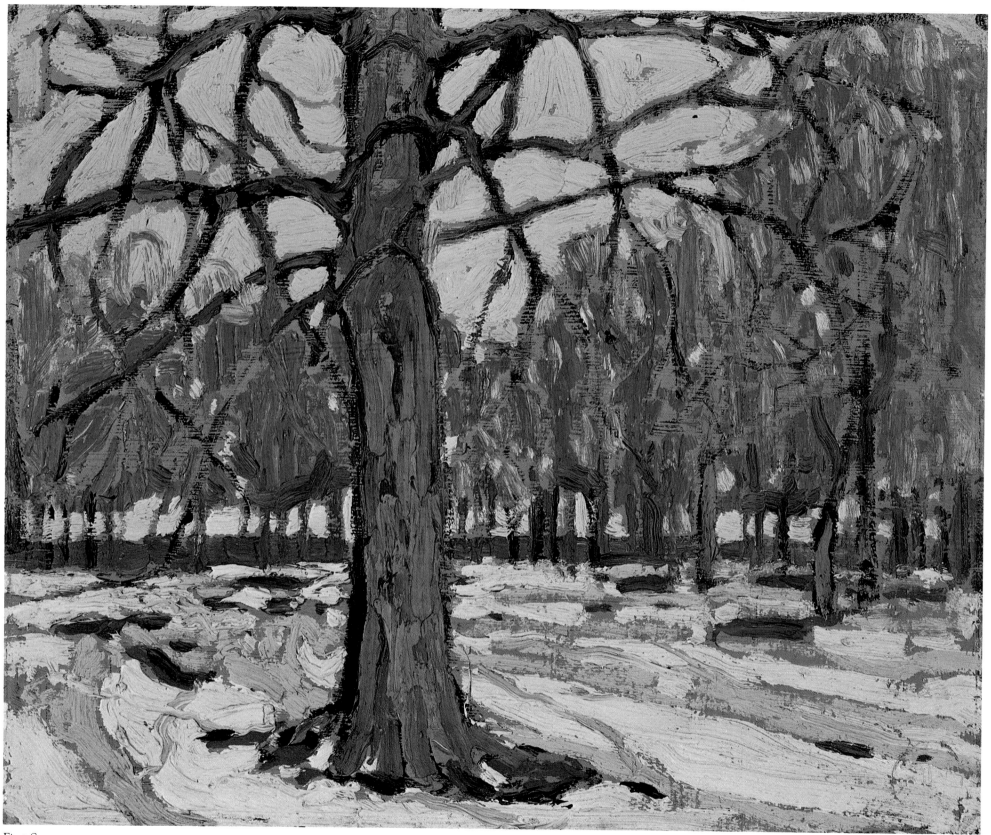

First Snow

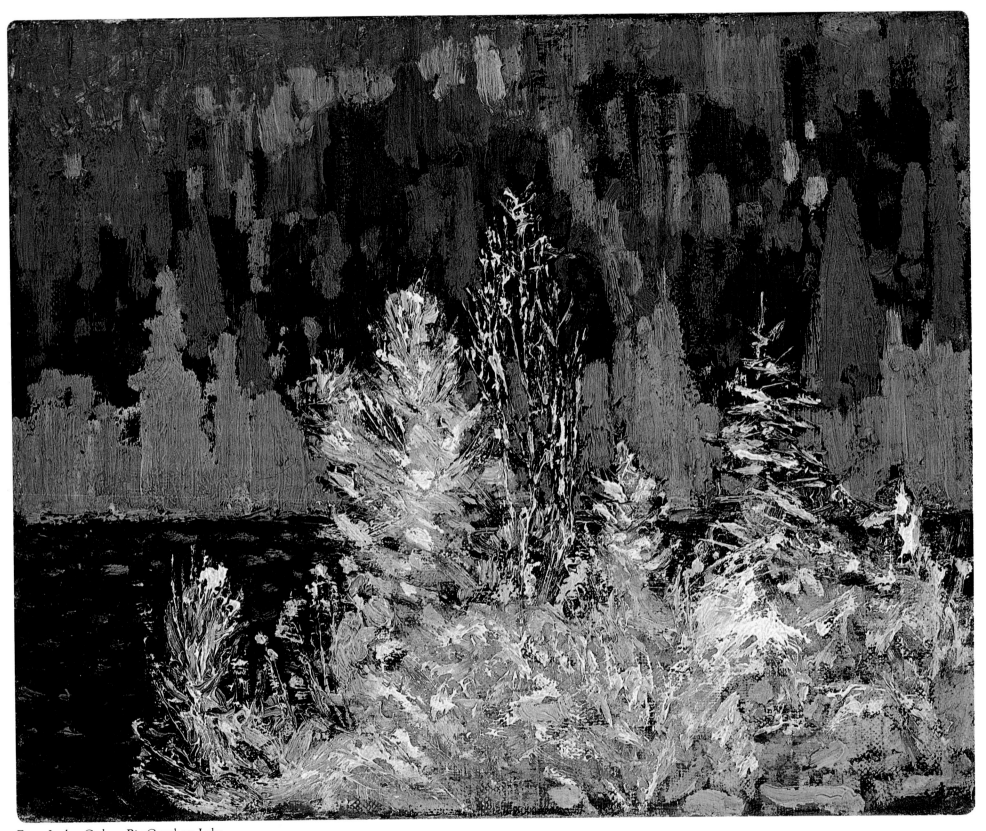

Frost-Laden Cedars, Big Cauchon Lake

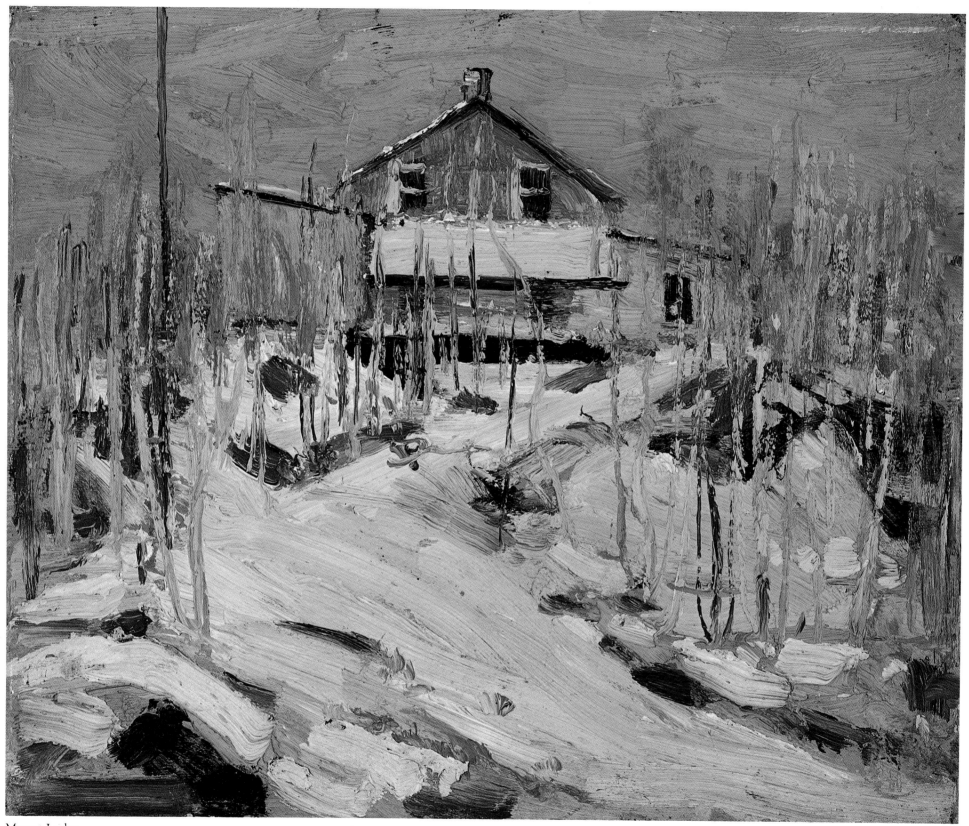

Mowat Lodge

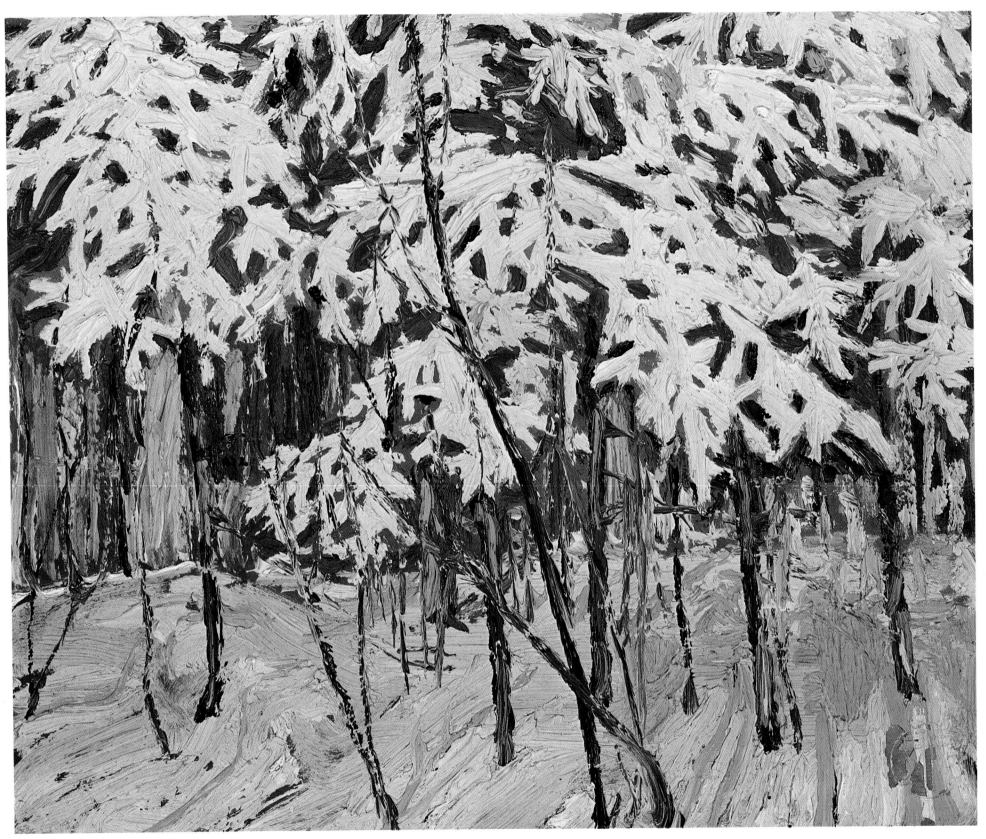

Snow-Covered Trees

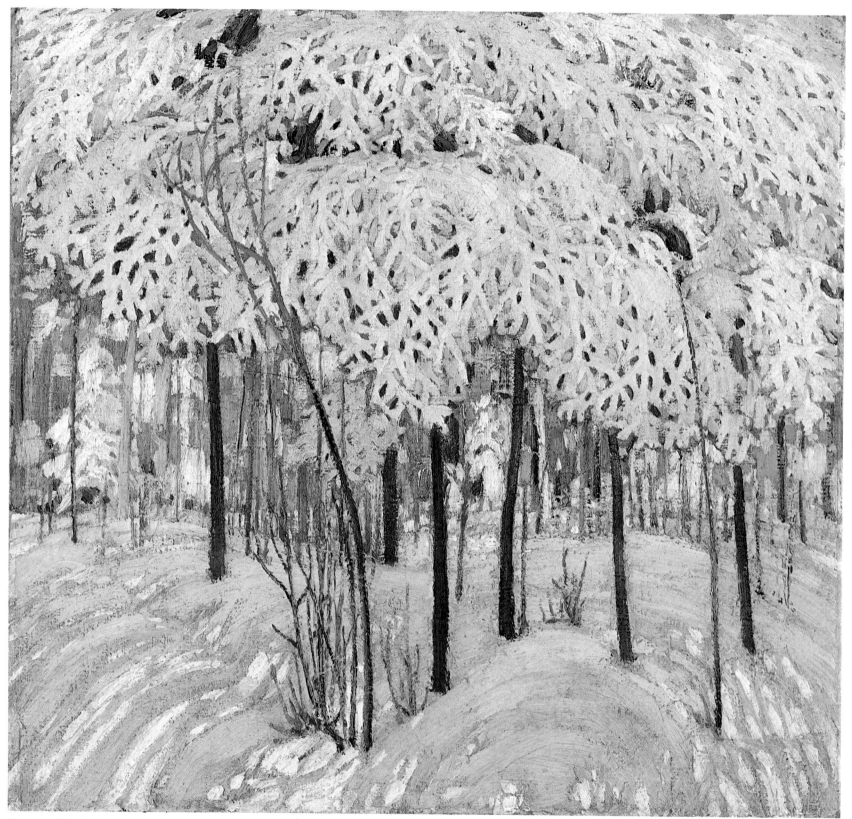

Snow in October

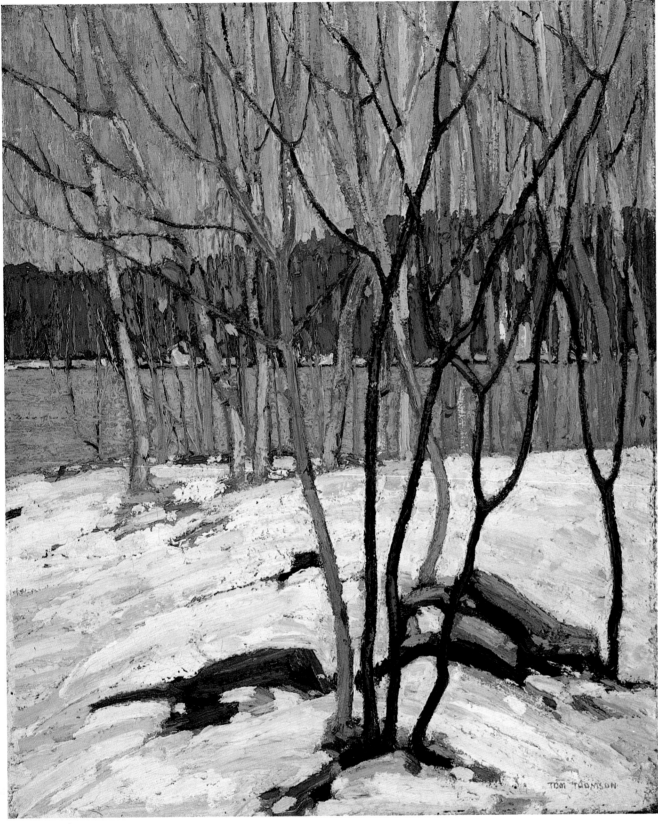

White Birch Grove

Spring in the bush is a young girl dancing with a clean old man. The music is sun and as the night wears on the motion stops frozen till noon. It is a time of beautiful effects, green shoots stabbing through the heart of winter, brown collars at the base of trees, ice against the shore frappéing in the warmth. Even weeds, dead since fall, snap back to attention as the white weight melts away. The weather is kind and the landscape artist with his studio pallor can't wait to face a pretty prospect in the sun.

Thomson resisted the Rites of Spring as readily as he did any forest blandishment. Not for him the straining buds and blossoms of Pissarro or the infinite detail of Gustav Klimt's bursting meadows. He took the unfinished aspect of spring – that place in time where you dream of summer and then go inside and put on another sweater – as his moment, which combined both fall and winter and was in fact a continuum, a three-pack of seasons.

Thomson's springs denied summer, the season in which he paid with other work the price of being a painter.

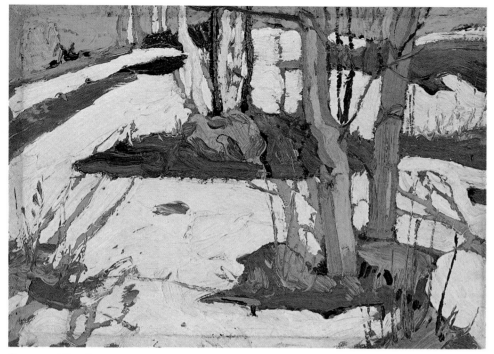

Snow and Earth

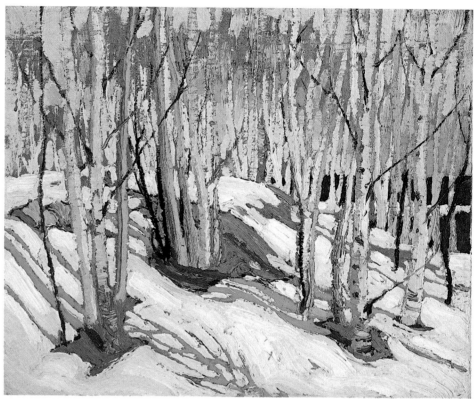

Early Spring

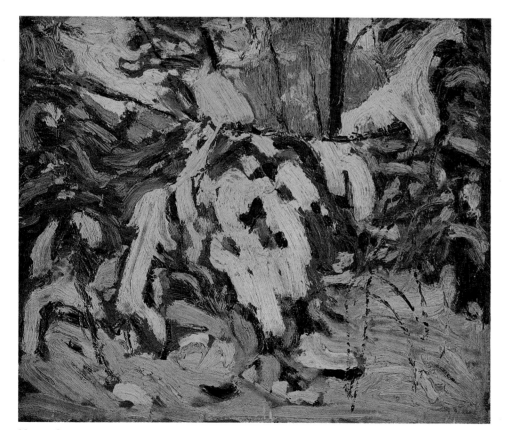

Heavy Snow

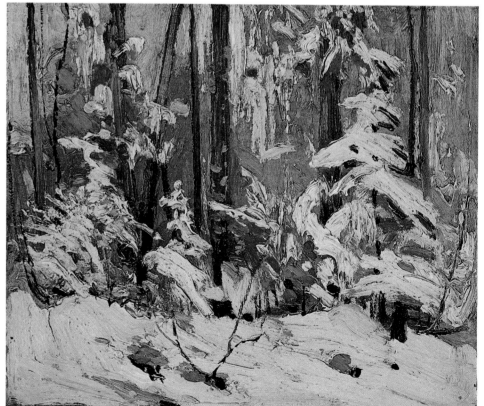

Wood Interior, Winter

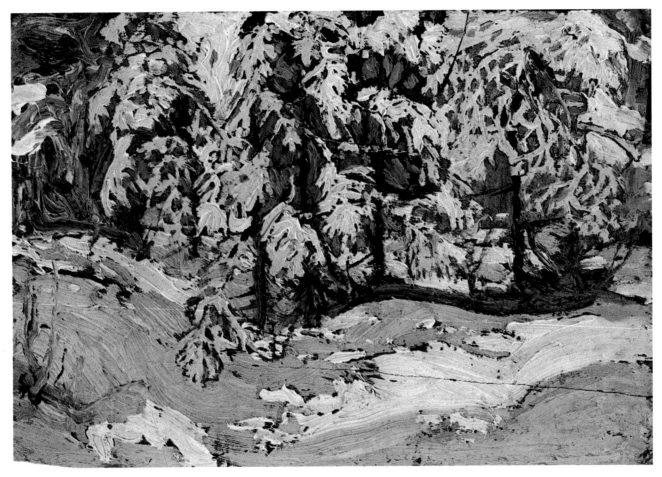

First Snow in Autumn

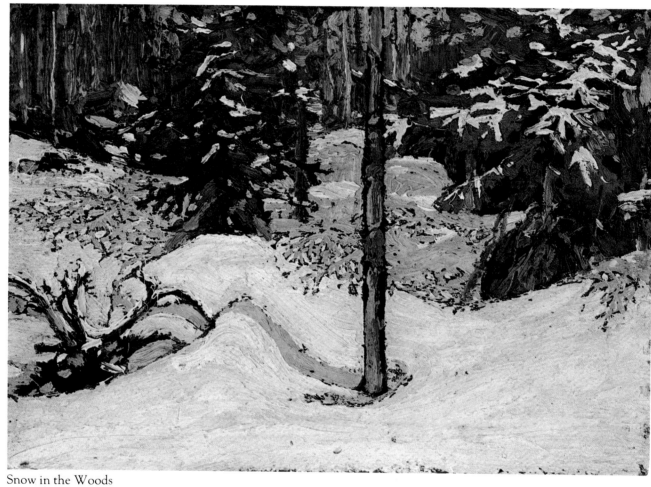

Snow in the Woods

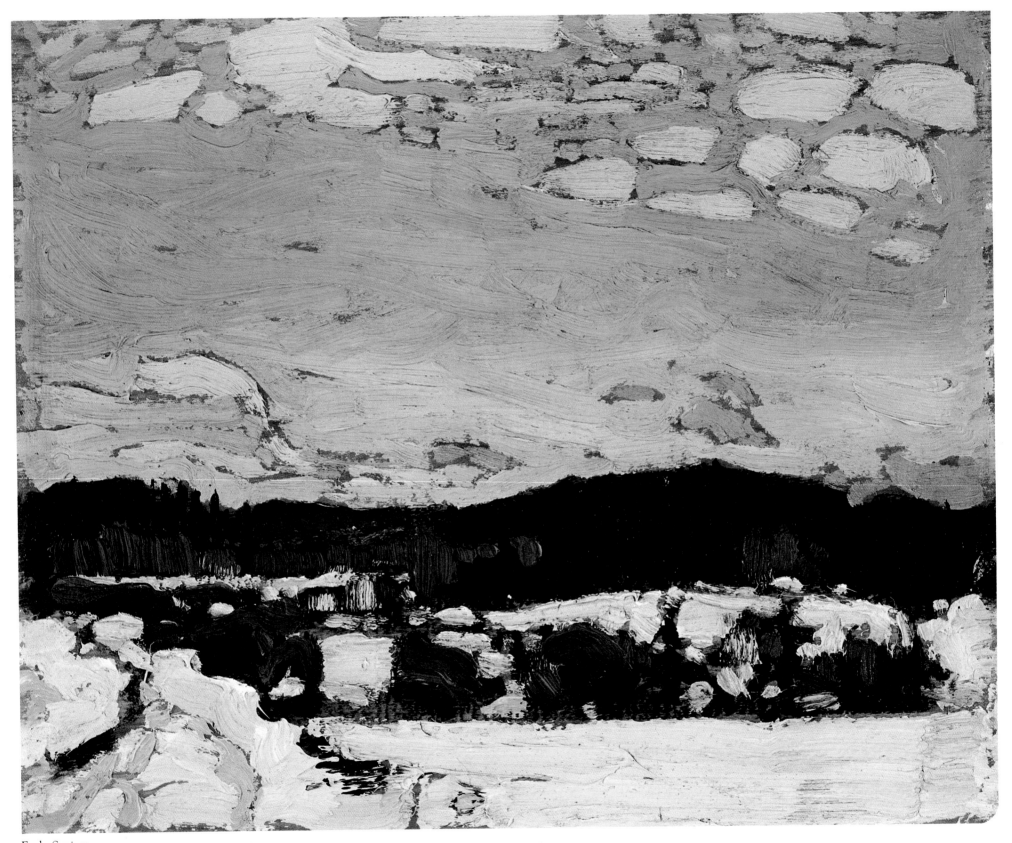

Early Spring

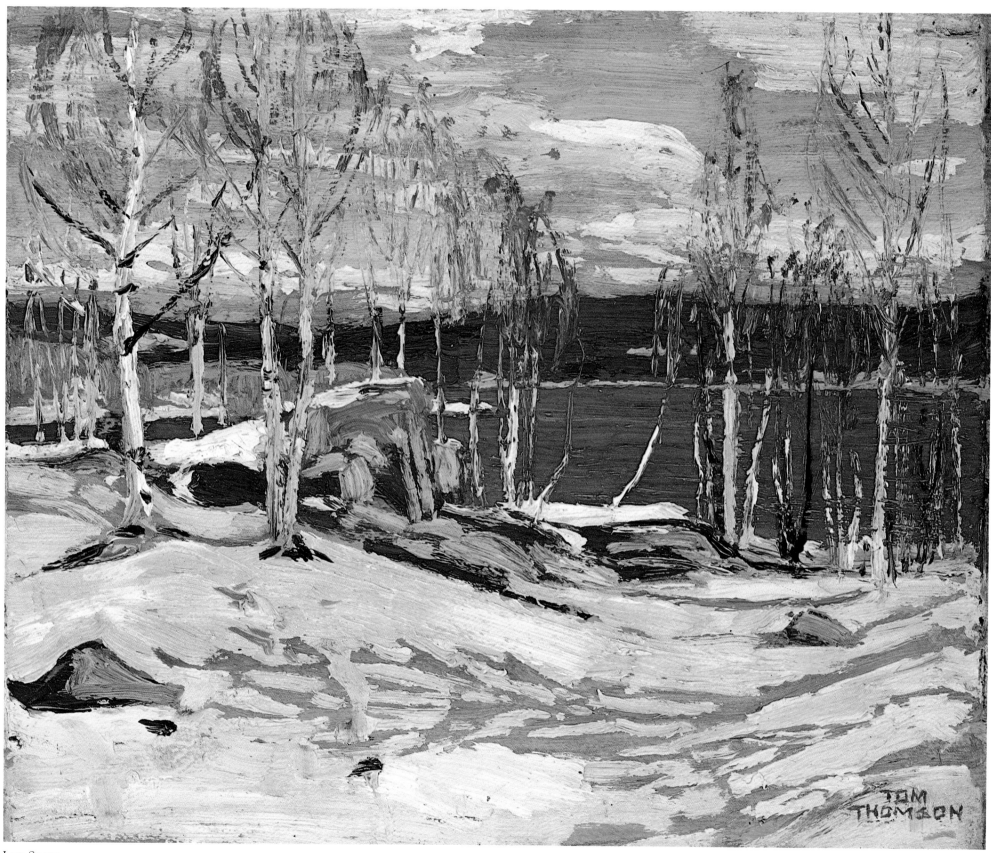

Late Snow

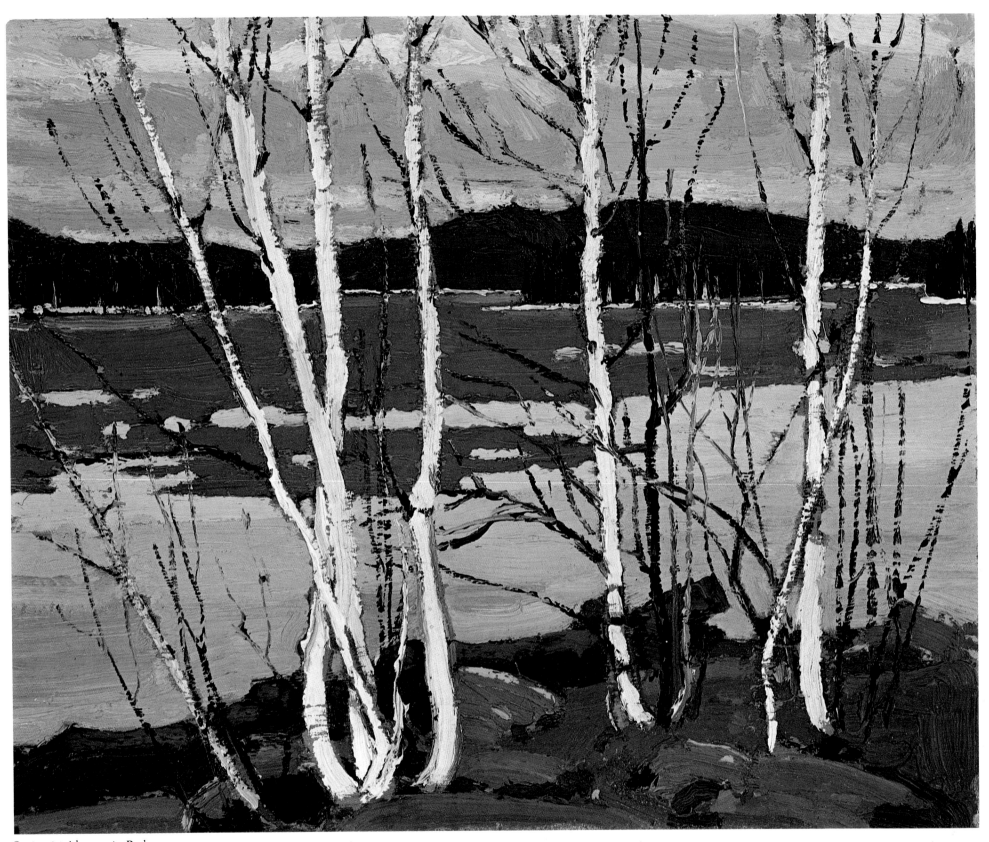

Spring in Algonquin Park

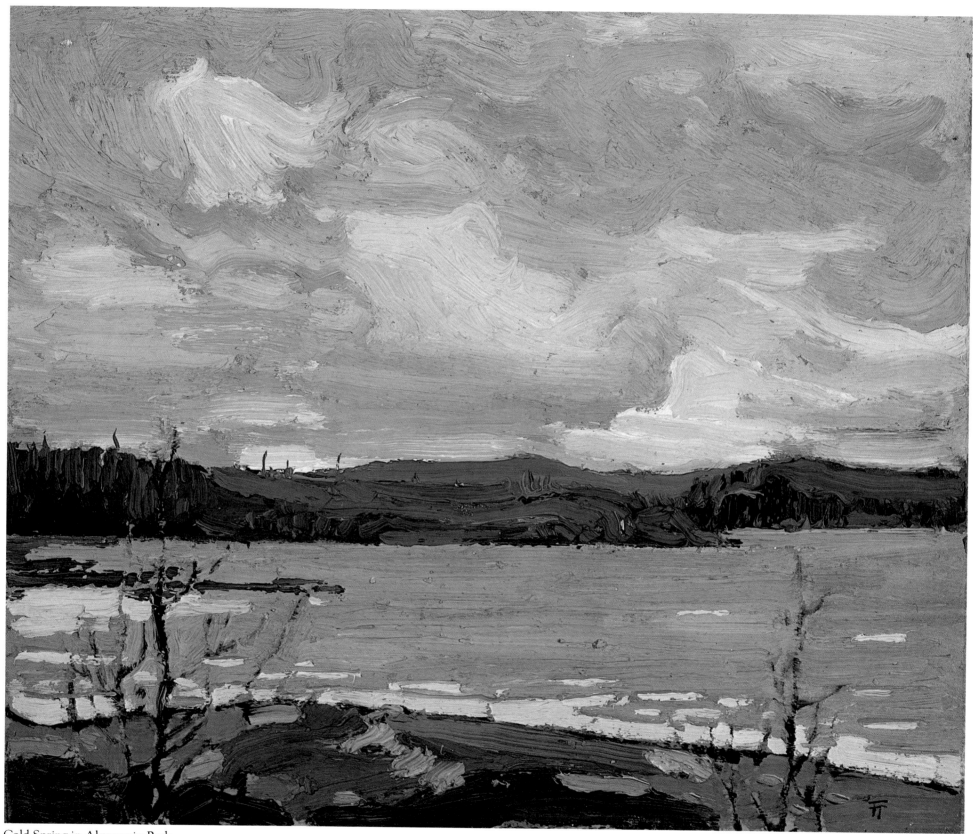

Cold Spring in Algonquin Park

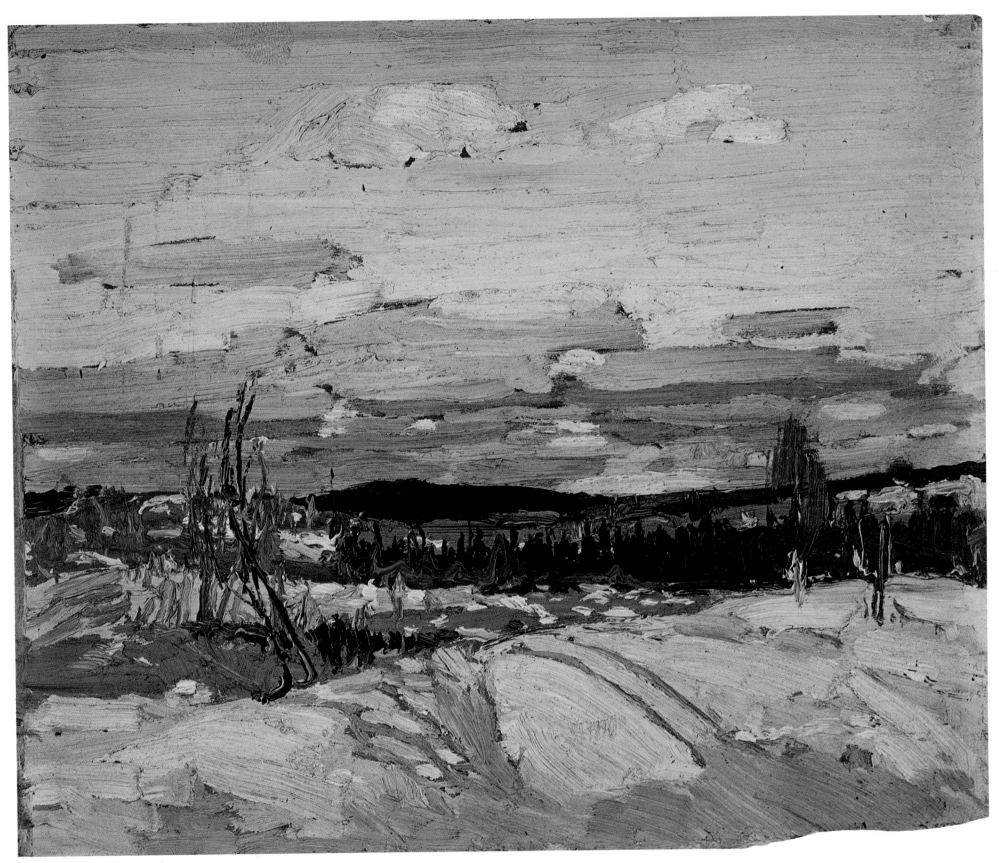

Afternoon, Algonquin Park

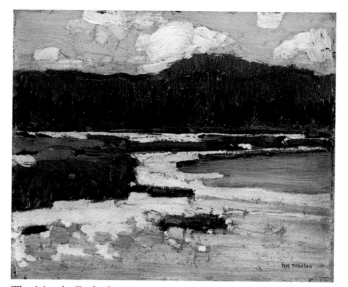

The Marsh, Early Spring

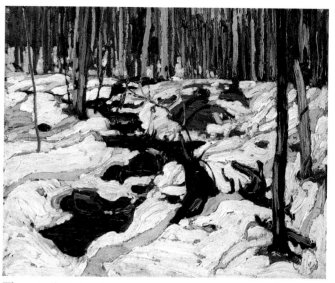

Thaw in the Woods

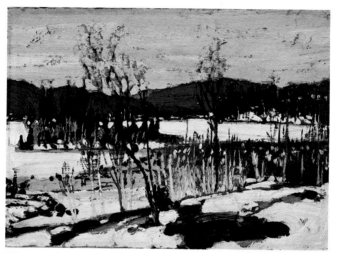

Winter Thaw

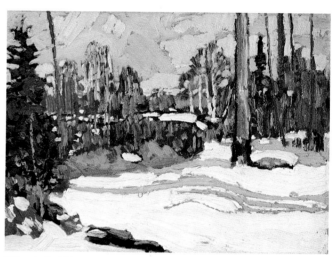

Woods in Winter

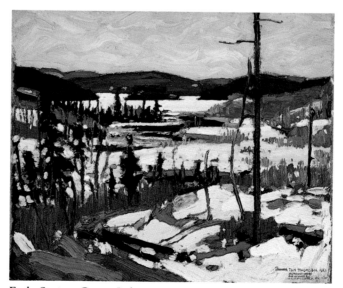

Early Spring, Canoe Lake

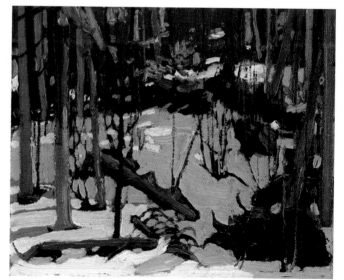

Winter in the Woods

191

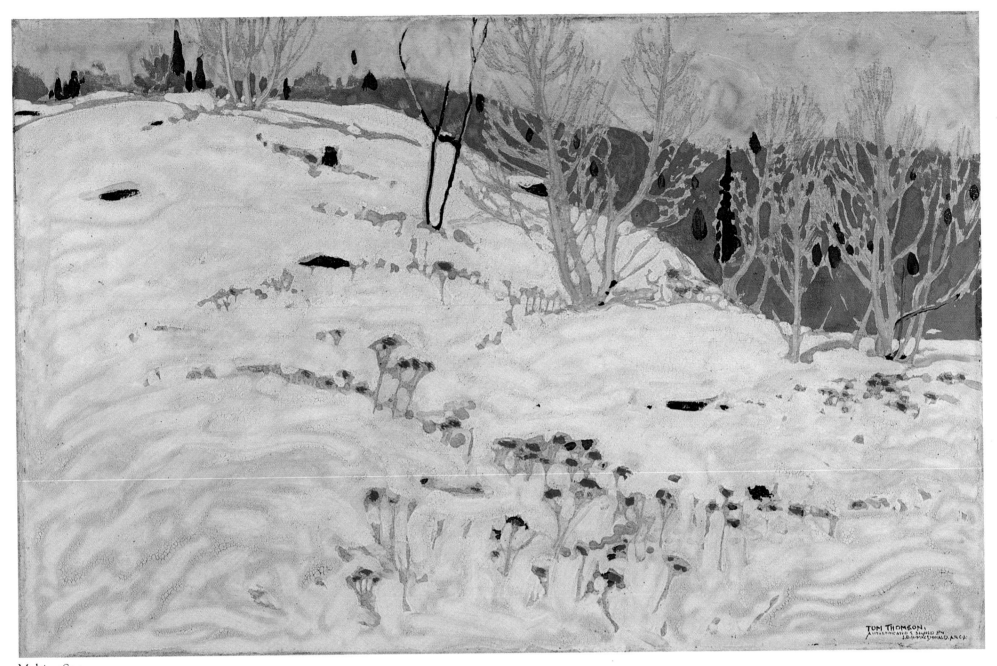

Melting Snow

The Tom Thomson Legend

From the moment of his death Thomson became a legend. Certainly he was not the first man to die, full of promise, even at nearly forty. Indeed, it is ironic that while tens of thousands of younger men died in agony on the plains of northern France, this single loss far behind the lines has never ceased to reverberate in the minds of Canadians. What prompted the legend? How has it grown and changed over the years? Which are the legitimate and truthful claims, and which are suspect? Behind all the exaggeration and fiction, is there a Tom Thomson whom we do not yet know? If we answer these questions honestly, nothing can be taken from the man that would diminish his real gifts and qualities, and these, with his paintings, his most important legacy, are more than ample to keep his memory bright.

Three related factors contributed initially to the avid interest in Thomson. The most obvious was the apparent mystery of his death, and the unwillingness of people to believe that a simple accident could have caused so dire a loss. The second was that he was immediately hailed as the one Canadian painter "who would have achieved an international reputation." There was an unshakable conviction on the part of his colleagues and friends that he was destined for great things. What other artists does one know who have had cairns erected in their honour? Lastly, he was seen, rightly or wrongly, as the prophet of the North. With *The West Wind* and *The Jack Pine*, Thomson gave Canada iconic images of herself, symbols of the "true North, strong and free." And when he died, his work only just begun, a definition of Canada that might have told us who we were died with him. Our coming of age as a country had to be rescheduled. Thomson became the symbol for all our missed opportunities, our hope for bravery, our striving for self-assurance, self-reliance and international achievement. No one stopped to ask if he too did not feel uncertain, inadequate, doubting and afraid.

The contemporary documentation upon which the certain facts of the Thomson legend are based is miniscule. Thomson's letters are scanty in number and length, and in any case are neither informative nor revealing. There are no diaries or journals. He was seldom mentioned by others. Most of his life, except for a few bald facts about his employment, addresses and movements, is hazy. His life was so unnoteworthy, until just before it was over, that no one kept track of it. The lack of earlier information was a vacuum that was tempting to fill, and his untimely death undoubtedly qualified or conditioned many of the reports that were written later. William Colgate, for example, as early as 1926, assumed that Thomson had always spent his summers in the North, yet we know that not to have been the case. The image of Thomson as the self-taught artist was groomed by statements made by MacCallum, who claimed that "Thomson did not discuss theories of art, methods of painting or choice of motives." MacCallum would be an unlikely person to discuss such things with, since he had an *idée fixe* about a painting being true to nature and lauded Thomson for just this point: "so it were true to nature, the technique might be anything." Jackson also made the point about Thomson not caring much for theories of art, but on technical matters Thomson was a conscientious learner and a courageous if somewhat mercurial experimenter.

It is a natural tendency to try to find in an artist's life the reasons for his success or his abilities to create. But recalled anecdotes cannot explain what only the work itself reveals. We are unlikely ever to know more about Thomson's life than we now do, and what his own thoughts or ambitions or intentions were will remain in obscurity unless they are perceived in his paintings.

Nearly all of the material that conveys first-hand knowledge of Thomson was written long after his death, some of it even in recent years. Blodwen Davies' efforts in 1930 to coax remembrances out of relatives and friends provided most of the anecdotes that are still being hawked about today. Even then there were anachronic slips, and these have grown more numerous as time has unravelled the narrative threads of the past. Much of the material was written with a good heart and a fond memory if with a somewhat unsteady pen, and one is thankful to have it rather than not. Yet, whether it is the style of the writing or the remembrance itself, many of the recollections have a false aroma about them, as if, in many cases, they had been innocently redrawn in the mind over the years, or as if there were parts missing. Some simply have no point at all, and divulge nothing about Thomson that anyone could or would want to know. Sadly, much that might have been said was omitted or suppressed.

Apart from the Thomson circle, who knew and revered him, nearly all the others who wrote about him knew little about either art or writing, and some of

Installation photograph of the Tom Thomson Memorial Exhibition at the Art Gallery of Toronto, 1920

them knew little about the North. My favourite example of the kind of writing I mean is not about Thomson but it can be mentally recast to apply to him. It is by J.W.L. Forster:

> Mr. [G.A.] Reid is steadily producing a glorious set of mural decorations which show the history of the world, and make it possible for people to see in a comparatively few minutes what would require hours of reading.

Nearly all of the writing about Thomson has been set with a single focus. He has been extracted from the context of his time, presented without the perspective of history, and his work has been considered outside the framework of art history in which it can find the true measure of its worth. This is not to dismiss such writing as without value, but to be clear that its purpose is largely eulogistic, and a contribution to social history and popular mythology rather than to biography and an explication or appreciation of Thomson's achievement as an artist. Nevertheless, if all the adjectives in it were eliminated, it would be half its size and not quite so purple.

It is something less than inspiring, for example, to read such passages as:

> When the spring fret came over Thomson, this was the land that offered him the solace and the inspiration of its splendid calm. Like the gulls, he arrived as soon as the ice began to break up. The pines that artists considered unpaintable were to him beautiful There is something courageous about these trees that have adapted themselves to the furious elemental heat and cold, winds and frosts of the North, and preserved their beauty and their usefulness. That fragrant, evergreen foliage, pyramided up to a delicate, aspiring tip, seems to symbolize man's deathless spiritual yearning to reach to that which is not yet attained, in spite of all the buffetings of experience and initiation.

Or this from *Country Life* in 1918:

> Tom Thomson, whose name is almost a fetish among the young school of Canadian artists, broke away into a new and freer manner to paint Canada's woods, lakes and rivers as he saw them. A cross in the northern woods marks the place where the waters he loved so well claimed him too soon.

Or, on the subject of his demise:

> The valley and the little hills were hushed the day it happened.

Or to learn that:

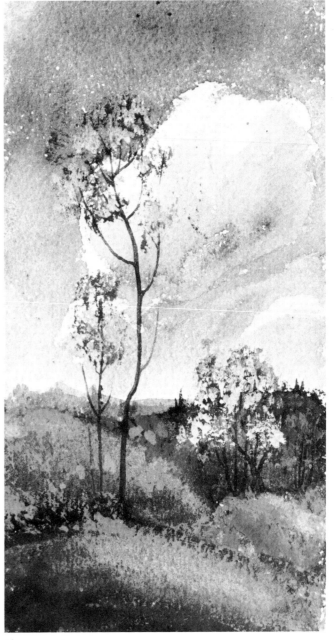

Flowering Trees

He breathed deep the musky scent of coon and fox and of the tang of pine and cedar. He knew the delicate, crisp taste of watercress that had been brushed by flirting trout.

The scholarly work on Thomson is, unfortunately, as sparse as the semi-fiction writing is endemic and verbose. The most information is contained in Joan Murray's catalogue for the 1971 Thomson exhibition and a good, but brief, account is given in Peter Mellen's book, *The Group of Seven*. Apart from these two, there has been little that has done adequate service to Thomson, and there still remains a need for a comprehensive *catalogue raisonnée*.

The most exaggerated and misunderstood aspect of the Thomson legend is his relation with what was called the Northland or the North. According to A.Y. Jackson, who, it will be remembered, only knew and saw Thomson for a year, Thomson had "a passion for the North" and was "the instigator of the movement to the North Country." Jackson subsequently revised the latter statement to give some credit to the others who had been there before Thomson, but his earlier pronouncement still echoes. Harris called Thomson the "informing spirit of the North," and there can be little doubt that Thomson liked the outdoor life and cared passionately, after 1912, about spending much of his time there. Once he had discovered that he could find personal fulfilment in painting there, he became a missionary. But one may surely ask if his reputation as a modern *coureur de bois*, braving the wilderness with all its dangers, has not been more than a little overblown. The trouble with misrepresentations is that if they are repeated often enough, as many of them about Thomson have been, people come to believe them.

First of all, Thomson was raised on a farm on the shore of Georgian Bay in Southern Ontario, but with ready access to woods and bush country. The "North," which has generally meant any of the areas of the Precambrian Shield, was not something he discovered, but something he grew up with. Further, the fringes of wilderness around the settled parts of Canada were well known to Jackson, Harris and MacDonald and to the generations that preceded them. The travels of Kane, Morris, Kreighoff and Verner had already set a pattern and a tradition. Jackson, with rather more veracity, also wrote that "when Thomson started camping and painting up north he did what a lot of other boys had been doing with pretty much the same results up to the end of 1913." J.W. Beatty, D.F. Thomson, Neil McKechnie, William Broadhead and others had already made their way to Algonquin Park to paint, and although Thomson's passion for that part of the country was genuine, he was not such an exception. Besides, there are some aspects of Algonquin Park, to which he first went in 1912, which are worthy of careful note if Thomson is to be sited in his proper place.

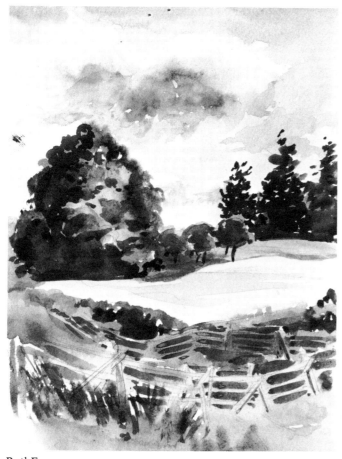

Rail Fence

Algonquin Park, a game sanctuary and recreation ground, lies less than a hundred and fifty miles northeast of Toronto and to the east of Leith where Thomson spent his boyhood. It was established, among other things, as an area of resorts for convalescents at a time when it was believed to have air that was especially restorative. The ranger Mark Robinson and Robert P. Little (both of whom knew and wrote about Thomson), and many others, moved to Algonquin for their health. Whether Thomson's "weak lungs" were part of his reason for going there is not mentioned, but it is possible. Mowat Lodge, at Canoe Lake, where he stayed and had his headquarters, advertised its "health-compelling climate."

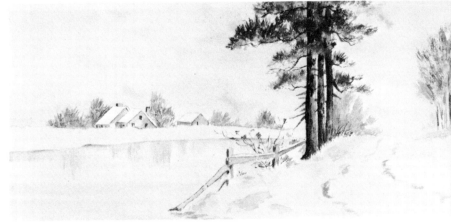

Untitled Landscape

The town of Mowat, just a decade before Thomson arrived, had a population of between six and seven hundred souls. This had dwindled with the bankruptcy of a lumber business. The logging operations had left a desolation of cut and burned-over areas, sawdust piles, dead-heads and driftwood for those who came after. But it was far from being an unsettled place, and was hardly virgin wilderness.

Other activities followed in the wake of the timber companies which continued operations near Huntsville and in the northern end of the park. In 1908 the University of Toronto established a forestry research station there, and by 1911 the place had a telephone. Communication had already been facilitated by over one hundred miles of roads, largely established by the lumber enterprises. There were regular air patrols by 1921. In 1921, also, the Taylor Statten Camp for boys was founded on Canoe Lake, followed three years later by a camp for girls.

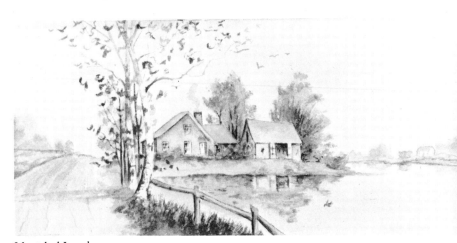

Untitled Landscape

The park was serviced by two railways by 1915, and these made it possible to provision and to carry customers to the four large and splendid vacation hotels that were built and operating there by 1914. Lismer, in writing about his trip there with Thomson that year, mentioned that they arrived early in the spring before all the toffs with their formal dress and city elegance had descended upon the place. Not long after Thomson died, the summer population of the park was estimated at over two thousand people. Thomson might have said of it, as he did of Georgian Bay near MacCallum's cottage, that it was "getting too much like North Rosedale [in Toronto] to suit me."

It is also true that large tracts of this area, even setting the timber business to one side, were distant and virgin. To a man in a canoe it presented some dangers and called for a degree of resourcefulness. Yet the fact is that Thomson was seldom far from civilization, except on the one trip he made in the summer of 1912 to Biscotasing, and the only trip he made into Northern Ontario (then New Ontario). His "North" was the vacationland for the urban south.

Thomson's life in Algonquin Park is overlaid with anecdotes which portray him as more of a creature of the bush than he really was. He was said, for example, to have met Grey Owl, though Grey Owl did not yet exist, and if Thomson did meet him it was as George Belaney the adventurer who, on a wager, was trying to traverse the park as a poacher and had been arrested and was being held in custody. Thomson has been held up as someone with unnatural powers and an affinity with nature that is not given to most men. MacCallum wrote:

> He was wont to paddle out into the centre of the lake on which he happened to be camping and spend the whole night there in order to get away from the flies and mosquitos. Motionless he studied the night skies and the changing outline of the shores while beaver and otter played around his canoe.

The last phrase is pure pastoral baloney, but it is the sort of thing that people want to believe. While Jackson spoke of a "wolf-ridden" country, and Lismer described the wolf as "the most cowardly, cunning brute known," Thomson was once reported to have met on a trail a large wolf which sniffed him respectfully up and down and then went on its way. This is a rare occurrence, but not extraordinary in the light of what is now known about wolf behaviour. But it helped to reinforce the empathy with wild creatures that Thomson was supposed to have had. In fact, Robinson tells that wolves would not even approach some supplies that he had left overnight on a frozen lake, though they circled round. Thoreau MacDonald wrote later that Thomson "brought his sketches out of the bush as naturally as a hunter brings out fish or partridges," as if one went and bagged a painting that happened to be there.

Thomson's oneness with nature has been a favourite theme in popular writing, and one person who knew him recalled:

> As I grew older I began to understand Tom's moods, they seemed to react according to the weather. When a storm was brewing he became restless and when the electric storm would be at its height, his eyes would glow— we kept very quiet—and I had the feeling that he and the storm were one or undivided. His every mood was so pronounced.

Lawren Harris once watched him sprint out and hunker behind a stump to paint while a storm broke violently toward them, and as Harris described it, he seemed "one with the storm's fury." The following poem by D. Reid has the same pantheistic innocence as its major theme:

His palette held some secret of the woods,
His brush was kindred to the feathering leaves,
He lightly stepped, and saw where autumn broods,
Where for her vanished beauty she must grieve.

He caught the stark sad splendour of the pine,
And e'er the wood gods claimed him for his fate,
He was vouchsafed, with colour and with line,
A skill to make the north articulate.

It strains credulity, but enhances the image of innocence, to read that Mark Robinson and Thomson "spent many happy hours on the trail and by the campfire, discussing the beauties of nature." It is probably the prevalence of such supernatural attributes that prepared the way for later reports of ghost canoeists on Canoe Lake and even a report of a comet flashing across the Algonquin Park night sky on an anniversary of Thomson's death.

Thomson's reputation as a canoeist also needs to be qualified. He is held up as an expert among experts, yet, according to Robinson, Thomson's own admission in 1913 was that he knew next to nothing about canoeing. While he could and did become quite expert in a short time, since he had the strength and agility, he was neither infallible nor unsinkable. His friend John McRuer wrote to him after receiving a report of his having upset and lost most of his supplies: "However, you might have been drowned you devil; and that was not the first time you were bumped, eh!" Jackson, who camped with Thomson for six weeks in 1914, reported that he paddled like an Indian, a description that added lustre to the reputation. Another claim was that he paddled with one hand and fished with the other, a feat possible only in the imagination. Others, such as Milne, were just as adept with a canoe, but it served the Thomson legend to insist upon his superiority. Few people wanted to believe that his death could have been due to his doing something foolish in a canoe. It went against the whole idea of romantic tragedy. Therefore, it was claimed that he was too fine a canoeist for that to occur. Yet all the praise for his canoeing skill came after his death and was undoubtedly gilded in the remembrance.

Thomson's reputation as an expert canoeist and expert woodsman has been one of the chief reasons for his popular reputation as an expert painter. The transference is an easy and a natural one to make, and it has the further advantage of avoiding the idea of the artist as an aesthete or as a namby-pamby urbanite without roots in the soil, or as a remote intellectual. Jackson, as usual, with verbal facility and an energetic if rather flat-footed way of missing the real point, had this odd assessment of MacDonald:

> As an interpreter of the north country [he] . . . approaches closely to Thomson, which is rather remarkable because he could not paddle a canoe, or swim or swing an axe, or find his way in the bush.

An ability to find one's way in the bush is perhaps the least qualification for painting imaginable. One might as well insist that Toulouse-Lautrec dance the can-can to be able to paint those who did.

For all the palaver about Thomson as the forerunner of today's conservationists, there is no evidence to support such a view, and there are few works which show this imagined side of his personality. Practically none deal with birds and animals, or about camping and canoeing. Contrary to the popular view of him, Thomson occasionally went hunting, and he pursued the lumber drives avidly. He painted many sketches which show the wreckage that much of Algonquin Park was when he arrived there: dam-flooded lakes, acres slashed by timber operations, rotting flumes, and burnt-over country. He dealt with these not as painful wounds in the naturalist's sensibility, but as straightforward facts. Jackson left no doubt about the matter:

> Thomson was much indebted to the lumber companies. They had built dams and log chutes, and had made clearings for camps. But for them the landscape would have been just bush, difficult to travel in and with nothing to paint.

The abstract treatment Thomson gave to most landscape tended to minimize the naturalist's concerns for sharp realism in particulars and, once again, to propel our attention back to the aesthetics and methods of painting.

Despite Thomson's spectacular success in his own time, legend soon confused him with the ceaseless complaint of the Group of Seven about hostility and opposition to their work. Writers other than members of the Group have made this a canon of belief, and not so long ago J. Russell Harper, a reliable scholar, wrote about "reams of bitter denunciation and invective," an "incredible flood of adverse publicity" and "massive criticism." Yet nowhere are these to be found. In all the reviews of the period there are only a few isolated attacks against the "modern" approaches of the Thomson circle. The vast majority of reaction to Thomson's work and that of his colleagues was laudatory. In writing of the Royal Academy Exhibition of 1914, Hector Charlesworth found Thomson full of "real promise" and doubted if "a better collection of Canadian pictures had ever been gathered together." The truth is that the new work was not as avant-garde as it later was remembered as being, and even the fact that it won such ready acceptance should have made the artists a little leery of the direction they were going, unless

201

their purpose was more social than artistic. The myth of fighting against heavy opposition was, in part, a camouflage to conceal their lack of significant originality and of contemporariness.

A corollary of the supposed critical rejection was that poverty and adversity accompanied it. The shack that Thomson moved into in 1915 has made it seem as if he lived on the brink of starvation, a sort of non-citizen who eked out his subsistence in the city through the charity of a few friends, and who ate berries and fish in the bush. Jackson, who shared a studio with him for little more than six weeks in 1914, flattered this view of him by recounting that "there was a time when Tom and I used to have trouble finding 15 cents to visit a movie on Saturday nights." This sentiment was later revised to read "a movie on Saturday night was all we could afford in the way of recreation," but the main thrust of the complaint is intact.

Thomson had made a good living as a commercial artist and he was unwilling to relinquish it. Jackson wrote that he "was dubious about his ability to make a living out of his painting, doubtful also of his own talents." Thomson did not cast himself upon the mercy of the art market: what finally persuaded him to devote his whole time to painting was MacCallum's offer to meet his expenses for a year, probably a modest offer, but at least a guarantee. He was no doubt also spurred on by the sale of a painting that year to the Ontario government. One of the observations made by several of Thomson's friends is that he was indifferent to money, so long as he had enough for his immediate purposes. He spent it easily, and seemed not to care or take any concern in the matter of selling his work. He once wrote to MacCallum, who was about to sell a sketch for him, "if I could get 10 or $15 for it I would be greatly pleased but if they don't care to put in so much let it go for what they will give." Indeed, he gave his paintings away with such unbecoming generosity that one wonders if he needed attention and acceptance so desperately. He never seemed to know whether or how much money he had in the bank, but none of his own writings contain so much as a whimper about lack of money.

The suppositions about Thomson's impecunious state do not square entirely with other facts about him. The canvas he had sold in 1913 had earned him $250, hardly a king's ransom, but a sum on which a university student might then survive for a year. Two years later, when he was sharing a studio with Thomson, Franklin Carmichael wrote of eating handsomely for $2.50 a week. With rent for the shack at one dollar a month, Thomson could have had food and board for as little as $150 a year. Before he died his work had reached selling prices of up to $500. This did not compare with the princely Horatio Walker who received his honorary doctorate from the University of Toronto in 1915 and $15,000 for his *De Profundis* in the following year; but Walker was something of a rage in New York at the time.

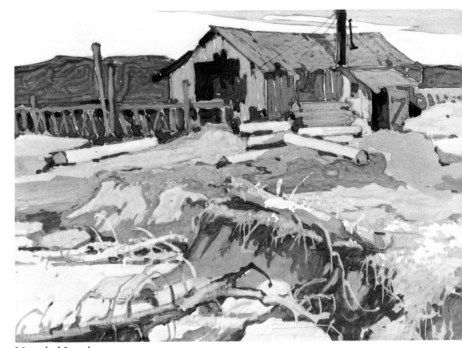

Untitled Landscape

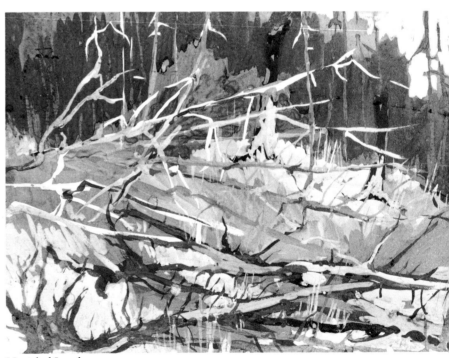

Untitled Landscape

What Thomson earned allowed him to give concert tickets to his niece from time to time, to attend concerts himself, to go to movies and boxing matches and baseball games. He sported gaudy silk shirts and to give maximum comfort to his camping he purchased a silk tent, the best available. He used good paints, and once used a tube of expensive pigment to give a distinctive shade to one of his canoes which were also of good quality. When he died there was correspondence to clarify and to confirm repayment of a $200 loan he had made to Shannon Fraser, the owner of Mowat Lodge. Thomson might have liked to have had more money, as who does not, but he spent what he made easily and he did not seriously want for anything. His life as a painter was not one of hardship. Considering the enormous contribution he made to the country, of course, he did not receive close to what he deserved. Milne later said of the Group of Seven, and he would have included Thomson, that Canada might have given them each a million dollars and still be in their debt.

For his art, it was claimed, Thomson "sacrificed everything, money, society of friends, comfort and other things which others could not live without." It is doubtful if he sacrificed very much at all. The revelation that he was planning to marry in the fall of 1917 meant that he felt reasonably secure, for one seldom married in those days without a promise of security. Some members of his family, succumbing to the repetitious complaint of the Group of Seven, and perhaps comparing later picture prices with those of 1913-17, later recalled Thomson's poverty and lack of recognition. Yet when the possibility of suicide was raised after Thomson's death, his brother-in-law countered by citing that the "outstanding recognition he had met with" would have made Thomson optimistic.

Thomson's personal image has also been overlaid with attributes that have been paid, in general terms, to the Group of Seven. As far as these have gone they have not distorted or misled. He shared their love of the country, their goals in art, and their high-spiritedness. He tried, with them, to extract Canadian art "from the sloughs of old world influence." Yet one is often left with the impression that this band of painters padded off into the woods like a troop of wide-eyed boy scouts, foregoing drinking, swearing, womanizing and other activities of a dubious moral character. The idea that they were human enough to be vaguely bohemian, to drink occasionally to excess, to blaspheme or to chase after the opposite sex is not discussed in all the literature about them. There must have been a good deal more mischief than we know about, and the angelic uprightness that they are normally described as having seems uncomfortably incomplete.

The Thomson image is particularly sainted. He was portrayed as someone not only affable, generous and humorous, but he also paddled like an Indian, was a born naturalist and painter, and walked with mysterious innocence in the midst

of danger: a romantic paragon. Yet information about his drinking was gently suppressed from early accounts, and those who have written about him have been reticent to admit that from time to time he drank too much. There is the euphemism that Thomson accepted "the occasional social glass," but one must interpret the conventions of the day. Varley accepted the occasional social glass too, and he had a severe alcoholic problem.

Thomson's relations with women is another difficult subject to deal with, since documentation again is very scarce. By all accounts he was a handsome, strutting, even dashing man, for all his shyness, and women were smitten by him almost instantly. He loved dancing and singing, and when he was feeling festive, he could carouse for hours and hours. The "young women whose shadows flit across his path" remain largely unknown, but there is no doubt that Thomson had several girlfriends. Who they were or what Thomson thought of them is unrecorded.

Very little satisfactory light has been shed upon the relationship with Winnifred Trainor, whose family had a cottage on Canoe Lake and who, it is speculated, was his secret fiancée at the time of his death. Later speculation about Thomson's death raised the possibility of acute rivalry between Thomson and someone else for the hand of Miss Trainor, but this seems far-fetched. Charles Plewman, who knew Winnie, as she was called, wrote many years after the fact that "the relationship that existed between Tom and Winnie Trainor was more intimate than most people at the time supposed." He then went on to say, possibly to support a suggestion of suicide, that "she was pressing him to go through with the marriage," that a "showdown" was in the offing and that Tom "could not face the music." That, too, seems to be vacuous speculation, though there is some evidence that, unbeknown to any of his friends, Thomson had reserved a cabin for a honeymoon that was planned for the autumn of 1917.

We do know that one of the older women to take a keen interest in Thomson's work was the painter, Frances McGillvray. She not only visited his studio in Toronto, but also went to see him at Canoe Lake in the spring of 1917. Although she was about fifty at the time, her vivacity and her interests may have brought the two of them together. Thomson was reported as having said that of all those who knew his work, only she grasped immediately what it was that he was trying to achieve. Whether she was a mistress or simply a good companion, she liked Thomson's work and gave him courage and confidence to press on with it.

In about 1930 Blodwen Davies, a writer, blew the smoky uneasiness over Thomson's death into flames of alarm. She wanted to know how an expert swimmer and canoeist could have drowned, as the official verdict of the inquest suggested, and if drowned, how a dead body could bleed. In hysterical italics she asked:

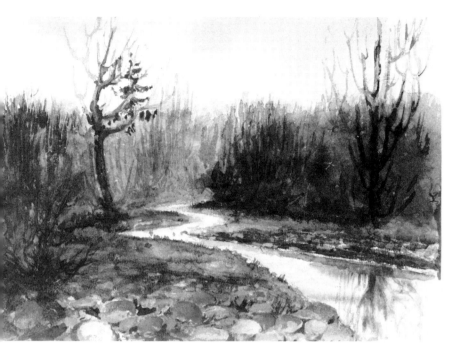

Stream in the Marsh

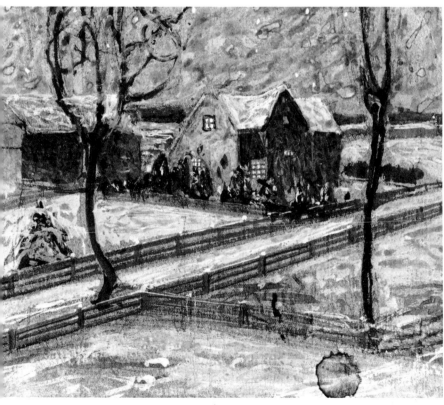

The Farm at Night

Who met Tom Thomson on that stretch of grey lake, screened from all eyes, that July noon?

Who was it struck him a blow across the right temple – and was it done with the edge of a paddle blade – that sent the blood spurting from his ears?

Who watched him crumple and topple over the side of the canoe and sink slowly out of sight without a struggle?…

Did Thomson's body take eight days to rise in a shallow lake in the middle of July?

Had he been murdered? Was it over Winnie Trainor? Or was it a dispute between Thomson and a Martin Bletcher who was said to be a German sympathizer? When Mr. F.W. Churchill came to exhume the body, did he really do his job, or did he save himself some work by filling the coffin with earth and leave Thomson at rest beside Canoe Lake? With these questions hanging tantalizingly in the air, Thomson's fame was practically assured. The Taylor Statten Camp had a memorial exhibition and set a canoe full of flowers adrift below the cairn. The press made good copy out of all this.

The legend from that time forward was out of the hands of those who had earlier promoted Thomson's talents and achievements. J.E.H. MacDonald firmly disassociated himself from any further sensationalizing. This is his entire letter to Blodwen Davies on May 21, 1931:

> I regret any disturbance of an ideal I may have caused but I feel sure that it is best for me to associate myself with the silence of an old friend. When I have an opportunity, I will make a search for the sketches you mentioned, and will turn them over to Lismer to be used as he thinks fit.

About the death itself there is no new evidence, but a few factors could be re-emphasized. Suicide is the most unlikely possibility, since drowning was the only method available, and dead people do not bleed. Besides, Thomson's frame of mind, his melancholy days notwithstanding, was very positive. Murder is also unlikely, since there was no attempt to hide or to destroy the canoe or the body. Thomson was capable of defending himself except against a bullet, and no one suggested that until nearly forty years later. Dr. Howland, who did the medical examination and was at the inquest, would have recognized a bullet wound in spite of the decayed state of the corpse.

I have never understood or read any plausible explanation why George Thomson visited Canoe Lake immediately after Thomson's disappearance, and

then not only left while everyone else continued the search for his brother but took most of Thomson's sketches away with him. If he presumed him dead, why did he not take all of Thomson's belongings? And if he thought that he might still be alive, why would he not have helped with the search, and why did he take away work that Thomson might have wanted? His behaviour was odd, to say the least.

J.E.H. MacDonald designed the plaque which adorns the cairn (though he got the place of birth wrong) and he and J.W. Beatty were chiefly responsible for erecting it. Beatty devotedly carried what MacDonald estimated must have been six tons of rocks up the knoll. This was later reported confidently as nine tons. MacDonald also designed a metal monogram stamp to imprint Thomson's work with, and in November 1917, he and his son Thoreau branded each sketch front and back. It was a convention then to mark work in artists' estates, but the way that paint has been chipped off in so many cases makes one wonder at this method of identification. In one or two other cases MacDonald has authenticated and signed Thomson's work posthumously for him. His charge for designing the cairn and the stamp and for setting the imprimatur on the sketches was $52, paid by MacCallum.

The sketches, some three hundred of them, "were stacked in a tall set of shelves marked Snow, Sunset, Summer, Fall and so on." The largest collection of them today, at the National Gallery of Canada, still sits in tall filing cabinets, classified by acquisition number. These, and the unsold canvases, were the assets of Thomson's estate, and they were gradually sold, with the family as beneficiaries.

MacCallum continued his care for Thomson's work and was the chief agent in selling it, with advice and help from Jackson and Harris. He still purchased for himself, but he was unstintingly aggressive and shrewd in disposing of the paintings. He added 20 per cent to the price "set by the artists" to come closer to his own convictions, and he tenaciously drove up the prices over the few years after Thomson's death. The National Gallery paid $750 for *The Jack Pine* (page 124) in 1918, even while squirming under the severe restraint of wartime budgets. In 1926 MacCallum wrote that "we ought to take advantage of the situation and see if we cannot get more for the picture [*The West Wind* (page 175)] out of either Toronto or Ottawa." He set a low figure of $1,500, subject to no discount, but added: "I am in hopes that we may get 2000.00 for the West Wind," a picture that Jackson had estimated to be worth $700 to $800 four years earlier. It was finally sold for $1,500 to Dr. H.M. Tovell for the Canadian Club which presented it to the Art Gallery of Toronto that year.

In the same year, MacCallum managed to sell *The Drive* (page 83) for $250 to the University of Guelph:

It was an unfinished picture – Tom had just laid it in and not really started to paint it when he went North in the spring. As it was in an

unfinished state we thought it a stroke of luck to be able to sell it at all. I do not think anyone else would have bought it.

It remains today in an unfinished state, particularly the lower and left halves. The stark white tree on the left is uncomfortably awkward and would surely have been changed, but the suggestions that someone later added to it are not borne out by a close examination.

In 1922, Jackson estimated that there were still about 145 sketches in the Studio Building. He thought that there were about "twenty-five worth $50 each, fifty worth $40 each and seventy for which $20.00 would be a good price." Much later he claimed, rather pejoratively, that Thomson's sketches "went begging for $25," which is slightly at odds with his earlier advice that they be stored for two or three years and not let out too quickly. At the same time Harris persuaded the Laidlaw brothers to buy some, and he wrote to MacCallum: "Enclosed cheque for one thousand bones. R.A. Laidlaw and Walter Laidlaw purchased together twenty of Tom's sketches at fifty iron men each."

The prices of Thomson's work more than doubled in the five years after he died and have continued to double every few years since. This has been partly due to scarcity, partly to the Thomson legend, and partly to the quality. One canvas that Jackson thought downright bad and MacCallum despaired of ever selling has so far fetched the highest price ($285,000), an indication that quality has, in some respects, been the least of the considerations governing the sales of Thomson's work. One shudders to think what astronomical sum *The West Wind*, turned down by the Art Gallery of Toronto in the twenties at $1500, would realize at auction today. There have also been a number of forgeries because of the attractive prices. The most amusing of these was declared a forgery by several self-appointed experts, on the grounds that the signature spelled Thomson "Thompson." An astute dealer who had originally handled the sketch from the estate quietly bought it up and had the false signature removed from an authentic work.

In 1956 the legend benefited from another gruesome twist. Four men, in what many would consider a morbid if not illegal inspiration, dug up Thomson's Canoe Lake grave site to see if he was, perchance, there. They discovered a skeleton with a small broken hole in the temple which suggested a bullet hole, though no bullet was found. A forensic study determined that the skeleton belonged to a much shorter man than Thomson and one of Mongolian extraction. No one knew how that person managed to get buried in Thomson's grave. The forensic report incredibly suggested that in the course of seeking identification, not a terribly scientific way of going about it, "the jaw bones were shown to members of the family, but they were unable to help." The McKeen sisters of Owen Sound later recalled that

the casket had been opened before Thomson's funeral, and that Thomson's father had "experienced relief that he no longer had doubts as to the whereabouts of his son." There can have been little or no doubt or suspicion in 1917.

All the notoriety that has arisen since 1956 has created a different kind of folk hero to the one that had been created in the years immediately following 1917. The cairn, the postcards of the paintings, the historical plaque, the memorial museum and all the paraphernalia of popularity have made Thomson a hero with only vague associations with his work as an artist. Souvenir hunters have picked the lead lettering out of his gravestone. There have been feverish and extended searches for his canoe, which disappeared years later.

People live easily with contradictions of facts and with impressions they no longer want to change. Accounts of the shack, which was rebuilt in Kleinburg as part of the McMichael Canadian Collection, have varied. One popular writer, Paul Duval, has on three occasions given three different variations of what it was before Thomson occupied it: that it was a cabinet-maker's premises, a construction shack for the raising of the Studio Building (it was both), and that Thomson "with his own hands hammered together the semblance of a building." And this earlier description of John Thomson, the artist's father, is in the same vein:

> And his venerable but vigorous father, the hale and hearty ploughman, hunter and fisher, with a leonine head that literally cried for a canvas, looked like the true father of the true artist.

The impression people have of Thomson's poverty and lack of recognition was further etched by such recollections as that of Helen Bannerman, who remembered as a child the thrill of being given the key to the Thomson garage to look at Thomson's paintings. The point of her story was that there was no more room in the house and that Thomson's work lingered in obscurity.

Thomson and his work, however, hardly needed the benefits of all the contrived views of his life and work to make their way. Before long he was recognized as "a romantic hero," and foreign critics referred with enthusiasm to "the School of Thomson." Graham McInnes, writing in 1938 about the Canadian exhibition at the Tate Gallery in London, England, referred to Thomson as the master, and expressed the opinion that Canadian art "has yet to produce a movement as strong, solid and generally honest as that of Thomson and his followers." Whether Thomson was the most accomplished painter of his circle is, in the circumstances, an unfair question, but he was certainly the spiritual leader. McInnes felt that "MacDonald was the better painter and Thomson the greater artist," a judicious summary which would be difficult to refute. Whether one is discussing the aesthetic, commercial or iconic qualities of Thomson's paintings,

there is little doubt that he stands in a favoured and superior place among his fellow artists.

All these things having been said, however, it is imperative to acknowledge the symbolic importance of Thomson as a woodsman, guide, pathfinder and solitary explorer. As a bush traveller he aligned himself with the earliest explorers of the country and assumed the reputation they had as self-reliant conquerors. He embodied the romance rather than the gritty reality of the pioneers. But the parallel between Thomson the woodsman and Thomson the painter meant that he was also the pathfinder of the Canadian imagination. His paintings were a definition of the country both literally and figuratively. As icons of our environment it matters little that they are made up of borrowed conventions or conservative ideas. They pulse with both real and imagined authenticity. D.P.S.

Thomson's Sketchbook

Drawing is the armature of painting, the bone and fibre that holds colour within those sequential isolations of touch that are formed to unity by the mixing eye. Line, naked and alone on the stage of the paper, is like an unaccompanied violin – every clinker and fumbled note is instantly perceived.

Morandi's remark, "I believe that nothing can be more abstract, more unreal, than what we actually see," is true of great drawing, which is a line from the heart to the uncharted regions of abstract feeling – for line is an infinitesimal edge of form capable of describing an entire subject with only a thousandth part of its total. We all draw. It is as easy as humming, a natural part of everyday life, from the doodles on a scratch pad to a WET PAINT sign; but to master the skill of intimating continuation in those purposely omitted spaces between line that make the viewer see and feel weight and apprehend form, even colour, is as difficult as singing under water. Drawing has few masters, for it requires a consistency of verve and a calculated daring to sustain force. Whistler in his "Ten O'clock Lecture" said, "the work of a master ... suggests no effort and is finished from the beginning." To this quality, which is the benchmark of great draughtsmen, Picasso added another factor: a special tension, a matador courage that would risk any drawing, no matter how accomplished, on the chance that his hand could surprise his heart.

The temptation to sit back in the armchair of safe, even brilliant, accomplishment is within every artist; the guts to risk failure again and again is the thermostat for the heat of genius.

Thomson's sketchbook is a touching testament to the man, a revealing record of the struggle of a natural colourist to master line. St. Thomas Church, St. Catharines, has that frightened, blurred look of the drawings I made in the Gaspé Peninsula as a fourteen-year-old art student and reminds one of Corot's remark about the drawings in his sketchbook. "If they rub together a bit in travelling, I no longer recognize them. Nothing should be left to chance."

Thomson's calligraphy is impatient; it is thrown on the paper. The face of *Boy's Head*, for example, is well defined but the drawing in the hair and body is nothing more than desperate filling in, a sort of thrashing about in weeds for a snake. *Sleeping Figure*, though made lively by forceful lateral pencil strokes, lacks even a slight semblance of consequential form. However, *Old Man Reading in a Rocking Chair*, comprised of awkward, open, disconnected lines, has a surprising power, reminiscent of early drawings of Van Gogh. And the elegant bearded figure with pince-nez,

Church in St. Thomas

Gordon Harkness, the artist's nephew

Figure in a Rocker

Reclining Figure

made with delicate downy strokes, displays Thomson's multi-directional potential.

Sleeping Dog is the most accomplished of these drawings. The flashing line stays within form even in the waving detail of the edge of fur, and the sense of stretch, comfort and the capability of sudden movement is gracefully expressed.

Though Thomson was the least talented draughtsman of his peers, it was in this limitation that his strength was born. He came to the brush as a spatula for paint, not as a pencil for thick drawing, realizing the North in slabs of form; lines were too paltry for his sensibility, the naked board between paint was all the drawing that he needed.

At his death he had the disciplines of printmaking, watercolour and drawing still before him. He had mastered painting, and the few mainly pedestrian drawings and watercolours that he left make the power of the *Nocturnes* and *Brown Bushes, Late Autumn* all the more miraculous. H. T.

Sleeping Dog

Man with a Pince-nez

Study of a Young Boy

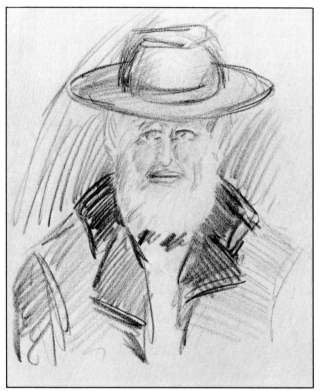

Man in Black Hat

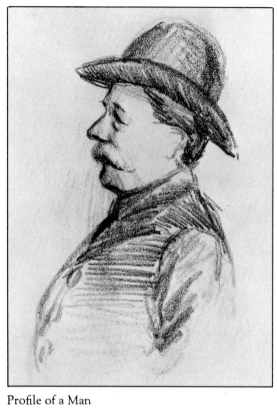

Profile of a Man

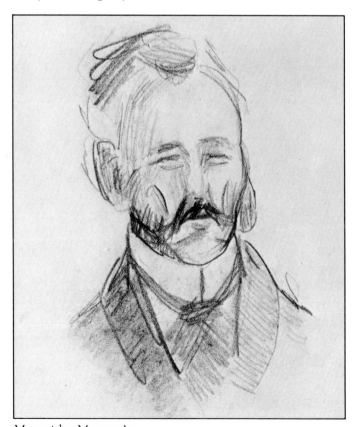

Man with a Moustache

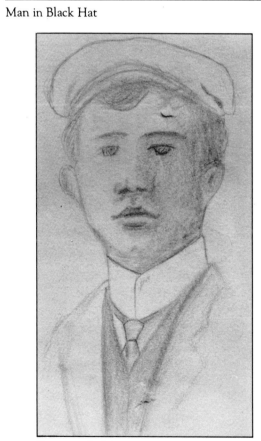

Portrait of a Man

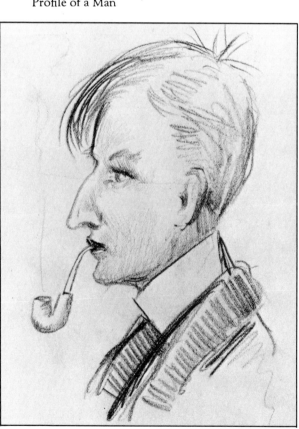

Self-portrait

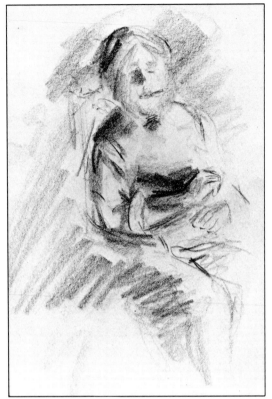

Sketch of a Woman

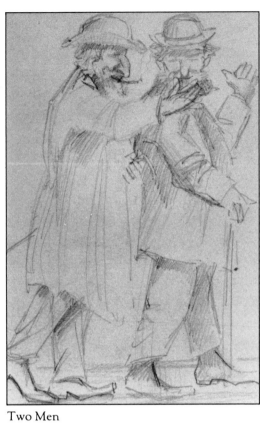

Two Men

Two Ladies

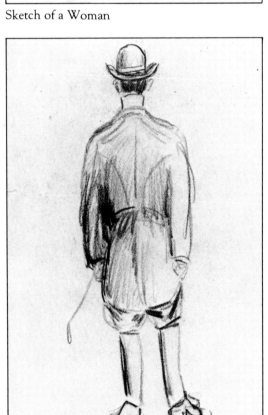

Man in a Riding Costume

Woman Sweeping

Seated Half-figure

Sailboats

Sailboat

Landscape

Thomson's Photographs

Photography, though much older than those cracked earth faces dug up in the hinterlands of Rumania by makers of yogurt commercials, remains in the public mind an infant art – or at best adolescent.

As the first machine art, photography offers a staggering variety of new equipment – mechanical stuff that promises the easy fulfilment of simple requirements or the production of inspired concepts, yet delivers nothing superior to the work of pioneers such as the Frenchman Nadar (G. F. Tournachon), the Englishman Roger Fenton or the American Matthew Brady. Photography was pulled from the backs of cameras fully developed. Unlike painting, which had to waste centuries just inventing perspective, the mystery of photography was instantly perceived. Miracles could be made in a second; it was the first people's art of the Industrial Revolution. Though a permanent image was produced by Joseph Nicéphore Niepce between 1816 and 1822, the first practical photographic process was invented by Jacques Daguerre in 1839, and nineteen years later techniques such as montage, doubling, combined negatives, flashbacks, painted drops and serial storytelling were in use.

From Leonardo da Vinci's desire to permanently fix the image of the *camera obscura* through the Magia Catoptrica, a primitive lantern slide first demonstrated by Athanasius Kircher in 1640, the camera evolved into a box with a lens that scattered images over the entire earth. Right from the beginning the process and its possibilities fascinated painters, who saw in it not only a short cut over work to the playing field of art but scientific proof of what their trained vision told them about motion. Jean Louis Meissonier, an historical painter whose work is currently receiving a deserving reassessment, introduced the American photographer Edweard Muybridge to a distinguished gathering of Parisians which included Alexandre Dumas, Steinheil and Goupil to prove that horses in various stages of gallop had all four hooves off the ground. From the time of Degas' use of the photograph, whether on a glass, tin plate or today's polaroid snap, photographic images and five-colour reproductions hang over the artist's consciousness, prodding the memory of what he has actually witnessed in life and flattening out emotion.

The photographs found among Thomson's possessions and assumed to be made by him have no notable characteristics that would distinguish them from any other pictures of the period taken on a Kodak. There is the usual amount of double

Squirrel

Two Trout

Baking Fish

Catch and Net

exposure, negative damage, light leakage and hopeless attempts to photograph fauna in a welter of obliterating grey flora. Yet they demand a closer scrutiny simply because Thomson took them. The squirrel seated on a stump, for instance, is a typically cute animal picture except for the fact that it is shot from a low angle so that the squirrel, stump and trees behind form a horizon line for the entire picture. And the seven bass arranged around a fish net with spin tackle could well be a photo layout for a story on outdoor cooking.

Given the ease with which the format of a photograph could be changed from the horizontal to the vertical by merely repositioning the camera, the horizontal pull of the Algonquin proved so strong for Thomson that twenty-five of the thirty-six photos are in the landscape direction.

The portraits are actual records of people within the legend. A surprisingly formal Winnie Trainor displays the bony angularity of Katharine Hepburn and from the strain evident in the sinews of her arm appears to be having some trouble holding what can't be more than twelve pounds of fish. She is thin of mouth – might have had bad teeth – and projects a tension that has me believing the Thomson family accounts of her strangeness. Two portraits are uncanny, in that Thomson has caught the face of a friend on two different occasions, one while wearing casual attire, the other stiff-collared and Sunday-suited, in exactly the same position. The whole idea of Sunday best dress in Huntsville when filtered through the Algonquin myths of paddle and lonely campfire is, in this Age of Denim, both amusing and quaint.

There is no hard evidence that Thomson intended to use photography instead of on-the-spot sketches and colour notes as the model for his studio painting during his winters in Toronto. Nevertheless one wonders, given his dash and the fact that colour plates had been on the market since 1906 and equipment was improving rapidly, just what Thomson would have done with the process.

As it stands, the photographs are a faint grey echo of a time when Thomson and colour were synonymous and, if anything, they diminish his myth to the size of those typical snapshots that record a camping trip and increase our realization of just how much he gave, how much he brought to a landscape that could often be quite dull.

H. T.

Winnifred Trainor

Unknown Man

Unknown Man

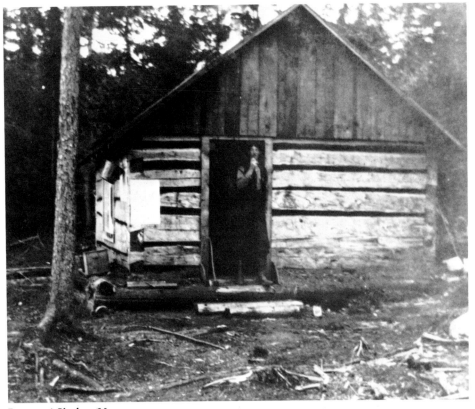

Rangers' Shelter Hut

Men in a Canoe

Burial Marker

Shoreline Reflected

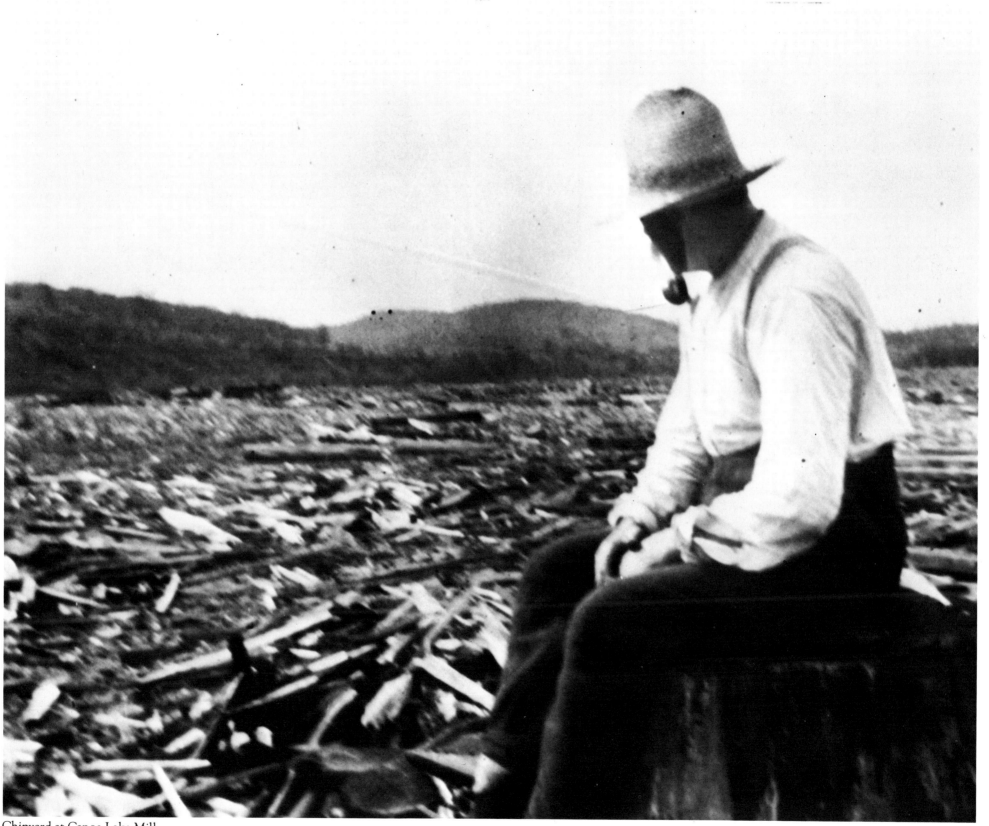

Chipyard at Canoe Lake Mill

Ducks

Groundhog

Beaver Dam

Beaver Pond

The New Queen's Hotel

South River, Ont., Sept 8 1915

Dr MacCallum

Dear Sir. I sent a check down to the Bank at Bloor & Yonge, which would arrive here Sat. morning and so far have not heard from it so conclude that my account has gone broke there. It was for $25.00 for stocking up again, could you see Harris and get the amt. from him and have it sent to me here as I am stranded

Sent down my sketches (up to a month or so ago) in a a suit case to Macdonald and have not heard if it landed

Have travelled over a great deal of country this summer, and have done very few sketches, it will be about a hundred so far. I may possibly hear from the Bank today but have almost given up hope but another week in here & I will be sent to Orillia. Yours truly Tom Thomson

The New Queen's Hotel

South River, Ont., Sept 9 1915

Dr MacCallum

Dear Sir. I am always getting excited when there is no cause for it, my letter from the Bank came last night after I had posted yours so I will get on the trail again this morning will go back up South River and cross into Tea Lake and down as far as Cachon and may make it out to Mattawa but it's fine country up this river about 10 miles, so there is lots to do without travelling very far

There are stretches of the country around here that is a good deal like that near Sudbury mostly burnt over like some of my sketches up the maganettewan River, of running the logs. but have not heard if they ever got to Toronto.

We have have had an awful lot of rain this summer and it has been to some extent disagreeable in the tent, even with a new one, the very best, you get your blankets wet and if you spread them out to dry it is sure to rain again. But if Homer or any of the boys can come up get them to write me at South River. I should like awfully well to have some company

Yours truly Tom Thomson

[margin: one of the Park Rangers came out here quite often & will take any mail in to me & so I could come out here most any pole at any time]

Letters by Tom Thomson to Dr. James MacCallum

Mowat P.O., Ontario, July 7 — 1917

Dr MacCallum

Dear Sir: I am still around Mowat
and have not done any sketching since
the flies started. The weather has been wet and cold
all spring and the flies and mosquitos much worse
than I have seen them any year and fly dope
doesn't have any effect on them. This however is
the second warm day we have had this year and
another day or so like this will finish them. Will
send my winter sketches down in a day or two
and have every intention of making some more
out it has been almost impossible lately. Have
done a great deal of paddling this spring and the
fishing has been fine. Have done some guiding
for fishing parties and will have some other trips
this month and next with probably sketching in
between. Received the ship of paper a day or so ago
and don't know anything about it. Would you give
it to Jim McDonald or someone around the bldg.
with permission to do anything about it they see fit
if they will. I will be greatly obliged.

Hoping you are well I am

Yours truly Tom Thomson

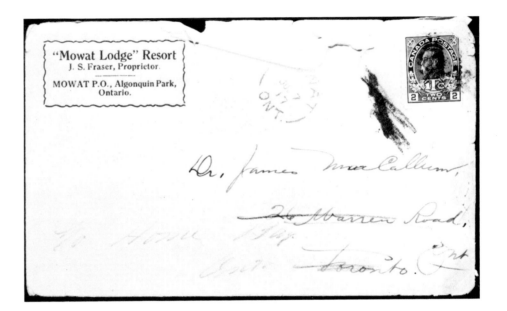

The Tom Thomson 100th Anniversary Re-issue
1877 - 1977

These etchings were ordered in 1914 from Legge Bros. Engraving Co. of Toronto, which employed Tom Thomson to make the design. J. Stuart Fleming, who made these plates available, was then an officer of the Owen Sound branch of the Children's Aid Society. He was instrumental in selecting Tom for the job. "He was selected because he was a good commercial artist, and I knew him and he was familiar with the features of Owen Sound to be illustrated". These stamps according to Mr. Fleming, represent a very creditable example of color letterpress design of sixty years ago.

The Tom Thomson Memorial Gallery and Museum of Fine Art, Owen Sound, Ontario, has re-issued these stamps on the 100th Anniversary of Tom Thomson's birth.

A Project of Tom Thomson Memorial Gallery and Museum of Fine Art, Owen Sound, Ontario.

Commercial design to promote Owen Sound

Appendices

Colour Illustrations

61 *View Over Lake to Shore with Houses*
17.8 cm x 25.4 cm (7″ x 10″)
National Gallery of Canada,
Ottawa

Thundercloud
21.6 cm x 26.7 cm (8½″ x 10½″)
National Gallery of Canada,
Ottawa

Canoe Lake
21.6 cm x 26.7 cm (8½″ x 10½″)
Private Collection

Smoke Lake
17.8 cm x 25.4 cm (7″ x 10″)
National Gallery of Canada,
Ottawa

View Over a Lake: Sunset Sky
17.8 cm x 25.4 cm (7″ x 10″)
National Gallery of Canada,
Ottawa

Northland Sunset
16.8 cm x 25.4 cm (6⅝″ x 10″)
Tom Thomson Memorial Gallery and
Museum of Fine Art,
Owen Sound

62 *Thunderhead*
17.5 cm x 25.1 cm (6⅞″ x 9⅞″)
National Gallery of Canada,
Ottawa

63 *Sunset*
21.6 cm x 26.7 cm (8½″ x 10½″)
Private Collection

64 *Spring, Algonquin Park*
21.6 cm x 26.7 cm (8½″ x 10½″)
Agnes Etherington Art Centre,
Queen's University, Kingston

65 *Burnt Area with Ragged Rocks*
21.6 cm x 26.7 cm (8½″ x 10½″)
Private Collection

Windy Day: Rough Weather in the Islands
21.6 cm x 26.7 cm (8½″ x 10½″)
National Gallery of Canada,
Ottawa

Sunset, Canoe Lake
12.7 cm x 17.8 cm (5″ x 7″)
Private Collection

Algonquin Park
21.6 cm x 26.7 cm (8½″ x 10½″)
Private Collection

66 *Evening Sky*
12.7 cm x 18.6 cm (5″ x 7⅜″)
National Gallery of Canada,
Ottawa

67 *Windy Sky*
12.7 cm x 17.8 cm (5″ x 7″)
National Gallery of Canada,
Ottawa

68 *Rain Clouds*
21.6 cm x 26.7 cm (8½″ x 10½″)
Hart Massey, Esq.

69 *Sky: The Light That Never Was*
17.5 cm x 25.1 cm (6⅞″ x 9⅞″)
National Gallery of Canada,
Ottawa

70 *Spring Ice* (sketch)
21.6 cm x 26.7 cm (8½″ x 10½″)
National Gallery of Canada,
Ottawa

70 *Spring Ice*
Oil on canvas
70.5 cm x 101 cm (27¾″ x 39¾″)
National Gallery of Canada,
Ottawa

72 *Petawawa Gorges*
21.6 cm x 26.7 cm (8½″ x 10½″)
National Gallery of Canada,
Ottawa

73 *Petawawa Gorges*
Oil on canvas
64.1 cm x 81.3 cm (25¼″ x 32″)
National Gallery of Canada,
Ottawa

74 *Swift Water*
21.6 cm x 26.7 cm (8½″ x 10½″)
National Gallery of Canada,
Ottawa

75 *A Rapid*
21.6 cm x 26.7 cm (8½″ x 10½″)
Art Gallery of Ontario,
Toronto

76 *Dark Waters*
21.6 cm x 26.7 cm (8½″ x 10½″)
National Gallery of Canada,
Ottawa

77 *The Rapids*
21.6 cm x 26.7 cm (8½″ x 10½″)
Agnes Etherington Art Centre,
Queen's University, Kingston

78 *Trestle at Parry Sound*
21.6 cm x 26.7 cm (8½″ x 10½″)
Private Collection

Timber Chute
21.6 cm x 26.7 cm (8½″ x 10½″)
Art Gallery of Ontario,
Toronto

79 *Bateaux*
21.6 cm x 26.7 cm (8½″ x 10½″)
Art Gallery of Ontario,
Toronto

80 *Tea Lake Dam*
21.6 cm x 26.7 cm (8½″ x 10½″)
McMichael Canadian Collection,
Kleinburg

81 *Tea Lake Dam*
21.6 cm x 26.7 cm (8½″ x 10½″)
National Gallery of Canada,
Ottawa

82 *Log Jam*
12.7 cm x 17.2 cm (5″ x 6½″)
McMichael Canadian Collection,
Kleinburg

Timber Chute
21.6 cm x 26.7 cm (8½″ x 10½″)
National Gallery of Canada,
Ottawa

Alligator
21.6 cm x 26.7 cm (8½″ x 10½″)
Private Collection

Log Run
21.6 cm x 26.7 cm (8½″ x 10½″)
Private Collection

83 *The Drive*
Oil on canvas
120 cm x 137.5 cm (47¼″ x 54⅛″)
University of Guelph,
Guelph, Ontario

84 *Lumber Camp, Night*
21.6 cm x 26.7 cm (8½″ x 10½″)
National Gallery of Canada,
Ottawa

85 *Nocturne*
21.6 cm x 26.7 cm (8½″ x 10½″)
Vancouver Art Gallery,
Vancouver

86 *The Pointers*
Oil on canvas
101.6 cm x 45.6 cm (40¼″ x 45½″)
Hart House, University of Toronto,
Toronto

87 *The Pointers* (detail)

88 *Burnt Over Forest*
21.6 cm x 26.7 cm (8½″ x 10½″)
P.G. McCready, Esq.,
Toronto

89 *Fireswept Hills*
21.6 cm x 26.7 cm (8½″ x 10½″)
Private Collection

90 *Sand Hill*
21.6 cm x 26.7 cm (8½″ x 10½″)
Mrs. F.E. Fisk,
Owen Sound, Ontario

91 *Forbes Hill, Huntsville*
21.6 cm x 26.3 cm (8⅜″ x 10⅜″)
Art Emporium,
Vancouver

92 *Georgian Bay, Byng Inlet*
21.6 cm x 26.7 cm (8½″ x 10½″)
Private Collection

93 *Summer Shore, Georgian Bay*
Oil on canvas
73 cm x 77.5 cm (28¾″ x 30½″)
McMichael Canadian Collection,
Kleinburg

94 *Northern River*
Watercolour on cardboard
26.7 cm x 29.8 cm (10½″ x 11¾″)
Private Collection

95 *Northern River*
Oil on canvas
114.3 cm x 101.6 cm (45″ x 40″)
National Gallery of Canada,
Ottawa

96 *Evening, Canoe Lake*
Oil on canvas
41.3 cm x 50.8 cm (16¼″ x 20″)
Private Collection

109 *Moccasin Flower*
26.7 cm x 21.6 cm (10½″ x 8½″)
Private Collection

110 *Flowers*
21.6 cm x 26.7 cm (8⅜″ x 10½″)
Art Gallery of Ontario,
Toronto

111 *Wildflowers*
21.6 cm x 26.7 cm (8½″ x 10½″)
Tom Thomson Memorial Gallery
and Museum of Fine Art,
Owen Sound

112 *Canadian Wildflowers*
21.6 cm x 26.7 cm (8½″ x 10½″)
National Gallery of Canada,
Ottawa

113 *Water Flowers*
21.3 cm x 26.7 cm (8⅜″ x 10½″)
McMichael Canadian Collection,
Kleinburg

114 *Thunderhead:*
Pink Cloud Over a Lake
21.6 cm x 26.7 cm (8½″ x 10½″)
National Gallery of Canada,
Ottawa

Dark Thunderheads
21.6 cm x 26.7 cm (8½″ x 10½″)
Private Collection

115 *Burned Over Land*
21.6 cm x 26.7 cm (8½″ x 10½″)
McMichael Canadian Collection,
Kleinburg

Spring
21.6 cm x 26.7 cm (8½″ x 10½″)
Art Gallery of Ontario,
Toronto

Burnt Country
21 cm x 26 cm (8¼″ x 10¼″)
Tom Thomson Memorial Gallery
and Museum of Fine Art,
Owen Sound

Yellow Sunset
21.6 cm x 26.7 cm (8½″ x 10½″)
National Gallery of Canada,
Ottawa

116 *Nocturne*
21.6 cm x 26.7 cm (8½″ x 10½″)
National Gallery of Canada,
Ottawa

117 *Nocturne: The Birches*
21.6 cm x 26.7 cm (8½″ x 10½″)
National Gallery of Canada,
Ottawa

118 *Lightning, Canoe Lake*
21.6 cm x 26.7 cm (8½″ x 10½″)
National Gallery of Canada,
Ottawa

119 *Rainbow*
(verso *Snow-Covered Trees*)
21.6 cm x 26.7 cm (8½″ x 10½″)
National Gallery of Canada,
Ottawa

120 *Clouds: The Zeppelins*
21.6 cm x 26.3 cm (8½″ x 10⅜″)
National Gallery of Canada,
Ottawa

121 *Summer Clouds*
21.6 cm x 26.7 cm (8½″ x 10½″)
Private Collection

122 *Ragged Lake*
21.6 cm x 26.7 cm (8½″ x 10½″)
Art Gallery of Hamilton,
Hamilton, Ontario

Sunset Sky
21.6 cm x 26.7 cm (8½″ x 10½″)
National Gallery of Canada,
Ottawa

Sombre Day
21.6 cm x 26.7 cm (8½″ x 10½″)
McMichael Canadian Collection,
Kleinburg

Storm Cloud
21.6 cm x 26.7 cm (8½″ x 10½″)
Private Collection

123 *Grey Sky*
21.6 cm x 26.7 cm (8½″ x 10½″)
National Gallery of Canada,
Ottawa

124 *The Jack Pine*
Oil on canvas
127.7 cm x 139.7 cm (50¼″ x 55″)
National Gallery of Canada,
Ottawa

125 *The Jack Pine* (detail)

126 *Pine-Cleft Rocks*
21.6 cm x 26.7 cm (8½″ x 10½″)
McMichael Canadian Collection,
Kleinburg

127 *Tamarack Swamp*
21.6 cm x 26.7 cm (8½″ x 10½″)
National Gallery of Canada,
Ottawa

128 *Hillside*
21.6 cm x 26.7 cm (8½″ x 10½″)
Private Collection

129 *Rocky Shore*
 21.6 cm x 26.7 cm (8½″ x 10½″)
 National Gallery of Canada,
 Ottawa

130 *Petawawa Gorges*
 21.6 cm x 26.7 cm (8½″ x 10½″)
 Private Collection

131 *Petawawa Gorges*
 21.6 cm x 26.7 cm (8½″ x 10½″)
 Private Collection

132 *Untitled*
 21.6 cm x 26.7 cm (8½″ x 10½″)
 Private Collection

 Cranberry Marsh and Hill
 21.6 cm x 26.7 cm (8½″ x 10½″)
 Art Gallery of Hamilton,
 Hamilton

 Woodland Stream
 21.6 cm x 26.7 cm (8½″ x 10½″)
 Private Collection

 The Waterfall
 21.6 cm x 26.7 cm (8½″ x 10½″)
 Vancouver Art Gallery,
 Vancouver

133 *Cranberry Marsh*
 21.6 cm x 26.7 cm (8½″ x 10½″)
 National Gallery of Canada,
 Ottawa

134 *Pine Country*
 21.6 cm x 26.7 cm (8½″ x 10½″)
 Tom Thomson Memorial Gallery
 and Museum of Fine Art,
 Owen Sound

135 *Tamarack*
 21.6 cm x 26.7 cm (8½″ x 10½″)
 National Gallery of Canada,
 Ottawa

136 *Pink Birches*
 21.6 cm x 26.7 cm (8½″ x 10½″)
 Private Collection

137 *Larry Dixon Splitting Wood*
 21.6 cm x 26.7 cm (8½″ x 10½″)
 Private Collection

 In the Sugar Bush (Shannon Fraser)
 26.7 cm x 21.6 cm (10½″ x 8½″)
 Art Gallery of Ontario,
 Toronto

138 *Figure of a Lady*
 21.6 cm x 26.7 cm (8½″ x 10½″)
 Private Collection

139 *Artist's Camp*
 21.6 cm x 26.7 cm (8½″ x 10½″)
 Private Collection

140 *Old Lumber Dam, Algonquin Park*
 15.6 cm x 21.6 cm (6⅛″ x 8⅜″)
 National Gallery of Canada,
 Ottawa

141 *Campfire*
 26.7 cm x 21.6 cm (10½″ x 8½″)
 National Gallery of Canada,
 Ottawa

142 *The Fisherman*
 Oil on canvas
 51.1 cm x 56.9 cm (20⅛″ x 22⅜″)
 Edmonton Art Gallery,
 Edmonton, Alberta

143 *Little Cauchon Lake*
 26.7 cm x 21.6 cm (10½″ x 8½″)
 National Gallery of Canada,
 Ottawa

144 *The Tent*
 21.6 cm x 26.7 cm (8½″ x 10½″)
 Private Collection

157 *Unfinished Sketch*
 26.7 cm x 21.6 cm (10½″ x 8½″)
 Private Collection

 Late Autumn
 26.7 cm x 21.6 cm (10½″ x 8½″)
 McMichael Canadian Collection,
 Kleinburg

158 *Red and Gold*
 21.6 cm x 26.7 cm (8½″ x 10½″)
 P.G. McCready, Esq.,
 Toronto

159 *Tamaracks*
 21.6 cm x 26.7 cm (8½″ x 10½″)
 Upper Canada College,
 Toronto

160 *Maple Woods: Bare Trunks*
 21.6 cm x 26.7 cm (8½″ x 10½″)
 National Gallery of Canada,
 Ottawa

 Ragged Oaks
 21.6 cm x 26.7 cm (8½″ x 10½″)
 Private Collection

 Maple Saplings
 21.6 cm x 26.7 cm (8½″ x 10½″)
 Private Collection

 Burnt Land
 21.6 cm x 26.7 cm (8½″ x 10½″)
 Private Collection

161 *The Hill in Autumn*
 21.6 cm x 26.7 cm (8½″ x 10½″)
 National Gallery of Canada,
 Ottawa

162 *Cedars and Pines*
 21.6 cm x 26.7 cm (8½″ x 10½″)
 Private Collection

163 *Big Birch*
 21.6 cm x 26.7 cm (8½″ x 10½″)
 Private Collection

164 *Autumn Tapestry: Tangled Trees*
 21.6 cm x 26.7 cm (8½″ x 10½″)
 National Gallery of Canada,
 Ottawa

 Black Spruce and Maple
 21.6 cm x 26.7 cm (8½″ x 10½″)
 Art Gallery of Ontario,
 Toronto

 Autumn, Algonquin Park
 21.6 cm x 26.7 cm (8½″ x 10½″)
 Agnes Etherington Art Centre,
 Queen's University, Kingston

 Forest, October
 20.6 cm x 26.7 cm (8¼″ x 10½″)
 Art Gallery of Ontario,
 Toronto

165 *Brown Bushes, Late Autumn*
 21.6 cm x 26.7 cm (8½″ x 10½″)
 National Gallery of Canada,
 Ottawa

166 *Dead Spruce*
 21.6 cm x 26.7 cm (8½″ x 10½″)
 National Gallery of Canada,
 Ottawa

167 *Tamarack*
 21.6 cm x 26.7 cm (8½″ x 10½″)
 Private Collection

168 *The Birch Grove, Autumn*
 Oil on canvas
 101.6 x 116.8 cm (40″ x 46″)
 Art Gallery of Hamilton,
 Hamilton

169 *Golden Autumn*
 Oil on canvas
 71.8 cm x 76.5 cm (28¼″ x 30⅛″)
 Power Corporation,
 Montreal, Quebec

170 *Round Lake, Mud Bay*
21.3 cm x 26.7 cm (8⅜″ x 10½″)
Art Gallery of Ontario,
Toronto

Wild Geese
21.6 cm x 26.7 cm (8½″ x 10½″)
London Public Library and Art Gallery,
London, Ontario

Chill November
Oil on canvas
91.4 cm x 106.7 cm (36″ x 42″)
Sarnia Public Library and Art Gallery,
Sarnia, Ontario

171 *Moose at Night*
21.6 cm x 26.7 cm (8½″ x 10½″)
National Gallery of Canada,
Ottawa

172 *Autumn Foliage*
21.6 cm x 26.7 cm (8½″ x 10½″)
Edmonton Art Gallery,
Edmonton

173 *Northern Lights*
16.2 cm x 25.1 cm (6⅜″ x 9⅞″)
Tom Thomson Memorial Gallery and
Museum of Fine Art,
Owen Sound

Northern Lights
21 cm x 26 cm (8¼″ x 10¼″)
Private Collection

Snow Pillars in the Sky
21.3 cm x 26.3 cm (8⅜″ x 10⅜″)
National Gallery of Canada,
Ottawa

174 *The West Wind*
21.3 cm x 26.7 cm (8⅜″ x 10½″)
Art Gallery of Ontario,
Toronto

175 *The West Wind*
Oil on Canvas
120.7 cm x 137.5 cm (47½″ x 54⅛″)
Art Gallery of Ontario,
Toronto

176 *Snow and Rocks*
26.7 cm x 21.6 cm (10½″ x 8½″)
National Gallery of Canada,
Ottawa

177 *First Snow*
21.6 cm x 26.7 cm (8½″ x 10½″)
Agnes Etherington Art Centre,
Queen's University, Kingston

178 *Frost-Laden Cedars, Big Cauchon Lake*
Oil on canvas
30.5 cm x 38.1 cm (12″ x 15″)
National Gallery of Canada,
Ottawa

179 *Mowat Lodge*
21.6 cm x 26.7 cm (8½″ x 10½″)
Poole Collection, Edmonton Art Gallery,
Edmonton

180 *Snow-Covered Trees*
21.6 cm x 26.7 cm (8½″ x 10½″)
National Gallery of Canada,
Ottawa

181 *Snow in October*
Oil on canvas
81.9 cm x 87 cm (32¼″ x 34¼″)
National Gallery of Canada,
Ottawa

182 *White Birch Grove*
Oil on canvas
64.1 cm x 54 cm (25¼″ x 21¼″)
Private Collection

183 *Snow and Earth*
12.7 cm x 18.4 cm (5″ x 7¼″)
Private Collection

Early Spring
21.6 cm x 26.7 cm (8½″ x 10½″)
McMichael Canadian Collection,
Kleinburg

Heavy Snow
21.6 cm x 26.7 cm (8½″ x 10½″)
Private Collection

Wood Interior, Winter
21.6 cm x 26.7 cm (8½″ x 10½″)
McMichael Canadian Collection,
Kleinburg

184 *First Snow in Autumn*
12.7 cm x 18.6 cm (5″ x 7⅜″)
National Gallery of Canada,
Ottawa

185 *Snow in the Woods*
12.7 cm x 18.4 cm (5″ x 7¼″)
National Gallery of Canada,
Ottawa

186 *Early Spring*
21.6 cm x 26.7 cm (8½″ x 10½″)
Art Gallery of Ontario,
Toronto

187 *Late Snow*
21.6 cm x 26.7 cm (8½″ x 10½″)
Private Collection

188 *Spring in Algonquin Park*
21 cm x 26 cm (8″ x 10″)
Private Collection

189 *Cold Spring in Algonquin Park*
21.6 cm x 26.7 cm (8½″ x 10½″)
Consolidated Bathurst, Montreal

190 *Afternoon, Algonquin Park*
21.6 cm x 26.7 cm (8½″ x 10½″)
Private Collection

191 *The Marsh, Early Spring*
21.6 cm x 26.7 cm (8½″ x 10½″)
National Gallery of Canada,
Ottawa

Thaw in the Woods
12.7 cm x 17.8 cm (5″ x 7″)
Private Collection

Winter Thaw
12.7 cm x 17.8 cm (5″ x 7″)
Private Collection

Woods in Winter
14 cm x 19.2 cm (5½″ x 7¾″)
Tom Thomson Memorial Gallery
and Museum of Fine Art, Owen Sound

Early Spring, Canoe Lake
21.6 cm x 26.7 cm (8½″ x 10½″)
Private Collection

Winter in the Woods
21.6 cm x 26.7 cm (8½″ x 10½″)
National Gallery of Canada,
Ottawa

192 *Melting Snow*
Tempera on silk
36.2 cm x 55.9 cm (14¼″ x 22″)
Private Collection

Black and White Illustrations

Chronology

1849 Birth of William Cruikshank

1858 Birth of Horatio Walker

1863 Birth of Edvard Munch

 Le Déjeuner sur l'Herbe by Edouard Manet

1864 Birth of Ozias Leduc

1865 Birth of James Wilson Morrice

1866 Birth of Maurice Cullen, Wassily Kandinsky

1867 Confederation of Canada

 Birth of Curtis Williamson, Pierre Bonnard, Emil Nolde

1868 Birth of Edouard Vuillard

1869 Birth of J.W. Beatty, Aurèle de Foy Suzor-Coté, C. W. Jefferys, Frank Lloyd Wright, Henri Matisse

1870 Birth of John Marin

1871 Birth of Emily Carr, Edmund Morris, Giacomo Balla

 Death of Paul Kane

1872 Birth of Piet Mondrian, Aubrey Beardsley

 Death of Cornelius Krieghoff

1873 Birth of J.E.H. MacDonald

 Ontario Society of Artists formed

1874 First Impressionist Exhibition, Paris

1875 Death of François Millet, Jean-Baptiste Corot

 The Gross Clinic by Thomas Eakins

1876 Birth of Constantin Brancusi

1877 **Birth of Thomas John Thomson near Claremont, Ontario, August 4**

 Thomson family moves to Leith, Ontario, in October

 Birth of Marsden Hartley

 Death of Gustave Courbet

234

1879 Birth of Francis Picabia, Paul Klee

Death of Honoré Daumier

1880 Birth of Joseph Stella, Arthur Dove

Royal Canadian Academy of Arts founded

1881 Birth of Frederick Varley, Pablo Picasso, Fernand Léger

1882 Birth of David Milne, A.Y. Jackson, Edward Hopper, Umberto Boccioni, Georges Braque

1883 Birth of Charles Sheeler, E.J. Pratt

Completion of the Brooklyn Bridge

Death of Edouard Manet

1884 Birth of Max Beckman

1885 Birth of Lawren Harris, Arthur Lismer, Robert Delaunay

1886 Birth of John Lyman

Toronto Art Students League formed

1887 Birth of Kurt Schwitters, Juan Gris, Marc Chagall, Marcel Duchamp

1888 Birth of Franz Johnston, Jean (Hans) Arp

1889 Eiffel Tower completed

1890 Birth of Franklin Carmichael, Giorgio Morandi

Death of Vincent Van Gogh

1891 Birth of Frederick Banting

1893 Birth of Joan Miro

Algonquin Park made a provincial game preserve

1894 *Breaking a Road* by William Cruikshank

1896 Klondike goldfields discovered

Logging in Winter, Beaupré by Maurice Cullen

1898 Birth of A.J. Casson, Alexander Calder, Henry Moore

Death of Aubrey Beardsley

Hector Guimard begins designs for Paris Metro Stations

Thomson apprentices at Kennedy's, Owen Sound, for eight months

1899 Boer War begins

Thomson tries to enlist

Joins Ancient Order of Foresters; registers at the Canadian Business College in Chatham, Ontario.

1900 Birth of Charles Comfort

Death of John Ruskin

The Flood Gate by Homer Watson

Mont Sainte Victoire Seen from Bibemas Quarry by Paul Cézanne

1901 **Thomson arrives in Seattle; studies for six months at the Acme Business College**

Birth of Jack Humphrey

Death of Henri de Toulouse-Lautrec

1902 **Thomson employed by Maring and Blake, Engravers**

1903 Birth of Carl Shaefer

David Milne arrives in New York

Death of Camille Pissarro, Paul Gauguin, J.A.M. Whistler

The New North by D.F. Thomson

1904 **Thomson returns to Toronto**

Birth of Jean-Paul Lemieux, Gooderige Roberts, Willem De Kooning, Salvador Dali

First Fauve exhibition, Paris

1905 Birth of Paul-Emile Borduas

Alfred Steiglitz opens Photo Secession Gallery ("291"), New York

Die Brücke group of German Expressionists formed in Dresden

Collected Poems by William Wilfred Campbell published (a possible inspiration for Thomson)

Saskatchewan and Alberta become provinces

1905-6 **Thomson possibly studies with William Cruikshank**

1906 Birth of Alfred Pellan, Maxwell Bates

Death of Paul Cézanne

1907 John Lyman and A.Y. Jackson arrive in France

J.E.H. MacDonald joins Grip Limited

Canadian Art Club formed by Edmund Morris

Blue Nude by Henri Matisse

The Nude by Georges Braque

Les Demoiselles d'Avignon by Pablo Picasso

1907-8 **Thomson hired at Grip Limited by Albert Robson**

Meets J.E.H. MacDonald

1908 The Arts and Letters Club founded, Toronto

First exhibition by The Eight (The Ash Can School), New York

1909 Birth of B.C. Binning, Jack Bush, Jack Shadbolt

Manifesto by the Futurists, Milan

The Ferry, Quebec by J.W. Morrice

1910 Emily Carr pursues studies in France

Eric Brown appointed Director, National Gallery of Canada

Exhibition of Independent Artists, New York

The Vaughan Sisters by William Brymner

Première Niege (First Snow) by Horatio Walker

The Evening Cloud of the Northland by J.W. Beatty

Houses, Wellington Street, Winter by Lawren Harris

The Edge of the Maple Wood by A.Y. Jackson

1911 Arthur Lismer and Franklin Carmichael join Grip Limited

Beginning of outdoor sketching trips to York Mills, Lambton Mills, Weston, Lake Scugog

Der Blaue Reiter (Blue Rider) German Expressionist group formed, Munich

1912 Birth of Jackson Pollock

Dr. James MacCallum and Lawren Harris meet J.E.H. MacDonald at the Ontario Society of Artists exhibition

Thomson makes first visit to Algonquin Park with H.B. (Ben) Jackson in May

Thomson makes long canoe trip with William Broadhead through Mississagi Forest Reserve (west of Sudbury) in August and September

Thomson moves to Rous and Mann Press, following Albert Robson, Franklin Carmichael, and Arthur Lismer; they are joined by Frederick Varley

Thomson begins to "paint up" the first of his northern sketches

Wassily Kandinsky's *Concerning the Spiritual in Art* published

The Drive by Lawren Harris

Tracks and Traffic by J.E.H. MacDonald

Billboards by David B. Milne

Nude Descending a Staircase by Marcel Duchamp

1913　Thomson exhibits and sells *A Northern Lake* at the Ontario Society of Artists spring show

Thomson summers in Algonquin Park; introduced to A.Y. Jackson by Dr. MacCallum in the fall; leaves Rous and Mann to work full-time as an artist, with assistance from MacCallum to meet expenses

Plans announced for a public gallery in Toronto

National Gallery of Canada Act passed

Harris and MacDonald visit exhibition of Contemporary Scandinavian Art, Buffalo, New York

Harris and MacCallum agree to finance construction of the Studio Building

A.Y. Jackson meets MacCallum, Harris and others

Central Ontario School of Art and Design becomes Ontario College of Art

Death of Edmund Morris

Kazimir Malevich outlines Suprematist theory in Russia

International Exhibition of Modern Art (The Armory Show), New York

Terre Sauvage by A.Y. Jackson

Unique Forms of Continuity in Space by Umberto Boccioni

Bicycle Wheel by Marcel Duchamp

1914　Completion of the Studio Building, January

Thomson shares Studio One with Jackson, January-February

Jackson visits Algonquin Park, February-March; goes west with Beatty for the summer in April

Thomson exhibits *Moonlight, Early Evening* in Ontario Society of Artists exhibition; it is sold to National Gallery of Canada

Becomes member of the Ontario Society of Artists

Meets Lismer in Algonquin Park in May for two weeks

Does some guiding for fishing parties

Travels by canoe to MacCallum's cottage on

Georgian Bay and back to Algonquin Park

Paints with Jackson in the park in the fall; they are joined by Varley and Lismer

First World War begins; **Thomson tries to enlist;** Jackson returns to Montreal

Exhibits *A Lake, Early Spring* at Royal Canadian Academy

Contributes *In Algonquin Park* to the Canadian Patriotic Fund Sale

Shares Studio with Franklin Carmichael, then moves into shack, winter 1914-15

Green Apples by Ozias Leduc

Nine Malic Moulds by Marcel Duchamp

1915　Jackson enlists

Thomson exhibits *Northern River* and *Split Rock, Georgian Bay* in the spring Ontario Society of Artists exhibition; the former is purchased by the National Gallery of Canada; the latter donated to it by the Kitchener Art Committee

Paints in Algonquin Park, April to November

Possibly to Georgian Bay in October to measure MacCallum's walls for projected murals

One-man show at Arts and Letters Club in December

Vladimir Tatlin introduces Constructivist theories in Russia

Panama-Pacific Exhibition, San Francisco

Marcel Duchamp arrives in New York

1916　**Thomson exhibits *Spring Ice* in Ontario Society of Artists spring exhibition**

Works as a ranger in Algonquin Park during the summer; travels the Petawawa River; returns to Toronto for the winter to paint *The Pointers*, *The West Wind*, *The Jack Pine* and *The Drive*

The Tangled Garden by J.E.H. Macdonald and ensuing controversy

Golden Snow by Ozias Leduc

Dadaist Manifesto, Zurich

The Forum Exhibition, New York

Death of Thomas Eakins, Odilon Redon

1917　**Thomson returns to Algonquin Park in March; gets guide's licence; fishes with MacCallum in May; visited by Frances McGillvray**

Thomson drowned in Canoe Lake, July 8

Cairn erected by J.W. Beatty and J.E.H. MacDonald

Memorial exhibition of Thomson's work at Arts and Letters Club

Birth of Andrew Wyeth, Jacques de Tonnancour

First publication of *De Stijl* magazine

Death of Auguste Rodin, Edgar Degas

1918　End of First World War

The Brooklyn Bridge by Joseph Stella

White on White by Kazimir Malevich

1919　**Commemorative exhibition, Arts Club of Montreal**

Death of Auguste Renoir

1920　**Commemorative exhibition, Art Gallery of Toronto**

First exhibition of the Group of Seven, Toronto

Birth of Alex Colville

1922　Death of William Cruikshank

1924　Birth of Harold Town

Manifesto of Surrealism

Death of James Wilson Morrice

1933　Group of Seven dissolves; Canadian Group of Painters formed

1934　Death of Maurice Cullen

1936　Death of Homer Watson

1937　Death of Aurèle de Foy Suzor-Coté

1938　Death of Horatio Walker

1941　Death of J.W. Beatty

1944　Death of Curtis Williamson

1945　Death of Emily Carr

Selected Bibliography

The following is a partial list of the works consulted in the preparation of this book. Altogether the material came from 55 newspaper and 81 magazine articles, 41 books, 111 letters, 15 catalogues and a number of other miscellaneous documents. Additional information was obtained from interviews and from transcripts of interviews.

The archival holdings of the Public Archives of Canada (which include the Blodwen Davies Papers), the MacCallum Papers at the National Gallery of Canada, the Colgate Collection in the Public Archives of Ontario and the letters held by Mrs. F.E. Fisk were particularly helpful. The records of the Arts and Letters Club, the library of the Art Gallery of Ontario and the files of the Tom Thomson Memorial Gallery and Museum of Fine Art were also useful, as were the files of the McMichael Canadian Collection.

General

Colgate, William. — *Canadian Art: Its Origin and Development,* Toronto: Ryerson Press, 1943 (paperback edition, 1967)

Harper, J. Russell. — *Painting in Canada, A History,* Toronto: University of Toronto Press, 1966

Harris, Lawren S. — *The Story of the Group of Seven,* Toronto: Rous and Mann Press, 1964

Housser, F.B. — *A Canadian Art Movement, The Story of the Group of Seven,* Toronto: Macmillan Company, 1926

Hubbard, R.H. — *The Development of Canadian Art,* Ottawa: National Gallery of Canada, 1963

Jackson, A.Y. — *A Painter's Country,* Toronto: Clarke Irwin and Co. Ltd., 1958 (paperback edition, 1964)

MacDonald, Thoreau. — *The Group of Seven,* Canadian Art Series, Toronto: Ryerson Press, 1944

MacTavish, Newton. — *The Fine Arts in Canada,* Toronto: Macmillan Company, 1925

McInnes, Graham C. — *Canadian Art,* Toronto: Macmillan Company, 1950

Mellen, Peter. — *The Group of Seven,* Toronto: McClelland and Stewart Ltd., 1970

Reid, Dennis. — *The Group of Seven,* Exhibition Catalogue. Ottawa: National Gallery of Canada, 1970

Robson, Albert H. — *Canadian Landscape Painters,* Toronto: Ryerson Press, 1932

Books and Catalogues on Tom Thomson

Addison, Ottelyn. — in collaboration with Elizabeth Harwood. *Tom Thomson, The Algonquin Years.* Foreword by A.Y. Jackson, Drawings and an Appendix by Thoreau MacDonald. Toronto: Ryerson Press, 1969

Davies, Blodwen. — *Paddle and Palette: The Story of Tom Thomson.* Notes on the pictures by Arthur Lismer. Toronto: Ryerson Press, 1930

————. — *A Study of Tom Thomson, The Story of a Man who Looked for Beauty and for Truth in the Wilderness,* Toronto: Discus Press, 1935. Revised Memorial Edition with Foreword by A.Y. Jackson, Sketches by Arthur Lismer, Vancouver: Mitchell Press, 1967

Hubbard, R.H. — *Tom Thomson,* Society for Art Publications, Toronto: McClelland and Stewart Ltd., 1962

Little, William T. — *The Tom Thomson Mystery,* Toronto: McGraw Hill, 1970

MacCallum, J.M. — *Tom Thomson: Painter of the North.* Catalogue: Loan Exhibition of Works by Tom Thomson, Toronto: Mellors Gallery, 1937

Montreal, The Arts Club. — *Catalogue of an Exhibition of Paintings by the Late Tom Thomson,* Foreword by A.Y. Jackson, March, 1919

National Gallery of Canada. — *Thomson's Photographs,* Bulletin #16, 1970.

MacCallum, J.M. — "Tom Thomson: Painter of the North." *Canadian Magazine,* L (1918), pp. 375-85

Robson, Albert H. — *Tom Thomson, Painter of our North Country, 1877-1917.* Canadian Art Series, Toronto: Ryerson Press, 1937

Saunders, A. — *Algonquin Story,* Toronto: Department of Lands and Forests, 1947

Toronto, Art Gallery of Toronto. — *A Memorial Exhibition of Paintings by Tom Thomson,* February 13-19, 1920

Toronto, Art Gallery of Ontario. — *The Art of Tom Thomson,* by Joan Murray, Curator of Canadian Art, October 30-December 12, 1971

Town, Harold. — *The Pathfinder,* Great Canadians, Canadian Centennial Library. Toronto: McClelland and Stewart Ltd., 1965

Articles on Tom Thomson

Buchanan, Donald W. — "Tom Thomson, Painter of the True North." *Canadian Geographical Journal,* Vol. XXXIII, no. 2 (August 1946), pp. 98-100

Colgate, William, ed. — *Two Letters of Tom Thomson, 1915 and 1916.* Weston, Ontario: The Old Rectory Press, 1946. Also published in Saturday Night, November 9, 1946.

Comfort, C. — "Georgian Bay Legacy." *Canadian Art,* VIII, no. 3 (Spring 1951), pp. 106-109

Fairley, Barker (B.F.) — "Tom Thomson and Others." *The Rebel,* III, no. 6 (March 1920), pp. 244-48

Lamb, H. Mortimer. — "Studio-Talk: Tom Thomson." *The Studio,* LXXVII, no. 317 (August 1919), pp. 119-26

Lismer, A. — "Tom Thomson, 1877-1917, A Tribute to a Canadian Painter." *Canadian Art,* V, no. 2 (1947), pp. 59-62

Little, R.P. — "Some Recollections of Tom Thomson and Canoe Lake." *Culture,* XVI (1955), pp. 200-208

MacDonald, J.E.H.	"Landmark of Canadian Art." *The Rebel*, Vol. II, no. 2 (November 1917), pp. 45-50
Pringle, Gertrude.	"Tom Thomson, The Man, Painter of the Wilds was a Very Unique Individuality." *Saturday Night*, Vol. XLI, no. 21 (April 10, 1926), p. 5
Sharpe, Dr. Noble.	"The Canoe Lake Mystery." *Journal, Canadian Society of Forensic Science*, Vol. III, no. 2 (June 1970), pp. 34-40

Newspaper Stories on Tom Thomson

"Pictures by Sydenham Boy Worth Seeing. Mr. Thomson's Pictures Show Decided Talent of Promising Talent." *Owen Sound Sun*, April 10, 1917

"Toronto Artist Missing in North." *Globe*, Toronto, July 13, 1917

"Toronto Artist Drowns in North." *Globe*, Toronto, July 18, 1917

"Tom Thomson's Aged Father Typifies Son's Rugged Scenes." *Toronto Star*, February 4, 1926

"Canoe Discovered by Boy on Lake Is Believed to Be Tom Thomson's." *Mail and Empire*, Toronto, August 9, 1930

Blodwen Davies, "Young Pirates Hunt Lake Artist's Canoe." *The Star Weekly*, Toronto, August 9, 1930

"Totem Pole Honors Tom Thomson's Ideal." *Mail and Empire*, Toronto, August 18, 1930

"Bark Canoe Carries Memorial Flowers." *Globe*, Toronto, August 19, 1930

St. George Burgoyne, "Tom Thomson, Painter of the Wilds, Lost to Canadian Art 20 Years Ago." *Montreal Gazette*, September 25, 1937

Percy Ghent, "Tom Thomson at Island Camp, Round Lake, November, 1915." *Toronto Telegram*, November 8, 1949

T. Arthur Davidson, "Tom Thomson Grew to Manhood in Leith Area and Later Became Canada's Best Known Painter." *Owen Sound Sun-Times*, January 21, 1956

"Bones at Canoe Lake Not Those of Artist." *Globe and Mail*, Toronto, October 19, 1956

Paul Duval, "Tumbledown Shack–Or Art Shrine?" *Toronto Telegram*, May 6, 1961

Ronald Grantham, "Artist Suddenly Saw What Canada Is Like." *Ottawa Citizen*, January 13, 1968

"Morbid Curiosity Should Not Be Satisfied." *Owen Sound Sun-Times*, February 4, 1969

Index of Illustrations

This book was designed by Harold Town and Bob Young
Tom Thomson monogram was designed by David Shaw
Studio stamp design was designed by J. E. H. MacDonald
Typesetting by Howarth and Smith Limited
Film separations by Herzig Somerville Limited
Stocks: Rolland Paper Company and Abitibi Provincial Paper
Lithography by Ashton-Potter Limited
Cloth: Columbia Finishing Mills Limited
Binding by The Hunter Rose Company